The Life of Emily Carr

The Life of Emily Carr

Paula Blanchard

Douglas & McIntyre
Vancouver/Toronto

The University of Washington Press
Seattle

Financially assisted by the Government of British Columbia through the British Columbia Heritage Trust.

Douglas & McIntyre Ltd., 1615 Venables Street, Vancouver, British Columbia V5L 2H1

Canadian Cataloguing in Publication Data

Blanchard, Paula, 1936–
 The Life of Emily Carr

 Bibliography: p.
 Includes index.
 ISBN 0-88894-604-X

 1. Carr, Emily, 1871–1945. 2. Painters–
Canada – Biography. 3. Painters – British Columbia –
Biography. I. Title.
ND249.C3B56 1987 759.11 C87-091196-1

The University of Washington Press, PO Box 50096, Seattle, Washington 98145

Library of Congress Cataloging-in-Publication Data

Blanchard, Paula.
 The life of Emily Carr.

 Bibliography: p.
 Includes index.
 1. Carr, Emily, 1871–1945. 2. Painting, Canadian.
 3. Painting, Modern–20th century–Canada. 4. Painters–
Canada–Biography. 5. British Columbia in art.
 I. Title.
ND249.C3B55 1987 759.11 [B] 87-15910
 ISBN 0-295-96680-7

All care has been taken to trace ownership of images in this book. Omissions will be corrected in subsequent editions, provided notification is sent to the publisher.

Front jacket: *Self-portrait,* by Emily Carr, c.1938, oil on paper.
 Private Collection, Toronto
Back jacket: Emily Carr in her studio, c. 1936. In the background is
 Sunshine and Tumult. Photo by Harold Mortimer Lamb
Design by Barbara Hodgson
Typeset by The Typeworks
Printed and bound in Canada by D.W. Friesen & Sons Ltd.

Contents

Author's Note

MANY PEOPLE helped me over the seven years this book was in the making. They shared their memories of Emily Carr, gave me valuable advice, dug out facts from dusty corners and half-buried boxes, read the manuscript, and offered tea, sympathy and assorted varieties of moral support. I cannot name them all, nor would I try for fear of leaving out even one and unintentionally returning offence for kindness. They do know who they are, and I here extend to each my heartfelt thanks.

I owe a few special debts: to Merloyd Lawrence, who introduced me to Emily Carr and helped the book along in many ways; to Edythe Hembroff-Schleicher, who gave generously of her time, opened new material to me and enlarged my understanding of the old; to my husband, Byron, who shepherded the book and me through the mysteries of word-processing; to Lydia N. Breed, Dr. Joseph H. Brenner, Mrs. Caroline Moody and Dr. D. van Zwanenberg for their help in various important ways; to Kerry Mason Dodd, curator of the Emily Carr Gallery; to Mrs. Elizabeth Cross and the reference librarians of the Cary Memorial Library in Lexington, Massachusetts.

For information on Emily Carr's exhibiting career I have relied heavily on the thoroughly researched facts provided by Edythe Hembroff-Schleicher in her book *Emily Carr: The Untold Story*.

I would like to express my gratitude to the staffs of the following for their patient assistance: Boston office of the Archives of American Art, Smithsonian Institution; Art Gallery of Ontario; Canadian Centre for Folk Culture Studies, National Museums of Canada; Emily Carr Arts Centre (now closed); Glenbow-Alberta Institute; Edmonton Art Gallery; Musée des Beaux Arts Contemporaires, Montreal; National Gallery of Canada; Provincial Archives of British Columbia, which now houses the Emily Carr papers; Provincial Museum of British Columbia; Public Archives of Canada, which organized and described the Emily Carr papers during my research; San Francisco Art Institute; Seattle Art Museum;



University of British Columbia Library; Vancouver Art Gallery; Greater Victoria School Board (District 61).

I gratefully acknowledge the following: Archives of American Art, Smithsonian Institution and John Davis Hatch, for permission to quote from the correspondence of John Davis Hatch and Emily Carr; Archives Collection of the Art Gallery of Ontario, for permission to quote from letters of C. Marius Barbeau and H. Mortimer Lamb; Marius Barbeau Collection, Canadian Centre for Folk Culture Studies, Canadian Museum of Civilization, National Museums of Canada, for permission to quote from the correspondence of Emily Carr and C. Marius Barbeau; Irwin Publishing Inc., for permission to quote from the published works of Emily Carr; Edythe Hembroff-Schleicher, for permission to quote from her published works, her unpublished correspondence with Emily Carr, and her taped interview with Frederick Brand; John I.D. Inglis, for permission to quote from the Phylis Inglis Collection of Emily Carr papers; J.E.A. Parnall, for permission to quote from unpublished Emily Carr papers; Margaret H. Knox and Lawren P. Harris, for permission to quote from letters of Lawren Harris.

A word about orthography: In quoting from Emily Carr's unpublished manuscripts, I have regularized her inimitable spelling and punctuation. I have done so with a certain amount of regret, for they add spice to her writing and, I believe, would prejudice none but the pedantic. But since I have often had to work from notes rather than original copy, I decided to regularize her orthography for the sake of accuracy and consistency. Some idea of the original can be gained from the excerpt on pp.271–72.

Introduction

EMILY CARR is a familiar figure to Canadians, as familiar as Robert Frost or Andrew Wyeth is to Americans. Her paintings have been reproduced time and time again on post cards, stamps and calendars, almost all her books are in print over forty years after her death, and countless articles and several books have been written about her. She is still widely admired as a painter, though in the last fifteen years galleries and museums have given higher priority to more recent artists. As her reputation settled somewhat in those years, the Vancouver Art Gallery had some trouble raising enough money to restore the large collection of Carr paintings in their care, though eventually they managed to do so. Similar difficulties still hamper efforts to have her childhood home maintained as a national treasure.

Still, Emily Carr herself *is* a national treasure, and among most Canadian art historians her place as one of the country's leading painters is secure. It is some measure of the parochialism of Americans and the international community that she is so little known outside Canada. Particularly puzzling is the neglect of feminist art historians. Although Emily Carr's paintings have represented Canada abroad in many international exhibitions, she was omitted from such recent feminist studies as *The Obstacle Race* by Germaine Greer, *Women Artists: Recognition and Reappraisal from the Early Middle Ages to the Twentieth Century* by Karen Petersen and J. J. Wilson, and *Women Artists: 1550–1950* by Ann Sutherland Harris and Linda Nochlin.

Recently two Canadian writers, Doris Shadbolt and Maria Tippett, have contributed to a new understanding of Carr's life and work, one as an art historian and the other as a biographer.[1] We also have two personal records written by a friend, Edythe Hembroff-Schleicher, who added to her own memories a definitive history of Carr's exhibiting career.[2] But there remains room for a biography that focusses primarily on the inner conflicts of a woman painter of Emily Carr's time and place and tries to answer once more the nagging, familiar question of why one woman

transcended them when others did not. This book is one attempt to fill that space. It brings also the perspective of a foreigner, who assumes no more previous acquaintance with Emily Carr than the author herself had in the beginning.

The sources for much of this book, particularly the early years, are the published autobiographies, supplemented by unpublished stories, letters and journals. Readers who already know Emily Carr's books will find much that is familiar, but I have tried to use the distance of history to see her life in a way she herself might not recognize and certainly would not approve. She winced at the thought of any stranger poking into her life; that was one motivation for writing it herself. Her books are highly crafted autobiography, dense with the personality of the writer. They are her self-vindication, a way of putting to rest old guilts and airing old grievances. A passionate sensibility, looking back at its own growth, creates its own priorities. It sees events as part of what it believes it has become and what it wishes to be. Emily Carr's books are her resolution of the problem of personal myth, and they are primarily concerned with emotional rather than factual truth.

Where other sources are lacking, I have taken her at her word, though always with a reservation I hope the reader will share. Where other sources are available, as for instance on the identity of her friends in *The Book of Small*, I have found her to be truthful in the broad picture, though inconsistent in details. Often it has been possible to check her memories by comparing one version with another, and then the distortions come to light fairly easily. For example, she consistently portrayed herself as younger than she was; she exaggerated her isolation on her trips north; she suppressed the identity of the man she loved; she submerged the encouragement of some Victorians under the hostility of most, tarring them all with the same brush; her published memories of her father are in some respects harsher than reality and in others not harsh enough; she needed to maintain that her two eldest sisters were English-born; she was shy of revealing the depth of her feeling for Ira Dilworth; in her bitterness over her years of "landladying" she made herself seem more sinned-against by her tenants than she actually was. And finally, the full force of her revulsion against the ordinary mass of human beings has been understated in the published writings, both by Emily herself and by the editors of her posthumously published journals.

Such distortions show us the writer building her idea of herself, and ultimately it was her idea of herself that helped her achieve what she did. Charles Taylor expresses the feeling of many students of Carr when he writes that she needed "to feel rejected, to be an outcast and a rebel."[3] Both as an artist and as a person, she exaggerated the indifference and petty persecutions she encountered until she made of them a visible, potent antagonist, one worthy of the energy of genius. Nothing is so deadening to an artist as to be trivialized, and women artists have often

been patronized nearly to death. They have been smothered under mountains of feathers. Emily Carr too had her paintings discussed on the women's page, and some of her strongest supporters, among them the dealer Max Stern and her last and best friend, Ira Dilworth, praised her for painting like a man.[4] Emily's usual response to being patronized was to draw on a considerable reserve of rage, stored up since childhood. It reinforced the sense of alienation which helped her preserve her creativity.

In one sense her entire life was a campaign against what she saw as "sham." She found it everywhere, in English manners, formal religion, art critics, philistines, rival artists, and suspiciously often in the close relations of her friends. She fought it passionately, and part of the appeal of her writing lies in her use of active, even violent verbs which seethe with the energy of her personal crusade. Things are flung, hurled, slammed, scrubbed, snapped, smacked, seized and pushed; people (especially children) howl, squeal, wriggle, and give and get "terrific hugs." The verbs are given more force by being confined in simple, declarative sentences and by the spare, sensual vitality of her images. She uses all her senses. The effect is one of extraordinary immediacy; we really are absorbed in her experience. Beyond that, the lean sentences, barely long enough to hold the verbs still, create an illusion of childlike candour. This is conscious art, since the narrator Small, the child in Emily Carr, was a persona she evoked at will in later years and the part of herself she liked best. In Small's voice telling us about her childhood we hear a child's impatience at meaningless restraint and her quick sense of injustice. We are disarmed, and her villains become ours. All the same, without any intention of misleading us, she has transformed her life into a finished artifact, with all the awkward ends tucked in.

Besides being a remarkably fine painter, she demolished some traditionally cherished notions about women artists. Her colours are strong, her style deeply sculptural or bold and sweeping. She was not tied to the personal: she did not paint portraits or domestic scenes. Nor did she leap into abstraction. She was the rarest kind of woman painter, a landscapist, identifying with that larger, impersonal universe once thought the exclusive province of the free-roaming male. Among modern women painters, perhaps only Georgia O'Keeffe is comparable in both conception and stature.

In this book I have concentrated on Emily Carr as a creative personality and particularly as a creative woman. Creativity itself, of course, is beyond explanation. Nothing infuriated Emily Carr more than to have some well-meaning critic or curator question her about dates and influences or hint at some theory about subconscious motives. But the nurturing of creativity is another question, and the towering scorn she heaped on such hapless souls is itself evidence of how well she defended the mysterious sources of her art. She was, in fact, a remarkably angry

person, and if in the following pages I return often to that theme, it is
because I have been fascinated by the constructive use Emily Carr made
of anger. Certainly I had no such preconception when I began my re-
search, but it became more and more inescapable as I came to know her
better.

The positive uses of anger, particularly women's anger, is a subject
that needs more exploration than it has yet received. Perhaps because our
culture is more uncomfortable with anger than it is with sex, or because
of the strong Freudian influence in traditional psychology, there has been
little written about anger on the layman's level except for Carol Tavris's
Anger: The Misunderstood Emotion. In recent years it has become part of
the popular wisdom that anger expressed is "healthy" and "clears the
air," and that anger turned inward is destructive and causes depression
and various psychosomatic ills. (Tavris, by the way, questions both these
assumptions.) But most of us have not given much thought to the ways
in which justified anger can contribute to creative expression. If we do
think about it, we can relate it more easily to the lives of social reformers
and politicians than to those of artists. Margaret Sanger was angry, and
Norman Bethune and Charles de Gaulle. The link between their rage and
their achievement is clear. But although many people in the arts have had
legendary tempers, their anger is not generally thought of as being neces-
sary. It just seems to be part of the general emotional baggage they carry
around with them.

In the case of Emily Carr, we see a clear example of anger contributing
substantially to a creative career. I do not mean to confuse her anger with
her art, for the two are quite distinct. It goes without saying that Carr's
paintings are utterly free of polemic. Yet the fierce energy that helped her
shake off discouragement and even despair, that spilled over into her re-
lationships with people and prickles under the surface of her writing—
that energy was generated by her rage against the society into which she
was born. She would not be what "they" wanted her to be, and it was
partly to spite "them" that she became what she was. She was rare in her
unconscious ability to draw upon a force that, in another woman, might
have fizzled into helplessness.

Of course, she had many other impressive qualities: physical endur-
ance, courage, a powerful set of old-fashioned values, a stubborn in-
nocence, a love of play, a saving sense of irony and a deep—if skittish
—capacity for love. "I don't love many," she once wrote, "but when I
do I love *hard*."[5] Certainly all these are as characteristic of Emily Carr as
anger. But in a culture that discouraged both anger and artistic vitality in
women, Emily Carr conspicuously preserved both and remained whole.
If she was difficult, as she certainly was, at least we can applaud her for
not allowing Victoria to make her into an anonymous pleasant lady.

Richard Carr

IN 1837 AN ENGLISH BOY, following the example of thousands during the hungry thirties, boarded a ship for America. His name was Richard Carr, and he was the youngest of thirteen children. His mother had borne him in her forty-seventh year, and his brothers and sisters had long since scattered. He had not seen most of them in years. His father, Thomas Carr, was a tradesman who could give his children little opportunity for formal schooling. Although Richard had been to Europe the previous year and knew a little of the world, he had small acquaintance with the basic rules of spelling and grammar. But making one's way in America did not depend on booklearning as much as on a cool head and an eye for the main chance, and in both these respects young Richard was any man's equal. At eighteen he was a sober, judicious youngster, not easily surprised nor indeed moved to any emotion. Methodical in everything, he kept a journal in which to write down his impressions of the New World.

Richard's brother Thomas was homesteading in Alabama, but Richard made no immediate attempt to find him. Instead he took temporary lodgings in New York City and tried to get his bearings. What he saw was not particularly cheering. He wilted in the steaming summer heat, and his native fastidiousness was offended by the table manners of his American fellow boarders: "To see them eat anybody would suppose their [*sic*] was a heavy bet depending—to be awarded to the one that done first. . . . have not formed a very favourable opinion of them so far they may improve as I get better acquainted with them."[1] But they never did.

For the next eleven years he wandered the Americas from Quebec to Peru, living from hand to mouth. In the beginning he worked as a seaman in winter, shipping out of New Orleans on regular cargo shuttles to eastern ports and Cuba. In summer he would move north and stay until fall, finding work where he could. Through it all he kept his journal,

recording the geographical and commercial statistics of each city in his ponderous schoolboy style.

Brawling frontier America showed him her worst side. In Tuscaloosa he saw four shootings, one a double murder committed by an eighteen-year-old in a family vendetta. In New Orleans duels and saloon riots were commonplace, and in Natchez a vigilante group had recently dealt imaginatively with a nest of gamblers.

Carr watched it all from a discreet distance and was appalled. No frequenter of saloons, he could keep well out of danger on land. Danger at sea, though, was beyond anyone's power to avoid. Meticulously he noted down each disaster: "One of the sailors fell from the main arm. . . . was not expected to recover" (25 Oct. 1838); "One of the passengers was confined with a mail [sic] child it only lived about 4 hours — was consigned afterwards to the fish" (9 Nov. 1841); "Fell in with the wreck of the brig Wisconsin. . . . her crew had most likely been washed overboard" (17 Oct. 1842); "Several of the ships in port have lost nearly the whole of their crews [from yellow fever]" (10 Oct. 1843). Once, his vessel was nearly wrecked and had to be run aground, and along the Florida coast he routinely ran the gamut between the Seminoles on land and the privateers at sea.

But if restlessness is any measure, then danger did not threaten Richard Carr half as much as boredom. He seldom stayed more than six or eight weeks in one place. Even the prospect of leading a settled life in Canada could not tempt him to leave off wandering, though his heart melted with homesickness whenever he crossed the border:

> I always feel great pleasure in entering any part of the British Dominions or even when I see the colours of my native country waveing proudly in the breeze it brings to my mind the scenes of my childhood and friends far away. I like canada far better than the United States when I am here I feel at home, the inhabitants are mostly of British de[s]cent and attached to the mother country.[2]

Homesteading, in Canada or elsewhere, was out of the question. He got a taste of it in 1838 when he briefly visited his brother in Alabama. Thomas and his family lived in the middle of a dense and cheerless forest, a mile and a half from even the nearest passing wagon. Richard could not bear the tedium. To break it he walked four days through the forest to Tuscumbria, reached it, gave it the cursory glance it deserved and walked back again. After six more days of reminiscing and turkey-shooting, he bolted.

He spent the winter of 1839 ice fishing with two other men off an island on Lake Michigan. They lived in a tiny cabin they built themselves.

They had no reels; when one of them got a bite he picked up the line and set off running to land the fish. They wrapped themselves in layers of clothes and blankets, and the cold raised blisters on their hands and faces. They lived on potatoes and bread, and fish when they had enough of it.

That winter Richard came to know more about the native peoples. He had seen Cherokees in Alabama being rounded up and moved from their lands. Not understanding what was happening to them any more than they did, he had simply noted that they were "healthy looking and cleanly dressed."[3] Now he lived among Ojibwas and Chippewas, who were about to be removed in their turn. They shared their fishing grounds with the white fishermen, taught them elementary survival, carried their mail and occasionally pulled them out of the lake. Richard admired the natives' clothes, wigwams and canoes, and sometimes thought the "red man" superior to the white: "I believe [the women] to be more virtuous than the generallity of white females[.] I always found [the natives] civil and obliging and very honest, much more so than their white neighbours who never miss an oppertunity of cheating them."[4]

From his own neighbours he held aloof, as he did from his fellow seamen. From all his years of wandering he would gain no lasting affection, no dependable loyalty. He formed acquaintanceships only, with people he was casually glad to see and casually sorry to leave. He was not lonely; he was simply self-sufficient.

Dogged by bad luck, he gave up fishing the following summer, made his way back to New Orleans with 37½ cents in his pocket and signed onto his old ship. He was at sea for several years. It was a gruelling life, but it did have one advantage: he could visit home. He had never lost touch with his family, and twice he managed to get ashore at Liverpool and make his way to Beckley, Oxfordshire, where his parents lived. The second time, in 1842, he found that his mother had died six weeks before. His father was bewildered, visibly failing and alone, though a sister visited briefly while Richard was there. Father and son drew closer together, and afterward the pace of family correspondence quickened somewhat. But Thomas Carr remained alone, and when he died in 1846 only two of his relations saw him buried. The emotional distance in the family cannot entirely be explained by geography. Years later Richard would comment dryly on how little he owed to the help of his family, and it was not until he was in his mid-forties that he learned such basic bits of family history as the birth dates of his brother Samuel and his sister Eliza.[5]

By 1845 Richard had his head full of yet another enterprise. He had just learned daguerrotype photography, and he was determined to try his new trade in New Orleans, the city which seems to have drawn him more than any other in America. But his luck was still dismal. The rich

clients he had hoped for never appeared. He gave them three weeks, and then turned his back on them and on the States, heading for the dubious promise of lands farther south.

So began a three-year odyssey of astonishing hardship that took him from the Yucatan to Peru. Alone except for a dog, he wandered from settlement to settlement, taking pictures where anyone could afford to buy them. Somehow he made a living; occasionally he made a little more than a living and bought a chicken to go with his tortillas. He was cheated and regarded with suspicion—once he was even arrested—but he also met with surprising kindness from total strangers. Again he was moved by the sufferings of the native people, who in the Yucatan had been driven to insurrection. He saw them hunted and flogged, and once he saw three shot by a firing squad.

Still poor, still waiting for the New World to be kind to him, he was in Ecuador in 1848 when rumours reached him of the California gold rush. Certainly this was the ultimate main chance. Reluctantly he set off for San Francisco, though his view of Americans had not sweetened with time. "The Americans I detest," he commented as primly as if he had never left his New York boarding house. "In all the time that I have been with them I have not became [sic] acquainted with one that could with propriety be termed a gentleman."[6]

He found San Francisco in chaos. Markets went untended and mills stood idle, while ships in the harbour lost their crews overnight to the gold fields. Astonished at the inflation—a blanket cost $40— Richard was quick to turn it to his own advantage, charging twice his usual rates. For once he was in the right place at the right time. In a month he had made $400, and a few weeks later he set off for the mines himself. He worked his claim for two years, until he was rich enough to open a provisioning business in Alviso. Soon, with a partner, he was able to open three more stores in neighbouring towns. After fourteen years of knocking about the continent, he had turned into a prosperous, settled burgher.

Yet the most surprising thing about Richard Carr is that he had never been anything else. Badly educated though he was, he had clung to the rules of English middle-class decorum, idealizing them in his mind and planting somewhere in the field of his imagination a Union Jack as the symbol of all that was orderly in the world. The affection another man might have felt for family or friends had all been centred on his native country. Nor had all his hardships managed to shake his native celibacy and sobriety. The brutality of a seaman's life had not added so much as one mild blasphemy to his working vocabulary. Outwardly he had lived the life of the classic nineteenth-century adventurer; inwardly he had always been a wholesale grocer having adventures.

He was now in his mid-thirties: a straight-browed, grey-eyed, solemn, bespectacled man with thinning brown hair, plagued now and

then by gout and beginning to thicken around the middle. Except for three young women he had corresponded with briefly years earlier, there had been no women in his life to speak of. Now he met a solitary young Englishwoman, living in a boarding house in San Francisco. Her name was Emily Saunders and she came from Eynsham, Oxfordshire. She was about eighteen, slight and pretty with dark hair drawn evenly back from an oval, serious face. An illegitimate child,[7] she seems to have had no one to look after her except an older Englishwoman, Mrs. Quantack, who lived in the same house. Possibly she had come to America as a governess and been left stranded. At any rate, she was in need of a protector, and when Richard Carr proposed marriage she accepted.

They wanted to be married in England, but this created an awkwardness, since she had no chaperone for the journey. Quietly Richard booked passage for them both, and they sailed in October 1854. Propriety was no doubt fully observed, and it requires a keen eye to find in Richard's account of the voyage any clue that Emily was with him at all. Their embarrassment was resolved when they reached home and were married in her home parish on 18 January 1855.

They immediately returned to Alviso, where they enjoyed five years of placid domesticity. In quick succession Emily bore two daughters, Edith and Clara Louisa. Richard enjoyed at last the luxury of friendships ripening over time and finally felt he was surrounded by people who cared whether he went or stayed. Yet always, in the back of his mind, was the picture of an idyllically green and tranquil England. When his wife's health began to fail in 1861, he decided to go home and retire. By now he was worth about $30,000. He invested most of it in four shiploads of California wheat and flour, left his remaining affairs in the hands of a friend and sailed for England on the *Great Republic*, rumoured to be the fastest ship afloat. In the hold below them was one of his own cargoes of wheat, the first ever to be shipped around the Horn.

The family settled in Barnstaple, Devonshire, and devoted themselves to becoming English once more. But England as it was could not possibly come up to England as Richard remembered it. He admired the lush fields but suffered irritably under the rain that kept them green. He saw with distaste that Swansea was black with factory smoke. He chafed at the inconvenience of shopping for furniture piece by piece, recalling that in California you could buy a complete bedroom set in one large store. The old-fashioned kitchen fireplace devoured coal at an alarming rate and gave little heat in return, so in exasperation he sent for a "Yankey stove."[8] Active all his life, he had sudden misgivings about retirement, wished his garden were bigger and resolved to lengthen the time he spent on his daughters' lessons.

Moreover, England's climate seemed bad for the family's health. Emily's cough and shortness of breath did not improve, and when she

bore a son a few months after their arrival he lived only four days. Another boy, born the following year, died at two days and was buried next to his brother.

Except for grief over the death of his first son, very little of all this found its way into Richard's journal. But clearly his wife's bad health and the loss of his sons must have helped convince him that coming home had been a mistake. By March 1863 he was looking west again:

> I am got tired of living here doing nothing, do not like the climate to[o] much rain—everything seems different to what I exspected, but the change is with me, 25 years absence makes things appear different even in ones native country[.] I have decided on returning to California my children will have a much brighter prospect before them in that or some other newly settled country.[9]

Accordingly, back they sailed. They stopped briefly in California to see old friends and to deliver a horse that Richard, somewhat rashly, had volunteered to escort from England. It was probably the last rash act of his life. The Carrs sailed on to Vancouver Island. There, where the British flag flew even more proudly, if possible, than it did over England itself, Richard Carr would at last strike roots; and there he would thrive and grow into that sturdiest of English oaks, the Victorian paterfamilias.

Victoria

VICTORIA, THE CITY the Carrs finally would call home, had recently become the capital of the new colony of British Columbia. For all its exalted status, it was unprepossessing enough: a grid of dusty streets lined with a miscellaneous hodgepodge of shacks, log cabins and wooden storefronts. Here and there a solid brick or stone building added ballast, as if to keep the whole flimsy assemblage from blowing away.

Before this unlovely nest of human enterprise lay a small harbour of fairytale loveliness, and to the east around the tip of the island the coastline curved northward from beach to shining beach along the Juan de Fuca Strait. From there one could see, like giant sentinels guarding the mainland, the peaks of the Olympic Mountains fitfully emerging from their swathes of cloud.

Richard Carr was impressed:

> I certainly am agreeably surprised to find this place the town it is[.] It is beautifully located—contains about 6000 inhabitants though only laid out as a town in 1858 when the great rush took place. . . . on some days at that time as many as 3000 people landed here in a day. . . . real estate is very high now . . . in the immediate vicinity land is selling for $1000—and upwards per acre. . . . the streets and sidewalks are generally speaking very good, much better than is usually the case in new towns—7 churches, 3 daily papers. . . . shops well supplied with goods—but prices high.[1]

He was wrong about the population, which was fluctuating wildly, but otherwise his optimism was not misplaced. It was true that there were a great many saloons (there would be eight-five by 1865, many of them brothels and gambling houses), but the basic character of the town was as firm as that of the queen for which it was named. Ladies passing saloons simply looked the other way.

Victoria had a checkered past. It was founded in 1842 as a trading post

by the Hudson's Bay Company, who were worried about the large in-
flux of American settlers pouring into the Oregon country. The Amer-
icans, according to the Company and its friends, were ruffianly or
destitute or both; besides, their arrival in such numbers stirred up the
native peoples. Even more alarming was the fact that the American Con-
gress, bent on protecting its settlers, was casting a newly acquisitive eye
on the Pacific Northwest. The Hudson's Bay Company, historically
based on the Columbia River, decided on a graceful retreat to a place that
was indisputably British. So, right from the beginning, the fortified is-
land post was a symbol of British national pride. Its very existence was a
defiant gesture aimed at the upstart newcomers to the south.

The early fort was small and primitive, consisting of a few wooden
buildings enclosed by a wooden palisade. The ground between the build-
ings was dotted with horse manure and cluttered with wagons, and dur-
ing the winter rains it sprouted signs here and there warning of mudholes
that were, as far as anyone knew, bottomless. All lumber had to be split
and planed by hand, and drinking water was hauled from a spring a mile
away. Nevertheless, the semi-military protocol of the Hudson's Bay
Company was scrupulously observed. Officers dined at a segregated
mess from tables resplendent with white linen, silver and crystal. And
presently there appeared within the walls of the fort an English garden,
planted with heliotrope and mignonette and other flowers dear to the
English heart.

The fort was a tiny enclave, built on a small area of coastal grasslands.
Beyond it, to the north, stretched three hundred miles of virgin forest,
infested with bears and panthers and so dense that even the native tribes
lived only along the beaches. The same damp, mild climate that nour-
ished Victoria's gardens gave the forest its stubborn, quasi-tropical
fecundity. Battalions of firs, spruce and ancient cedars locked arms
against the settler's axe.

On the fringes of Victoria, farms nibbled at the edge of the wilderness,
and there were coal mines a few miles up the coast. But most people
turned their backs to the forest. They cultivated the coastal land, sold
their produce to the eager markets of San Francisco, traded with the
whalers and waited for the English ships that arrived regularly in the
tiny, beautiful harbour. They gave very little thought to the remote, un-
easy alliance of eastern colonies that would eventually be known as Can-
ada. It was to England that they looked for tea, tweeds, whiskey, books,
and news of the outside world.

In time Victoria became a crown colony, though it grew slowly,
partly because of restrictive clauses designed to favour wealthy settlers.
By 1858 there were only about five hundred souls. In that year the town
received a rude shock: some 25,000 prospectors, drawn by rumours of
gold in the Cariboo, descended on Victoria to outfit themselves for the

trip inland. In their wake followed hordes of entrepreneurs of all stripes, until the English were all but swamped by waves of unruly foreigners. Nearly two hundred new businesses opened, saloons and bawdyhouses sprang up overnight, and water suddenly cost 50 cents a bucket. As the miners moved on, many businesses stayed, and certain parts of town took on an exotic flavour as Chinese, German and Jewish merchants made them their own.

The wave took a few years to recede, but as it did the old Victoria emerged once more—somewhat changed, of course, a bit more cosmopolitan and certainly a lot more prosperous, but still British to the core. If anything, the invasion may have stiffened the lady's back a little and made her virtue a bit more unassailable.

This was Richard Carr's kind of city: full of the scent of New World possibility (there was yet another rumour of Cariboo gold), but thoroughly steeped in Old World culture and values. It did not take him long to scout out a place to live. Beside the business district lay an evil-smelling tidal inlet called James Bay, spanned by a new wooden bridge. On the other side of the bridge were the new parliament buildings, a covey of squat, pagodalike wooden structures aptly nicknamed The Birdcages. Beyond them—and safely beyond the smell—lay some of the island's oldest farmland, now being broken into house lots. Here, near the foot of Beacon Hill, Richard Carr bought ten acres of ground and built a house.

Local timber was still scarce, so like many of his neighbours Carr built his house of imported California redwood. The house was not very large, but it was lovingly designed in the fanciful Italianate villa style, with double-arched upper windows, a full front veranda topped by a balcony and a generous frosting of carved fretwork. The style, according to one of its early proponents, was meant to evoke "emotions of the beautiful and the picturesque," in imitation of the summer retreats of the European rich. Discreetly hidden behind the house was a lattice-screened utility yard and a fenced barnyard flanked by two barns, and beyond them was a pasture with a small, stream-fed pond. In front of the house and on both sides Carr planted the gardens he had always wanted: beds of perennials edged with banks of flowering shrubs, traditional favourites from imported English stock. A young grapevine curled over the veranda railing, and rows of sturdy fruit trees were set out among the vegetables. Around the pasture, between an inner and outer fence, he planted a maze of formal shrubbery with a meandering gravel path. Except for the pasture every inch of space was tamed and classified. The garden was enclosed by a substantial fence, and the gate was flanked by poplars. "Father wanted his place to look exactly like England," Emily recalled. "He planted cowslips and primroses and hawthorn hedges and all the Englishy flowers. He had stiles and meadows and took away all

the wild Canadian-ness and made it as meek and English as he could."[2]

Only one flaw disturbed this illusion of perfection. In an ill-advised moment in 1863, soon after he bought his land, Carr sold an acre of it to William and Harriet Lush, hotelkeepers. They promised they would not build a hotel on it, and from the depths of his curiously untouched naiveté he believed them. They immediately went back on their word, and the hotel, built to cater to the horse-racing trade in Beacon Hill Park, opened with much fanfare in 1864. It was called the Park Hotel, though later the named was changed to the Colonist. By all accounts it was a rough and bawdy place. William Lush himself was hauled into court at least twice, once for brawling and once for selling liquor to a native Indian. Richard Carr was outraged. He was no teetotaller himself, but the flagrant breach of faith was insupportable, as was the sight of "tipsy sailors and noisy ladies" so near his wife and daughters. We can well believe his daughter that it "hurt Father right up till . . . he died."[3]

Aside from this intrusion, which he minimized as much as possible by planting a high hedge, his little park was the perfect setting in which to play the country gentleman. It was not so perfect for the gentleman's lady, and when his wife first saw the isolated site of her new home she burst into tears. By the time they moved in, her husband was established in the wholesale provisioning business, and every morning except Sunday he disappeared on foot down the grassy track to the city, followed by his daughters on their way to school. Had it not been for a single neighbour, Mrs. Bissett, Mrs. Carr would have had no one to talk to except the Chinese servant, who spoke little English.

But gradually James Bay became a fashionable place to live, and other houses were built near them. The Carr family grew with the neighbourhood. A third son was born in 1865, but died after five months. Then there was a succession of hardy daughters: Elizabeth Emily was born in 1867, Alice Mary in 1869, Emily in 1871. Finally, in 1875, Mrs. Carr gave birth to a frail but surviving son, who was named Richard Henry.

In 1871, the year Emily was born, British Columbia became a Canadian province. By then the spindly young plants around the house had burgeoned into a lush mass of greenery and colour, to which Richard Carr gave every moment he could spare. Each summer he took a plateful of strawberries to the editor of the Victoria Daily Colonist, to prove he grew the biggest ones in town. One from the crop of 1869 measured 6½ inches around the middle, and the editor obligingly displayed it in the front window. The grapevine had acquired a name, Isabella, and had begun to yield some very beautiful, if rather sour, purple grapes. The road in front of the house had to be widened; Carr donated a strip of land for this purpose sometime around 1885, and the road was named in his honour. Cows wandered it at will, enjoying a freedom denied the city cows. They clambered into the deep drainage ditch and feasted on the

damp, succulent grass that grew there, their backs half-hidden by cas-cades of wild roses. They disputed possession of the plank sidewalk with pedestrians, who shooed them away with canes and parasols. One of small Emily's duties, when she grew old enough, was to call for a timid lady who lived down the road and would not visit Emily's mother unless she had an escort to stare down the cows.

Emily was called Milly by her family and by most native-born Vic-torians throughout her life. Even as a baby she was the prettiest of the sisters, a plump child with an English complexion, wide almond-shaped grey eyes, and blonde curly hair that darkened as she grew. In her teens, as her facial structure became more pronounced, her wide cheekbones would lend her face a piquant, slightly exotic cast, utterly un-Carrlike. When she was small her roundness and high colour suggested robust health, but she was subject to "bilious attacks" that came from no dis-cernible cause. They were treated with bitter yellow pills and "black draughts," which she dreaded more than the sickness itself, and of course she got little sympathy because nobody believed such a hearty-looking child could have anything wrong with her.[4]

Temperamentally, too, she resembled no one else. Impulsive, volatile, quick with her tongue, prankish, affectionate, critical, often sullen and occasionally rude, she exasperated and embarrassed the other members of her family, whose own emotions were generally firmly reined in. In Emily's books we see her through her own eyes, of course, and the child she shows us is forever planting her two feet, looking some officious grownup squarely in the eye and saying "No." In the absence of other evidence we have every right to doubt her, but the adult she became con-firms the image of the child.

She was physically demonstrative both in love and anger, and she was bossy. Children who seemed too good or too passive provoked her to bullying. She could not resist persecuting a little girl who lived nearby, for no other reason than that the child looked so meek and mealy-mouthed. She sometimes attacked her sister Lizzie and bit her, though Lizzie was bigger than she was. On the other hand, her sudden rushes of affection moved her to fierce hugs that were distinctly out of place among the Carrs. Animals, she found, were more responsive, and very early she discovered a feeling for them more perfect and satisfying in its way than what she felt for people. She was drawn to animals as her father was to his garden. She worried over them when they were sick. Once she disgraced herself by doctoring a peaked-looking hen with castor oil, indoors, in someone else's house. The indignant bird recovered on the spot.

Her four sisters were very different from Emily and each other. Edith was called Dede (pronounced "Dee-dee"). Fifteen years older than Emily, she had a hot temper which was kept well submerged under a

strong sense of propriety. Keenly interested in missionary work, she eventually helped found Victoria's YWCA and was active in the Protestant Orphanage. She organized Bible study groups, taught Sunday school, and in other circumstances might have been a missionary herself. But when Emily was small their mother's health was weakening, and it was Dede who took on the direction of the household. It seems clear that the younger children bore the full brunt of her deflected missionary zeal. She bathed them every Saturday night, after filling the kettles and wash-boilers by "working the kitchen pump-handle furiously." Dede didn't just wash, she "scrubbed hard," and spanked with the dipper handle if anyone squirmed.[5] She dressed them in the morning—always, it seems, rather roughly—and then took them to their mother for inspection. Emily resented and frequently defied her, earning a smack or a box on the ear. And yet the eyes that look back at us from Dede's extant photos are full of humour, and Emily teasingly called her The Kaiser. After the Saturday night bath she rushed the children upstairs pick-a-back, and one can imagine tussling and horseplay, and perhaps pillow fights before prayers. April Fool's Day at the Carrs' was celebrated with elaborate pranks even after the children reached adulthood, and it is hard to believe they were always and only Emily's.

Clara, or Tallie, was two years younger than Dede. Like her brother Dick, she was thought to have weak lungs, and she was excused from family obligations that might tax her strength. When Emily was ten Tallie married John Nicholles, a militia officer and son of a retired dental surgeon. Then a clerk for Wells, Fargo, he later became a partner in a store specializing in hardware and heavy machinery. Emily found various reasons to dislike him in retrospect, mostly because he left her sister after about twenty years of marriage. But during her childhood they were happy enough and prosperous, and they were the most socially conspicuous members of the family.

Both before and after her marriage, Tallie was a shadowy figure in her younger sisters' lives. She was someone "who did not rule over us as Dede did,"[6] someone to visit, the owner of a prolific cherry tree, the mother of babies, the occasion of their being called Aunt. But she was somehow on the outside; she was the sister who married.

Lizzie preferred to be called Betty, but Emily called her Lizzie nevertheless. Pious and fastidious, she seems to have worked very hard all her life at being a good child. In Emily's memory she would always remain a caricature of the smug, chilly saints of English evangelicalism—a Mrs. Proudie in miniature. In *The Book of Small* Lizzie is the tattletale, the child whose hair ribbon never comes untied. She knows enough to eat her cake as if she didn't like it. Like Dede, she wanted to be a missionary. She knew her Bible well and could use it as a weapon when she chose. "If

you did not see things just in Lizzie's way," Emily complained, "you were dead in your sins."[7]

> [Lizzie] is the first person I remember quarreling with—she loved Alice deeply so did I. Alice was the halfway between us two. When she bickered too hard I kicked over the traces she knew just exactly how to aggravate then when you threw *all* sanity and reason to the winds and hit or tore or scratched she put on the saint and quoted scripture. . . . [Once] I scratched her hand. I can feel the burning shame now at those two or three nail marks. . . . how vile I was and yet how *supremely* she could aggravate and go off with that saintly air and a text thrown back at you. How she knew just how to set the match that burst you into flame.[8]

They could play happily together, but their childhood was punctuated by the marks of Emily's teeth on Lizzie's lean arm. When Lizzie died at the age of sixty-nine, she would leave behind a pile of religious tracts and pamphlets that still had power to ignite Emily's rage, even in the midst of grief.

Between them, the peacemaker and centre of their stormy competition, was Alice. Ostensibly mild and reserved, she had a will as strong as any of the others, but expressed it only passively. Alice, when provoked, dug in. She never openly questioned authority but silently backed Emily's small rebellions. When Emily loses a handkerchief in *The Book of Small,* it is Alice who slips her another one so she will not be scolded. Throughout their lives she was Emily's close friend and ally, but more often than not she would lend her voice to Lizzie's in chorus: "Oh Milly, I wish you had not done that." She preferred dolls to animals, and when she grew up would become a schoolteacher: a "diminutive, kindly lady" who tempted sparrows into her schoolroom with bits of bread and looked rather like a bird herself, but who kept strict order with the help of a little black ruler.[9]

Dick was born when Emily was almost four. From the beginning it was clear that he was fragile and might share the fate of his three brothers. Like Emily he was a beautiful child, dark and blue-eyed, though he was thin and easily tired. His mother guarded him fiercely—it was one of the few points on which she differed from her husband—and he would not have been allowed to join his sisters' outdoor games even if he had wanted to. In himself he formed another family unit, just as the two sets of sisters did. Emily petted him, protected him and may have been a bit jealous of him, but she did not know him well. He may have seemed like one of her exquisite wax dolls from America, that melted when they were left in the sun.

For the Carr children daily life began with a cold plunge in a tub of

water kept under each bed, for their father held firmly to the popular be-
lief in the health-giving, mind-toughening properties of cold water. "If
your nose were not blue enough at the breakfast table . . . there was
trouble."[10] Then there were morning prayers, led by their father from a
prayer book that had been covered with black cotton because its own
cover was purple "and Father did not think that was reverent."[11] After
breakfast and a quick visit to the cow yard to see the animals, Emily
would walk with her father to the James Bay bridge; she was not allowed
to cross it because of the saloons on the other side. When she got home
there were lessons with Dede, at least until the three girls entered school
when Emily was seven. In the afternoon they might play "ladies" with
the three Cridge sisters from across the street, either in the Cridges' field
or on the ridge behind the Carrs' pasture, where their play house was a
clearing surrounded by spirea and syringa bushes. At a quarter to six
they were called to wash and change for tea.

Evenings were spent quietly. Their mother was too tired at night to go
out, and she tended to see her friends in the afternoon, when other
women came to sew and drink tea in the garden while their children
gorged themselves on summer fruit. Sometimes friends did come in the
evening, to sing songs around the rosewood spinet brought from En-
gland, which only Dede could play. Now and then the whole family
would go to a church *conversazione,* which was family entertainment on a
larger scale. Occasionally there were Saturday picnics, when the children
could fish off the rocks or bathe (dressed in nightgowns) in the sea. Once
or twice a year friends from America or England would arrive and stay
for weeks at a time, and every May twenty-fourth the Carrs joined the
rest of Victoria in a day-long, outdoor celebration of the Queen's
birthday.

But they seldom joined the city's more sprightly entertainments—the
cricket, shooting and polo matches, the horse races and mock fox hunts
that were held in Beacon Hill Park. Nor did they go to the garden
parties, tennis games and balls where Victoria's young people mingled
with the officers from the nearby Esquimalt naval base, though now and
then Dede and Tallie went to the big annual ball given by the navy in re-
turn for the city's hospitality. Richard Carr did not want his girls casting
about for navy husbands, or for any husbands at all. "He had made a nice
home for us and thought we should stay in it."[12]

Except for a brief visit from one of their Uncle Samuel Carr's sons, the
children never met any of their relations and knew almost nothing about
them. There were Carrs living in Canada and doubtless in England too.
There may have been relations on the Saunders side as well. Emily's
mother once remarked to her that she was just like her Aunt Nancy, but
there was no explanation of who Aunt Nancy was, either then or later.[13]
One obvious explanation is that there was some embarrassment over

Mrs. Carr's illegitimate birth. There may also have been a conscious decision on Richard Carr's side to disown his relations, for whatever reason. And so the family was curiously adrift, almost as though Richard and his wife had summoned it out of thin air.

They were, according to one neighbour, "a very, very stay-at-home sort of family."[14] Even for daily necessities they did not have to stir very far. Many things were brought to them or done for them. Bong, their Chinese man-of-all-work, cooked, milked the cow and did most of the heavy housework. He came every morning except Sunday, arriving between half past six and seven o'clock and staying until the evening dishes were washed. He fed the stoves and fireplaces, scrubbed the floors and carried the water upstairs to the children's tubs. Through the gate and into the gravel-paved yard came a regular procession of deliveries: fuel was bought from Negro vendors who drove from house to house in large, heavy vans; drinking water from Spring Ridge was sold from a white cart, drawn by a white horse; bread and meat were ordered in town by Richard Carr and delivered; fish, vegetables and wild fruits were sold door to door by native Indian and Chinese men, and even household utensils and sewing notions could be bought in one's own kitchen from peddlers. Eggs, milk and most vegetables and fruits were produced at home. There was little reason for Bong or any of the Carr women to venture often into town.

And in a sense the Carrs' peaceful, predictable life was reflected in the life of the city itself. After being hustled suddenly into another era, Victoria was allowed to sit down and breathe, rearrange her skirts and look around her. The boom was over, and continued growth depended on the Canadian Pacific Railway, which was slowly, painfully nosing its way over the Rocky Mountains. Victorians hoped it would leap the Georgia Strait and come all the way to their island. But when it finally did reach the coast, it halted at the new mainland city of Vancouver and refused to budge another inch. In that year, 1887, the commercial centre of the province shifted permanently to the mainland. Victoria was still the capital, still the naval base, but there were no more noisy invasions from the outside world. People felt regret, and a resentment of upstart Vancouver that lingered into the twentieth century; yet they also felt relief that the old values and gentle rhythms of English life were still alive. Secure on its island, the city drifted a bit farther from the mainland, through space that no geographer could measure.

CHAPTER
3

Father and Daughter

EMILY'S RELATIONSHIP with her father was complicated and intense. Its boundaries of love and hate marked the boundaries of her childhood. Its exclusiveness (for there was no question of where his favour lay) gave her a precocious sense of confidence, a sense of being the chosen one who could break the rules.

By the time she was born her father had carefully arranged his life to suit a pattern. All trace of the ice fisherman, footloose photographer and gold miner was gone, or else it showed only in a negative image. "Our family had to whiz around Father like a top round its peg," Emily wrote.[1] Richard Carr was fifty-three when his youngest daughter was born, and he looked like an Old Testament patriarch, with his long, grey, square-cut beard and the skull cap he wore indoors to cover his bald spot. He was rather stout and not very tall, yet he was an imposing presence even to a stranger. The walking stick he carried was not an affectation, since he was still much troubled by the gout, but like his skull cap and spectacles it seemed essential to the man.

When he set off for work each morning he took his youngest child along as far as the James Bay bridge. Lizzie and Alice had each enjoyed this privilege in turn, and then it became Emily's. She held it for several years, longer than any of the others. In *Growing Pains* she remembers hearing her mother explain to someone how this came about:

> "My husband takes no notice of [the children] till they are old enough to run round after him. He then recognizes them as human beings and as his children, accepts their adoration. You know how little tots worship big, strong men! . . .
>
> "Each of my children in turn my husband makes his special favourite when they come to this man-adoring age. When this child shows signs of having a will of its own he returns it to the nursery and raises the next youngest to favour. This one," she put her hand on me, "has overdrawn

her share of favouritism because there was no little sister to step into her shoes. Our small son is much younger and very delicate."[2]

In all likelihood the barbs of irony in this passage are Emily's own. As an adult she knew that her "adoration" of her father had involved some compromise of her own integrity, but as a child she was enormously pleased at being singled out. Her father did not seem to mind her having a will of her own, and she suspected he despised her small brother's weakness. When he was home in his garden he wanted her "at his heels every moment," following him around and handing him his tools. When they all walked to church on Sunday she walked next to her father and held his hand, and during Dr. Reid's interminable sermons she was allowed to sleep against his rough sleeve. "Father kept sturdy me as his pet for a long time," she wrote. " 'Ah,' he would say, 'this one should have been the boy.' "[3]

Her recollections of him are laced with her keen sense of the absurd. We see him fussing over his grapevine like an elderly nursemaid; building a succession of equally ingenious, equally impractical bathrooms; sneaking into a roadside tavern after carefully driving past it so no one would see. He never sat on the horsehair furniture in the drawing room because its "unhappy arrangement of castors" had a way of tipping people on the floor; so at Tallie's wedding he fetched a cane chair from the dining room for himself and hovered near it all evening for fear someone else would sit on it.[4] Like Emily Dickinson, Emily Carr delights in making an overbearing father look ridiculous. But Richard Carr was a stronger adversary than Dickinson's father, and there was no open family alliance against him, no conspiratorial snickers behind the door when he was being especially pompous. When Emily reached adolescence, her mild rebellion erupted into a paroxysm of rage and guilt (for reasons that will presently be explained), and a good deal of this later anger colours her descriptions of her father, giving them a darker tone than she herself realized. She tried to do him justice in her writing, to admire "the beauty of orderliness that was in all Father's ways."[5] At the end of her life she thought her portrait of him in *The Book of Small* had "perhaps . . . in some way atoned for all my years of bitterness."[6] But if it was an atonement, it was also a kind of exorcism.

When he came home in the afternoon the family and their friends scattered like minnows. Visiting ladies gathered up their sewing and their babies and scuttled out the door, playmates melted away over the pasture fence, and the Carr children were shooed upstairs to make themselves presentable. "The routine of our childhood home ran with mechanical precision,"[7] Emily writes, and if the machine ran ever so slightly awry there was an inevitable explosion. Yet his irritability, though a trial to everyone, was also part of the family ritual. Emily thought he actually

"enjoyed" his temper, and she thought the rest of them did as well; it added sauce to their lives and kept them awake. There was a certain set of hot-pads for the serving dishes that he hated the sight of. When he found them on the table he would hurl them into the fireplace, and whoever sat nearest would have to fish them out before they burned. But it is clear from the way Emily tells this that it was all a predictable sequence, and at at least for a while no one bothered to devise another way to protect the table from the hot dishes.[8]

When he had the gout his temper grew worse, and then they really did all try to placate him. Only the crusty Scots physician, Dr. Helmcken, could face him down. "How is Carr today?" he would call as he climbed the stairs to the invalid's room. "How's his temper?" Then he would administer some noxious medicine which depressed the patient so much that it actually brought him to tears, terrifying the whole family into wishing his temper back again.[9]

In the published writings we get only occasional glimpses of his lighter side, of the "twinkle [that] forced its way through" whenever he was in a mellow mood.[10] We see a man who forbade his children to read fairy tales, and we wonder how many other harmless pleasures were forbidden. "Father," Emily tells us, "was ultra-English, a straight, stern autocrat. No one ever dreamt of crossing his will. Mother loved him and obeyed him because it was her loyal pleasure to do so. We children *had* to obey from both fear and reverence."[11] In the unpublished stories and journals this hardness is softened somewhat, and we can better understand the tender relationship that grew up between the elderly businessman and his youngest daughter. We discover that "The Lady of the Lake" was not tarred with the same brush as Andersen and Grimm. Emily's father gave her a copy of Scott's poem for her birthday, and she learned long passages from it by heart. It was the only poem she had ever read. At some point late in her childhood she began to write poetry herself, bad verses which she went to some trouble to hide from the eyes of her sisters.[12]

Emily desperately wanted a dog, and she was not allowed to have one. That was one of the grievances she later held against her father. Much as he loved dogs, he loved his flower beds more. He kept his own dog chained, and he would not hear of Emily's owning one. Cats, though, were another matter. Her father's warehouse was full of cats, and he took milk from home to them each morning. Once he brought home three kittens for the younger sisters, provoking a rare protest from his wife, who pointed out that there were three cats in the house already. Emily's kitten was called Tibby. It died when it was half-grown and in no way took the place of a puppy; nevertheless it was her own and represented her father's effort to meet her halfway. When it died a friend gave her a canary to console her.[13]

As for the flower beds, there was one fine moment in Emily's child-hood when she and her father together symbolically put them in their place. Snow was rare in Victoria, and Emily's first memory of a deep snowfall dates (with allowances for her shaky chronology) from when she was three. She stared out the window in astonishment and asked her father to explain it, and he "did not believe in fairy tales and told me deeper than I could follow." She demanded to go out and *feel* the snow, so her mother dressed her warmly and put long black stockings over her shoes, and she went out with her father. "Where shall we go?" her father asked. She wanted to go to Beacon Hill Park, but first she wanted to walk all over his "best flower beds and not hurt a thing." So they stomped together over his hyacinth beds, which Emily found so satisfy-ing she decided she did not want to go to the park after all.[14]

In another unpublished story she remembers going with her father and sisters on a steamer excursion near the city. The steamer caught on a rock a little distance from shore, and it was some hours before they were brought ashore in rowboats. Then they had to walk the four miles home. Emily was very young (she says she was four) and very tired, and her father held her hand and walked a little ahead of the others. They pretended they were trying to catch the moon; they discussed whether the moon ever got tired, whether she would burn if they did catch her, and whether, if the moon yawned as widely as Emily, she would split in two.[15] The story is slight and self-consciously cute, but it tells us that the definition of "fairy tales" did not shut out all fantasy and play, and it partly answers the question of what sorts of dialogues father and daugh-ter had on their long walks together, when the others were left behind.

And the others, it seems, always *were* left behind. Sometimes they chose to be; her sisters were invited to feel the snow too, but they refused. In any case, Emily always shows her sisters as beings less imag-inative and less adventurous than herself. They are always hanging back, worrying about right and wrong and whether they will get their clothes dirty. More scrupulous than she is, they are also less sensitive. Naively, unabashedly, she shows herself as more spirited, more intelligent and altogether more worthy of her father's notice than they. An undercurrent of elitism and thinly veiled jealousy runs throughout the stories, and cer-tainly it was reciprocated. Dede and Lizzie thought her spoiled and un-mannerly, and the conflict among the sisters must have been sharpened by the competition for their father's meagre demonstrations of love. Once Emily heard Lizzie and a family friend wondering if there could have been a gypsy strain in the family that would account for Emily. For all her pretended indignation at this, she clearly enjoyed being a gypsy, and she nursed her sisters' antagonism as her father nursed his temper.

Even allowing for his playful and indulgent side, the fact remains that Emily's father was a domestic tyrant. The opening chapter of *The Book of*

Small describes Sunday, the day when they all felt the full weight of his oppressive will. Sunday was the one day when they did not escape his eye for a moment unless they were under Dede's, which was much the same thing. From the time they awoke to the sight of him standing over them, summoning them to prayers, through church, Sunday school, the invariable cold-mutton dinner, the ceremonious walk around his land and the Bible-reading at night ("begat chapters and all"),[16] every action was rigidly preordained. The day had its brighter moments, like the serial story from *Sunday at Home* that once turned out to be by Thornton Burgess, but there was no part of it that was their own. It belonged to their father and the Lord, and very likely the Lord was cheated of His full share.

The chapter makes us feel how strictly the children's father attempted to control their lives. It sets the tone for the entire *Book of Small;* it is the Word in the beginning. Very early in life, Emily came to associate formal religion with "Father's unbendable iron will."[17] Both increasingly became aspects of the same sterile, bullying authority. What is remarkable about the Carrs' Sundays is the degree to which the outside world, which after all was God's creation, was literally fenced out. Other families went picnicking on Sunday; if the Carrs went on a picnic they went on Saturday.

There was one part of Richard Carr's land that had been left wild and (at his own pleasure, of course) was somehow outside his jurisdiction. It was the lily field:

> Nothing, not even fairyland, could have been so lovely as our lily field. The wild lilies blossomed in April or May but they seemed to be always in the field, because, the very first time you saw them, they did something to the back of your eyes which kept themselves there, and something to your nose, so that you smelled them whenever you thought of them. The field was roofed by tall, thin pine trees. The ground underneath was clear and grassed. The lilies were thickly sprinkled everywhere. They were white, with gold in their hearts and brown eyes that stared back into the earth because their necks hooked down. But each lily had five sharp white petals rolling back and pointing to the treetops, like millions and millions of tiny quivering fingers.[18]

In Emily's mind the lily field would always remain a superlatively lovely place, a symbol of God's creative joy and of what she loved best in Canada.

In *Small* Emily uses religion to emphasize the contrast between her mother and her father. Her father went to the First Presbyterian Church, her mother to the Church of Our Lord (Reformed Episcopal). Her father's religion was "grim and stern," her mother's "gentle."[19] The chil-

dren, except for Tallie and Dick, always had to go to Sunday morning service with their father, but in the evening their mother often went to her own church, which was just across the James Bay bridge. Emily loved to go with her, partly because she loved to go anywhere with her mother, partly because she loved to walk across the bridge at night and watch the stars and city lights reflected in the water. The service itself, in contrast to the austerity of the Presbyterian rite, was a drowsy blur of pleasant sensations: organ music, red velvet pew cushions, patterns of light from the chandeliers that danced across the ceiling to the soothing continuo of the bishop's voice. Nothing in her mother's church seemed forbidding, least of all the saintly, abstracted Bishop Edward Cridge, who finished each service with a benediction so comforting one could wrap it around oneself and wear it all the way home. The Presbyterian, Dr. John Reid, could hardly compete with this, even though he was "a very nice minister and the only parson that Father ever asked to dinner."[20] It was Dr. Reid who had wrestled a struggling Emily flat on his knee when she was seven, in order to baptize her and present her "kicking furiously to God."[21]

Yet the difference between them was not so very wide; it was just that Emily saw each church as a setting for each parent. Her mother's church was distinctly evangelical, encouraging Bible study and rigorous self-examination just as the Presbyterian church did. It was from both traditions that Lizzie and Dede drew their fervent proselytizing and habit of strenuous prayer. As for Richard Carr, he was hardly a religious fanatic. He went to the First Presbyterian only because he was rather deaf and Dr. Reid was blessed with a hearty pulpit voice. Carr's early diaries seldom mention Sunday worship except for an occasional Unitarian, Methodist or Shaker meeting he attended out of curiosity. Any violation of the sabbath had always shocked him, but to an Englishman sabbath observance was not necessarily a measure of religious conviction; it was simply an unshakable social ritual. When it came right down to faith, Richard Carr seems to have been utterly conventional. He believed in God and feared judgement, but scarcely to the point of obsession. And his Sundays hint strongly of obsession.

Clearly Sundays served some other purpose. For one thing, Richard Carr was anxious about appearances. Behind the country-gentleman facade lived a semi-literate man of obscure birth who had led a knockabout kind of life. If religion struck no deep roots in Carr's soul, gentility did, and gentility meant piety. Then, too, he may have thought religion was "good" for the children in a rather abstract way, like cold baths and cod-liver oil. And of course religion exalted the role of patriarch; if fathers had to be obeyed on weekdays, they had to be doubly obeyed on Sundays.

Perhaps the best explanation is offered by Charles Taylor in his *Six*

Journeys: A Canadian Pattern. He says Richard Carr is a prime example of what Northrop Frye once termed the "garrison mentality" of early Canadians:

> Initially this mentality erected physical barriers against all those hostile forces which lay beyond the precarious homestead. . . . It included not only a fear of wolves and frozen forests, of Indians and Americans, but also a terror of the soul, a terror of what is savage and passionate in ourselves. . . . With Richard Carr . . . the garrison mentality was carried to its psychological extreme: a fearful denial of all that was sentient and spontaneous.[22]

Probably Carr's garrison mentality was formed very early, long before he reached the shores of New York; one senses it in the detachment with which he sailed not so much *through* his early adventures as *past* them. The very nature and variety of his experiences suggests that he may have built up a very elaborate inner fortress indeed in order to escape being overwhelmed. Now he extended it to his family, shielding them from all manner of unknown threats, of which the worst were those of the imagination and senses.

The stronger a child's need is for the "sentient and spontaneous," the harder such confinement is to bear. Emily's father enlisted allies: Dede, Lizzie, family friends. Among them they wove a thorny hedge of Thou-Shalt-Nots at which Emily hacked furiously all her life. Her best weapon as an adult was humour, but that was not available to the child. And sometimes her father's narrowmindedness caused real physical suffering, as when she was forced to endure the pulling of three teeth, without anaesthetic, because her father thought that filling teeth was nonsense.

Emily made up for a mild but constant deprivation of the senses where she could. Like all children she was drawn to flowers, but with unchild-like subtlety she loved them not only for their colour but for the silky texture of their petals and the tiny aura of cool air about each one. Their fragrances too had special appeal, and her writings are full of them: the smell of wild roses on the beach mingling with the smell of the sea; the heavy scents of lilac, wild phlox and mock orange; the spiciness of firs; the ethereal essence of the lily field.

She had an immoderate love of sweets and hoarded them to eat furtively by herself. (She almost envied Dick his sickly constitution because Dr. Helmcken prescribed two tablespoonfuls of Devonshire cream for him each morning.) She was always a bit overweight, a "wide and energetic" child who burst the buttons and strained the seams of her clothes, keeping her mother's mending basket full.[23] In Victoria it was considered indecent for women and girls to go without corsets, and she

was laced tightly into them long before adolescence and suffered extra agonies because she was so chubby.

The children's father liked to hand out treats. Their mother often sent the children to his office during the day, either to deliver a message or to bring him a stone jar full of soup when his gout was bothering him. Part of the fun was exploring the dark, fragrant warehouse, where a dozen or so half-wild cats prowled among the boxes, their eyes shining eerily in the sputtering gaslight. But in the office itself, behind their father's big table, were four shelves lined with jars of sample English candies. When the children opened the door they saw their father framed in candy. There was always the suspense of wondering whether he would take down one of the jars and hand it around. Usually he did, but they could never count on it. Once, when he left Emily and Alice alone there for a few moments, Emily climbed up on his desk and stole six candies, three for herself and three for Alice. They hid them in their pockets undetected; on the way home they were so overcome with guilt that they pushed them all through a knothole in the sidewalk.[24]

In general, though, such small pleasures were dressed up in the language of sin and redemption. One could have either jam or butter with one's tea, for example, but both only on Sundays. On Sundays, too, pieces of candy were given out at home, but only as a reward for having been "very good all week."[25] Tallie liked to tell her own children of one Christmas when she and Dede were small and everyone was hanging up a stocking for St. Nicholas. Her father complained that his stockings were too small, so he fetched a suit of long underwear and hung it up instead. In the morning the children found a doll in each leg of the underwear. They were always known as "Father's dolls," and the girls could play with them "when they were very good."[26]

On the whole, in spite of all the petty restrictions, Emily's early childhood was happy. There were certain advantages to being a Carr. For one thing, because the family lived so quietly there was no pressure on a dreamy child to belong to groups. Nor, with so many hands to do the housework, was she expected to help much at home. She found time to be alone, and as she grew older she was allowed to range the woods and fields by herself, wandering through the groves of firs, the scrub oak thickets and masses of broom on Beacon Hill until she came to the silent eastern beaches. There she could strip off shoes and stockings and wade barefoot, trading stare for stare with the Olympic Mountains, or sit on a grassy bluff and watch the native Indians pass by in their canoes. She could spend hours, if she wanted to, luring a chipmunk or a gull to take bread from her hand.

Even her father's misguided protectiveness had its positive side. A dictatorial father could be reassuring in a family where everyone knew

(though nobody mentioned it) that their mother had tuberculosis and might some day die. Emily may have envied other children their more permissive fathers, but from childhood she developed a contempt for weak, indulgent men that never left her. Whenever her mother suffered an acute attack and the abyss of possible loss temporarily opened, it was a comfort to have an invincible father, a being somewhere between St. George and the governor general.

In one particularly shining respect Emily's father did not fail her. When she was about eight she drew a picture of his dog Carlow on a piece of wrapping paper, using a charred stick from the fireplace. Her father tucked it away among his papers, where it was found years later. After that she was allowed to take drawing lessons, first at school and later from a local artist, Eva Withrow. Lizzie and Alice went with her, and they were all set to copying photographs and drawing from casts. Emily begged casts of her own from a monument maker and drew from them at home. When she drew portraits of her parents and Tallie's baby from a photograph, her father gave her five gold pieces and an order for three copies. A place was set aside, first in the pantry and later in her bedroom, where she could keep her paints, brushes and easel and work undisturbed.

Aside from art, the single most important pleasure in her life was "creatures," and here again—except for the matter of the dog—her father and the whole family backed her up. Everyone, even Dede and Lizzie, was fond of animals; nobody would have dreamed of forbidding her to play with them. She was allowed to visit the cow yard as much as she pleased. She spent a good deal of time there, carrying around large, awkwardly shaped hens and ducks whose dangling feet left muddy tracks on her clothes. Her father's love of animals was purely un-sentimental, and he relentlessly slaughtered Emily's barnyard babies when they grew big enough for the dinner table. But before she left the house each morning with her father she visited the cow yard, and when she came in muddy she was not punished but was given a clean pinafore to slip over her head. In *The Book of Small* she is forever being rebuked for being dirty, yet it is her sisters, not her parents, who scold her. From her parents the message was mixed, though undoubtedly the child who "should have been the boy" was given some of a boy's liberty.

CHAPTER
4

Cow Yard Child

IN "THE BOOK OF SMALL" Emily sums up a lifelong view of herself and her sisters in a childhood image:

> Of the three little girls who played in the Cow Yard, [Lizzie] tired of it soonest. Right through she was a pure, clean child, and had an enormous conscience. The garden rather than the Cow Yard suited her crisp frocks and tidy ways best, and she was a little afraid of the Cow.
> [Alice] was a born mother, and had huge doll families. She liked equally the tidy garden and the free Cow Yard.
> [Emily] was wholly a Cow Yard child.[1]

In the cow yard, when they sat around the embers of the annual spring bonfire and roasted potatoes, even Lizzie could tell "grand and impossible" stories that "soared beyond imagining."[2] Underfoot, the damp, April earth "pulsed with rich growth" wherever it was not trodden flat by the roaming, rooting, scratching, grub-hunting, dust-bathing creatures that lived there.[3]

The cow yard was the only place where Emily was moved to sing. That was probably just as well: she could not carry a tune, and Dede tried vainly to get her to silently mouth the hymns in Sunday school. When she was there alone she would climb up on the woodpile, take her pet rooster on her lap and serenade the cow at the top of her lungs. That would provoke a torrent of scolding from Dede, along with pleas to consider the neighbours. Then Emily, of course, would sing even more loudly, until the cow abandoned whatever sprig of greenery she had found under the fence and ambled over to listen, nose pointed straight up and ears twiddling in honest tribute from one mooing creature to another.

In the cow yard "continually hovered the spirit of maternity," embodied most strongly in the "warm life-giving existence of the great

red-and-white, loose-knit Cow."[4] Every spring the hens would flatten themselves on their nests, warning off intruders with "beaky growls" and "staring into space as though their orange eyes saw something away off."[5] Three weeks later they would be clucking and scratching about the cow yard, followed by large broods that they borrowed and lent among themselves in a grand communal mix of indiscriminate motherhood. Meanwhile the rabbits barricaded the doors of their boxes and made fierce stamping noises if anyone came near, until they too were ready to come out and disclose "more [babies] than you could count."[6] The cow herself acquired a calf, by a process the children never questioned very closely, and licked it until it all but tottered over from the force of her rough tongue.

Whatever Emily felt about the "spirit of maternity" as a child, it was true that in this best of all places the freedom to love, move, sing, shout and be herself was joyfully and emphatically female. Usually being female meant being shut in and buttoned up and obeying countless rules that had nothing to do with the way people really felt. In the cow yard there did not seem to be any rules except nature's, and they were miraculously sufficient. It was not Emily's only experience of the natural world, but for a long time it was the most powerful. Everywhere else was the world of human beings, so cluttered that neither body nor mind could move without bumping into the furniture.

Superficially, her own mother had nothing in common with whatever earthy deities presided over the cow yard. But in spite of her illness, her reticence, her decorous manners and her deference to her husband, Mrs. Carr was the warm, calm centre about which the family revolved. Not surprisingly, she was the only person who encouraged Emily's cow yard singing; she herself understood the impulse to sing. Emily writes of how her mother and an old friend forgot themselves so much in reminiscence one afternoon that they burst into song, sitting bolt upright on the Carrs' treacherous horsehair chairs, their sewing lying neglected in their laps. They sang "love songs, nursery songs, hymns, God Save the Queen, Rule Britannia,"[7] while the astonished child beside them glimpsed a person in her mother she had never seen before, an English girl who was hardly more than a child herself. After that, spontaneous singing (as opposed to social singing around the spinet) became a slightly disreputable secret they shared, and in the context of *Small* it links mother and cow yard child, maternity and creativity.

Emily adored her mother, though in this as in all adoration there is an element of rosy unreality. She tells us very little about her mother as a whole person—whether she was capable of losing her temper, whether there were things she passionately disliked, whether she ever dropped a plate or burned a finger. Nor are there any other accounts to fill in what

Emily has left out. Yet we can easily sense what the mother meant to her youngest daughter. Emily describes her as

> a quiet woman—a little shy of her own children. I am glad she was not chatty, glad she did not perpetually "dear" us as so many English mothers that we knew did with their children. If she had been noisier or quieter, more demonstrative or less loving, she would not have been just right. She was a small, grey-eyed, dark-haired woman, had pink cheeks and struggled breathing. I do not remember to have ever heard her laugh out loud, yet she was always happy and contented.[8]

She did not talk, she did not laugh, she did not move quickly; she is described mostly in negatives. She was "Father's reflection—smooth, liquid reflecting of definite, steel-cold reality." But her "reflecting was stronger than Father's reality, for, after her death, it lived on in our memories and strengthened, while Father's tyrannical reality shrivelled up and was submerged under our own development."[9]

In spite of her illness she was a capable housewife. Emily liked to watch her make Devonshire cream in the morning, setting the pans of new milk in boiling water and skimming the rich, crinkled top as it rose. Now and then, instead of the usual porridge for breakfast, she would slip Emily a piece of bread smeared with cream. She was a sympathetic neighbour, ready with soup for the needy and tea for the weary, and she was full of practical advice for younger women like their neighbour Mrs. Wolfenden, who had married a widower with six children. As a parent she could be strict, but never unfair. She especially understood that "[Emily] will lead, but she *won't* be pushed."[10] For the children the mere thought that one had done anything to "worry Mother" was punishment in itself. She never seems to have exploited that knowledge, and she consistently minimized her illness. When the children arrived home from school they immediately went to her room to talk, even though her reserve kept them from truly confiding in her. The strongest emotional current between mother and children flowed beneath and around words, but it was no less strong on that account.

Now and then her illness would flare up suddenly, and the children would be hushed out of the way or sent to stay with friends. At such times the whole family existed in a kind of suspension. Only when she had recovered and was moving about the house again in her careful, measured way were they able to resume their normal lives. Without acknowledging it, they rehearsed her loss many times. And it was all but inevitable that, simply by managing to exist as long as she did, she became the angel in the home, the goddess celebrated in countless reams of Victorian verse. After she died her memory would crystallize into a per-

fect, shining ideal of motherhood, and her children would be spared the
normally painful task of discovering that their mother was an ordinary
human being. To Emily, in retrospect, she was an infallible source of
consolation and protection, the only one in the family who did not de-
mand constant explanations and apologies. "I am *not* a *good Carr*," Emily
wrote in 1943, "and *I never was* except for mother oh I WAS there. To all
the rest I was too different."[11]

Emily took her mother's rare displeasure very much to heart. One
evening when the children were alone after tea and the grownups were
cooking their own meal in the kitchen, Emily and Lizzie quarrelled over
an older couple who were friends of their parents. "Beastly people,"
Emily said, and Lizzie retorted that Emily's language was "disgusting."
Emily flew at her sister and bit her; Lizzie howled; elders appeared. Their
mother took Emily by the hand and marched her through the kitchen to
the back veranda, stopping to pick up a ball of twine and the dog's pan of
scraps. Then she tied Emily firmly to the veranda post and set the scraps
down beside her, telling her she could "bite any old tramps that come
around."

They all went inside, leaving her alone in the dark. She could smell the
chops and potatoes sizzling on the stove, but except for one half-
triumphant, half-remorseful glance from Lizzie through the window,
they seemed to forget about her. She was there a long time, staring at the
shapes of barns and trees against the dark sky, listening to night noises
and half afraid a tramp *would* come. The experience intensified her fear of
the dark. It also succeeded where several previous whippings had failed.
She never bit Lizzie again.[12]

Outside the serene circle of Emily's love for her mother, and the more
agitated circle of her love for her father, were her sisters, and beyond
them were other children. Dede, of course, is the punishing sister. Her
punishments rankled afterward as her mother's did not and were mag-
nified and multiplied in Emily's mind. Lizzie was a playmate, Alice a
confidante. Emily and Alice shared a room and a big, old-fashioned
spool bed, where before they went to sleep each night, they conferred to-
gether on the day's events while munching apples they had stowed
beneath their pillows. Other children were by no means left out: there
were the three Cridge sisters, Rhoda, Nellie and Maud, and another set
of sisters Emily calls Fanny, Nellie and Edie (possibly three of the five
Fawcett girls from next door). There was a clergyman's daughter named
Elsie, with whom Emily once made a futile pact that neither would
endure kissing from anyone but parents and siblings.

Emily's closest friend from early childhood through adolescence was
Edna Green, daughter of the prominent banker Alexander Green. The
Greens' house on Birdcage Walk, near the parliament buildings, was

crammed with luxuries unheard-of in the Carr house: "a rocking-horse, real hair on their dolls, and doll buggies, a summerhouse and a croquet set."[13] On Sundays the Green family, with six boisterous children, would straggle past the Carr house on their weekly outing to the beach, and Emily would hear them as she marched in strict Indian file behind her father as he paced his own land. Any plea to be allowed to go with them was brusquely refused. In the 1880s Green built his family a mansion, then one of the city's finer homes and around which the Art Gallery of Greater Victoria has been built. Emily visited them there and at their summer house in Shoal Bay, where she and Dick spent several summers. The easygoing, unconstricted atmosphere of the Green household contrasted sharply with the austerity of the Carrs' and must have been a welcome and perhaps instructive change for Emily.

Other friends included the Wolfendens, who moved to Simcoe Street, diagonally across from the Carrs, when Emily was seven. The youngest daughter, Madge, would become a friend of Emily's in adulthood, but she was too young to know her as a child. Madge's older half-sister, Roberta, knew Emily well and has left us a slight but provocative description:

> [Milly Carr] was an oddity—a great pal of mine. And she was always climbing up on fences. And many a time I've climbed up with her and sat on the big wooden fences in those days—not pickets but big boarded fences. She would sit up there, and I had to go and sit up there with her, and we'd talk and play. I asked her one day, I said: "Milly, what are you watching all the time? What are you looking at?" Well, she was looking at the birds. She was always watching to see what the birds were doing or something. Of course, I didn't think much about it in those days. I thought she was just odd, always looking. And she always wanted me sitting up on the wooden old fence with her till I got tired.[14]

The voice is that of a 92-year-old woman whose childhood memory was probably coloured by the habit of seeing the grown-up Emily Carr as Victoria's most celebrated "oddity." Still, the picture seems true—not only of Emily sitting on fences and watching the birds but of Roberta's impatience and incomprehension. She clearly had her reservations about Emily as a playmate, and possibly other children did too.

Emily did not usually play with boys unless they happened to be around when she was playing with their sisters. Bolder and more active than most girls, she nevertheless stuck to their quiet games, and when she tried to join the boys' rougher play she was hampered by her cumbersome clothes and her lack of practice. Once she sneaked off on a Sunday to join the Greens on the beach: "Father had the gout and did not

know. We had fun and I got 'show-off' from being too happy. The boys dared me to walk a log over the sea, and I fell in. When I came home dripping, Lizzie had a text about my sin finding me out."[15]

She could not help noticing that in general boys seemed to have more fun. When she went to her first birthday party and everyone climbed into Mr. Winter's picnic wagon for a trip to the beach, it was the boys who got the best seats: "The boys were all up in the front seat, swarming over Mr. Winter like sparrows. Behind sat all the little girls—so still—so polite." Sitting with the girls, she had to keep even more still than the rest because she was sitting on the door handle and was afraid of falling out. But once they got to the beach she played just as hard as the boys and got "all mussed up." "Lizzie was just as clean as when we left home, Alice was almost as clean . . . but they were not having half such a good time as I." She spent the rest of the day getting even more mussed up, mortifying Lizzie by eating too much cake and spilling cocoa, while her sisters stayed clean in their "girls' clothes so starchy they rattled if they moved."[16]

She envied the delivery boys who rode all over town on horseback, balancing baskets of bread or meat:

> It was a wonder the boys did not grow crooked balancing such heavy baskets on their hips, but they did not—they were straight and strong. I used to wish I were a delivery boy to throw my leg across a horse and shout "Giddap!" to feel myself rush through the air, but I should have preferred bread to meat in my basket.[17]

When she grew up, she thought, she might "join a circus and ride a white horse through hoops of fire."[18] She wanted a horse almost as much as she wanted a dog, and in her impatience at not having one she once tried to ride the cow—to that mild beast's considerable and emphatic astonishment. Eventually her father did buy a horse, but in the meantime she had to substitute fantasy horses for real ones.

She describes one of these daydreams in the chapter "White Currants" in *The Book of Small*. At the end of her father's garden there was a row of currant bushes, and the currants on the last bush were white: "The white currants ripened first. The riper they got, the clearer they grew, till you could almost see right through them. You could see the tiny veins in their skins and the seeds and the juice. Each currant hung there like an almost-told secret." Between the white currant bush and the fence, growing through the jumble of garden rubbish that was dumped there, was a clump of the deep pink, richly scented wild phlox we know as dame's rocket: "The leaves and the blossoms were not much to look at, because it poured every drop of its glory into its smell. When you went there the colour and the smell took you and wrapped you up in them-

selves." Wrapped in the colour and the smell, the warmth of the sun, the droning of the bees, she would watch the flickering wings of numberless white butterflies that were drawn to the flowers, until

> Everything trembled. . . . you began to tremble too; you seemed to become a part of it. . . . Somebody else was there too. He was on a white horse and he had brought another white horse for me.
>
> We flew round and round in and out among the mauvy-pink blossoms, on the white horses. I never saw the boy; he was there and I knew his name, but who gave it to him or where he came from I did not know. He was different from other boys, you did not have to see him, that was why I liked him so. I never saw the horses either, but I knew that they were there and that they were white.
>
> In and out, round and round we went. Some of the pink flowers were above our heads with bits of blue sky peeping through, and below us was a mass of pink. None of the flowers seemed quite joined to the earth—you only saw their tops, not where they went into the earth.
>
> Everything was going so fast—the butterflies' wings, the pink flowers, the hum and the smell, that they stopped being four things and come one most lovely thing, and the little boy and the white horses and I were in the middle of it, like the seeds that you saw dimly inside the white currants, . . . like a big splendid secret getting clearer and clearer every moment—just a second more and—

But here the narrative is interrupted, and the child's flight is brought crashing down to earth by crude utility in the form of a grownup "picking beans."[19]

In this passage, as in many others, we see the child's experience and the artist's enriching and transforming one another. The child's exquisite fantasy of freedom is the transcendental vision of the artist. Reading about it, we are simultaneously flying with Small and floating in the centre of an Emily Carr painting, caught up in the ceaseless, mysterious flow of vitality that links all living things. For the artist, the "almost-told secret" of the white currants was that hidden life, which she strove to bring to visible reality. But for the child, the moment must have been magically complete, unburdened by any meaning outside itself.

CHAPTER
5

Friends and Enemies

WHEN EMILY WAS about seven her parents decided to send the three younger girls to school. Until then they had had their lessons from Dede, for their parents shared the widespread mistrust of the so-called Free Schools. Established less than thirty years earlier, the public schools had been intended to "give a good sound English education and nothing more" to "the children of the labouring and poorer classes."[1] In other words, nobody went to them if he could possibly afford to go somewhere else. In the 1860s the public schools had actually been closed for a while for lack of public support. It was not only the elite but the majority of Victoria's children who went to the private academies Emily describes in *The Book of Small*.

Like many other sparsely educated immigrants, Richard Carr set a high priority on good education for his children, and he was not happy with the fashionable smattering of knowledge his elder daughters had picked up in one of the academies. By the late 1870s the public school system was healthy, but the old suspicions lingered and many people still kept their children away. Attending Girls' Central School, Alice and Lizzie were in fact the neighbourhood scouts. After they began there was a general grownup effort to keep a close watch on their language and manners. As an added precaution, they were ordered to walk to Tallie's house every day for lunch so as to avoid unnecessary mingling. The extra walk meant a total of five miles a day (not six, as Emily claimed). That was thought to be too much for Emily. Besides, she was heartbroken at the thought of giving up her morning walks with her father, and he himself would have been sorry to let her go. So she was enrolled in Mrs. Fraser's tiny private school for girls in Marifield, the cottage on Bishop Cridge's land that had been his first Victoria home.

For most of the private schoolmistresses she knew Emily already felt the beginnings of a violent dislike:

Politeness-education ladies had migrated to Canada, often in the hope of picking up bread and butter and possibly a husband, though they pretended all the while that they had come out on a very special mission—to teach the young of English-born gentlemen how not to become Canadian, to believe that all niceness and goodness came from ancestors and could have nothing to do with the wonderful new land, how not to acquire Colonial deportment, which was looked on as crude, almost wicked. The only teaching qualifications these ladies possessed, and for their services they charged enormously, had been acquired by generations of habit.[2]

Mrs. Fraser entirely lacked a sense of mission. She had a reputation for being "very well bred and well educated,"[3] and to a child's eyes she was "kind, particular about manners and kept her finger nails clean."[4] An old acquaintance of the Carrs, she had come to Victoria from a farm following the death of her first husband, and when she married again she would go to live on another one. In the meantime there was a good deal of the farm about her school. There was a neat garden in front, but the front door was never used and was entirely covered by a white climbing rose. The children entered at the back door, walking over wooden planks laid over Mrs. Fraser's mint beds, and sometimes giving a passing pat to Colie, the bishop's cow, who kept the grass mowed. The door led into the kitchen, where they might find Mrs. Fraser's brother Lennie frying potatoes and steal one or two as they trooped by, entering the schoolroom with burned tongues. The schoolroom was large and bright, with four windows overlooking the bishop's pasture and a fireplace before which sprawled six fat spaniels. Now and then one of the dogs would be sick—possibly from overeating—and then Mrs. Fraser abandoned all pretence of teaching and nursed it by the fire, while the children played "fairy" underneath their desks. At lunch and recess Emily would sit in the mint beds with her friend Lizzie Mason and read forbidden fairy tales from a book Lizzie brought from home. That was the "best part" of school.[5]

At one end of the room long benches had been pulled together to form a three-sided square for recitations. Mrs. Fraser's desk was at one side of the open end, and at the other was the dunce stool. Emily claims to have occupied it often, but only once did she get into a serious scrape. She took offence at something a classmate said and threw an apple core dipped in ink at her. Retribution was so severe as to suggest that she had done this sort of thing before. All her classmates except three put her in "Coventry" and totally ignored her, while at home her mother punished her "very hard."[6] The whole thing dragged on for some time, until Emily was so miserable that her grades began to fall. Then Mrs. Fraser called on her mother and some sort of peace was made (while the fat

spaniels sneaked into the kitchen and demolished the makings of after-
noon tea). Afterward Emily always remembered the school with affec-
tion, but the incident does remind us how easily her temper could flare
into physical aggression.

After two years Mrs. Fraser remarried, the school was closed, and
Emily had to go to Girls' Central. She hated it. Her grades were above
average, but they were lower than her sisters', and she was slow at arith-
metic. She decorated her arithmetic textbook with pictures of pigs
labelled "arithmetic" and donkeys labelled "Emily Carr."[7] She often had
to stay after school to do extra sums, and in winter she barely reached
home before dark. Even on ordinary days the five miles of walking were
so wearying that she would be close to tears. It was that weariness that
she remembered most bitterly later on, but much of it may have been
brought on by the boredom and pointless regimentation of a big public
school.

Outside of school Emily had a little circle of adult friends, very much
in the tradition of Mrs. Fraser, who seem to have been much more im-
portant to her than other children. They all appear in *Small*.[8] There was
Mrs. J. W. McConnell, whose dairy farm sat squarely in the middle of
Carr Street, separating it from the continuation that was Birdcage Walk.
A "splendid lady. . . . Irish with shiny eyes and high red cheeks, black
hair and long teeth with wide gaps," Mrs. McConnell spent her days
zestfully looking after a large brood of children and a great many living
creatures: "She sort of spread herself over the top of everything about the
place and took care of it."[9]

Then there were Anne and Henry Mitchell, an elderly couple who
owned a nursery garden and kept four guinea fowls they loved almost as
if they were children. There were Mr. and Mrs. William Gregory, old
friends of her parents from Devonshire, who looked after the Customs
House and had the sea lapping at their back door. There was Mrs.
Cridge, the bishop's wife, who baked spice cookies every week for the
Carr children when they came to her house to read Dickens, mixing the
batter with her fingers and greeting her guests at the door with flour on
her nose. On the night of Tallie's wedding, when Emily managed to fall
in the cow yard mud and besmirch her white bridesmaid's dress, it was
Mrs. Cridge who quietly took her into the kitchen and washed and
ironed the dress, with no one the wiser except Lizzie—who, for once,
didn't tell.[10]

There were Capt. and Mrs. Herbert George Lewis, who lived on
James Bay next to the parliament buildings. They were pioneer Vic-
torians. Mary Lewis had been a Langford, daughter of the colony's first
land bailiff, and Captain Lewis had commanded a succession of Hudson's
Bay Company vessels and still commanded the last of them, now a tour-
ist ship called the *Princess Louise*. When the captain was away Emily

would sometimes stay with Mary Lewis, who told her vivid stories of the old, rough days of the fort.

High on Emily's list of favourite people, though he could not exactly be called a friend, was Dr. John Sebastian Helmcken. Dr. Helmcken had come to Victoria in 1852 as the fort's first physician, and he had married the governor's daughter and served as the first speaker of the legislature. But Emily knew him only as a handsome, wiry, white-haired Scottish widower who took care of them all when they were sick—as his son did after him—and who dared to subject her father to "a little kind bullying."[11] His house was in James Bay, near the Lewises', but his office was in town. There, amid an indefinable clutter he would allow no housekeeper's hand to touch, he dispensed what seems to have been a very rough-and-ready kind of medicine. Certainly in every sense his talents transcended the hygienic: "He even told us what to do once when the cat had fits."[12]

Varied as they were, in one way or another the people Emily loved all resembled Mrs. Cridge: metaphorically speaking, they all had flour on their noses. Except for Dr. Helmcken they were all English-born, yet there can be no doubt that in Emily's mind they had all undergone a sea change and were irrevocably Canadian, even though the most passionately English of them all, Mrs. Mitchell, went home to die. In Canada Mrs. Mitchell had fretted unceasingly for her homeland. Her walls had been lined with pictures of the royal family, and she had told Emily the life history of each of Queen Victoria's children, dead or alive, in loving and meticulous detail. But when she returned to England she found, like Richard Carr before her, that it was "different from what she had remembered,"[13] and she longed for Canada. One could be both English and Canadian; one could not, on the other hand, be both Canadian and "ultra-English."

Emily remembered her own father as ultra-English, even though he too had been unable to go home again. Although she knew he loved Canada, his preoccupation with form and propriety kept him identified, in her mind, with the Old Country. She saw her two oldest sisters in the same way, insisting all her life that they had been born in England, though they had been born in California.

Equally condemned were the "politeness-education" schoolmistresses and the family friends who, along with Emily's own parents, feared that children educated in public schools might at any moment begin swinging from the trees. Ultra-English too were missionaries, of whatever persuasion, who used the Bible as a "civilizing" influence on children, native Indians and other assorted barbarians. So were certain maiden aunts,

who had attached themselves to the family circle of a married brother and who undertook the diction and deportment of his children, bitterly regret-

ting the decision of Brother to migrate to Canada, but never for one mo-
ment faltering in their duty to Brother's family, standing between his chil-
dren and colonialism.[14]

Emily's own aunts were conspicuously absent, but she had a surrogate
aunt who, though hardly a maiden, amply confirmed Emily's dislike of
aunts as a species. "Auntie" Hayes and her husband (they have no first
names, even in Richard Carr's diary) lived in San Francisco. They were
among the Carr's earliest Anglo-American friends. Every now and then
they would come to Victoria for a long visit, and then Emily would have
weeks in which to rediscover how very much she detested Mrs. Hayes
and all those other desiccated souls she came to represent.

"Auntie" was one of those women who kissed all children and called
them "dear," whether or not she liked them; in fact, the more annoyed
she was with them, the more she "deared" them. She was dominating,
condescending and devious; she was not above asking Emily to pick her
some flowers, for example, and afterward quickly throwing them away.
She was attended by a mild, doting husband who, Emily says ruthlessly,
"was like the long cushion in the church pew—made to be sat on."[15]

Auntie Hayes is at once herself and a prime example of what Emily
hated about the ultra-English. To be ultra-English was to carry the gar-
rison mentality to its most ludicrous extreme. It was to cling obsessively
to the safety of an obsolete tradition and to try to force everyone else to
cling to it as well. It was to turn one's back on the forest and peer out to
sea. The powerful ultra-English adults of her childhood were collectively
Emily Carr's *bête noire,* and they had a strong negative shaping influence
on her personality, accounting for much of her permanently embattled
stance. If they had not been extensions of everything she most disliked
and feared in her own family, perhaps they would not have brought on
themselves such a crackling intensity of feeling. On the other hand, her
anger against them became a constructive force, urging her to question
everything around her, to break free and discover her own creativity.

Besides the chilly ultra-English and the warm, commonsensical
Helmckens and McConnells, there was a rich variety of other kinds of
Victorians. There were pioneer families homesteading on the edge of the
forest, blasting and hauling huge tree stumps from their small plots and
chopping at the solid network of interlacing roots beneath the surface.
The Carrs sometimes visited families like these, and while the women
stayed in the kitchen Emily would follow the men to the fields and listen
to her father's stories of his own early days in California, stories which
must have seemed to belong to some mysterious stranger who had noth-
ing to do with the man before her. (It is not clear whether she knew any-
thing of his earlier, wilder adventures before she read his diary in 1935.)

At the edge of a field she would sometimes venture into a forest far

enough to feel the dim, cool canopy close above her. Yet the vast, virgin forest of the north she knew only by hearsay. In 1879 her father and two of her sisters sailed all around Vancouver Island with Captain Lewis, but Emily was told she was too young to go along. When they came back they told her about the scattered native Indian villages, huddled between forest and tide, and about a forest so dense that in three hours of steady chopping with an axe her father was unable to make the slightest impression on it.

Although unable to visit the northern villages, Emily did see native Indians every day in Victoria. Unrelated to the northerners, they were Songhees, a division of the Coast Salish, and they had originally occupied the site of the old fort. Now, along with transient visitors from other tribes, they lived on a reserve across the harbour from the town. Their tied-up canoes were a familiar sight at the wharves, and they padded barefoot up and down the sidewalk across from Richard Carr's office as they went to trade at the Hudson's Bay store. Natives sold fish and berries door to door, and by the Johnson Street landing every day a row of native women, shawled and impassive, sat behind a row of cedar baskets heaped with oysters, clams and salmon. Forbidden to cross to the reserve, Emily would sit on the Customs House wharf and stare at the canoes and moving figures on the beach, and behind them the plank-sided community houses where the families lived. Now and then she would see them making camp on the island's eastern beaches, where a whole family complete with children, tent, dogs, chickens, food and cooking pots would miraculously emerge from the depths of a single canoe.

Inevitably her feelings about the Songhees were mixed. Almost certainly her father's sympathy for the native people was conveyed to his children, whether or not they knew of his early adventures; but he also shared the patronizing attitude adopted by white Victorians towards a people who were now two generations removed from their old, self-sufficient life. Emily thought of the natives as children of nature, though they were not wild or mysterious or even particularly dignified. When she crossed the James Bay bridge at low tide she would see them mingling with white beachcombers on the mud flats, rummaging among the castoff kettles and baby carriages. She knew few well enough to speak to. One was the family laundress, Wash Mary. Mary was probably not a Songhees. She lived in her own house outside the reserve. She was gentle, smiling, always tired and very small; one could not possibly imagine her claiming descent, as the northern natives did, from some fierce wild spirit of eagle, whale, beaver, wolf or bear.

Another native Emily knew, though slightly, was Martha, who was raising an abandoned white baby as her own. Martha did not realize that she was considered only a foster mother, and when the boy reached

school age the "priests" abruptly took him away. Emily and her mother
visited her soon afterward, and the sight of the weeping woman sitting
on the floor, bewildered and incoherent with grief, left a searing impres-
sion on the child's memory.[16]

Once a year Emily saw wild, northern natives more or less on their
own terms. On May twenty-fourth, the Queen's birthday, there was a
regatta at the Gorge, a narrow arm of the harbour that was a favourite
pleasure ground. Natives from as far away as the Queen Charlotte Is-
lands came to compete in the races, and the best of all was the race of the
klootchmen, or native women. Hurtling under the Gorge bridge to the
cheers of the watching children, the teams of native women with their
paddles flashing in unison yielded nothing in seamanship to any man, red
or white.

Besides the natives, there were several other distinct peoples in Vic-
toria, each keeping its own identity. The Chinese had come early to Brit-
ish Columbia and were still arriving. They did most of the city's launder-
ing and tailoring, worked in its canneries and grew much of its food.
And they ran its homes. The Carrs' family servant, Bong, came to them
when he was twelve and stayed until he was twenty-four, when he went
back to China. In all that time, Emily came to know him even less than
she knew Wash Mary. A withdrawn, melancholy boy, he was only truly
comfortable with Emily's little brother and the cow, both of whom
reminded him of home. His unshakable reserve baffled Emily, who
thought that on the whole she preferred the easygoing native people to
the thrifty, industrious Chinese. Of the Chinese as a whole, who lived in
their own tightly knit community, she seems to have known absolutely
nothing.

Also outside the pale of regulated English life were the eccentrics
among the English themselves—the beachcombers, the alcoholics, the
half-crazed, the senile and the very poor. They were sometimes harassed
by the children, but on the whole people were tolerant of them. One
gave to tramps who came to the door; the west was full of men who had
been defeated by the wilderness. Emily knew many eccentrics, and the
ones she remembered best later on were probably the O'Flahtys. She tells
about them in *The Book of Small,* where she undoubtedly misspells their
name. There were two brothers, known only as Fat and Lean, and a
maiden sister. They lived on Toronto Street in James Bay, in a shack
built entirely of driftwood hauled from the beach on a wheelbarrow.
Around it was a driftwood fence, secured by a padlocked gate.

Miss O'Flahty fell ill, and Mrs. Carr sent her children to call with a pot
of soup. The sick woman, lying in a driftwood cubicle inside the dark
shack, refused the soup and soon afterward died. Somehow the brothers
managed to have her body embalmed and put in a casket. Then they
loaded the casket on their wheelbarrow and wheeled it on board a ship

bound for home. It happened to be the same ship Auntie Hayes was tak-
ing after one of her prolonged visits, and Emily was on the dock seeing
her off. The O'Flahtys' load was heavy; they stopped for a moment just
behind Auntie, who inadvertently stepped back and brushed the coffin
with her cloak. She yelped in shock and revulsion, bringing all eyes to
bear on the sight behind her. But the brothers, paying no mind to any-
one, picked up the handles of the wheelbarrow once more and trundled it
slowly down the deck and into the hold.[17]

Reading Emily's account of this we are teased, as we are often in her
writings, by what she does not say. As a child she had her own terror of
death: a dead, ivy-covered tree in the cow yard became the lair of lurk-
ing, undefined malevolence; invited to see and kiss Mrs. McConnell's
dead baby, she was terrified for weeks afterward of going near her old
friend. Emily the child may have felt some twinge of the feelings she at-
tributes entirely to Auntie. Indeed, the very presence of Auntie, that
paragon of hypocrisy, is so necessary to the point of the story that we
may wonder whether she was there at all.

Obviously what Emily felt in retrospect was not only sympathy for
the brothers' grief but identification with their courage. The very queer-
ness of the O'Flahtys was their badge of honesty, and their indifference
to the funeral customs of the ultra-English (which she mocks wickedly in
Small) was a source of pride. The confidence of the adult writer of this
passage cannot have been the confidence of the child. The remembered
certainties must have been painful ambiguities, and the slow process of
sorting out which bits and pieces even of the ultra-English tradition she
would keep and which reject is not a memory she easily shares. There are
times when Emily Carr would have us believe, as perhaps she believed
herself, that Small was born a full-fledged rebel. But clearly the difficulty
of discovering just what rebellion entailed became the chief task of her
childhood.

CHAPTER
6

Orphan

EMILY'S CLOSE RELATIONSHIP with her father lasted until her early adolescence. Until she left Mrs. Fraser's school she still walked to the bridge with him every morning, her steps measured to his stride, her conversation tempered to his mood. They might have stepped out of an engraving on the walls of one of the houses they passed—the kind that pictured "Age Supported by Youth" or "Dawn and Sunset of Life." There was the plump, grey-eyed child, curls escaping in tendrils from under her straw hat; and beside her the erect, white-bearded, stern-browed old man, leaning on his cane. Neighbours smiled indulgently at the sight of them together, and Mrs. McConnell praised Emily for being a "faithful lamb."[1]

When she entered public school the morning walks were over, but she was still the favourite child, and when her father had been irritable at the breakfast table her mother and sister would send Emily to walk home with him in the afternoon, hoping she would ease him into a better mood. For a few years she obeyed willingly, not realizing why she was sent. But gradually, by her own account, she began to understand that she was

> being used as a soother for Father's tantrums; like a bone to a dog, I was being flung to quiet Father's temper. . . . I resented this and began to question why Father should act as if he was God. . . . I decided disciplining would be good for Father and I made up my mind to cross his will sometimes. At first he laughed, trying to coax the waywardness out of me, but when he saw I was serious his fury rose against me. He turned and was harder on me than on any of the others. His soul was so bitter that he was even sometimes cruel to me.[2]

But this hardly explains the intensity of Emily's later anger at her father; nor can we understand quite how she managed to provoke him to

"fury." In fact, the trust that had grown up between them was suddenly and violently shattered by an event Emily could not bear to mention to anyone until, very late in life, she told her friend Ira Dilworth. From her letters to him and her late journals the story can be pieced together, though much is left unexplained. What is clear is that one day when she was entering her teens her father took it upon himself to describe, very bluntly and possibly in anger, the mechanics of human sex. Emily was totally unprepared. Although she had lived all her life among animals, the spring calf had always been presented as a morning apparition, something God and the cow had concocted between them overnight. With a child's sure instinct to avoid what might be upsetting, Emily had ignored the quick couplings of chickens and rabbits as behaviour she would rather not know anything about. Certainly they had nothing to do with her, and the question they hinted at could not possibly be framed in words. Now her father forced her to confront it in the starkest terms, unsoftened by any context of gentleness or affection. She was overwhelmed by fear and disgust, and she could talk to no one—least of all to her mother, whom she now saw with an embarrassed sympathy that tormented her with unwanted, explicit images.

This was the incident Emily referred to privately as "the brutal telling."[3] Maria Tippett has suggested that it may have gone further—that there may have been some sort of "misguided attempt to illustrate the explanation by some action."[4] But what we know of Richard Carr's rigid, inhibited personality makes this seem unlikely. It does seem likely, though, that his language was blunt to the point of brutality. Never a man to be facile with words, he was probably embarrassed, possibly annoyed with her. He may have felt forced into it. Emily was beginning to be a very pretty girl. She habitually roamed the woods and fields alone, and she had a frank, open manner that a wandering hobo might possibly misinterpret. Her father may have ordered her to stay home and been met with a flat refusal. Then, stung to anger, he may have tried to frighten her into avoiding all strange men by describing sex as rape. For reasons we can only guess at, he was a very possessive father, and he was particularly possessive of this daughter. Whatever the explanation, the damage was severe, and Emily was left with a lasting revulsion.

She shrank from her father's presence, and the love and awe she had felt for him vanished. He was now "a cross gouty sexy old man who hurt and disgusted me. I resented his omnipotence his selfishness and I was *frightened* of him. . . . When he saw the horror he had created in me he was bitter probably more with himself than me. Then he was cruel and I hated him."[5]

It was to avoid being alone with her father, and not just because she thought he "needed disciplining," that she asked to be excused from fetching him home in the afternoon. In her journal she recalls that this

made her mother look "perplexed and worried," and she wonders if her mother "knew more than I thought."[6] But in her published writing her refusal leads to an epiphany, a silent covenant between mother and daughter that ushers the daughter into the adult world.

In *Growing Pains,* when Emily's mother asks her why she no longer wants to walk with her father, Emily cries out, "He is cross, he thinks he is as important as God." Her mother is apparently "supremely shocked," having raised her family in "the English tradition that the men of a woman's family were created to be worshipped."[7] But she expresses her shock in a peculiar way: she takes Emily on a picnic in Beacon Hill Park. This is a rare treat, since the children almost always have to share their mother's attention among them. Emily and her mother pack some cookies in a basket and walk together through the pasture, through the lily field—now in glorious bloom—to the padlocked fence on the edge of their land.[8] There Emily's mother unlocks the gate.

> The binding-chain fell away from the pickets. I stepped with Mother beyond the confines of our very fenced childhood. Pickets and snake fences had always separated us from the tremendous world. Beacon Hill Park was just as it had always been from the beginning of time, not cleared, not trimmed. Mother and I squeezed through a crack in its greenery; bushes whacked against our push. Soon we came to a tiny, grassy opening, filled with sunshine and we sat down under a mock-orange bush, white with blossom and deliciously sweet.
>
> I made a daisy chain and Mother sewed. All round the opening crowded spirea bushes loaded with droops of creamy blossom having a hot, fluffy smell. In these, bees droned and butterflies fluttered, but our mock-orange bush was whiter and smelled stronger and sweeter. We talked very little as we sat there. . . .
>
> I was for once Mother's oldest, youngest, her companion-child. While her small, neat hands hurried the little stitches down the long, white seams of her sewing, and my daisy chains grew and grew, while the flowers of the bushes smelled and smelled and sunshine and silence were spread all round, it almost seemed rude to crunch the sweet biscuit which was our picnic—ordinary munching of biscuits did not seem right for such a splendid time.
>
> When I had three daisy chains round my neck, when all Mother's seams were stitched, and when the glint of sunshine had gone quiet, then we went again through our gate, locked the world out, and went back to the others.[9]

The passage is one of the few Emily wrote about her mother. Her earlier book, *The Book of Small,* had been about her early childhood and was very much concerned with her father—his personality, his authority, his

religion. *Growing Pains* is mostly the story of her adult life, beginning with her break with her father and the picnic that became the final confirmation of her mother's love. Her mother died when Emily was fourteen, and they never again were close in quite this way.

So the meaning of the picnic is deepened by an unspoken context: her revulsion against her father, her adult grief for her mother and the remembered shock of discovering that she was—and could not possibly be —a sexual being. Then there is the larger context of her other writing, for the chapter gathers into itself images from other passages. Her father is entirely, vividly himself, but he is also fence and padlock, "binding chain," social convention and religious authority. She reminds us three times of her father's hubris. ("I began to question why Father should act as if he was God" . . . "He is cross, he thinks he is as important as God" . . . "The men of a woman's family were created to be worshipped.") Her mother is the lily field, the mock-orange bush, the boy and the white horses, singing, young calves in spring, virginity and maternity in one—everything that is joyful, spontaneous and creative. On the day of the picnic several lines in Emily's life converged. She turned away from her own body, which suddenly repelled her, and from her father and her father's God. She turned towards her mother, expecting disapproval. Instead there was the picnic. Instead of being locked out of the garden, she was invited in. On that afternoon her mother offered both blessing and rite of passage. It was all right, on the most important level, to violate the rules by which her father dominated their lives. They were, literally, the rules of idolatry.

Meanwhile, of course, she had to go back and live in the same house with her father. She avoided him, ducking out of the room when they were alone together and averting her face when he spoke to her. Hurt by her withdrawal (and probably, as she suggests, by his own remorse), he constantly found fault with her. One can imagine the petty reproofs he left behind each morning, to follow her around all day like a cloud of stinging insects. Dede kept them lively, for she noticed her sister's sullenness without understanding the cause. So began a pattern of conflict that continued for several years.

All the time their mother was steadily losing her long battle with tuberculosis. In September 1886 she was seriously stricken, and on the twenty-first her husband stayed home from work and sat all day beside her bed, holding her hand while she fought for breath. The children, kept from school, hovered in the background. Late that night they kissed her and went to bed; a few hours later someone turned on the light over the bed Emily and Alice shared, and they found Mrs. Cridge, wrapped in a grey flannel robe with her plaited hair all dishevelled, sitting beside them and crying. "Happy, happy children," she said over and over again. "You have a mother in heaven."[10]

For a while Emily drew closer to her father. Her mother's coffin lay in the drawing room. Her sisters were all busy upstairs, where they and a group of friends sat sewing mourning dresses and arm bands. Emily's father sat in the sitting room all day, unmoving, while tears ran down his face. Emily was appointed to look in on him now and then. At one point he roused himself, called them together and asked them to help him choose a family plot in the raw, new cemetery at Ross Bay. They all went there together, and a place was chosen on high, unshaded ground, where the sun beat down and the wind rustled in the scorched grass. Emily alone had held out for a small hollow with two willow trees, but the others insisted on "healthier" ground. Her father took her arm as they climbed back up the ridge and tried to comfort her.[11]

He never recovered his vitality, and Emily was surprised and moved to pity. She had never thought he loved his wife very much; his ceremonial visits to her sickbed every afternoon had been largely silent. Now he withdrew into a private abstraction, abdicating most of his authority in favour of his eldest daughter.

The year before Emily turned sixteen could hardly have been more difficult. Still mourning for her mother, she was confused by the turmoil of love, hate, pity and fear she felt towards her father, and more frightened than most girls of her feelings towards men in general. Except for Alice and a few friends, the world seemed hostile and full of obscure dangers. Most of all, she resented Dede's attempt to usurp their mother's place. Dede was now nearing thirty. She was a square, sturdy woman with a resolute jaw whose considerable energy had never found a proper channel of its own. She took on her new responsibility with enthusiasm, earning plaudits from everyone who knew her. She loved her youngest sister and showed it whenever Emily allowed her to, but Emily presented a very prickly surface, and Dede's temper matched her own. Almost certainly Dede felt that God had called her to labour in the family vineyard rather than in the larger world; she needed recognition of her calling, especially from the children who were its object. But only Emily and Dick (now eleven and beginning to have a mind of his own) could possibly be called children. The more she tightened her grip, the more they fought back. And the more they fought back, the more Dede's friends showered her with the sympathy she needed.

So the roles set from Emily's early childhood became more exaggerated than they already were. Like Lizzie quoting the word of God, Dede was invincibly in the right. Emily used that righteousness as she used Lizzie's, to define herself as someone set apart, the persecuted alien. Both needed to behave as they did, and both loved to play the martyr: Dede was the Christian virgin whose youth had been sacrificed for the sake of others, and Emily was the honest soul persecuted by Pharisees, with a touch of Lord Byron thrown in.

One of the few pleasant influences in Emily's life that year was the presence in Victoria of Mr. and Mrs. C. A. de L'Aubinière. Both were artists, both European: he was French, she English. Arriving in Victoria in 1886, they tried hard to establish art schools and a museum, but they were plowing stony ground and after a year they moved away. In the meantime, though, Emily met them and may have taken lessons from them, and they strongly encouraged her to study abroad. It was probably the first time she had considered such a thing, but from then on she nursed the hope of serious study in England or France, though she knew she would have to wait several years, assuming she was allowed to go at all.

In 1888, when Richard Carr was seventy, his failing health forced him to retire. He set up his office desk in the downstairs room below his wife's bedroom and would sit there motionless, staring out at the garden, while his children tiptoed past the door. That fall Emily enrolled at Victoria High School, as Lizzie and Alice had before her. Few Victorians went to high school; it served as a normal school in the absence of any other, and most graduates took the government qualifying exams for teachers. Despite her distaste for booklearning, Emily may have had some such idea in mind, and probably it was what her family expected of her. If she went to art school at all, she knew it would not be soon; and if her family finally refused to send her, teaching would offer independence and a chance to save up the necesssary funds.

Meanwhile the conflict with Dede erupted into open warfare. Emily constantly provoked her sister, and Dick followed her lead. If Emily can be believed, Dede retaliated "every day" by lashing them about the legs with a riding whip.[12]

Things came to a head when a friend of Dede's, a remittance man, came with his wife to stay for six months. Remittance men were Englishmen, usually younger sons from wealthy families, who lived in Canada on a small allowance from home and a little help from their friends. Like many Canadians Emily disliked all such people as parasites and snobs, and the story of her running quarrel with Frank Piddington is told in *Heart of a Peacock* and *Growing Pains*.[13] The quarrel began over Emily's mischievous pet crow and escalated when Piddington deliberately made Emily seasick during a boating trip, humiliating her in front of her friends. When Emily called him a "sponger and a bully," Dede—who, to her credit, had tried to mediate between the two—lost her patience and thrashed Emily "till [she] fainted." Afterward, in Emily's words, "I said to my sister, 'I am almost sixteen now, and the next time you thrash me I shall strike back.' That was my last whipping."[14]

Dede stopped whipping Emily, but she made up for it by lashing her with her sharp tongue. She could reduce Emily to tears by saying that

she had troubled their mother's dying days by her rebellious behaviour. The accusation haunted Emily all her life. In her seventies she would still need reassurance that it was not true, perhaps because to some extent it probably was.

A few weeks after Emily entered high school her father was taken ill. He weakened rapidly. The children stayed near his bedside, Emily in particular hoping for some word of reconciliation. The bishop arrived to pray—not at Carr's request, since he and the bishop had always kept their distance, but at Dede's. The children were sent to an adjoining room, and while they were thus excluded their father died. Any unsaid words he had for Emily died with him.

At her father's burial, listening to the earth falling on the coffin, she was conscious of how bizarre her feelings were:

> I was the closest I was peering down into the fast filling hole and in my heart there was *relief*. Nobody knew the sinking agonies of terror I had suffered when I had been alone with father because before I'd been his favourite trotting after him like a dog. Now I was breathing free the first time for several years. [Dr. Helmcken] came up and put his arm around me. "Come lassie," he said. "This is no place for you" but none of them knew, not one, what feelings were going on in me.[15]

Richard Carr left $50,000 in trust for his children, enough to assure them an adequate income. It was administered by a lawyer and family friend, James Lawson, in consultation with other trustees and Dede. Lawson was appointed guardian of the younger children. Although the house was willed to Dede, Emily believed, no doubt rightly, that it was meant "as a home for us all." In practice Dede "owned everything and us too. . . . We younger ones had no rights in the home at all. . . . We younger ones did not exist."[16]

Everyone seemed to be on Dede's side:

> Outsiders saw our life all smoothed on top by a good deal of mid-Victorian kissing and a palaver of family devotion; the hypocrisy galled me. I was the disturbing element of the family. The others were prim, orthodox, religious. . . . Not content with fighting my own battles, I must decide to do battle for the family rights of all us younger children. I would not sham, pretending that we were a nest of doves, knowing well that in our home bitterness and resentment writhed.[17]

They were not as hypocritical as all that, nor was the "palaver" of family devotion all false. But though their friends knew there was conflict, they knew nothing of the violent emotions that erupted in private, nor could they have understood them if they had known. Dede was well

liked in Victoria, and Emily was known to be petulant and difficult. The view of one woman, published in 1952, is typical. Edith, she said, was an "unusual and gifted woman" who "had instincts and powers that might have made her a great painter." She had "a strong sense of duty and a vast capacity for love. . . . Laying aside all thought of herself and her own life, she devoted all her capabilities and powers to her young sisters." Milly was a spoiled baby, and a clash between them was inevitable: both were "gifted, determined, humorous, self-willed."[18]

There is in these resolutely generous remarks, and especially in the tacit equation of Edith's flair for china-painting and craftwork with Emily's towering talent, a hint of the tea-table kindliness of Victorians that drove Emily to churlishness and even to despair. To such people passions of all sorts were inconvenient, and Edith was a conscientious woman who was sorely tried. As for any thought that Dede was as ruthlessly assertive in her way as Emily was in hers, it was simply beyond belief.

To escape from home Emily took to the woods, sometimes with Edna Green for company but often alone. The family now owned a trail-wise circus pony named Johnny, who was not afraid to push his way down some overgrown, abandoned trail, where the young branches scratched his nose and swished together behind his tail. Emily would duck low over his neck until they came to a clearing where she could slide off and stretch full length on the ground. There she could lie on her back and stare at the shifting, translucent patterns of green above her head, while Johnny cropped and munched, cropped and munched, in a soothing monotony that said there was nothing on earth so important as grass. The woods around them were silent except for the rustlings of small, drab birds that busied themselves among the leaves and flitted from tree to tree like minute streaks of shadow.

She finished the year at high school after her father died, and then refused to go back. But she kept up her art lessons, working in a class with two slightly older girls, Sophie Pemberton and Theresa Wylde, both of whom were headed for serious careers in painting. It is possible that Dede refused to pay her tuition, for Emily writes that she was allowed in the class in exchange for the loan of her plaster casts.[19] In the course of the year Sophie, possibly inspired as Emily was by meeting the de L'Aubinières, managed to persuade her parents to allow her to study in England. It was an unprecedented step; no woman from Victoria had ever before studied abroad. But Sophie went, and in two years Theresa, fortified no doubt by her example, would follow. Emily meanwhile bombarded Dede with requests to be allowed to go too. Dede refused to listen.

Finally Emily went over her sister's head, to her guardian James Lawson. She did not ask to go to London; instead she begged him to send her

to the California School of Design, which was just down the coast. Law-son, cornered in his office, hardly knew how to answer her. She was flushed, angry, tearful and fully capable (as he no doubt knew) of making a scene. He peered at her over his glasses and reminded her that her sister was an "excellent woman" and San Francisco a "wicked city." She says that she in turn reminded him that she was "sixteen, almost,"[20] but in fact she was eighteen, in appearance and presence a grown woman. Law-son gave in and allowed her to go. The "disturbing element" left the family in the fall of 1890, no doubt to the relief of several other people besides herself.[21]

CHAPTER
7

San Francisco

JAMES LAWSON was right: San Francisco was a wicked city. But it was wicked only in spots. With each neighbourhood the city put on a different personality, like an actress trying on a trunkful of clothes. It was still a gold-rush town, something like what the Victoria of the 1850s might have become had not the solid character of England reclaimed it as its own. Here, as in old Victoria, the English language was only one of many on the streets, though in San Francisco the various foreign presences were more visible. Chinatown was too familiar to Emily to seem exotic, and the Kanakas, or Hawaiians, were much like those at home. But the French community was large enough to stage a vigorous celebration yearly on Bastille Day, and the Spanish and Italians marked Columbus Day with a parade through town. The Germans had their own theatres and beer gardens, the Italians their cafés and pasta factories, and there were sizable populations of Irish, blacks, Jews, Poles, Finns, Scots and Welsh. And despite San Francisco's image north of the border as an unruly Yankee town, a large percentage of its citizens were British-born. Underneath all this, like some half-obliterated fresco, was the warm and lingering colour of the Spanish empire.

If one wanted wickedness, one found it among the grog shops along the waterfront, where unsuspecting sailors were still being shanghaied after being plied with doped whiskey; or one found it in Chinatown, with its opium dens and Tong wars and sinister underground passages; or in the red-light district or the relatively tame but free-living artists' colony on Telegraph Hill. If one wanted opulence, one went to the millionaires' enclave on the next hill over, or the Grand Opera House on opening night. If one wanted respectability interrupted by nothing more exciting than a fire alarm, that was easy enough. One simply stuck to the streets that were lined with row upon row of identical grey, two-storey houses, each with its tiny garden under its front bay window. The fire alarms one could not avoid, for as a precaution against earthquakes San

Franciscans had built their city, outside of the business district, almost entirely of wood. Nothing united the hodgepodge that was San Francisco more firmly than the fire brigade.

Emily's guide through the paths of respectability was Dede's old friend, Mrs. Piddington. Needless to say, Emily objected, but she was told she could have San Francisco with the Piddingtons or Victoria without them, and that was no choice at all. She made the best of her new quarters, a small bedroom on the top floor of the Lyndhurst Hotel at 501 Geary Street. The Piddingtons lived on the ground floor, so at least she had a staircase as a token guardian of her privacy. For company she had her old canary, Dick, whose battered cage she hung in the window.

On weekdays it was easy to escape Mrs. Piddington. Emily went off to school in the morning and came home around five o'clock. Weekends were more difficult, for the school was not open to students then and any excursion with friends had to be explained beforehand. She could not escape the Piddingtons at meals, and she must have spent many long evenings before their hearth, hiding behind a book to escape Frank's leering banter and his wife's prying questions. At least her days were all her own, and she had never been able to say as much before. They were hers even though they belonged to the school, for to Emily there was not a particle of difference between the two.

The California School of Design had been founded in 1874 as a teaching arm of the San Francisco Art Association. Since then it had grown into a thriving and respected institution, though it was criticized in some art circles for being too cautious and conservative. Students were accepted after submitting a sample of their work in advance (as Emily undoubtedly did, despite her claim to the contrary in *Growing Pains*).[1] There were no other restrictions placed on them save that they be over fourteen years old. Tuition was $12 per class per month, $16 for oil painting; a few students were admitted free. Materials, except for oil painting, were supplied. Classes met from nine to four on weekdays; there was a Saturday class, but it was not part of the regular course. The curriculum included drawing from the antique and from life, portraiture, still life and landscape painting, composition and perspective. There were usually sixty to seventy students and four faculty members for the regular course of study.

The new director, Arthur F. Mathews, was fresh from studying at the Académie Julian in Paris, where he had won the rare distinction of a Grand Gold Medal. But five years in France had not softened his suspicion of the new trends in French painting. His own work in San Francisco ran to historical and allegorical subjects, bearing titles like *Cupid and Psyche, Death of Ariel* and *The First Sorrow*. As a teacher he was dictatorial and sarcastic, but his pupils emerged from his classes with a firm grasp of the essentials.

Emily knew Mathews only through drawing from the antique, for she could not bring herself to enter his life class. Her scruples were shared by only one other student, the friend she calls Adda, whose puritanical upbringing matched her own. Emily knew she was being backward, but she could not help it. "The modesty of our families was so great it almost amounted to wearing a bathing suit when you took a bath in a dark room," she writes, and her lifelong aversion to nudity bears this out.[2] Eventually she overcame it, at least in her art; but not while she was in San Francisco.

She studied portraiture with Oscar Kunath, still life painting with Amédée Joullin, landscape painting with Raymond D. Yelland and later with Lorenzo P. Latimer. The landscape class, with its Wednesday excursions into the countryside, was far and away her favourite. But it was Joullin who quite literally drove her to break through the stylistic timidity of the beginning painter. "I can still remember the French painting teacher[3] badgering me with rages so as to get my best work out of me," she wrote in 1939,[4] and in *Growing Pains* she recalls how, driven to a fury by his everlasting "Scrape" and "Scrape again," she would literally hurl the paint onto the canvas.[5] Joullin himself was known for the boldness and rapidity of his style, and he was the first teacher to push Emily towards her later quick decisiveness with a brush. Later in life he would become known as a painter of the southwest native Indians, one who lived with them and knew them as Emily would know those of the northwest. In the early 1890s his native Indian sojourns still lay ahead of him, but Emily must have seen the vivid pictures of Chinatown that prefigured his later work. He was also the first San Francisco artist to paint the northern California sand dunes.

The school was inelegantly housed in quarters sublet from the Bohemian Club at 430 Pine Street, above the old California market. Emily loved its inelegance; it had something of a comfortable cow-yard squalor about it, complete with plates of rotting fish and wilting vegetables. The floor was littered with scraps of bread used for rubbing charcoal, and underfoot the rats quarrelled companionably over them like so many chickens. The entire school consisted of one large hall, high-ceilinged and lit by north windows and a central skylight, and divided here and there by screened alcoves separating one class from another. Scattered about were casts and reproductions of classic sculpture, most of them donated by the French government: The Discus Thrower, Apollo Belvedere, Venus de Milo, bas reliefs from the Parthenon and many others. Scattered about them, in turn, were easels, and before each easel was a student. These were as miscellaneous as San Francisco itself, saving only the fact that none was wicked, or at least not conspicuously so. Mrs. Piddington distrusted them nonetheless and called them "that Art School outfit."[6] There were people of all ages and nationalities and

both sexes, society women who never bothered to wear smocks, or-
dinary penny-pinching students like Emily whose smocks were much-
used and very dirty, a retarded Jewish boy, a hunchbacked girl, people
who were very gifted and people who were just passing the time. The
school took them all in, though many fell by the wayside by the end of
their first term.

The comraderie of the students disarmed all but the very shy. New-
comers like Emily were immediately drawn into the group without
ceremony, with smiles and advice tossed over a shoulder about where
supplies were kept and how to find the washroom. Everyone ate lunch
from paper bags around the stove. Emily made particular friends of two
young women, the straightlaced but kindly Adda and the homesick
English Stevie, who brought Emily flowers every day as a tribute to
their common British heritage. Later Emily grew close to the blue-eyed
American Nellie McCormick, for whom art school was a refuge from a
domineering and possibly abusive mother. But she liked all the students.
Many were far from home, and they looked after one another in a way
that moved her and somehow brought her closer to the memory of her
mother. One can detect between the lines of her written memories of this
period a new preoccupation with mothers and mothering, which might
have been a way of finishing her own long-suppressed grieving. Mothers
are important, either in good ways or bad. Jimmy Swinnerton, whose
pranks disrupt the class, is forgiven because he is a "poor motherless
lamb."[7] Adda's every move is dictated, via the mail, by her loving but
overprotective mother. She feels a little superior to Emily, who envies
her a bit in spite of the maternal restrictions on her freedom. Nellie's
mother is "a beast,"[8] and Nellie in turn envies Emily, who has no
mother at all. In Growing Pains Emily becomes Nellie's mother for a
while, in a passage that combines images of singing and the lily field,
images fraught with memories of her own mother.[9]

Being an orphan had certain advantages. Free from real maternal inter-
ference, she was also free to question the authority of Dede and Mrs. Pid-
dington, who had no maternal claims on her. For parental guidance of a
gentler sort she turned to Lawson, who responded faithfully if rather
stiffly to her confiding letters and sent her money for board and fees.
Essentially independent within these bounds, Emily probably saw as
much of San Francisco as she wanted to. But quite apart from Mrs. Pid-
dington's warnings, her own timidity probably kept her from exploring
very far. She saw little art outside of the Art Association's own gallery.
Wealthy San Franciscans were collecting some fine European paintings,
and if there were no Monets on their walls there were at least Corots; but
Emily had no access to the homes of the rich. She took guitar lessons on
an instrument borrowed from a sister (probably Dede), and in 1893 she
joined a guitar and mandolin club and went to meetings. Aside from that

she seems to have had no social life outside the school and little ac-
quaintance with the city. Her two accidental visits to "wicked" neigh-
bourhoods—one to Telegraph Hill and one to the red-light district
—terrified her after the fact, especially since Mrs. Piddington sat her
down and explained in frightening detail the perils of being kidnapped
into "white slavery."[10] Emily afterward took this as evidence of Mrs.
Piddington's own prurience and malice, but in fact any San Francisco
matron would have done the same. The high-class bordellos along Grant
Avenue, where Emily had wandered, were a thorn in the side of the la-
dies of the city, who would soon succeed in having them all moved far-
ther north, though not abolished altogether. One intersecting alley,
Morton Street, had houses as rough as any on the waterfront. (Beyond
Bush Street, where it became even more disreputable, Grant Avenue was
called Dupont Street. After the 1906 fire the whole street became Grant
Avenue, and Morton Street became, of all things, Maiden Lane.) No re-
spectable woman walked along Grant Avenue, and Mrs. Piddington's
fears that Emily might be accosted were justified, even if she dressed
them up to make a point. In *Growing Pains* this incident, as Emily tells it,
holds some of the horror of the earlier incident with her father. In the
book she represents herself as having been completely innocent at the age
of eighteen, and clearly she transfers the brunt of her anger and disgust
from her father, whose transgression she could not write about, to a
woman who meant nothing to her.

The closing of school for the summer brought new trials for Emily,
for rather than pay the fare to Victoria Dede sent her sister to stay with
Auntie Hayes in San José. Auntie's circumstances had changed a bit. Her
first husband had died years earlier, and she now lived with her second
husband and his three children. But stepmotherhood had not mellowed
Emily's old enemy. She still kissed and "deared" as much as ever, and
she was still the same sugary, petulant, iron-willed fuss-budget that
Emily remembered from childhood. Emily spent at least one summer,
and probably two, under her critical eye, and during each visit Auntie
devoted herself to patching up any damage San Francisco might have
done to Emily's manners. There was nothing Emily could do about it
except "[lead] the stepdaughters into pranks, hoping it would put Aunt
off inviting me next time." But it "never worked," for Auntie was deter-
mined to do her best by the daughter of her dear departed friend.[11]

Emily was spared the San José ordeal in 1892, for that spring her sisters
came to spend a year with her in San Francisco. They all lived in a house
at 1717 McAllister Street, which they apparently shared with the Pid-
dingtons. Emily was delighted to have Alice with her, but the fun was
dampened by the new restrictions placed on her time. Dede was not so
easy to evade as Mrs. Piddington, and even pleasant family obligations
drew Emily away from her work. There was bickering at home, not

only between Emily and her sisters but between Dede and Mrs. Pidding-
ton. Finally, after a stormy row between these two that must have given
Emily some quiet satisfaction, Dede suddenly left for Victoria. Lizzie and
Alice followed. The Piddingtons left San Francisco, and in the spring of
1893 Emily was sent to board with a widow in Oakland.

Her account of her life there gives us some insight into her growing
conflict over being both woman and artist. At twenty-one Emily was a
striking young woman. Still fearful and resentful of men, she neverthe-
less thought that someday she might fall in love, marry and spend her life
surrounded by an understanding family who would leave her free for art.
But she knew no one who led such a life, and now she was confronted
with a vision of the dream gone wrong. The widow, whom she calls
Mrs. Tucket, was an artist. Emily makes it clear she was a bad artist, but
that was beside the point. What was important was that Mrs. Tucket was
a bad mother. Entirely absorbed by art, she referred to her two children
as "my encumbrances."[12] She got along on no visible income except
Emily's board money, and by the end of each month the four of them
were living on scraps of food fried over Emily's spirit lamp. When the
little boy, whom Emily loved, fell seriously ill, he almost died because
his mother would not or could not afford to call a doctor. Emily was
outraged, not only at the woman but at the vocation that demanded such
a sacrifice. "Art I hate you, I hate you! You steal from babies!" she cries
out in the story. She could safely imagine herself above the likes of Mrs.
Tucket and believe her own life would be entirely different. But she
could not deny that even the most idyllic marriage might involve impos-
sible conflicts. However much she despised Mrs. Tucket, the woman's
devotion to art matched her own.

After the summer holiday that year she moved to a San Francisco
boarding house, where she was happy. She was the pet of several elderly
female boarders, and soon she was "very overmothered."[13] They shook
their heads over the dowdy wardrobe with which Emily, more or less
deliberately, disguised her good looks. They lent her trinkets and even
went so far as to make a dress for her, but the result disappointed them,
probably because Emily wore it with calculated ill grace. Afterward she
joined the landlady's daughter in learning to sew and made her clothes to
suit her own purposes.

In the boarding house she met a new art school student, Ishbel Dane.
A few years older than Emily, Ishbel lived in apparent luxury and
seemed to have no friends except for Emily and the male leader of the
guitar club to which they both belonged. The collective mothers in the
boarding house would have nothing to do with Ishbel, and Adda—after
quickly sizing her up—refused to meet her. The guitar club leader took
Emily aside and charged her, with peculiar intensity, to "be good to Ish-

bel."[14] And so she was. Ishbel became Emily's "trust," and Emily was her "funny little mother-girl."[15]

A good deal of what San Francisco meant to Emily, and of what "mothering" meant as well, was tied up in this relationship. To be singled out as the only friend of an accomplished older girl was to experience the first sense of being a responsible adult. Like Nellie's, Ishbel's dependence made Emily feel strong and free. She was not, after all, the eternal baby sister that Dede and Lizzie made her out to be. Not only was she beginning to see her career take solid form beneath her hands but she was discovering, with some considerable pride and wonder, that she herself had some of her mother's reserves of quiet strength. If she was strong enough to take care of others, then she was strong enough to break free of her family and make her art career a reality. And so Ishbel gave Emily at least as much as Emily gave her. Yet Emily—for all Mrs. Piddington's graphic warnings—apparently was baffled by Ishbel's mysteriously sinful aura and could not understand why the girl was ostracized. It was only after she had left San Francisco, when she received a letter telling her that Ishbel had died in compromising circumstances, presumably of an abortion or miscarriage, that she began to understand why one so obviously fortunate should have been yet another waif.[16]

In the spring of 1893 Edward T. Searles, widower of Mary Hopkins Searles, donated the Hopkins mansion on Nob Hill to the California School of Design. The school moved from the old market to the mansion, and its name was changed to the Mark Hopkins Institute. Emily was sorry to leave the market, which she apparently thought had been condemned. (It stood until the fire of 1906, and the fashionable landscape painter William Keith set up his studio there.) She did not much like the thought of being an "institute," and the Hopkins mansion was not the sort of place where you threw bread crusts on the floor.

As it turned out, Emily did not have much time to worry about where to throw her bread crusts. She finished the fall term, but by then the 1892–93 depression had hit both San Francisco and Victoria. The Carr estate began to feel the strain, and Emily was called home in December.

She left one family member behind in California. In January 1892 her brother Dick, then sixteen, had entered Ridley College, a prep school in Ontario. A year later, showing symptoms of tuberculosis, he was forced to leave school and was sent west to a sanitorium in Santa Barbara, where his sisters were able to visit him regularly. But after the older women went home Emily saw him only once before she herself left for Victoria.

Love and Ucluelet

COMING HOME was like suddenly being plunged into one of the little white bathtubs of Emily's childhood. Not only was the immersion an icy shock but the tub itself was absurdly small. San Francisco, in contrast, had been an ocean to strike out in, and a warm Mediterranean ocean at that. There she had learned to see her family from a distance, and she had discovered that her own decisions, contrary to what she had always been taught, did not always or even often lead to calamity. She had learned that her talent was worth taking seriously, and that she was one of many who intended to make art the real centre of their lives. And she had found that emotionally she was not the inept, demanding, spoiled child of the Carr household, but a woman as strong as anyone, strong enough to lend support to someone else.

Now all that self-assurance had nowhere to go; it counted for almost nothing. She was again the family baby. If anything, her voice had lost what little influence it had, for they had learned to do without her while she had learned to do without them. They had even expanded in her absence, so she was hard put to find her old niche. Alice was distant and preoccupied with a new set of friends, whom Emily on principle disliked. Lizzie, still intent on being a missionary, filled the house with "long-faced samples" of that calling.[1] Dede was active with the Protestant Orphanage and was president of the Victoria YWCA, which she and Lizzie had helped found the previous autumn. The members met in one another's homes, where they devoted themselves to Bible study, prayer and practical good works. The good works included raising funds for a lunch room for working women, but if Emily noticed that fact she chose to ignore it. All she saw was the Bible study and the interminable praying. She seemed to be forever stumbling over "doubled-over ladies, with their noses on the seats of our chairs, and their praying knees down on our carpets."[2] On Sundays all three of her sisters taught Sunday school classes at home, forcing Emily to take refuge in the barn or lily field.

Altogether she felt besieged. Dede and Lizzie pressed her hard to at least teach a Sunday school class, and they took her heated refusals merely as a sign of a benighted godlessness that would, in time, yield to Christian perseverance.

Emily did not exaggerate in her sisters' militant piety. Her nephew Richard has described his two elder aunts as "very, very straight," "very, very religious," and altogether rather forbidding to him as a boy. (Emily, by contrast, taught him to smoke when he was fourteen, no doubt partly to spite her sisters.)[3] Edythe Hembroff-Schleicher, who is generally rather skeptical of Emily's complaints about her sisters, remembers coming across Lizzie's "doubled-over ladies" in the 1930s.[4]

Partly as a peace gesture, and partly because she really did feel she needed some sort of religion, Emily went with her sisters now and then to the Church of Our Lord. But usually they went without her. They always sat in the same pew: Edith wearing a bonnet, though bonnets were a generation out of style; Lizzie, "bird-like" and "very conventional"; and Alice, smiling and reserved under the luxuriant mass of auburn hair that somehow symbolized the subtle ways she found to set herself apart from the others.[5]

Not all the peacemaking was on Emily's side. Dede was genuinely happy to have her sister home again and wanted her to stay. She made Emily a present of a young retriever, asking only that he be chained whenever he was not with Emily. Emily was grateful, but the gesture did not bring the sisters any closer together. The dog just gave Emily an excuse to slip off to the woods by herself without having to answer any tiresome questions. Old Johnny gave her another excuse. Alone or with Edna Green and Edna's cousin, Ethel Worlock, she would range the countryside on horseback for hours. Even the sisters gained from these expeditions, for Emily returned from them sweet-tempered and obliging. Eventually, taking the dog but not the horse, she began to go on camping trips lasting several days.

She had come home with no fixed idea of the future. She still thought of marriage now and then, with all the awkwardness of art excised: a home that was an ark laden with gentle beasts, and her man a Noah. Alternately, she thought of setting up house with Alice. But Emily was not the only sister to whom San Francisco had brought emancipation. When Emily spotted a small, isolated house for rent on Moss Street and proposed that she and Alice live in it together, Alice "frowned tremendously" and wanted to know what she would do all day while Emily was off painting. She could do whatever she wanted, Emily said, "just live and boss and [do] housekeeping."[6] Alice was incensed—she was not, she said icily, going to be Emily's *housekeeper*. She too must have had her own misty vision of marriage, but failing that, she was beginning to think of opening a school.

Teaching held no appeal for Emily, yet when the neighbourhood mothers began asking if she would give their children art lessons, she decided to try. At first she taught in the house, but there were collisions with the praying ladies and complaints about the mess. Later, with the help of a carpenter and the Chinese handyman, she fitted out the barn loft as a studio, tightening the walls and installing a window, a skylight and a stove. She loved this snug retreat, where she not only gave lessons but entertained her own friends. Not all of these were human: the cow chewed and stamped below, cats prowled the rafters, the dog slept by the stove and a magnificent peacock from the park was a regular visitor. Her pupils were as delighted with it as she was, and she actually enjoyed teaching. When she had time she went on steadily with her own work, and in 1894 she received her first public recognition, a prize for a now unknown pen and ink drawing at the Victoria Fair.[7]

She was a "natural teacher" according to her nephew, who took lessons from her.[8] She handled discipline problems with a combination of brusqueness and good fun: when one class of boys plagued her by eating the bread she passed out as erasers, she dosed the bread with salt. Following the example of her San Francisco teachers, she forbade her students to copy and took them sketching outdoors whenever the weather permitted. Mistakes were brushed aside with a patient suggestion to begin again. If the next effort was no better, she might sit down and dash off a sketch of her own to show how it was done. But she never touched a student's work, and any success a child had was his own.

Now that she had a definite vocation, money of her own and the hope of going abroad, life at home became more comfortable. Tensions relaxed a bit. Emily never mentions pranks and parties in her written memories of home, but there was no lack of either in this houseful of young women. One friend remembers how on April first, 1894 or '95, her father received a summons to call at the Carr home and talk to Dede. He was the Reverend W. Leslie Clay, the new Presbyterian minister, young and rather shy, and since Dede was an Episcopalian he was more than a little puzzled by her message. But he went, and was shown into the drawing room, and presently Dede appeared. They both sat down and there was a small silence. Finally the minister said, "I understand you wished to see me, Miss Carr?" "Why, Mr. Clay," Dede answered, "I understood that you wished to see *me*." Whereupon Emily emerged from behind the curtains with a shout of "April Fool!" and a whoop of laughter.[9]

Not all her sisters' friends were missionaries. There were picnics, teas and dinners, games of tennis were regularly played on the new courts that had been laid down over part of the garden, and Tallie's children were in and out of the house. Emily's old friends welcomed her home, and in 1895 she took a summer cycling holiday along the Cowichan

River with Edna Green and a woman she calls Mac.[10] Tallie and her husband gave weekly dances for the fashionable younger set at their new house on Dallas Road. Their pretty daughter Una was there, as were Edna Green and her cousins the Worlock sisters. Emily went too, though at first she did not dance; an acquaintance remembers seeing her sitting on the stairs, glowering fiercely at the dancers below.[11] Nevertheless, by the end of the decade she was taking dancing lessons.

But however life at home had improved compared to what it once had been, the bottom line was her increasing need to get away from her family permanently and do what she had wanted to do ten years before: study in Europe. Sometimes that need crowded everything else out of her life. Teaching was only a means to break free, and she saved every cent she could.

The tenuous peace she achieved with Dede received a sharp setback when they clashed over Emily's dog. Watch, the retriever, was snappish, and Dede was afraid he might bite someone. He had already nipped two people, one a maid who was teasing him and the other a student whose playfulness with Emily the dog took for a threat. The crisis came when Emily was injured in a carriage accident and went away to visit friends in the country while she recovered. When she came back the dog was gone. There had evidently been a complaint, and Dede had allowed the police to shoot him. Emily never forgave her, and of all the grievances she nursed against her sister this was surely among the worst.

In the spring of 1899 Emily finally had a chance to get away, at least for a week or two, when she was invited to visit the west coast of Vancouver Island.[12] A friend of Lizzie's, May Armstrong, taught at the Presbyterian mission school at Ucluelet, a remote Nootka reserve on Barclay Sound, about halfway up the coast. Lizzie had visited her there before and served as assistant teacher. Now May invited Emily to come too and do some sketching, and Emily eagerly accepted. Almost certainly Lizzie went with her, though Emily always spoke and wrote about the trip as if she had gone alone. Still, if we look carefully for the fastidious Lizzie in the chapter "Ucluelet" in *Klee Wyck,* we can find a hint of her in the "Lesser Missionary" who hates to walk the overgrown trail because she cannot see where she is putting her feet.

The Nootka at Ucluelet had hunted whales and seals from open canoes along the stormy coast for generations before the white man came. Now, despite their isolation, they were suffering the usual fate of cultural disintegration and all its attendant ills. But they still lived in community houses, depended on the sea for food and preserved their old kinship alliances. Never a warlike people, they tolerated the missionaries among them and adopted as many of the external forms of Christianity as suited them. The actual white population was tiny, since the only access was by sea. The Presbyterians had only been there five years.

Emily stayed at the mission house, sharing its sparse amenities with May and Lizzie and eating her meals from a pie tin because there were not enough dishes to go around. On her first morning there she went to the schoolhouse, a rough-timbered structure that doubled as a church on Sundays, and watched the beginning of class. Then she slipped outside. The mists were rising from the water, and the first rays of sunlight warmed her back. The school stood on a narrow crescent of beach separating two villages, Etedsu and Kwa-Imp-ta. Barely above the tide line the forest crowded the shore, claiming every inch it could get from the sea, and at its feet ran a root-studded, half-obscured trail. Human activity was confined to the trail and the little strip of open land. Emily had been warned that the woods were full of cougars. Now and then they raided the mission meat-safe at night, and the women would wake to the sound of claws ripping off the wire grating. She was not especially interested in the forest anyway—it seemed too dense and forbidding—and she turned her attention to the villages. Each was made up of several large communal houses,

> made of thick, hand-hewn cedar planks, pegged and slotted together. They had flat, square fronts. The side walls were made of driftwood. Bark and shakes, weighted with stones against the wind, were used for roofs. Every house stood separate from the next. Wind roared through the narrow spaces between.[13]

She went from house to house, politely knocking on doors, but the natives were puzzled by this behaviour, and soon she found that she could just come and go as she wished, sketching either outdoors or in the dim, smoky interiors. At first the older people were unwilling subjects, sharing the widespread native belief that a portrait can imprison one's soul. But through smiles and gestures Emily gradually won them over, and after a few days she began to feel thoroughly at home among the Nootka, and they gave her the name Klee Wyck, "the laughing one." Without entirely realizing it, she began to form an enduring alliance with them. She barely noticed the things that repelled other whites, the smells and dirt and drunkenness. What was important to her was the wholeness and integrity of the people's lives. Nothing seemed to be missing and nothing seemed to be forced. Entering a native house, she felt the shaping hands of time and nature in each separate utensil, in the cedar mats and baskets, the hammocks suspended from the ceiling, the massive hand-hewn beams, the very floor of hard-packed earth. Where the missionaries saw poverty, Emily saw a marvellous sufficiency. Where they saw ignorance, she saw a way of life that had been carefully and thoughtfully formed through many centuries. She experienced no artistic revelations on this trip, but Ucluelet marks the beginning of a deeper connection

with the native people; through them she would reach the sense of unifying, universal life that pervades the painting of her later years.

She tells of an old man she met on the beach who was "luscious with time like the end berries of the strawberry season." He warned her about cougars; white people did not know what was dangerous and what was not. He himself was lithe and toothless, pared down to a fine economy of tough old age. He was sawing wood, and he did it "as if aeons of time were before him, and as if all the years behind him had been leisurely and all the years in front of him would be equally so."[14] Teeth did not matter. Sun, wind, age, and the prospect of death in its time did not matter. Cougars did matter. Here was the essence of what Emily came to love in the natives. It was their fine sense of discrimination, their acceptance of that part of nature that was in themselves so that they could fight what was really alien. White society began by rejecting nature and then picked out bits and pieces of it to accept. The English and Anglo-Americans had honed this to a fine art: one breathed "fresh air" through open windows, spared the picturesque elms in one's pasture, took one's afternoon walk or drive in all weathers and began the day with a cold bath. All this Emily had grown up with. It was a kind of sentimental, selective acceptance of nature, and underneath it lay the hidden premise that nature as a whole was foreign and essentially hostile. And as for God, the God of the missionaries—He lived indoors.

The native Indian saw things the other way around. He accepted nature and fought it only where he absolutely had to. For Emily, the brief experience of life at Ucluelet confirmed a relationship to the natural world she had felt since childhood without really being able to put it in words. Nor could she put it in words yet, at twenty-seven. But she sensed that the native lived in a universe she recognized as her own, and that his resistance to the missionaries' God was essential to his living in that universe.

It was on the way home from Ucluelet that Emily got to know "Mayo" Paddon, the young man she calls Martyn in *Growing Pains*. His full name was William Locke Paddon, and he was the purser of the *Willapa*, the steamer that was Ucluelet's main link with the outside world. Emily must have met him earlier, on the voyage north, but she would not have talked much to him under Lizzie's appraising eye. Now she was probably alone, and the return voyage was three days long. By the time they reached Victoria Paddon was halfway in love. Emily was hesitant, feeling only that she had met someone she wanted to see again. Paddon was gentle and sympathetic. The son of an Anglican priest, he was also earnestly religious, though his piety did not offend Emily as her sisters' did, and in his company she began to see Christianity in a softer light. He lived in Victoria when he was not at sea, and he asked to come and see her.

He came often, but for Emily the tranquil beginnings of this friendship were eclipsed by the sudden, disturbing onset of love for another man. We will probably never know who he was, except that he was one of the family friends who played tennis with the Carr sisters. Emily left only a few scattered, oblique references to him in her writings, and those are concerned not with the man himself but with the tumultuous nature of her feelings and the lingering bitterness they left behind. From several unpublished drafts we can tell how it all began, though we must allow for Emily's having altered the facts for dramatic effect. As usual, she calls herself Small.

She remembers that it was spring, and her father's fruit trees were heavy with creamy blossoms. The sisters were expecting guests for tennis and dinner, and the nameless young man—whom she already liked, perhaps more than she could admit—was to be among them. Emily had been climbing on the roof, tacking up her father's grapevine with a knife-sharpening stone filched from the kitchen. When the company came she joined them, leaving the stone where it was. Later, at dinnertime, she remembered the stone and ran to fetch it before Dede should miss it. As she reached the ladder she heard the man's voice behind her, warning her not to "clamber up the roof."

> "Thinks girls can't climb ladders," scoffed Small and had reached gutter
> level at monkey speed before he caught her up. She picked up the stone and
> ran down the ladder, her face to the wall. Two rungs more and she would
> have run away but before that [a] pair of strong arms folded her. Small
> dropped the stone. It was never found again. She lost something else too, a
> perfectly whole heart, and the old pact she had made with Elsie about kiss-
> ing was broken like a bubble.[15]

That, of course, is altogether too neat and pat; it is Emily's storybook version of an experience she needed partly to disguise, partly to reduce to manageable proportions. But however it actually happened, she did fall very much in love, and she thought the man loved her. The power of the feeling, once admitted, was proportional to the strength of her old resistance and fear. It was no light thing for Emily to allow herself to trust a man so far. Too reserved to express her feelings directly, she poured them out in torrents of bad poetry that she hid in the green bag where she kept her dancing slippers. The man may not have been aware of her love, or perhaps, as she afterward thought, he was only playing at a springtime flirtation. In any case, he wandered off, and Emily was left struggling with a torment of anger and shame strong enough to keep her from ever again consciously acknowledging sexual temptation. The humiliation made sex seem twice as ugly as it had before. To have conquered so much in herself, and then to find her love "was not wanted and never

never quite to know why . . . to eat ones heart out *alone* always never daring to tell a soul shamed and broken and hurt at your own indecency of loving so furiously so overwhelmingly . . . to find the caresses and kisses were only sport, selfish amusement"—that was a real and lasting pain.[16] She says it took her fifteen years to "kill love," and then she "could not see that anything was accomplished except a terrible amount of pain kept well under cover."[17]

Without questioning the real emotional impact of the episode, one cannot help noticing that in the end it helped her resolve her conflicts over sex, marriage and art. Perhaps the rejection was not all on one side; on some level she may have chosen to love a man she could not hope to marry. She all but says as much in the story, for a man who began by believing girls couldn't climb ladders would have ended by believing they couldn't do much of anything else. Again Emily Dickinson comes to mind. Both women, one in anger and one in a quiet exaltation of sorrow over her lost, mysterious "Master," nursed an unrequited love and made of it a defence against all others, at once a validation of their womanhood and a protection of their art.

"Almost simultaneously," Emily writes in *Growing Pains,* "an immense love was offered to me which I could neither accept nor return."[18] This was Paddon's. By summer he had declared himself and was writing ardent letters which also found their way into the green bag. They troubled her, but not so much that she could bring herself to break off the friendship. Every now and then he would propose, and she would turn him down. Perhaps it crossed her mind that she was not being "straight" with him, but his steady nature was a refuge from the tumult of her own emotions, and his sympathy a balm for old anxieties. She told him of Dede's accusation that she had grieved their dying mother, and his comforting reply—that if she was the "naughtiest," her mother must have loved her "a tiny bit the best"—almost persuaded her to love him out of sheer gratitude.[19] She went regularly to church with him and took Communion. Her sisters, pleased and no doubt astonished, made him very welcome. So they drifted for a while, and like any model Victorian lover Paddon resolved to be very, very patient.

Meanwhile Emily reached a decision that promised to solve several problems at once. She had finally saved enough money to pay for study abroad. She decided to go to London and study at the Westminster School of Art. Besides furthering her career, she would escape the scene of her own recent misery, and she hoped that Paddon's love would quietly and painlessly cool while she was gone. We have one final picture of her from that summer, written by a family friend who was then a child. We see her at a garden tea party, advancing across the lawn, carrying a bowl of gooseberry fool. She is "a sturdy young woman, her round rosy face set in rather glum lines, her mass of dark curly hair piled on her

head. She wears a large full-skirted white frock of soft material that billows as she walks and is held at the waist by a bright sash."[20] Her sulkiness, the friend later guessed, was probably caused by having been called away from painting for the sake of being polite. To that likely cause we can add another, the perplexities of a very unhappy triangle. A few weeks later, in August 1899, she put it all behind her and set off for England.

CHAPTER
9

London

LONDON AS EMILY first saw it was in an inhospitable mood, baking under a late-August heat wave that would have blighted even the freshest of spirits. Emily's spirits were already limp from the ten-day ordeal of the sea voyage, which she had spent in a semiconscious blur of nausea. She went immediately to lodgings recommended by a friend in Victoria, but found nothing there to cheer her. Miss Amelia Green's guest house was in West Kensington, the dreariest outpost of respectability in London. The six female guests were distant to Emily and effusive to one another; she felt them passing judgement on her as a "colonial" and "hated them right away."[1]

The Westminster School of Art was still closed for the summer when she arrived. Already desperately homesick and continually on the brink of tears, she began to explore the city, discovering those particular corners of it that offered solace or quiet: St. Paul's Cathedral, whose cool space enclosed a peace that whole coveys of rustling tourists could not disturb; Paternoster Row, where "all the Bibles, prayer-books, [and] hymnals in the world began life";[2] the Seven Dials district, dark and squalid but redeemed by its shops full of caged birds; the tops of London omnibuses, where she could ride back and forth on the same line many times, if she wanted to, safe above the hot and jostling crowds; the Abbey cloisters (which she much preferred to the Abbey itself); St. James's Park; Guildhall with its flocks of pigeons. Best of all was Kew Gardens, with its wide lawns and cool shades, its zoo and its grove of Canadian spruces and cedars.

She always wrote of these first weeks as if she were utterly and wretchedly alone. Maria Tippett has reminded us that that was not true, for Emily's old sketching partner Theresa Wylde was still in London.[3] She had actually spent most of the past seven years there, and by now had had a painting hung at the Royal Academy; so had Sophie Pemberton, who was now studying in Paris. Given Emily's old jealousy of both

women, their success could hardly have sat well, and that may explain why she left Theresa out of her later accounts of London. In any case, whatever meetings they had seem not to have assuaged her loneliness.[4]

In September, in her first letter from home, she found news that increased her misery. Her brother Dick had died in California on 5 September. Now she wept indeed, both for the loss of her brother and for the waste of never really having known him.

Friends at home had provided her with a sheaf of introductory letters, most of which—after finding that they almost always led to disappointment—she destroyed. But one Victoria friend had simply told her, "Go and see Aunt Marion,"[5] and luckily she went now. Marion Redden turned out to be a slender, grey-haired widow with a wide, mobile mouth and large brown eyes that "stared when she was thinking—like caged things that had reached their limit."[6] She did think—that was one of the things Emily liked about her—and her thinking led to definite opinions, firmly expressed. Born in Canada, she had come to England in middle life and was solidly convinced of the superiority of all things English. She was a high-church Anglican and an ardent supporter of the Boer War. She teased Emily for being homesick for so insignificant a place as Canada, and more than once Emily stormed out of her house in a temper, only to return and make it up in a day or two. Every Sunday, after attending morning service alone in some obscure, half-empty church (the shade of Protestantism hardly mattered, so long as the church was peaceful), Emily would arrive at Mrs. Redden's for afternoon tea. Later, with Mrs. Redden's son Fred, they would go to evening service at Westminster Abbey. Marion Redden, more than anyone else, made London bearable for Emily in these early months. She became Emily's "English backbone,"[7] at once a mother and a bracing antagonist. She called Emily "child," not "dear" (the distinction was vital), and her aversion to kissing almost matched Emily's own.

Through Mrs. Redden Emily made other friendships. There was Fred Redden, a lawyer, who took an interest in the young Canadian that was (to the relief of both Emily and his mother) never more than brotherly. There was Mrs. Mortimer, also a widow, softer in manner than Mrs. Redden but no less candid, pink and delicate to look at and impressively learned in English history. And there were two other men, Mrs. Mortimer's son Edward and his friend Sammy Blake, both lawyers like Fred Redden. All of them had lived in Canada and remembered it with genuine, if somewhat patronizing, fondness. Among them they undertook a gentle campaign to win Emily over to England. They took her sightseeing and showed her all the "national astonishments" she had not yet seen. They took her canoeing on the Thames and introduced her to the city's concert hall and theatres. When they asked her if she had been to the National Gallery, she confessed that she had gone only once. A

guard had come up to her and said "something horrid,"[8] and she had been afraid to go back. But back she went with the Reddens, and they took her to the newly opened Tate as well, and to the annual Royal Academy exhibition.

Both the Reddens knew a great deal about art history, and they seemed to have a large number of relations who had sailed through art academies in England and France. At the National Gallery they would linger over every painting, reciting dates and influences, and they pored conscientiously over the catalogue at the Royal Academy. At home they had stacks of volumes on the Old Masters to be leafed through and admired. Altogether they told Emily far more than she wanted to know, till her head was swimming with unwanted miscellaneous facts. She could not share their taste, which ran to the mild pastorals and sentimental genre pictures that Victorian England loved, but she was embarrassed by what they showed her of her own ignorance. For all their good intentions, they fed her doubts about her own ability and her fears that at bottom she was too stupid ever to catch up. All the same, she was being shown more art, good and bad, than she had ever seen before, and she was learning to recognize what she liked. The very tameness and repetitiveness of most English painting could not help but push her, as it was pushing the younger generation of English artists, towards new and fresh directions.

Meanwhile, on 16 September, she had enrolled at the Westminster School, which was on Tufton Street on the second floor of the Royal Architectural Museum. She paid a total of £6 sixpence for a three-month term, and since she had avoided taking a life class in California she had to begin by spending six days a week in the one at Westminster. Her embarrassment in the presence of a nude model disappeared on the first day, lost as she was in her fascination with "the subtlety, the play of line merging into line, curve balancing curve."[9] In the life class she worked under the school's director, Mouat Loudan, a Scot of French extraction whose teaching seems to have been workmanlike but not at all inspired. And in general the Westminster School would not give her any new insights. She was back to basics, continuing the groundwork she had begun in San Francisco years before. In that respect, it was unlucky that she had chosen to go to England rather than France. She had thought briefly of studying in Paris, but had been frightened by the prospect of a foreign language and a foreign culture. England seemed so safe and comfortable by comparison, and Emily had had no experienced advisers at home to help her summon up the courage to go to France. Here the fact that she was a woman, brought up in a sheltered, colonial environment, was a real handicap. She had evaded a challenge that would come back to confront her a decade later.

The difficulty was not only in the school. It was in English art in general. The great heyday of English landscape painting was over, and noth-

ing had moved in to take its place. There had been a brief flurry of excitement in the 1880s, when a host of new societies and galleries had sprung up to challenge the hidebound Royal Academy. Painters as varied as Whistler, Burne-Jones, G. F. Watts and the London Impressionists had brightened the art scene, and the Academy itself, under Frederick Leighton, had begun to show signs of life. The Westminster School was an Academy school, and for several years, under the leadership of Frederick Brown, it had moved in a mildly modernist direction. Aubrey Beardsley, drawn to it by Brown, had studied there in 1891–92. But then Brown had left, and the school slipped back into mediocrity, along with English art as a whole. The modernists were silent, not to be heard from again until Roger Fry's Post-Impressionist shows in 1910–11. Most of them were still young and untried: one, Duncan Grant, would come to the Westminster School in 1902, the year after Emily left, and would maintain afterward that he learned far more from his fellow students than he ever did from the faculty.

So Emily found England in a conservative lull between two modernist movements. If she had been able, like Grant, to mix with her more progressive classmates, she might have widened her outlook a bit. But in those days the most progressive students were likely to be men, and Emily's acquaintance was mostly limited to her own sex. The life classes were segregated, and she saw the male students only when they all met for lunch. Her insecurity about being a "foreigner" and a tendency to cliquishness among the students kept her from making many friends. Her two closest friends were women, neither one of them remarkably talented.

The first was Alice Watts ("Wattie"), a vicar's daughter from Cambridgeshire whose calm, even temperament steadied Emily through bouts of homesickness and illness. The two women roomed together — for Emily soon fled West Kensington — first in lodgings near the school and later in Vincent Square, which was only a few blocks away. Steady, industrious Alice knew "Art History from the Creation to now"[10] and had a thorough grounding in anatomy. Like the Reddens, she awed and oppressed Emily with the weight of her knowledge. She carried it lightly, as if it were simply part of being born and bred in England. Her work never slipped from the same high, unexceptional standard. Emily felt her own more uneven, more imaginative work to be inferior, and no one at the school tried to dissuade her.

After Alice gained her certificate and moved to India in 1901, Emily's closest friend was Mildred Crompton-Roberts ("Crummie"), who came from a wealthy Belgravia family. Here again Emily was awed, this time by a social tradition that was carried as gracefully and unconsciously as Wattie's intellectual one. There was no trace of snobbery about the

Crompton-Robertses, who took great pains to put Emily at ease when she visited them. But in this relationship, as in her other close friendships in London, Emily was the child in need of protection. Tippett has remarked, rightly, that Emily was seldom comfortable in friendships unless she was either mothering or being mothered.[11] In San Francisco she had been the mother-figure, finding her own strength. In England it was usually the reverse; here she was the outsider from the hinterlands, the newcomer to the feast. She constantly felt a need to cover up her imagined shortcomings. It was not a situation to encourage growth, either personal or artistic.

As the months went on Emily's early dislike of London deepened into a loathing that hung over her spirit like one of the city's black, evil-smelling fogs. Her early notions of London had been largely formed by Dickens, and it was her misfortune to live next to a neighbourhood that might have been a setting for the darker pages of *Oliver Twist*. The shortest daily route to school lay through the Westminster slums, and unlike Dickens Emily could not sentimentalize the squalor and bitterness of those streets. Dickens's saintly Jo had been a crossing-sweeper, but there was nothing saintly about the real sweeper who deliberately swung his dripping, stinking broom against Emily's skirt one day and sent his jeers after her as she fled weeping towards the school. Shamed by her own snobbery, she allowed Mrs. Redden to coax her into doing some "slum visiting" in St. John's, her own parish. It did the poor no good and only made Emily more miserable: she had enough doors slammed in her face to try the patience of a Christian martyr.

To Emily all of London was an extension of the dark, rat-infested warren of streets behind her school. In her mind the city took on a life of its own, a positive animus of evil. "Always as I approached London," she writes, "the same feeling flooded over me. As we left the fields and trees, and houses began to huddle closer and closed, and the breath of the monstrous factories, the grime and smut and smell of them came belching towards you. By swift degrees you saw the creature solidify from the train window." And when you were swallowed into the station, the "stomach of the monster," there was "no more You an individual but You lost in the whole. Part of its cruelty part of its life part of its wonderfulness part of its filth part of its sublimity and wonder, though it was not aware of you any more than you are aware of a pore in your skin."[12]

It was not only the filth and noise and smell of the city she hated but the terrible anonymity of it, and above all the fear that she herself might be diminished or perhaps lost altogether. That was a real terror, a modern one shared (had she but known it) by many urban dwellers before and since. In Emily's case it was probably linked to her gnawing sense of helplessness as a foreigner and to a more general sense of being the

eternal child. It may be that Emily's terror of London was one symptom
of a wider fear that drove her to aggressively flaunt her individuality all
her life.

To add to her depression, she was physically ill. She had arrived in
London with an inflamed big toe, probably left from the carriage acci-
dent a year or so earlier. It was because of the toe that she cut through the
slums alone each day, while Wattie took a longer, pleasanter route. All
winter the pain steadily increased, but it was not until early summer of
1900 that she saw a doctor. He diagnosed an unhealed dislocation and
fracture and recommended immediate amputation. The operation did
not go well, and Emily was in constant, severe pain for four days and
nights. Then there was a long convalescence in a London nursing home,
followed by a visit to Wattie in Cambridgeshire and several weeks with
another classmate (probably Polly Anderson) in Scotland. It was months
before she could walk comfortably, and always after that she would
carry a camp stool in her sketching kit because she could not paint stand-
ing up.

Meanwhile Mayo Paddon had been writing faithfully from Victoria,
and it was clear that Emily's absence had not had the cooling effect she
hoped for. In the early fall of 1900 he arrived in London to lay siege at
closer quarters. Emily was all too glad to see him—he seemed all of Brit-
ish Columbia incarnate—and in her delight she misled him once again.
He hated the city too, and together they fled to Hyde Park, Kensington,
Kew—any patch of greenery and trees. They spent one shining day in
Epping Forest, wandering down grassy paths together, running hand in
hand for the sheer joy of being in the woods, even tamed and manicured
English woods.

Paddon lingered for three months, proposing marriage every few
days. Mrs. Redden, who welcomed him to her Sunday afternoons,
beamed over the couple and ostentatiously found reasons to leave them
alone together. Francis Ford, the kindly curator at the school, and Mrs.
Dodd, Emily's landlady, made it all too plain that they had settled
Emily's future to their own satisfaction. Emily herself was caught in the
same paralyzing muddle as before. She was genuinely fond of Paddon,
and it must have been harder for her to turn him down than she ever ad-
mitted, or else she would have dismissed him sooner. She began to
neglect her art, which troubled her because she had already lost so much
time to illness. Finally she told him flatly that she could never marry him
and begged him to go home so she could work. Obedient as always, he
left, still nursing a hope that was not extinguished even when he finally
burned her letters several months later.[13]

Paddon was the last of a succession of suitors Emily had in England.
"Suitors" is perhaps too strong a word, but there were two other men

who paid her serious attention. One was the ship's doctor who had seen her through her illness at sea. He sent several letters and a photo, and eventually he arrived in person, only to be very firmly discouraged. So was Wycliffe Piddington, Frank's brother, who proposed to her by mail and followed it up with a visit. Hints of matrimony came from other quarters as well: Emily suspected Mrs. Mortimer and Mrs. Redden of conspiring to marry her off to Ed Mortimer. But she never had any sense of humour about herself, and this was probably no more than banter. She liked Mortimer well enough, but he and Fred Redden both treated her like a "senseless kitten,"[14] and though she was quite content to be Mrs. Redden's "child" she resented being patronized by the men.

Sammy Blake was different. He was less formal and less condescending than the others, and he treated her like a "sane adult." Typically, Emily saw this in nationalist terms. "Canada," she once wrote, "still peeped out of Sammy Blake."[15] Tippett believes Emily fell in love with him,[16] but Emily's own references to love all point back to the man in Victoria. She did once remark that the man she loved enlisted in the Boer War, as Sammy Blake did;[17] yet it is possible that her nameless tennis partner was one of the handful of Victoria men who volunteered for South Africa.

Emily was so terrified of the whole question of love and sex that she wrote and said very little about it, and so we are left mostly with our own conjectures. It seems very likely that all this sudden pressure from other people to marry, or at least think of herself as marriageable, forced her to realize that she had reached a decisive turning point in her life. She was nearly twenty-nine. By her own account she was still smarting over her lost love, but that did not prevent her from dallying with Paddon more than she wanted to. Paddon offered her affection, children, roots; with his piety and patience, he may have seemed (though he could hardly have realized it) a brotherly, companionable kind of partner whose sexual demands would be relatively low-key.

Balanced against marriage and family was art—a promise still nebulous and a talent still largely untried. The old vision of an ark, with her benevolent Noah steering while she set up her easel on deck, had to be relinquished. Real art meant total commitment, and total commitment for a woman meant being alone.

In Emily's case it also meant a chance to shed old fears that now became, once and for all, irrelevant. There had been at least two incidents in England that fortified her distrust of men. One was the encounter with the guard in the National Gallery; and once, while she was sitting in church with Mrs. Redden, the hand of the clergyman sitting next to her stole into her lap and began to stroke her thigh. That did nothing to help her feelings towards men—not to mention ministers—and there must

have been other small harassments, especially in the Westminster slums. Altogether they would have strengthened her revulsion from sex and helped her make the final, decisive turn towards celibacy.

After Paddon left she threw herself into her work with fierce dedication. She did not tell herself that any irrevocable line had been crossed, only that she had lost a tremendous amount of time that suddenly had to be made up. Now she worked evenings as well as days, enrolling in night classes in anatomy, clay modelling and design. She pushed herself to the limits of her strength and was proud that she was finally getting on with what she had come to do.

By now Emily was living in Mrs. Dodd's boarding house for students at 4 Bulstrode Street. It was some distance from the school but handy to the Harley Street medical district, where the surgeon who had operated on her probably had his practice. Fifty-two women lived at Mrs. Dodd's, most of them five to a room. Emily and her roommates each had a sleeping-space six feet square, hung round with red and buff curtains. Storage space was almost nil: a few of the more privileged students paid sixpence a week for clothes cupboards, but the rest of them competed for a scattering of pegs on the walls. Despite some minor feuding, mostly over opening and closing windows, generally Emily's group of five lived peacefully together, sharing teas, laundry soap and confidences and helping one another fight off homesickness. Emily's closest friend was a sweet-tempered girl she calls Kendal, or "Kindle," who seems, like others before her, to have sheltered a bit under Emily's wing.

Holidays brought escape to the country. Emily spent her first Easter break in the tiny hamlet of Goudhurst, Kent. There she discovered the delicious English spring while clambering through the damp woods, filling her arms with flowers and listening to a sweetly foreign clamour of birds and newborn lambs. Christmas was less successful: she stayed with the Andersons in Scotland, and the penetrating cold and the unfamiliar meal schedule wearied her. She caught flu on the way back to London, and what was to have been a two-day stopover with Wattie in Cambridgeshire turned into a fortnight in bed.

This illness, along with the torment she was suffering in her toe, signalled the beginning of a slow but steady decline in her health. By January 1901, when she had sent Paddon home and had taken on an overwhelming burden of work, she began to show more ominous symptoms. Queen Victoria had just died, and against her better judgement Emily went with Kendal to watch the funeral procession. They waited for three hours, elbowed progressively to the rear by a smothering, jostling crowd. Emily's foot ached painfully, and though she had brought her camp stool she could not sit down, or move, or finally even breathe. She fainted, and had to stay in bed for several days with nausea and a splitting headache, while the repentant Kendal "wearily brought tea."[18]

Spring temporarily renewed her strength, and it brought news that Alice was coming to visit in June. Overjoyed, Emily temporarily left her lodgings and found rooms near the sights she knew Alice would want to see. But her strength was not equal to her spirits. When Alice came London turned steamy, and Emily was suddenly overcome with weariness. Dutifully she trailed her sister through churches, monuments and museums, while Alice—who was buoyant with excitement—could barely contain her irritation.

A special disappointment was Alice's coldness to her sister's work. Emily had pinned her pictures all over the walls of their rooms, but Alice totally ignored them. This was the first unmistakable sign of Alice's indifferent and uncomprehending response to Emily's art. It would later be seconded by Lizzie. Both sisters typically greeted Emily's work with silence, broken in Lizzie's case by pointed references to Emily's lack of commercial success. One family friend has suggested that the sisters liked Emily's work better than she thought they did, but were too timid to say so.[19] This may have been true of her early work, but it became less so as time went on and Emily's style grew more controversial. Only late in life did Emily's sisters become genuinely proud of her, but by then they were reacting to her fame as an artist rather than to the work itself.

In 1901 Emily's work was still conservative, and it is hard to explain Alice's indifference to the pictures except for the fact that many of them were probably nudes. Whatever the cause, her silence opened a breach that would never be healed. "It was then," Emily writes, "that I made myself into an envelope into which I could thrust my work deep, lick the flap, and seal it from everybody."[20]

Breakdown

EMILY DID NOT spend the summer in London with Alice. She may not have meant to in any case, but the coolness between them must have made it easier to leave. Instead she joined a sketching class in Boxford, Berkshire, returning to the city on weekends. The beauty and tranquillity of the village captivated her, as rural England always would, and the only sour note was her roommate, an art student who (the words become a refrain in Emily's English manuscripts) "despised [her] for a colonial."[1] That unpleasantness resolved itself when the girl left and another student took her place. So Emily met Mildred Crompton-Roberts, and the two lingered on together until the village had emptied of students and the fall term was near. By then they were close friends. Although Alice was still in London when they returned, Emily went to Belgrave Square to spend a week with Mildred and her mother and to learn at first hand what it was like to live in a mansion with a marble swimming pool, a conservatory and a staff of twelve. On the whole, it was not nearly as uncomfortable as she had expected.

She should have been bursting with health after a summer in the country, but instead she was feeling increasingly unwell. She was tired and had frequent nauseous headaches, and she quailed at the thought of another soggy winter in London. Mildred sympathized. Why, she asked, didn't Emily spend the winter in St. Ives, Cornwall, where a long-established colony of artists painted all year round? Emily consulted with Alice, and the upshot was that they both travelled to Cornwall in August. (Emily never mentioned Alice's accompanying her, but Maria Tippett has established that Alice was indeed there, staying at a local guest house.)[2]

Alice soon left for Canada, and Emily found rooms with Mr. and Mrs. Curnow, who owned an antique and curio shop on the lower of the town's two main streets. The sea wall was directly beneath Emily's window, and on stormy days the waves would crash against the house

and cascade greenly down the thick bottle glass till Emily, sitting inside, felt she was living in a submarine world. On fine mornings the beach was crowded with fishermen, bargaining over their catch with dealers from London. Above the beach the town rose sharply, from the commercial street where Emily lived to the wooded slopes above, where some of England's more notable families—among them the Leslie Stephens—had traditionally spent their summers. A fresh wind always blew through the streets, chasing the mists and tugging at the easels of the artists; Emily had to weight hers down with stones. After she left, the town would become a memory of "keen air, quaint poor people with a tang of melancholy pervading them, stone cottages pink blue or white washed, cobble streets and broken stone walls, and always the sea pounding."[3]

Emily studied under the the half-Swedish painter Julius Olsson, who at thirty-seven had gained a reputation as a masterly painter of seascapes in an Impressionist style. He was probably the best painter she met in England, but like many of her teachers he was short-tempered, blustery and dogmatic, and she disliked him from the beginning. He made no secret of favouring his male students, conferring with them over his work and treating them as colleagues. He and Emily clashed when he insisted that she spend her mornings painting on the beach, in the full glare of sun and water. Emily replied that the sun made her headaches worse, and she often set up her easel in the shaded streets, where Olsson would have to search her out in order to give her his criticism. He scolded her for that, and he scolded her for sitting while she worked instead of standing. Finding her stubborn on both points, he more or less gave up on her and took only a perfunctory interest in her work. His wife, who invited some of the "worth while" students to tea, never took any notice of Emily and soon earned herself a place in a growing gallery of "snobs."[4]

Luckily Olsson had a partner, Algernon Talmage, who criticized on alternate days. Talmage was a gentle, quiet man, and he was not a sea painter. An admirer of Constable, he painted tranquil meadows under soft, moody skies, and he nearly always populated them with cows.

Emily liked Talmage, and on the days he criticized she would climb to Tregenna Wood, a small stand of fine old ivy-draped trees above the town. It was Talmage who helped her in her first attempts to capture the subtle play of light and colour in a forest, the "indescribable depths and the glories of the greenery, the coming and going of crowded foliage that still had breath space between every leaf."[5] At Christmas, when Olsson sailed to Sweden on his yacht, Talmage patiently climbed up to the wood every day to criticize Emily's work. "Neurotic! Morbid!" Olsson roared when he saw the results,[6] but Emily had made a solid beginning in what was to be her own kind of painting. She was more bemused than discouraged by the violence of Olsson's reaction. It was, in fact, much like

the feeling of the early settlers in her native Victoria. "What was it," she wondered, "the English were afraid to face in the woods?" It was all the more puzzling since "English woods were only half-woods anyway. The deepness had been 'prettied' out of them."[7]

After a certain chill formality at Westminster, Emily found herself in a friendly, rough-and-tumble student group much like that in San Francisco. No longer segregated from the male students, she made friends with both men and women. The studio had about ten students of assorted nationalities, including a Frenchman, the two Australians Burgess and Ashton, Hilda Ferron from Ireland, Noel Simmonds from Weybridge, Surrey, and Maud Horne from St. Ives. Emily especially liked Noel, who sketched with her in Tregenna Wood, and Hilda, who joined her in hiring village children to pose indoors in the evenings. During the Christmas holidays she explored the neighbouring villages and shore with another student, whom she calls only "little cockney Albert,"[8] and feasted on plum pudding with the Curnows. She ate New Year's Eve dinner with Maud Horne and her family in their house high above the village, and spent the evening swapping ghost stories. No one in St. Ives, except for the Olssons, made her feel like an outsider.

Although she was relatively happy the attacks of headache and nausea, which she had blamed on the city, continued. Towards the end of the winter her health broke altogether. She probably left St. Ives in February 1902, for on the twentieth of that month her sister Alice noted in her diary, "Millie is in Surrey in an invalid's home, poor child she has had a whole year of illness."[9] What the nature of the illness was is not clear. In *Growing Pains* she mentions having flu after she left St. Ives but does not mention the nursing home,[10] and in general her accounts of this period are vague and contradictory. Whatever the problem, the nursing home did help, at least for the moment. When Emily felt strong enough to travel she left for Bushey, Hertfordshire, where she meant to enroll in the Herkomer School of Art.

Founded by Hubert von Herkomer, one of England's most successful painters, the Herkomer School had a solid reputation, though like the Westminster School it was a bit past its prime. Fred Redden had recommended it, possibly seconded by Algernon Talmage, who had studied there. But when Emily got to Bushey she did not enroll in the school after all, either because she was too old, as Tippett suggests, or because the school had shifted emphasis from fine arts to theatre. Instead she joined the studio of one of Herkomer's ex-pupils, John Whiteley.

Whiteley was a landscape and figure painter, primarily a watercolourist. His reputation was modest, but he was a good teacher and Emily liked him. He did not condescend to women students, and like Talmage he encouraged Emily to work in the woods by herself. His class

that spring worked from models, often posed outdoors, and the outdoors at Bushey were indeed beautiful:

> All night the nightingales sang and in daytime the woods bubbled with birds. The new foliage the lush grass the cuckoos and bluebells and primroses and anemones were just intoxicating. I used to sing and sing and sing in the woods and the horribles of London faded from my mind.[11]

Where Talmage had taught her a great deal about light effects in foliage, it was Whiteley who first taught her to see "the coming and going among the trees" and sharpened her awareness of them as living, growing, constantly moving things.[12]

If the countryside was enchanting, the students were not. Emily disliked most of them and heaped on them the full measure of her hatred of English complacency and class bigotry. This was a far more parochial group than the one at St. Ives, and there were no other foreigners to share her sense of strangeness. Four women in the class particularly snubbed her, and once again she felt "despised" as a "colonial." She in turn watched with undisguised contempt as they "grovelled" for praise from Whiteley, just because he was a man. "The English girls," she would remark later, "adored and idealized their Masters. . . . They mistook them all for geniuses." At the same time, they were shy and awkward with their male classmates. Emily got back at them by flaunting her friendships with two of the men, and by teaching the youngest girl to smoke and swear—habits she had picked up in London. Invited to tea with them, she "gulped" and "sniffed," wiped her mouth on her sleeve, smacked her lips, made uncouth faces and in general made herself into a caricature of the New World barbarian.[13] When a new woman student turned up in class with a chaperone, Emily wrote a wicked cartooned satire that was passed around and found its way to Whiteley. He liked it so much that he kept it, trading a sketch of his own in return, and on that small note of triumph Emily left to face the "horribles of London."

She was no sooner back at Mrs. Dodd's than her health broke down again. This time it was much more serious. She apparently fainted and fell down a flight of stairs while carrying a pitcher of scalding water. She was sent to Mildred's house, where she lay prostrate for six weeks. The headaches and nausea returned, and now she had lost sensation in her right arm and leg. A doctor was called in and looked appropriately grave; two nurses were hired and straw laid down in the street outside.

Again, her later memories of what happened then are confused. She says she was sent to a seaside nursing home, where the head nurse was a "snob" and the glare from the sea hurt her eyes, and that she feigned

recovery in order to escape to Noel's home in Surrey.[14] It was indeed in Surrey—not at Noel's but in a nursing home in nearby Addlestone—that her sister Lizzie found her when, frantic with worry and determined to take Emily home, she arrived on 13 July.[15]

Emily had no intention of leaving England. She felt she had made almost no progress in her work, and she did not want to be dogged by a sense of failure. The doctor backed her up, saying she was too ill to travel. So began six months of misery for both women, while they endlessly resurrected and belaboured the ancient, irreconcilable differences between them. Lizzie thousands of miles away was a beloved sister, but Lizzie in the same room became more symbol than person. She was gentility, conformity, self-abnegation—everything that Emily, through her art, had hoped to escape. And now, when art really seemed to have failed, the sight of Lizzie victorious, Lizzie come to bear her away to a life of piety and good works, was almost more than Emily could bear. Even at her best, Lizzie would have been the worst possible choice as a companion for Emily now. But Lizzie was not at her best. She herself, Emily recalls, was close to a nervous breakdown for some unspecified reason, and had come to England for a "change."[16]

When Emily tells us that Lizzie "fetched in a miserable curate, and had prayers offered for me in the local church," we may well wonder if she isn't stretching the truth.[17] But by the evidence of Lizzie's own diary, that is exactly what she did, and afterward she was convinced that Emily "took a decided turn for the better."[18]

Any turn for the better was brief. For months the sisters moved about restlessly from one boarding house to another, always keeping outside the city. Emily would sometimes seem to improve, only to relapse once again. In mid-December they finally consulted a London specialist, who diagnosed a "nervous breakdown" and recommended several months of complete rest.[19] There was another flurry of protest from Lizzie, who could not make up her mind either to leave or stay, but luckily James Lawson arrived in London at that point and calmed her down. On 11 January Emily left for the East Anglia Sanitorium at Naylands, Suffolk. Later that month Lizzie finally went home, having satisfied herself that Emily was "in the best of spirits and quite happy."[20]

The East Anglia Sanitorium primarily treated tubercular women, though it took in a few male patients and a few nontubercular women for whom rest had been prescribed. According to Tippett, Emily's illness was diagnosed as hysteria, or what would now be called a conversion reaction.[21] If this was indeed the diagnosis (and there is some question whether it was), Emily probably knew it, and she would have known too that it was almost universally applied to women, and that it was thought to result from the denial or suppression of the sexual functions

ordained for them by God and society. Of course she would have done her best to cover up such an implication in her writings, and that may explain why her accounts of her illness are generally unreliable and why later friends learned so little about it. She once told a friend that she had suffered from acute anaemia,[22] and to everyone else she would say her illness was brought on by overwork, flu and the misery of being penned up in the city. In *Pause,* her book about life in "the San," she tries to disarm any suspicion of emotional illness. She describes a conversation between two inmates, speculating on what could be wrong with her. Could she possibly be "mental"? "Mental nothing!" she has one of them retort. "Her tongue is sharp enough to mow the lawn."[23] But Emily herself never does say in that book just what ailed her.

Anything we can say on the subject must, of course, be speculative, and biographers should be wary of rushing in where clinicians fear to tread. The symptoms Emily mentions here and there include depression, fatigue, stuttering, headaches, nausea, heart palpitations, numbness on one side and a limp. The limp may have resulted from lack of sensation on one side or from the amputation of her toe, but the other symptoms seem to point to emotional strain. Numbness itself is a classic symptom of conversion reaction. In discussing Emily's breakdown, Tippett cites the traditional Freudian view of hysteria and emphasizes Emily's sexual conflicts, especially the impact of the "brutal telling." She goes on to say that Emily's "hysterical personality had manifested itself in other ways," including her social insecurity, her "obsession with taking malicious revenge," her "occasional attention-getting behaviour" and her "sexual frigidity."[24] But surely insecurity, irritability, the need for attention and a certain degree of malice are common enough among the ordinary population, let alone the highly gifted. As for sexual frigidity, we really do not know whether Emily was frigid or not. We only know that she had some powerful sexual fears, which is quite another matter. In any case the centuries-old view that hysteria originates in the "female organs" has been superseded, even among Freudians, if for no other reason than that conversion reaction occurs almost as often in men as in women. It is simply one of the many ways the mysterious construct of mind and body can react to overwhelming stress.

Turning to the nature of that stress, we can use Emily's insights as well as some of our own. First, there is her physical condition. When she fell ill in February 1902 she had been in England two and a half years. She had been driving herself to the point of exhaustion and had fainted at least once. Besides her frequent sick-headaches she had been weakened by at least one influenza attack and by the long torment with her foot and the shock of surgery. By the time she reached the sanitorium she must have been physically debilitated. She may well have had some form of

anaemia as she afterward claimed, possibly brought on by prolonged menstrual bleeding. Such bleeding could have resulted from severe emotional strain.

There is no doubt she was emotionally exhausted. One cause of that was London; Emily herself laid the lion's share of blame for her illness squarely on the city. It was to escape London that she went to St. Ives, and it was her return that brought on her final breakdown. London was bleak enough even to the ordinary Londoner in those days, but it was far worse for Emily. The city was a looming, engulfing, imprisoning presence. It cut her off from nature, diminished her to an "atom"[25] and clogged and choked the channels of renewal that were necessary to her art and well-being. She would never be able to tolerate human beings *en masse;* she could only like and trust them one by one. In England these feelings were still relatively vague and undefined, but it would always be her access to the natural world that kept them in check. It seems clear that her fundamental distrust of people and her corresponding love of nature had a sexual component; but added to it were the many other elements that estranged a gifted, passionate personality from a rigid, philistine society. Her emotional and artistic health depended on the natural world in its prehuman state, and in that sense her illness was as much spiritual as it was physical and emotional. London deprived her of what, for lack of a better term, we can only call God.

Beyond this, she was under enormous pressure to succeed as an artist. The pressure increased as she saw her funds dwindling away and she became more and more impatient with her slow progress. She had reached a crisis of commitment, brought on partly by her disappointment in love in Victoria and partly by her refusal of Mayo Paddon. In losing the man in Victoria she felt she had lost the possibility of passion. In refusing Paddon she turned away from a compromise, a life rounded with human affections, many-faceted, anchored in that strength she always drew from having others depend on her. She had hesitated a long time over that decision, and undoubtedly her sexual fear played a role in her final refusal. But fear in itself had not been enough to make her flee at the first sign that Paddon was considering marriage. Her decision was more complicated than that. She came to see not only that she could not have a sexual relationship with a man she did not love, but that the equal partnership she needed in marriage simply was not possible with Paddon. He would have left her no room. For all his gentleness, he was conventionality itself. She saw that he demanded "worship," just as her father had demanded of her mother.[26] Marriage would have meant the slow, sure stifling of her art.

The other artists she knew did not compartmentalize their lives in this way. The men could see marriage and family as something pleasantly peripheral to their careers. If they had conflicts, they were practical ones

having to do with the economic uncertainties of art. The unmarried women existed in a kind of hopeful limbo, and they seemed able to accept the prospect of a life divided between two allegiances. But Emily knew of no women artists who could be called truly distinguished (unless she knew of Rosa Bonheur, who of course was resolutely single). Those who married were committed to bearing and raising as many children as nature ordained, and to carrying out the thousand small duties that no conscientious housewife could possibly avoid. Emily's ideal of wifehood was her perpetually pregnant, cheerfully long-suffering mother. At the opposite pole was Mrs. Tucket, whose ruthless dedication to her art had hurt her children and probably driven away her husband. Somewhere in the middle was the modestly successful female artist who was devoted to her family, painted in her spare time, was universally praised in her community, and was content to let someone else burn with a hard, gemlike flame. That there had been exceptions is undeniable, but they had not thrived in the nineteenth century and it is very unlikely that Emily knew about them.

All this is implicit in Emily's decision. She did not spell it out in so many words. She felt only relief that Paddon was gone, mingled with the realization that she would probably never have to make such a choice again. Once the choice was made, art became the single emotional focus of her life, and she concentrated all her energies—"sublimated" energies, if you like—on perfecting it. Her ambition was not boundless, but to her mind it was higher than any Canadian artist had yet achieved. She wanted to paint the Canadian landscape as it really was, in all its roughness and wildness. Her own country constantly challenged her in absentia, dwarfing the soft, pastoral beauty of England. She believed her own talent would someday be worthy of it, but she had no one to support her faith or lighten her load of self-doubt. The passing praise of Talmage and Whiteley was encouraging, but it was not enough; she needed reassurance to match the full intensity of her commitment. Instead, everyone, including Mrs. Redden, had made it clear to her how trivial they felt her ambition was compared with the opportunity to marry. Alice had ignored her work, and so had Lizzie.

By refusing Paddon, Emily had rejected a life that most women would gladly have chosen if they had the chance. Now it was up to her to justify that choice, to others and to herself. Yet she could see no sign that her work was in any way out of the ordinary. Many of the personality traits Tippett mentions can be understood as symptoms of an accelerating anxiety over success. Emily's irascibility and social insecurity certainly had always been there and always would be, but they suddenly became more pronounced in England because she was particularly vulnerable to any hint that she might be second-rate. To be a woman artist was to be under an *a priori* suspicion of being a dabbler. And in England she was

also a "colonial," an ignorant outlander whose defects of education might be (for all she knew) incurable. Her defensiveness made her lash out at anyone who suggested as much, even in fun. And of course the superiority of England had been held up to her in one form or another for as long as she could remember.

Her breakdown, then, involved not only the culmination of her sexual conflict but a number of other things as well: the spiritual deprivation of the city, the pressures of time and money, the uninspiring state of English art in general, her shaky physical health, the social factors that forced women to see marriage as a vocation in itself, the subtle prejudices that discouraged them from aiming at the very highest rank of artistic achievement. Emily's response to all of them was to try to make her art so perfect that it was unassailable, a veritable tower of security. If it was not yet that perfect, she would simply work harder. But the harder she worked, the more physically debilitated she became; and the more debilitated she became, the less she was able to give to her work. She was locked into a cycle, and since she could not free herself by force of will, body and mind united to free her without her consent.

Of course no human crisis is as orderly as a writer is obliged to make it seem on paper. Emily's was as untidy as anyone's, with sudden rents in some places and slow unravellings in others. One of the slowest was her old love for the man in Victoria. She was still grieving over it when she was hospitalized, and now she set about deliberately exorcizing it: "While I lay in the sanitorium I . . . said die, die die and at last it . . . died. It had safeguarded me from many lesser loves and made me suffer furiously."[27] She is guilty of a little female vanity here, for the only "lesser love" she had really had to deal with was Paddon's. But in any case it was true that this one, unreturned love had given her the illusion of a grand passion, and in doing so had protected her from a prosaic and probably disastrous marriage.

Not only this feeling but all feeling was deadened during the course of her illness. Her treatment was a kind of cultivated apathy, which in time must have been indistinguishable from disease. For all the patients, tubercular or not, emotional stimulation of any kind was thought to be harmful. Not only were rest, food and exercise strictly monitored but tears and even loud laughter were firmly discouraged. Deaths were elaborately ignored, though they happened all the time. Feelings of all sorts had to be blown away on the winds that whistled through the paneless windows; ambition, if one had any, was buried under the little heaps of snow that accumulated on the bed. "As near as possible," Emily writes, "you became a vegetable. Sun rain and snow fell upon you, the coming of day and night, feeding and being washed. The past—the struggle of work got dimmer and dimmer till it was a gone dream. There was only an uneventful forever and forever ahead."[28]

She was allowed to see visitors, to read, to draw a little and walk a little, but she was forbidden to talk about or even to think about painting. Eventually, as her physicians intended, she lost all interest in her work. But her feelings of helplessness and despondency only increased as she contemplated the depth of her failure. The fact that no one ever treated the root of her depression probably explains why hers was such a particularly baffling and stubborn case.

She "detested" almost everyone at the sanitorium and kept much to herself.[29] She took a special aversion to Dr. Jane Walker, the head and founder, and, true to form, put her down as a snob who toadied to aristocrats.[30] Her friendship with a few of the patients and the kindly, melancholy nurse she called Jokey Hokey are described in *Pause*. Written at the end of her life, it is illustrated with sketches and verses she wrote at the sanitorium, chronicling its daily life: patients wincing at the sight of their loaded plates (for the TB patients were forced to eat mountains of food); patients napping outdoors under piles of blankets; Emily sailing down the windy, open-air corridor with her braid and dressing gown flying out behind her. Interspersed among these are sensitive line drawings of geese, rabbits, chickens, mice (trapped, alas) and especially of songbirds.

Birds played a special role in her recovery. She had always loved English songbirds. They were the one superiority she granted England over Canada. Emily asked for, and was given, permission to hand-raise some English birds for eventual liberation in Victoria. She stole whole nests full of thrushes, blackbirds and bullfinches and kept them by her bedside. When they outgrew their nests they were transferred to an outdoor aviary. The whole sanitorium helped her, and over her windowsill came a steady supply of grubs, worms and ant eggs. In the end she did not entirely succeed, for when she was put onto a strict regimen of treatment in 1904 she had them all chloroformed except for one pair of bullfinches. Those she did bring home to Canada. They did not populate the forests of British Columbia, but they livened up her studio for a while.

The new regimen began after she had been in the sanitorium for over a year without responding to treatment. She says she was isolated, seeing no one but a special nurse and the doctor.

> I was starved on skim milk, till they had brought me as low as they dared. Gradually they changed starvation to stuffing, beating the food into my system with massage, massage, electricity—four hours of it each day. The nurse was bony-fingered, there was no sympathy in her touch; every rub of her hand antagonized me. The electricity sent me nearly mad.[31]

The "electricity" has often been taken to mean electroconvulsive therapy, but it is extremely unlikely that shock treatments as we know

them would have been used in an English hospital as early as 1904. Even if they had been, Emily would hardly have had them every day, and the trauma would have been far greater than what she describes. She simply says her "nerves and spirit were in a jangle," not that she was severely disoriented.[32] Physicians around the turn of the century were experimenting with some harmless electrical devices, using them to treat a wide range of illnesses. One device consisted of a set of "magic tubes" that glowed in the dark. Another, probably the kind used on Emily, was an electric-massage instrument that produced no worse discomfort than a buzzing sensation on the skin. Emily's sister Lizzie would use such equipment in her later career as a physiotherapist.

Emily's grim description in *Growing Pains* is softened by a rollicking set of verses she wrote soon after she left the hospital. There she calls herself by one of her "San" nicknames, Gollywog. (Another one was Mammy, for her nurturing of the birds.) The nurse-masseuse is called Mrs. Noah, because the vast quantities she served Emily must have emptied the Ark:

> The sheep and cows went long ago the pigs and poultry too
> The Elephant made tender steaks the Elk we had to stew
> The Bear and tiger made sweet chops the noble Lion we curried
> But how to cook the Kangaroo our minds were greatly worried.[33]

The other main character of the piece is the Dutch Doll—probably a reference to looks, not nationality, for the presiding medical officer, Miss Ethel Maud Stacy, was British. The opening lines set the tone, and incidentally confirm the nature of the "electricity":

> Ah Noah! dear the Golly said when from me you've departed
> Perchance toward you some day I may feel sentimental hearted
> I'll seek and sit me gently down upon a bee hive dear
> And when the brutes buzz out and sting I'll dream that
> you are near.
> The grim old Noah never winced at this sarcastic mock
> But turning on the current full gave Gollywog a shock.
> And when she [Emily] had been tubbed and rubbed and
> battered every day
> Devoutly Mrs. Noah toppled on her face to pray
> And when the Dolly Dutch came in the Gollywog to see
> She found good Mrs. Noah prostrate upon her knee
> The Dutch Doll looked astonished, Old Noah looked quite daft
> I'm grieved to say the naughty little Gollywoggle laughed.[34]

Emily was not laughing when she wrote these lines, but they helped

her past the difficult first weeks after she left the hospital. Pronounced cured in March and warned never to work in London again, she had made her way back to Bushey. She wrote the skit to fend off depression while she waited two weeks for Whiteley's spring classes to begin. Outside the rain streamed steadily down the windowpanes, and Emily's face was streaming with tears as she searched for rhymes. Yet the relief of working off her anger under the guise of humour was a tonic, and by the time classes began she was ready to join them.

She stayed in Bushey through June. Then she left for Canada, still feeling utterly defeated, convinced that her five years in England had been an expensive and humiliating failure. In *Growing Pains* she says she slunk through London without saying good-bye, but elsewhere she writes that she probably did take leave of her friends, though the whole forlorn ceremony later slipped from her memory.[35]

In Toronto she rested for two weeks with family friends. The heat and forced social pleasantries of this visit did not sweeten her mood, and no doubt her hosts were as relieved as she was when she finally left. She continued on to the Cariboo country in British Columbia, where her girlhood friend Edna Green (now Carew-Gibson) lived with her husband. Edward Carew-Gibson managed the Cariboo Trading Company post at 150 Mile House, and there Emily spent eight weeks while she slowly regained her strength and spirits. The rolling countryside, with its immense Canadian skies, its autumn-gold grainfields and groves of cottonwoods and aspens, gently shouldered all the miseries of England into some obscure recess of her mind labelled "Later." She steeped herself in the moment. Edna taught her to ride astride on a Mexican saddle, and she spent almost all her waking hours outdoors. She tamed birds and small animals, made friends with the local native Indians and saw with astonishment her first flock of Canada geese (which did not migrate over Victoria). When she finally left for home she was nearly well, and when she reached Victoria on 14 October she was more or less ready to face the commiseration she expected to find there.

Home

IN FEBRUARY 1905 a reporter named Arnold Watson, working for *The Week* in Victoria, interviewed Emily Carr. He found her in the Fort Street studio she had taken over from Theresa Wylde, who had returned to Victoria briefly and was now back in England. When he arrived she was standing over the stove, and while she brewed tea he wandered around the room, looking at the sketches and paintings of Cornwall she had pinned to the walls and tossing a question over his shoulder now and then. She let him know at the outset that she would rather not be interviewed at all, but he was used to that sort of demurral from artists, and in the end he got enough material for a long feature article, which was run on the front page.

Had she liked London? Yes, she said guardedly, but it was a tiring city to live in. She had liked Cornwall much better. How were her new pupils doing? Not badly, except for the usual grumbling at fundamentals. Watson "suspects Miss Carr of firmness," and thinks that, grumbling notwithstanding, her pupils will work at fundamentals quite as long as they need to.

He asked if she was glad to be home. Yes, she answered, still cautious. England was pretty, but orderly. "One misses," she added in a prim masterpiece of understatement, "the mountains and the woods."

After tea they walked to Emily's barn studio, where they were greeted by a chattering, chirping assembly of birds and animals: squirrels, a family of Cariboo chipmunks, the English bullfinches (which Watson overlooked). Outdoors an aviary sheltered several canaries from the forays of a marauding owl. On the studio walls, among more English sketches, were some of Emily's native Indian paintings.[1] Watson's eye was especially caught by a painting of a coffin in a native cemetery. The painting had been called "weird," Emily remarked, and she herself had felt a little "weird" painting it, wondering if a panther was lurking behind her.[2]

Thanks to Arnold Watson's eye for detail, we have a neatly drawn ver-

bal portrait of Emily from a time when there is little documentation of her life. The article gives a visual portrait, too, a sketch of Emily by one of her English fellow students. It shows her in half-profile, leaning back in a chair and smiling slightly. There is no evidence of the illness and emotional strain of those years. She is a little plump, but altogether blooming—a very pretty woman who looks, as she said she did, much younger than her years. We wonder if the artist, Alfred Bentley, was not a little smitten; from the courtly tone of the article, we can be fairly sure Watson was.

Anyone familiar with the later Emily Carr can find in this early interview many basic lifelong themes: her love of native peoples and the forest; the animals that, in various forms, would always surround her; the public reaction to her native paintings, which would be called "weird" countless more times; her "firmness," and even her steadfast aversion to being interviewed. One remembers too how much was left unsaid: her vehement hatred of London, the ordeal of two years of illness, the torment of self-doubt she had brought home with her. Those are submerged under the image Watson wanted to see and Emily wanted to project, of a successful young artist who has about her the glamorous aura of study abroad. Watson playfully dismisses the "scalps in the way of diplomas she carries in her belt," but he thinks enough of them to remind his readers they are there.

In fact the image was not so far from reality as one would suppose. On the surface, Emily's recovery from her long invalidism was swift. The Cariboo had remarkable healing power, and when Emily arrived home she seemed, to Lizzie's great relief, "quite well." Emily for her own part was relieved to find none of the fussing and condolences she had feared. In some ways living at home was actually easier than before. The praying ladies had removed themselves to the new quarters of the YWCA. Her sisters no longer hounded her to go to church, and she attended when and where she pleased. There had been a few tense moments over her smoking and swearing (Dede made her smoke in the barn), but her awkward illness and supposed failure seemed far from everyone's mind but her own. To Victorians she was covered with the modest glory of having studied in England under the "great masters."[3]

Johnny's old stall was now occupied by a sprightly chestnut mare named Maud, and with Dede's consent Emily resumed her daily riding. She rode astride, as she had in the Cariboo, scandalizing her family and the neighbours—though her long, divided skirt swept all the way to her boots and must have partly mollified them. And, to her great delight, she had a new dog. How much he was intended as a peace offering from Dede is hard to tell, given the oblique way the Carrs made such gestures. All that is certain is that he had been given to the sisters some time earlier with the warning that he was "wicked," and that now he was turned

over to Emily. The only wickedness Emily saw him guilty of was killing a chicken. She punished him for that, gave him a bath, named him Billie and adopted him as her own.[4] A crossbred Old English sheepdog, three years old when she got him, he would be her inseparable companion for thirteen years.

She found her barn studio sadly altered, for Dede had rented it to a clergyman who had pasted newspapers all over the walls to keep out drafts. Emily ripped them off and briskly set the place to rights. Her Fort Street studio was more convenient for her pupils, though, and it gave her extra privacy and space. During her first year home she divided her time between the two.

Arnold Watson had seen her English sketchbooks, with their caricatures and doggerel verses, and he liked them so much that he arranged for her to be hired as a political cartoonist for *The Week*. Her captioned drawings appeared from 25 March to 17 November 1905. Most of the subjects, not to mention the opinions, must have been dictated: it is hard to imagine Emily getting worked up over the methods of provincial tax collection or Premier McBride's quarrels with the logging association. But now and then a subject would come along that was closer to home. The Canadian Pacific Railway was transforming the James Bay waterfront, filling in the bay, building a causeway in place of the old bridge and erecting the luxurious Empress Hotel. One of Emily's cartoons shows a cluster of people peering through the knotholes in the fence, as she probably did herself every time she walked by it. Another shows a newfangled automobile charging into a terrified moil of carriages and pedestrians. The caption reads: "We are not quite reconciled to the automobiles. They alarm the horses; the horses alarm the ladies; the ladies alarm the babies; the babies alarm the dogs, and much general confusion ensues."[5] That, somehow or other, seems entirely Emily's own.

Victoria was being radically transformed, not only by the automobile and the Empress Hotel but by a general influx of new people and new money. Farmlands were being chopped into house lots, and tourists were beginning to flock to the city in the summer, drawn by its increasingly self-conscious "olde England" image. Large parts of Beacon Hill Park were being landscaped into English prettiness, the frog swamps and scrub oak thickets giving way to tidy lawns and flower beds. The sleepy James Bay of Emily's childhood became an integral part of the city, still residential but no longer by any stretch of the imagination rural. The soft creak of a visitor's foot on the veranda was being replaced by the jangle of the telephone, and the Chinese vegetable peddlers turned to market farming. Before long the Songhees, whose notably unpicturesque reserve still sprawled along the harbour, would be invited to move to Esquimalt, across the harbour and to the west of Victoria.

But when it came to art, Victoria was as backward as ever. Emily liked

her classes, and she liked being able to sketch in her old haunts, but as the months passed she felt increasingly restless. There were no other professional artists and few opportunities to exhibit her work. She was in danger of becoming an art teacher first and an artist second.

She was lonely, too. Alice remained distant. She had opened a kindergarten while Emily was abroad, and her attention was centred on her pupils and her friends.[6] Emily's own friends were either gone or changed. Edna had been the closest, but in the Cariboo their intimacy had quietly come to a close. Emily had been appalled at the obvious pleasure Edna took in shooting game, while Edna had been irritated by Emily's delight in animals, the outdoors and the local natives. Finally she had announced that she had quite outgrown Emily, who was hopelessly immature and unsophisticated. In a sense, that was exactly right, for while England had tempered Emily into final independence and commitment to her art, it had only strengthened her hold on everything the child in her most loved. For Emily, maturity was the strength to choose the honesty and unclouded sensibility of a child. While Edna had toughened into a middle-aged pioneer matron, age had only increased Emily's wonder at the miracle of life in any form. The distinction was a Wordsworthian one: Emily was growing into the consciousness of childhood. The more her imagination ripened with age, the more tenderly she would cherish the child in herself.

Since Emily's adulthood took so paradoxical a form, it is no wonder that her sisters and acquaintances saw no change in her. She was still only "little Milly Carr," if anything a little more exasperatingly gauche than before. She longed to meet people who would accept her on her own terms, and as an artist she needed room to grow. She began to cast her eye towards Vancouver, a city younger than Victoria but much more expansive in every sense, and when she was offered a teaching job there she took it. In January 1906 she moved into a boarding house at 541 Burrard Street, renting a second-floor studio at 570 Granville.

The group that hired her, which she calls the Ladies' Art Club, was almost certainly the Vancouver Studio Club and School of Art. Formed in 1904 by a group of both men and women, mostly amateurs, the club did much to promote the cause of art in the city, organizing classes with open studios and sponsoring Vancouver's first professional exhibitions. But the zeal of the students did not match that of the leadership, and it is the students Emily lampoons in *Growing Pains* as "a cluster of society women" who met mostly to "drink tea and jabber art jargon."[7]

Her post did not take up much of her time. For the first six months she went to their studio once a week,[8] posed a model for them and criticized their work. In the summer she taught an outdoor sketching class. It is clear that she could not take her students seriously, nor could they do as much for her. The "little Milly Carr" syndrome was not something Vic-

toria visited upon her, but something she carried around with her. The Studio Club students wanted dignity and assertiveness in their instructor, and when instead they got someone who behaved like an "unimportant, rather shy girl," they lost whatever discipline they had. They straggled in at odd hours and re-posed the model without Emily's permission. Several refused to accept her criticism. According to Emily, they expected her to "be smart and swagger a bit."[9] One wonders if, in answer to that challenge, she did not deliberately act the bumpkin, as she had at Bushey or—going far back—as she had when she had "shamed Lizzie right through" at a birthday party at the age of four. The shadows of all the schoolmistresses and busybody matrons she had hated as a child, the shadow of Auntie Hayes herself, hovered behind the ladies of the Studio Club as they innocently downed their tea.

They did not dismiss her at the end of a month as she claims,[10] but she did leave by the end of the summer. As Edythe Hembroff-Schleicher points out, the bad feeling on both sides was clearly less serious than Emily later remembered. After leaving her job she entered paintings in several Studio Club exhibitions, and in 1907 was awarded one of four purchase prizes.[11]

She did not try to teach adults again (except for one brief attempt years later), but she went on teaching children, and she was still good at it. With children there was no need to take on any false trappings of authority; it was quite enough that she was bigger than they were. Her clash with the Studio Club was only one skirmish in her perpetual war with the adult world. She despised the pretentiousness of much normal adult behaviour, and she could not tolerate the social masks behind which other people hid their frailties. They were all "sham," no matter how harmless or transparently defensive they were. In moving to Vancouver, she had tried to leave behind the status of a child without betraying the child in herself. She had failed, because the two were inseparable. But she would somehow have to learn to live with adults, for it was they who held the power to give or withhold the recognition on which her career depended.

The Studio Club episode points up how fragile Emily's faith in herself still was. It shows us a side she had kept well hidden, from Arnold Watson among others, after she returned from England. Her sense of failure was still profound, and though she had gained in artistic commitment she had no clear sense of achievement in spite of eight years in England and America. She was at the mercy of every slur, real or imagined, from people whose opinion by now should have meant very little. She had not anchored herself in the art world. Away from home, timidity and lack of self-assurance had kept her from knowing artists more advanced and innovative than she was. The same timidity had sent her to study in England rather than in France.

It could not have helped to compare herself with Sophie Pemberton, who had blazed the trail for Emily and other Victorian women to study abroad and was now the darling of Victoria. The year Emily went to England Pemberton had won the prestigious Prix Julian in Paris—another first for a woman. She had been given an associate membership in the Royal Canadian Academy, which was as much as women could expect. She had exhibited in the Paris Salon (the academic one, presumably), and regularly had paintings hung at the Royal Academy, as did Theresa Wylde. They had both shot ahead of Emily; and though both would later fall behind—Pemberton as a result of marriage and ill health, Wylde through her own conservatism—in these years their highly visible success may well have confirmed her painful sense of inadequacy.

While Sophie Pemberton had whisked about the continent with an admiring family in tow, Emily had stayed with what she knew, with the familiar and the comfortable. Now she was stuck with it. Short of leaving British Columbia altogether, there was little she could do to escape. For all her bluster and seeming contempt of local opinion, she was very dependent on it. She would often behave as if she believed too much in herself, when in fact she believed too little. Time and time again she would complain of being misjudged, without realizing that she herself determined, at least in part, who had the right to judge her.

Some good came out of the Studio Club job, for one of the women there, an American who was also snubbed by the class, came to Emily afterward as a private student, along with her ten-year-old daughter. The daughter attended the Crofton House School, run by Miss Jessie Gordon. Soon her classmates began to come to Emily for lessons too. The school took notice, and though Emily had previously applied there for a job and been refused, they now hired her to teach a special class. Two other schools followed suit, and together they gave her a steady income while leaving her time for her own work and private classes.

The private classes were successful beyond all expectation. Before long Emily was teaching as many as seventy-five pupils in her own studio. Children loved her imaginative approach to teaching. She would begin with very young ones by asking them to illustrate nursery rhymes, encouraging freedom and fantasy rather than skill. Later they progressed to drawing from casts, models (human and canine) and still life in the studio, and when the weather was fine they sketched all over the city and in Vancouver's beautiful, forested Stanley Park. Vancouverites came to recognize the motley procession of children, Emily and the Scottish student-teacher Belle, laden down with easels, camp stools and a basket containing Emily's cockatoo, and shepherded by the amiable, vigilant dog. They were likely to settle anywhere, like a flock of chattering starlings. They drew barns, coach houses, tumbledown fishing shacks and weedy vacant lots. The miscellaneous choice of subjects irritated some

parents, and one class was cancelled because the mothers objected to their children sketching in lanes, "surrounded by garbage cans and horse manure."[12] But most parents were pleased. The student exhibitions Emily held in her studio drew large crowds, and her reputation as a teacher and artist steadily grew.

Emily kept her studio at 570 Granville about four years, living in separate rooms in a succession of boarding houses. (Early in 1910, not long before she left Vancouver, she moved farther up the street to No. 1035, where studio and flat were combined.) She was the only woman tenant at 570, sharing the building with several offices and with the elderly gentlemen of the Conservative Club, whose quarters were down the hall from hers. They beamed at Emily and the children when they met them on the stairs, and were forever trying to decoy Billie into their rooms for tidbits and petting. Neither the tenants nor the Chinese janitor, John, objected to Emily's rather boisterous ménage; they said it livened up the place. The ménage by now was substantial. Billie, the bullfinches and the chipmunks had been joined by Sally the cockatoo (traded for Emily's canaries), a green Panama parrot named Jane, another parrot (unidentified and temporary), and the white rats Peter and Peggy, who regularly had offspring. The animals were universal favourites. People would knock on Emily's door when she was out just to hear Jane shout "You old fool!" or Sally's "Sally is a Sally" through the transom. When Emily went home for weekends John was always willing to feed the creatures. On longer holidays, like Christmas, she would have to take them on the ferry with her, checked as baggage or stowed in baskets at her feet, where their chortlings and rustlings puzzled and sometimes alarmed her fellow passengers.

Emily's spare time was little enough, but such as it was it went into her painting. In style and technique she remained conservative, but these years saw a gradual consolidation of what she knew, a summing up of her training and a growing mastery of her craft. In subject matter she was still eclectic, painting portraits and still lifes as well as landscapes, though she was drawn most persistently to the forest. Vancouver's Stanley Park was wild and heavily forested, laced with meandering paths that were seldom visited by anyone. With Billie as a guard Emily sought out the park's remotest corners, scoffing at warnings that "suicides and queer things" happened there.[13] She loved the grove of immense cedars called the Seven Sisters, hidden at the end of a grassy trail and wrapped around by thickets of sheltering undergrowth. "The appalling solemnity, majesty and silence [there] was the Holiest thing I [had] ever felt," she writes.[14] Talmage and Whiteley had taught her much about light, shadow and movement in foliage. Now she tried to reach beyond the merely visual, to express the sense of sanctuary and peace she found only among these giants of her own country. As yet she could not go beyond

conventional religious symbols—the slant of cathedral light, the massive pillars of God's house. The surviving paintings of these trees are full of allusion. She felt the need to go beyond it without knowing how, and that in itself—apart from her love of the trees themselves—drew her back to them over and over again.

The church symbolism, conventional though it was, was honest. Emily scorned organized religion, but she had never broken with orthodox Christianity. Her God was a loving, personal God who had not entirely abandoned churches, though He was partial to empty ones: "*Alone* I crept into many strange churches, any denomination, in San Francisco, in London, in Indian villages way up north and was comforted by the solemnity." She believed in prayer, though she hated the way most church-goers went about it. She was glad when she and God could both escape: "God got so stuffy squeezed into a church. Only out in the open was there room. He was like a great breathing among the trees."[15] She never lost her faith in the God of the Christian Incarnation, the specifically human God. But it was God "breathing among the trees" that she wanted to paint.

Hello to Vancouver

EMILY HAD HOPED that the art climate of Vancouver would be different from Victoria's, and she was right. Vancouver might be young and raw, but it was free of the social clannishness of Victoria and had fewer prejudices of any sort. The population was growing at the rate of one thousand a month, and there was a small cadre of semiprofessional artists, most of them English-born and -trained. In 1908 Emily joined with nineteen other artists to form the British Columbia Society of Fine Arts, intended to "stimulate interest in art and hold regular exhibitions of a somewhat higher type than has been attempted before" (that is, by the Studio Club).[1] They held a juried show in April 1909 and followed it up with regular semiannual exhibitions. Emily entered ten paintings in the first show, ten in the second and six in the third. They included forest scenes (*Big Trees, Stanley Park*) and other local subjects; scenes from Victoria (*Indian Camp, Victoria; Wild Lilies*);[2] portraits of native Indians, of Alice (*The Schoolmistress*) and Billie; and scenes from distant native settlements like Alert Bay, Hope, Lytton, and Campbell River, which she visited in 1908–09. She also showed with the Studio Club and at the New Westminster Provincial Fair. Signed "M. Emily Carr" (to avoid confusion with Edith and Lizzie), her paintings were priced at $10 to $100, with most at $50 or below, and they sold well.

Vocationally these were happy years. She was working as hard as she could, and she had no financial worries at all. Her work appealed to the public, and she had a long honeymoon with the press. Her studio exhibitions were always noticed, her own work often praised: "Miss Carr gave a most successful exhibition of her students' work in her studio on Granville Street . . ."; "Miss Carr's studio on Granville Street was thronged with visitors . . ."; "A great improvement in the work of some of [Miss Carr's] students was noticed . . ."; "An artist of strong personality, which finds expression in vigorous work is Miss M.E. Carr, the quality of whose work improves steadily. . . ."[3] There was no question but that

she had established herself as a popular artist who would bear watching.

The only flaw in her contentment was an old one: loneliness. She missed her family and often fled back to Victoria on Sundays. Typically, they seemed much dearer to her and she to them when there were some miles between them. Dede always met Emily's Sunday morning boat in her little chaise, and Alice always saw her off when she left at midnight. In June 1906 Tallie's daughter Una married Frank Boultbee of Vancouver and moved to the city, and for a while Emily hoped to renew family ties there. But they quarrelled (Emily said years later that Una "told some lies and made trouble" for her in Vancouver)[4] and that was the end of that. "Kith what wants me lives away," Emily complained in a 1909 verse, "Kin what's here don't like me."[5]

In the art community, a natural source of friendships, she remained a loner. The student days when she could be an easygoing comrade among comrades had gone, and the jealous irritability she had shown in England was now firmly ingrained. She simply could not let down her competitive guard. The artists of the BCSFA found her abrasive and domineering, and though she was casually friendly with a few of the women, she was intimate with none. She was especially touchy about any sign of patronizing from the men, who she says were jealous because her work was stronger and "more like a man's" than theirs.[6] She says they hung her work "under the shelves or on the ceiling" in BCSFA exhibitions.[7] That is probably an exaggeration; we could believe it more easily if she had not repeated it almost word for word about another period in her life.[8] But she may very well have felt more subtle pressures, the kind of paternalistic, condescending teasing that she had resented from men like Frank Piddington.

Emily made one close, satisfying friendship in Vancouver, though it was not with an artist. It was with Sophie Frank, a Salish woman who sold baskets door to door. Sophie lived on the reserve at North Vancouver, a short ferry ride across Burrard Inlet. Emily says she arrived at her studio the first week she lived in Vancouver, a lean, angular woman in her thirties, dressed in the traditional full skirt, shawl and headscarf.[9] A baby was slung in the shawl and two other children tagged shyly behind her. Emily was much taken with one of Sophie's baskets, an oblong one with a snug-fitting lid, but she could not afford to buy it. Sophie said that was all right, she would take old clothes in trade instead. Emily's old clothes were all in Victoria, but Sophie was perfectly willing to wait, and she insisted that Emily keep the basket. Emily was moved, especially when she thought of how often her own race had proved unworthy of that kind of trust from the native people.

She fetched the clothes from home as soon as she could and took them to Sophie's three-room house next to the Catholic mission at the reserve. That was the beginning of a friendship that lasted over three decades, un-

til Sophie's death in 1939. When Sophie was in the city she would drop in for tea, and when Emily was feeling down and lonely she would take the ferry to the reserve. There she would sit in Sophie's house, sometimes with Sophie's aunt Sara and her friend Susan. The four would talk and giggle like schoolgirls all afternoon, while the calm light from the sea spilled over the floor where Sophie sat among her tumbling children, weaving baskets. The tranquillity was not entirely real, as Emily well knew. Sophie and her husband had had fifteen children and lost them all, and they would lose these three as well as three more, one of whom would be named for Emily. Yet Sophie's grief itself was calm, woven in among the perennially renewed strands of pride and hope she felt for whatever babies were living at the moment. She would lead Emily into the church next door, and for Sophie's sake Emily would dip into the shell of holy water and make the sign of the cross. It is easy to see condescension in this gesture and in the friendship itself—especially since Emily's warmest feelings were so often kept for native Indians, children and animals, none of which could possibly threaten her own tenuous security. But Emily did admire Sophie's strength and emotional endurance. She was proud of being accepted and loved by a native. Many times, in her journals, she would exclaim on how the barriers that should have separated them simply disappeared. "Her love for me is *real* and mine for her," she wrote. "Somewhere we meet. Where? Out in the spaces? There is a bond between us where color, creed, environment don't count. The woman in us meets on common ground and we love each other."[10]

Quite apart from Sophie, natives were increasingly important in Emily's art. She often sketched in North Vancouver or at the Songhees reserve in Victoria, and in August 1907 she was able to visit a reserve far from her own community. Alice had had a disturbing accident—she had sliced off the end of a finger with a kitchen knife—and to cheer her up Emily proposed a trip to Alaska. The sisters took a steamer to Skagway, a Klondike boom-town already well past its prime at the end of its first decade. They stayed there a week, their spirits sagging under five days of rain. A ghostly air of melancholy hung over the town, and a steady wind swept down from the bleak, encircling fortress of mountains. Finally the weather broke, and they rode the railway up to White Pass, following the pack trail that had taken thousands of lives; the bones of horses and oxen still littered the ground. It was hardly an excursion to banish depression, though the impact of the tragedy was softened by its already having passed into legend. The fallen shanties in the valley were buried under vines and brambles, as if their ruin, like that of some crumbling English cathedral, had happened centuries before.

Leaving Skagway, the sisters travelled to the old settlement of Sitka, on Baranof Island. Originally a Tlingit village, Sitka had been a Russian

trading post for sixty-eight years before the sale of Alaska. Although it was now a U.S. naval post, the natives were still there. Some of their finest totem poles, transplanted and gaudily painted for the tourist trade, formed the "Totem-Pole Walk" that was one of the town's chief attractions. Beyond the town, quite set apart from all that, Emily found the native village. It was drowsy and quiet, pungent with the smells she remembered from Ucluelet, of fir and cedar, tidal debris, woodsmoke, fish and human offal. There were many more poles here, too weathered to interest the tourists. In their own setting they were magnificent, for the Tlingit were famous carvers. It is unlikely that Emily had ever seen anything quite like them before, except perhaps a few museum specimens from the related tribes to the south. The natives she knew best, the Coast Salish of Victoria and Vancouver, did not carve at all, and the tradition among the Nootka was not highly developed. The Tlingit village was her first full exposure to native sculpture.

She was not so mesmerized by it that she forgot to be a tourist. With Alice she toured the beautifully decorated, historic Russian cathedral, went rowing and canoeing, and bought baskets and souvenirs. With another visitor, a Polish-born man, the sisters floundered up the steep side of Mt. Verstovia and managed to get themselves mildly lost. Alice began to perk up, and to entertain her Emily kept a "funny book," another of her diary-sketchbooks, where she chronicled each day's adventure in caricature and verse.[11]

But the high point of the trip was the hours she spent sketching in the native village. Soon after she arrived she encountered an American artist, Theodore J. Richardson, who regularly summered in Sitka and sold his work through a New York gallery. His paintings were "quite pretty," Emily thought, but "not Indian at all." She thought she could do better, and it was Richardson himself who convinced her that she had. "Had I done those," he said when she showed him her sketches, "I would be proud."[12] Spurred on by this praise from an older artist who seemed to have "vastly more experience" than she had,[13] Emily began to find a new direction for her art. For years she had been mourning the steady obliteration of native culture, but in these northern villages a highly sophisticated, intricate art still survived in the form of sculpture and painting. It was altogether unique, and it was vanishing. There was nothing to take its place. As her steamer nosed its slow way south past the villages of the coast, she decided to return and record as much of what remained as she could, before it was completely lost.

Emily never returned to Alaska, and it was several years before she was able to visit the villages of northern British Columbia. But in the next two years she visited Alert Bay, Campbell River and several smaller villages on northern Vancouver Island, all Kwakiutl settlements with a strong carving tradition. On the southern mainland, where the people

did not carve but still tried to maintain their way of life, she visited Sechelt, north of Vancouver, and travelled inland along the Fraser River to Hope, Yale and Lytton. She slept in mission houses when she could, and otherwise in tents, cabins, natives' homes and utility sheds. She travelled by steamer, wagon, fishing boat or canoe. Billie was always with her, sharing even her seasickness. And, typically, she collected an assortment of small wild companions—chipmunks, squirrels, crows and a raccoon. At Sechelt in 1908 she bought a baby vulture from the natives for 50 cents, taking it with her to Buccaneer Bay, where she holidayed with friends, and then to Victoria, where it lived several weeks in the calf pen before Emily finally found it a home at Stanley Park.

Her years of experience with open-air sketching now were invaluable, for she was able to work very quickly, setting down rough impressions in pen or watercolour that were later expanded into studio paintings. The Vancouver critics commented approvingly on the growing authority of her style. After calling her, in a passage already quoted, "an artist of strong personality," the *Province* critic went on to say, "Her subjects have a distinctiveness which makes them easily recognized by one familiar with her style." He praised the "strength and genuineness" of her work, her concern for her subject, the "persuasiveness" of her colour, her feeling for light and atmosphere, her "bold, free touch" and "large, opulent line."[14]

Yet to Emily herself her style was not bold enough. It seemed tame and fussy compared with the monumental simplicity of native art. Try as she might to eliminate detail, she was tied by her academic training to a style that was less and less suited to what she was trying to paint. She felt increasingly how much she had missed by not studying in France. Her teaching was paying her very well, and she had more money to spend than she had ever had before. She began to save for a year's study in Paris, and by the beginning of 1910 she had made definite plans to leave that summer.

Given her experience in England, the decision took considerable courage. Her sisters were alarmed and did everything they could to talk her out of it, remembering the doctors' warnings against big cities and wondering if France would mean another breakdown, another hospitalization, another futile rescue mission for one of them. Emily would not listen to them, but she must have had qualms. France was no less foreign now than it had been ten years before, and she knew not a word of the language. In the end she did not have to go alone, for Alice decided to close her school for a year, learn French and go with her.

In April Emily came down with a serious illness, possibly diphtheria, and she had to go home to Victoria for several weeks to recuperate. One can imagine the renewed anxieties, and the large doses of sisterly argument served up with each bowl of junket or chicken broth. It was no use.

Emily went back to Vancouver in June and collected her things, auctioning off some of her work and turning her studio over to the painter Anne Batchelor.

On 11 July Emily and Alice set off, taking Billie with them as far as Edmonton, where he was left with a friend. They travelled slowly, visiting the major sights along the way. When they reached Quebec after nineteen days of travel, they found that the railroad had shipped their trunks on to London ahead of them. That provoked a small panic, followed by some desperate ingenuities in the way of clothes, for they had two full weeks to spend in Quebec before they boarded ship. They managed somehow, and on 12 August they sailed for Liverpool on the *Empress of Ireland*.

Emily was miserable as always at sea and spent the whole voyage below decks. But once her feet hit the planks of the Liverpool pier she rallied at once and made a brisk search for their lost trunks, which had been pushed into a dusty storeroom and forgotten. The delay made the sisters miss their train, and to pass the time (and celebrate the recovery of their clothes) they went to Cross's, a famous clearing-house for birds and pets. There Emily bought a grey African parrot. Alice protested feebly, but ended up paying half the cost of the bird. Packed into a cumbersome, wedge-shaped box, the parrot went with them to London, where they spent two nights with Mrs. Dodd, and from there across the Channel to France. Rebecca turned out to be a sulky bird of no particular accomplishment, but she was a touch of the cow yard in Paris, a link with the wild, creaturely world left behind, and with all that was most enduring in Emily's art.

France

EMILY CAME TO PARIS determined to understand the "new art," and in that respect she was far ahead of most Parisians. Official Paris was only beginning to come to terms with the art of a quarter-century before. Gauguin had died in 1903, Van Gogh in 1890, Cézanne in 1906; but their work, with rare exceptions, still went unsold while the general public hesitated over Monet's seascapes and Renoir's sunny nudes. The French art establishment creaked along like some ponderous wooden cart whose wheels were clogged with mud, while the succession of hot-blooded young colts that had been hitched to it had simply broken traces and run away. Among the recent runaways were the Fauves, whose name in fact meant "wild beasts." It was these painters—among them Matisse, Derain, Vlaminck, Rouault and van Dongen—whose intensity of colour and willful break from mimetic tradition had especially outraged critics during the 1905 Salon d'Automne. "Decadent," "incoherent," the critics had howled, roused to their highest pitch since the emergence of Impressionism. Yet in the five years since then, Fauve intensity had been reworked and absorbed by other painters, and the critics had begun to accept them. Now the latest wild beasts to be hitched to the cart, the Cubists, were splintering its old planks with kicks.

Little of this upheaval touched Emily directly, though physically she lived right in the midst of it. In the cafés of Montparnasse, a few steps away from her flat, Picasso, Braque, Matisse and other assorted young Turks would gather nightly to set up the ideas of a new century and knock them down again, for fun. Several blocks to the north, every Saturday afternoon, more or less the same people carried on more or less the same conversation in the cluttered flat of Leo and Gertrude Stein.

But if Emily knew anything of Picasso and the Steins, it was only by rumour. She and Alice lived quietly on the rue Campagne Première, just off the boulevard du Montparnasse.[1] Their windows overlooked a central court, guarded at the gate by a "terrifying" concierge who "flew out

of her nest like a wasp" whenever anyone came or went.[2] The building was clean and well kept, though the plumbing was rudimentary and the kitchen stove as balky as any Victoria pioneer's. It was Alice who dealt with the stove, Alice who negotiated with the shopkeepers, and Alice who brought home in triumph a big tin bathtub, installing it in the kitchen as a surprise for Emily.

The sisters kept much to themselves. Largely insulated from the lovers' quarrels, the despair of failed careers, the desperation born of drink, illness, drugs and near-starvation that plagued the lives of many of their neighbours, they were shocked by only one domestic tragedy, the suicide of an American pianist who lived above them. Emily was doubly insulated, knowing no French. Alice spoke for both of them, and Alice's timidity surpassed Emily's own. Together they tentatively explored the city, delighting like all tourists in discovering a particular sunlit court, a particular flowerbed or crooked street, a particular slant of evening light on the Seine that they could make their own. When their feet were tired they would make their way to the American Student Hostel on the boulevard St-Michel. There, within reassuring earshot of their own language, they could read, drink tea and listen to lectures. On the way home they might have seen Modigliani, who was virtually living in the cafés of Montparnasse. One can imagine them passing him on the street—he ravaged, nattily dressed, a bit befuddled from brandy and hashish, they shrinking past him like Auntie shrinking past a coffin.

Shutting herself off from the obscure dangers of Paris, avoiding the cafés (which she probably confused with saloons), Emily also was oblivious to its innocent vitality. Montparnasse was not all art and anguish. It was full of ordinary, healthy, working-class families, whose laundry dried in the sun and whose children clattered through the streets on weekdays and played demurely in the Luxembourg Gardens on Sundays, dressed in their sabbath clothes and supervised by vigilant mammas. Resisting what she distrusted in the city, Emily closed her senses to its grace and abundance: the pushcarts loaded with mounds of gooseberries, strawberries, pears, apples, carrots and artichokes, silver mackerel and sardines; the sidewalks cluttered with baskets of roses and carnations; the shop windows neatly laid with cheese nestled in grapeleaves; the sounds of organ grinders and street vendors; the fragrance of the bakery where Alice bought their morning bread; the sheer luxury of seeing a windowful of brilliant colours resolve itself into rows of strawberry and apricot tarts. All this, had she been able to take it in, should have intoxicated the child who still loved to bury her face in flowers. And the city itself demanded nothing from her. The streets were open and sunny, and the level of civility was high.

But Emily, having spent all her courage in coming to Paris at all, felt only the threatening presence of yet another city. Afterward she would

always maintain she had hated it, as if Paris had been dark and gloomy like the Westminster slums. And indeed Paris in winter did become oppressive and would finally close in on her as London had. But the warm, sun-drenched city of late summer and early fall did not close her in. On the contrary, it may have been too expansive, too lush and too free.

Her well-bred female provincialism held her back again, as it had in England and San Francisco. It kept her in the suburbs, so to speak, of the new art. But it mattered far less here. Change was in the ascendant in France, and no particular effort was needed to find it. Nor did Emily feel any stigma attached to being a student or a foreigner. Almost everyone she met was a student, and everyone (since she knew no natives) was a foreigner. She could not help but see the work of the leaders of the new movement; it was in the 1910 Salon d'Automne, which she must have attended, and in that of 1911, in which she exhibited. Otherwise it reached her indirectly, through the work of the British artists under whom she studied. Even in this diluted form, its impact was quite enough to transform not only her style but her sense of the possibilities of art itself. Art, she saw, was infinitely variable, infinitely accommodating. It had room for the vision of a Matisse and the vision of a Picasso; better yet, it had room for Picasso's Tuesday vision and his Wednesday vision. She did not have to see the work of a select few in order to feel this. All Paris was experimenting and evolving, and part of the experience of being there was learning to trust oneself, to work from the inside outward.

It would be a long, slow process. She began by calling on the English artist Harry Phelan Gibb. A visiting woman painter in Victoria had recommended him to her and given her a letter of introduction. Emily and Alice found him living nearby, in a comfortable, well-appointed studio overlooking a convent garden, just off the boulevard Raspail. He opened the door himself—a slender, fresh-complexioned man with prominent blue eyes and a "queer twisted smile."[3] He greeted them courteously enough, and his Scottish wife, Marjory ("Bridget") did her best to make them comfortable. Yet there was a wariness in his manner, and Emily sensed immediately that he had "not a high opinion of the work of woman artists."[4] A tenacious, dedicated artist, he had survived his share of bruising criticism and would never receive much recognition. He was a member of the Stein circle, but in 1910 Gertrude Stein was still a silent, acquiescent figure there, overshadowed by her brash, ebullient brother, Leo. Although women were part of the new movement, they remained on the fringe; art in France was dominated by men, as it had always been. Now here was this dowdy, shy, unprepossessing spinster from Canada —western Canada, at that—who said she wanted to paint. A glance at Emily's native sketches might have helped break down Gibb's all-too-evident skepticism, but she did not show them to him at this first meeting. Instead, acutely sensitive to his suspicions and all but paralyzed by

nervousness, she found herself confronted with Gibb's own paintings, while he waited silently for her to say something intelligent.

It was Emily's first encounter with the kind of art she had come to see, and it left her at a loss. Alice, sitting on the sofa, glanced hastily at the walls and looked away. Emily looked more steadily, but she had seen little even of Impressionist art, and these paintings banished the illusion of perspective and detail far more thoroughly than Impressionism had. She responded at once to the "rich, delicious juiciness" of the colours, and she thought the landscapes and still lifes were "brilliant, luscious, clean."[5] But the boldly outlined, fashionably primitive nudes revolted her, and not for the reason they revolted Alice. Emily was accustomed to the distortions of native art, but there she was within a strict tradition, where distortions had a common source in religion and legend. Here she felt the presence of no tradition she recognized, and the distortions seemed arbitrary and harsh.

All in all, she said almost nothing to the expectant Gibb, except to ask him where to study. At the Académie Colarossi, he replied, where the classes were mixed and she would benefit from "the stronger work of men."[6]

For some weeks at the Colarossi the work of men was all she saw. She thought she might be in the wrong place and sent Alice to inquire, but they said, "No, Mademoiselle is quite well where she is. Other ladies will come by and by." Other ladies did, eventually—"grey haired kittens mostly who had nearly given up hope of being wives and [were] looking for outlets."[7] They were French, as was everyone else including the professor, whose criticisms Emily did not understand. She did find an American student to translate for her, but he hardly ever came to class. Increasingly discouraged, she floundered on, having gathered only that she was doing well and had good colour sense. The painting studio was hot and stuffy and stank of paint fumes; she took a modelling class as well, where at least the air was better. But again, as in England, she began to feel her will and confidence leaching away. She felt listless and indifferent, lost in the impersonality of the school and the vast, alien anonymity of the city. As before, she scourged herself to greater and greater effort, trying to compensate for her growing apathy through sheer perseverance. Meanwhile the grey-haired kittens came and went, came and went, and the professor bestowed his comments on the men in detailed and voluble French. Finally she went to Gibb for advice, and he suggested that she leave the Colarossi and study privately under John Duncan Fergusson.

Scottish-born and three years younger than Emily, Fergusson had lived in Paris since 1905. He had studied at the Colarossi and the Académie Julian and was a member of the Salon des Indépendants and, like Gibb, the Salon d'Automne. At thirty-six he had won considerably

more recognition than Gibb, both in England and France. He was something of a leader among English-speaking artists in Paris, where his magnificent equilibrium was a tonic to all who knew him. "He made no compromises with the world at all," said John Middleton Murry, who met him shortly after Emily did. "He did not rebel against it; he simply ignored it."[8] To Fergusson art was not something one did; it was something one was, a "quality of being," one of the natural rhythms of the creative personality.[9] Fergusson believed absolutely in rhythm—and, with Murry, would help found the short-lived English periodical of that name. His own rhythms never failed him. Disdaining formal schedules, he lived alone in oriental simplicity in an all-white studio on the rue Notre-Dame-des-Champs, eating when he was hungry and sleeping when he was tired. His paintings, which in 1910 were mostly portraits and figure studies, were themselves studies in rhythm, richly contrapuntal harmonies of glowing Fauve colour.

In October 1910, soon after Emily met him, Fergusson began teaching at the Atelier Blanche, also called La Palette, which he managed jointly with the French painter Jacques-Émile Blanche. Emily followed him there. Because both masters offered criticism in English, the studio was a haven for English-speaking students. Duncan Grant, whose path again parallels Emily's, had studied there in 1906–07. The American painter Marguerite Thompson was probably among Emily's fellow students, and her future husband William Zorach enrolled in December.

The students divided naturally into two groups, and there was some friendly rivalry between them. Blanche was the more conservative painter, an old-line Impressionist who distrusted the new trends of the past decade or so. Fergusson led the more progressive group, which he himself called Post-Impressionists a year before Roger Fry popularized the term.

Emily worked contentedly under Fergusson through November. She was looking forward to some criticism from Harry Gibb, who was scheduled to teach at the studio that winter. Meanwhile she kept up her outside acquaintance with the Gibbs. Although she dreaded going to see them because she felt "ignorant and silly" in their presence, she "always picked up some crumb of help," mostly from Bridget Gibb.[10] Gibb himself was as dour and laconic as before, but Bridget was no painter and therefore less intimidating. Under her sympathetic, informal guidance Emily began to understand something of what the new art was all about.

But she was driving herself as hard as she had in England, and her diffidence towards Gibb was partly rooted in the old anxiety that she would not measure up. As winter came on and the city grew damp and cold, she felt the familiar symptoms of depression increase. In December, just before she was due to begin working under Gibb, she collapsed with what she later variously called "flu aggravated by bronchitis and jaundice" or

"measles with complications."[11] She was sent to the Student Hostel infirmary, where she was put in a five-bed ward. (The few private rooms were "always saved for the men students.")[12] There, running a high fever and "nearly demented with headache," she spent six weeks, constantly fuming at her roommates' noisy visitors and bombarding Alice with demands to be taken home. (She apparently did leave for Christmas, for years later she remembered spending the holiday with Canadian friends.)[13]

In January she was released, but she was still too weak to do anything. Listlessly she sat by the window, watching the comings and goings in the court below and desperately longing for some green and quiet place. Finally she discovered that by putting a chair up on the bedroom bureau, she could look out on a tiny private garden next door. There she would stare for hours at the sleeping flowerbeds and leafless trees, bleak enough in winter but still a mental refuge from the encroaching city. Later, when she grew a little stronger, she and Alice would walk to the nearby Montparnasse cemetery and sit there on the benches in the pale winter sunshine.

The onset of this second breakdown was definitely tied to physical illness; the sexual conflict that had complicated her first breakdown was behind her. Otherwise the syndrome was much the same: pervasive self-doubt, a frantic crescendo of work to overcome it, exhaustion, the sense of being trapped and stifled by the city. Illness brought escape from the familiar cycle of weakness and despair, and from the stress of having to meet Gibb's criticism; on some level she may have willed it to happen. But in spite of her depression she did try to go back to work. She returned to the studio briefly, only to suffer a relapse and be condemned to the hated infirmary for six more weeks. (It is strange how often her illnesses lasted just this long. "Six weeks" begins to sound like a stock phrase in her manuscripts, but where actual chronology can be checked it usually comes out right.)

By now her doctors had reached the old verdict: she must keep away from big cities. Alice, who had been suffering the full brunt of Emily's nervous irritability, must have been very weary by now. She pleaded with Emily to go home, and Lizzie and Dede echoed her by mail. But Emily would not hear of leaving, and finally Alice agreed to travel with her to Scandinavia. They went by stages through Germany and Denmark to Göteborg, on the southern coast of Sweden. There, where the evergreen forests were almost as thick as those at home, they stayed with the parents of Mrs. Myrin, a young Swedish woman Emily had met in Vancouver. Mrs. Myrin herself was ill and in a sanitorium, but her parents did everything they could to make the Carr sisters comfortable. Later in the winter Emily and Alice moved to Långadrag, a coastal spa known for its hot baths. The hospitality of the Swedes, the fragrance of

the forest and sea, and the freedom from pressure all brought Emily steadily back to health. By spring she was beginning to look south again. It was the French countryside after all, and not Paris, that had really inspired the "new way of seeing"; and now the countryside was greening under an April sun.

She returned to Paris just long enough to look up Harry Gibb, who was about to begin a sketching class a short distance from Paris, at Crécy-en-Brie. Emily followed him there, leaving Alice in Paris to pursue her French lessons. (Alice loved Paris and had no use for the Gibbs, who she privately thought were "extremists." Later she would manage to forget that Emily had ever studied with Gibb at all.)[14] There was a small flat available in the house where the Gibbs lodged, with its own kitchen and access to a guest room for Alice. There, with her two parrots—Rebecca, the surly grey bird from England, and friendly Josephine, whose French was far better than Emily's own—Emily set up housekeeping and plunged wholeheartedly into work.

This was the France she may have expected all along, the France of Millet and the Barbizons, a timeless, tranquil idyll where the rude new century had not yet shown its face. A sleepy little river, the Petit Morin, wound through the town, between walled gardens whose fine old trees leaned out over the water and dipped their branches in their own reflections. White-coiffed women knelt on wooden trays and slapped their washing, laughing and calling back and forth. Children shouted, roosters crowed, dogs barked, wooden sabots and shod hoofs clattered down the cobblestoned main street, just under Emily's window. It was far noisier than her secluded Paris courtyard, but it was country din and she thoroughly enjoyed it. She was only mildly disturbed when the wine shop across the street set up outdoor tables to avoid the midnight-closing law. Robbed of sleep by a wedding party, she sat up and watched the dancing and tippling till dawn.

Her health was suddenly robust. Carrying fifty pounds of sketching gear and Josephine, she roamed the countryside. The fields lay "like a spread of gay patchwork against red-gold wheat, cool, pale oats, red-purple of new-turned soil, green, green, grass, and orderly, well-trimmed trees."[15] In every direction lay villages and farms, tiny clusters of neat stone buildings, large barns and small cottages with grapevines trained over their doorways. Most of them were empty during the day, but now and then a mother or grandmother would be home and invite her inside to rest. Everyone she met nodded and smiled, and if they spoke Josephine would answer them in impeccable French.

Emily felt for these people the same quick, impulsive affection she felt for native Indians. They seemed much alike. The natives had "the rich glory of wild for background," and the French peasants had

"the rich pattern of tilled fields."[16] However poor they were—and she did not sentimentalize their poverty—they seemed divinely touched and curiously blessed. Knowing nothing of Jean Jacques Rousseau, nothing of Tolstoy, nothing of the dozens of literary notables who had long ago celebrated the virtues of "natural man," Emily would have been puzzled if anyone had told her she was a Romantic. She simply felt that here, among people whose very livelihood was part of the natural beauty that surrounded them, human life might reach a certain level of integrity. The stuffy Anglo-American living rooms she had grown up with were a perfect spawning ground for Romantics, even if Romanticism in general had gone out of date. "Hypocrisy" was a complication of affluence, like porcelain knick-knacks and plush chairs; "sham" was like one of those hideous fringed lamps that hid the light underneath. And if the French peasant or the native Indian harboured more human imperfections than Emily was aware of, at least those imperfections were safely buried in the mysteries of language.

Harry Gibb was away for a few days when Emily arrived, and she dreaded his first view of her work. Even though she was far stronger than she had been the previous winter, he was still a touchstone for her and to disappoint him would have been a serious setback. But, to her relief, he began with praise: "I like the way you put your paint on, and your color sense is good."[17] Then, rather than go on in words, he sat down and sketched the scene before them while she watched. Her nervousness evaporated as she watched him work. "It was not a copy of the woods and fields, it was a realization of them. The colors were not matched. They were mixed with air. You went through space to meet reality."[18] After that, with his help, she began to progress rapidly. She finally showed him her native sketches, and in his laconic way he let her know he liked them. As her style developed, he seemed to deliberately keep her away from the other students, and he never showed her anyone else's work—not even his own. When she complained of being isolated, he said she was better off that way. When she worried over the larger isolation she would face at home, he told her to keep clear of "art jargon" and learn instead from the "silent Indian." But the last inch he would not concede: "He could never let me forget I was only a woman. He would never allow a woman could compete with men." He told her she would be "one of the painters—women painters" of her day.[19]

In June the Gibbs moved to the village of St. Efflam on the northern Brittany coast. Emily followed, and Alice went home to Canada. St. Efflam was a resort town, but the annual tourist invasion had not yet begun and Emily found a room in a small hotel at the off-season rate of five francs a day. The Gibbs lived about half a mile away. Below the village was a wide, flat beach, bounded on the east by a cliff, where the sea

roared and foamed among the rocks at high tide. Inland were gently roll-
ing fields and forests, laced with busy little streams that hurried down the
slopes to the sea. The damp air was spiced with the scents of heather,
seaweed and thyme, and on the crests of the hills the gorse bushes were
white with laundry left to dry and bleach in the sun. Overhead the cries
of gulls mingled with the songs of linnets and skylarks, the chattering of
swallows and the calls of the last cuckoos of spring. In the high pastures
children tended flocks of small, nimble cows. They watched shyly as the
foreign lady unpacked her easel and camp stool each morning and set to
work with her parrot on her shoulder.

Weather permitting, Emily kept to a strict routine. She worked in the
fields from eight o'clock to noon, returning to a big country dinner and a
rest afterward. In midafternoon she went out again, sketched until five,
unpacked and ate a cold supper, lay down and looked at the sky for a
while, and worked again until the late summer dusk. Every afternoon
Gibb walked up to her sketching site and gave her a lesson, and twice a
week he gave her criticisms at her hotel. No longer put off by his dour
manner, she thought him a superb teacher. And Bridget Gibb told Emily
she had never before seen her husband so interested in a student's work.

Everyone made her welcome. Her landlady, Mme Pichodou, did her
best to see that her "petite Mademoiselle"—whose plump form hardly
merited that endearment—did not waste away while toiling in the fields.
And, as at Crécy, Emily formed a "gesticulating, nodding, laughing ac-
quaintance" with the peasants.[20] Women asked her into their cottages,
which were often no more than stone shelters from the wind, with earth
floors and straw pallets. But there were prosperous farms as well, and
one chilly day in late summer—having been taken in out of the cold and
fed harvest cakes drenched with syrup—she set down the scene before
her in the painting Brittany Kitchen, which still survives. There is the gen-
erous room with its heavy black table, its wide stone fireplace, its green
lamp and shining brasses, its bacon and onions hanging from the rafters,
and its high wooden settle; and there is her hostess, dressed in black skirt,
white apron and cap, busy with the knitting which hardly ever left the
hands of a good Breton housewife.

In September 1911, faced with advancing winter and a depleted pock-
etbook, Emily began reluctantly to think of going home. She had
worked under Gibb for five months, and her work was beginning to go
stale. Increasingly, too, she thought that it was time to separate herself
from the French landscape and return to the far greater challenge of her
own country. No painter coming from a European tradition, Emily felt,
had ever successfully interpreted the spirit of the west. She was anxious
to try, but she realized too that she must remain rooted in the only art
that truly belonged to the west, the art of the native Indian. She took out
her native sketches and repainted several, trying to integrate the larger,

freer methods of the French style with the bold simplicity of the native material.

When she told Gibb she was leaving he seemed genuinely sorry, but he agreed it was time for a change. There were still a few weeks of good weather left, though, and it was probably at his suggestion that Emily decided to spend them at Concarneau, working under an "Australian" watercolourist who was almost certainly the New Zealander Frances Hodgkins. Gibb returned to Paris, taking with him two of Emily's canvases to submit to the Salon d'Automne. Titled *La Colline* and *Paysage,* they were accepted by a jury that included John Duncan Fergusson and were hung in the huge mixed exhibition, which opened 30 September.

Like all the Salon d'Automne exhibitions, this one (the ninth) included works by students, foreigners and interior decorators. Emily called it "the rebel Paris show of the year,"[21] and though it shares that description with the older, more prestigious Salon des Indépendants, the words are accurate enough. Although a great deal of the work shown was conservative, the Salon d'Automne was a forum for the unknown, the neglected, and the outrageous moderns—or as one reviewer in *Le Temps* called them, "les illetrés." By 1911 the critics were no longer offensive about these artists, but instead affected an indulgent, worldly tone, regretting their "excesses" and praising their freshness. The Cubists they dismissed with a shrug as madmen, but they had made their peace with the gentler Fauves. A retrospective of Pissarro lithographs was greeted with the respect due an established master. In such company, Emily's entries were thoroughly mainstream, and they escaped notice.

At Concarneau, a fishing and resort town in southern Brittany, Emily's zeal revived and she worked vigorously through the autumn. The authority, economy and disciplined freedom of surviving Concarneau paintings such as the watercolour *Concarneau* (sometimes called *Bottle Girl*) testify to the happiness of these weeks. Less well documented is the effect of knowing Frances Hodgkins, the only woman painter under whom Emily studied.

Neither woman left any written trace of their encounter, and we are left to guess at what it meant to Emily. But there are some striking similarities, as well as some significant differences. They were about the same age, Hodgkins being two years older. She too had suffered the double stigma of being a colonial and a woman. Like Emily, she came from a remote provincial town where artistic taste still clung to the Romantic Sublime. She had had no family opposition to contend with, since her father and sister were both gifted painters, but their very success as conservative artists had inhibited her larger talent. She did have some early advantages over Emily: she had, for example, painted from the nude as early as 1898, in an art school her own father helped to found. She had achieved early recognition in England, seeing a painting hung at

the Royal Academy while Emily was still a student at St. Ives. Yet that success had come only because she had dutifully followed in the footsteps of her father and sister, feeling overshadowed by both.

Except for one interval spent at home, Frances Hodgkins had lived abroad since 1901, and in France since 1908. It was only as an exile that she had gradually and painfully broken with the art tradition in which she had been raised. The more distinctive and individual her work had become, the more her New Zealand public had deserted her. Galleries at home could not sell her paintings, and finally she no longer bothered to send them. Nor were the English pleased: the Royal Academy, once so enthusiastic, refused her membership. She could only turn to the French, who long grudged her any sign of recognition. Now, after years of poverty and semineglect, she was finally gaining a reputation. In 1909 the American Student Hostel had awarded her a £20 prize and given her a studio where she had taught a class in watercolour. Successful summer classes followed, and early in 1910 she had been invited to teach a class at the Académie Colarossi—the first woman to be so honoured. In Concarneau in the summers of 1910–11 she taught at a school for watercolourists run by Charles Morice, a friend of Gauguin. There her classes were popular, attracting thirty to forty students.

In short, France was being good to her, but only after a long apprenticeship. Like Emily, she had been slow to disentangle herself from the values of her childhood. It was not until she was twenty-six, a successful art teacher, a painter of pleasant, inoffensive pictures and something of a social darling in her home town of Dunedin, that she left home for the first time to study and travel. Even now she was still pulled by the lure of home and comfort, and it was only after she met Emily—the following month, in fact—that she finally was able to make her decision to permanently live abroad. How much of all this she confided to Emily, if any, is an open question; but the prolonged struggle to achieve an individual style and a professional identity is much the same in both women.

Temperamentally they were much alike, and a description of Hodgkins in her twenties could apply equally to Emily: "[She is] high spirited, observant, humorous, endowed with a capacity for deep affection, and when she reports social functions and incipient love affairs, gifted with a talent for slightly malicious commentary."[22] Both women had turned down marriage proposals, Hodgkins for reasons she chose never to explain. Both could easily have rested in the tradition in which they had been raised, and both paid a high price for rejecting it. As women painters they constantly had to prove their worth, not only as innovators but as serious artists. For Emily the major portion of that battle, as she even now suspected, still lay ahead. For Frances it had meant cutting old affectional ties and avoiding any new ones that could possibly compromise her work. At forty-two she had become a tough, lonely,

rather brusque and salty soul, belonging to no country in particular and totally absorbed in her art.

Emily worked with Hodgkins until the end of October. Then, after a brief stopover in Paris, she left for home. In many ways these fourteen months had left her unchanged. She was as stolidly Anglo-Saxon and as implacably innocent as when she arrived. The enforced custom of drinking wine would gladly be resigned for the sake of tea, and the names of Cézanne and Van Gogh, having washed briefly over her consciousness, would be consigned to that little-visited corner of her mind that had to do with history and theory. Of Gauguin, a painter to whom indirectly she owed much, she may have known nothing whatever. But her painting had been permanently transformed. For the moment it drew what it needed from the very atmosphere of the Post-Impressionists and Fauves: an uncompromising, fresh and often strident palette; flattened perspective; a bolder emphasis of major forms and a disregard for detail. Less readily apparent, but equally important in the long run, was a sharpened consciousness of art as a constantly evolving process.

She was also bringing home a solid sense of competence, and a tougher dedication based on the examples of the artists she had known in France. Her present mood contrasted sharply with the sense of defeat she had brought home from England. Here it was taken for granted that the best artists swam against the current of society. The accepted stance was one of defiance, and the artist's vocation was—among other things—a test of personal integrity. Critics were adversaries whose insults were the scars of honourable battle. Gibb had met opposition head-on, becoming "a disappointed man . . . crusted over with hardness,"[23] yet an artist more worthy of respect than any other she had met. Fergusson had met little adversity, but it would not have mattered if he had. He built himself a tower. For Hodgkins, as a woman, artistic alienation had meant rejection of a larger, more pervasive tradition. It had meant loss of country, friends, and family real and potential; it demanded an even more stringent discipline than that required of the men. But all three were part of an acknowledged community. Emily gained from them a sense of place, and a permanent focus for the diffuse rebelliousness she had felt since childhood. From now on she would draw on it as a source of strength for whatever lay ahead.

"Critics" and a Journey

ON 17 NOVEMBER 1911, after a jubilant reunion with Billie en route, Emily arrived home. Her sisters and friends must have been glad to see her, especially since she was so obviously in vibrant health. One can imagine the kisses and exclamations, the succession of visits from welcoming neighbours, the old-fashioned Christmas with its holly-decked pudding and its carols and Tallie's children romping through blind man's buff with Aunt Milly. One has to imagine them, because Emily never described them at all. What she afterward remembered was the first unpacking of her French paintings, and her sisters' "dead silence . . . silent antagonism." Nor were her friends any more encouraging. She felt they pitied her because, after all the misery of her long illness, she had gone wrong in the end. They told her, she says, that she "used to paint quite nicely."[1]

After Alice's reaction to art in France and her dislike of the Gibbs, this really cannot have surprised Emily very much. And, after all, this was Victoria. She hoped for better from Vancouver, and in January found a studio flat there, at 1465 West Broadway. She moved in in February and by the end of March was ready to hold an exhibition. On the twenty-fifth she opened her studio to the public. About sixty old friends and students thronged to see her new work. Tallie came, and Una Boultbee and Edna Carew-Gibson (now living in Vancouver) were among the tea hostesses. The exhibition was followed by a regular Friday night open studio beginning 12 April.

So began Emily's one-sided feud with what she always called "the critics." A glance at the Vancouver reviews for 1912–13 makes it clear that she had no cause for complaint there. The press cheered her on, as they always had, though a cautious note crept in when a *Province* reviewer declared her work "interesting as indicating the trend of recent French work in the direction of brilliant color and a certain distaste for detail."[2] This sounds like a person trying to overcome an aversion for

something he thinks he ought to like. The same tone is struck, two days later, in the write-up of an interview at Emily's studio. Here the opening is flattering, even unctuous. Emily is said to have had two works in "the Paris salon" and to have "met with the most favorable criticism from distinguished masters." But when it comes to the paintings themselves, the writer is "startled" by the "riot of color" on the walls:

> The blues seemed so very blue, the yellows so unmitigated, the reds so aggressive, the greens so verdant.
> "Is this the latest French style, Miss Carr?"
> "Oh, these are all moderate. They may be said to represent a little of the movement towards vitality in art that is going on, but even these make my friends here gasp when they first see them."

Then Emily went on to explain both the need to go beyond copying nature and the creation of light effects through colour. "But," the journalist pursued, "do you see blue shadows like that in nature?" "I do," Emily said firmly, and they went on to talk about her native paintings and her experiences in France.[3]

This article appeared on the page given to "Casual Comment on Women's Activities and Interests." Flanking it were items presumed to have like appeal: a fashion-drawing of "a carefully tailored suit"; a titillating squib on the amours of the "poor, dear ex-princess of Saxony"; a notice that fashionable at-homes in London were giving way to sewing-bees and a stern warning to that new threat to womanhood, the "outdoor girl," not to wear her dreary everyday clothes to parties, lest she insult her hostess. The "outdoor girl," the writer scolds, has provoked a "certain amount of hostility" in the last few years by making "a great pose of her masculinity," and she had best try not to provoke any more.[4]

So much for climate. We should remember that the work of male artists was also trivialized, for all art was routinely discussed on the society page. But this was not even the society page, and here the context in which women artists were firmly put speaks for itself. Men had their difficulties as painters *per se,* but they did not have the additional burden of sexual stereotyping. Emily may not have been consciously aware of the offence in this case, but she was keenly aware all her life of the kind of mentality that spawned it. Male painters like Harry Gibb, whatever other indignities they suffered, never had to defend their work on a page devoted to fishing-flies and the mending of leaky roofs.

At any rate, the *Province* meant well, and from then on it continued to support her work. The other papers followed. Yet Emily, recalling this year in old age, remembered only "bored writeups" after her first exhibition, "deploring that one who had once given promise had thrown sanity

to the winds and was outraging nature."[5] This does apply fairly accurately to a Victoria review in 1913,[6] but in Vancouver the only outright attack was voiced in an anonymous letter to the *Province*. The writer, enraged by Emily's defence of modern art in her interview, trotted out the standard crank responses about the arrogance of artists who think they can improve on "nature in all her sublimity." He fired off a personal shot at Emily that fairly well matches her description of her "critics":

> Now this artist, before going abroad, had shown no inconsiderable talent in depicting local scenery, and had she continued on these lines she might have become one of those of whom British Columbia could speak with pride, but she has given up her inspiration, and exhibits nothing but work of an excited and vitiated imagination.[7]

Emily's reply, published a few days later, is a passionately reasoned explanation of the difference between an artist and a "mere copyist." It was only in the last paragraph that she showed a flash of real pique:

> With the warm kindly criticisms of some of the best men in Paris still ringing in my ears, why should I bother over criticisms of those whose ideals and views have been stationary for the past twenty years? When the "Paris Salon" has accepted and hung well two of my pictures, why be otherwise than amused at the criticisms of one who gives no name.[8]

So ended the only negative incident we see in print. But there is no reason to assume that Emily's memories of other hostile encounters were false. The press was more enlightened than the public and more anxious to give the benefit of the doubt to any artist, especially one who had studied in Europe. The ordinary gallery-goer was a different creature, and it is likely that this one bewildered, cranky *Province* reader spoke for many others. Vancouverites were hardly more prepared for a Fauve style in 1912 than Parisians had been in 1905, and their casual comments, of the standard I-could-do-better-and-so-could-my-pet-monkey variety, are easy enough to imagine. Emily habitually eavesdropped on people at her exhibitions, and though she may not have heard one acquaintance mutter "poached egg on a field of spinach" at her first show, she certainly heard many similar remarks. There were several sales at her exhibition, but there is some evidence that old friends bought out of loyalty and pity, and not because they liked the pictures.[9]

So when Emily afterward said that "the critics" demanded that she imitate the camera, she was not speaking of newspaper critics, but literally of people who were critical.[10] It was not the press that attacked her, but

the person off the street, the person who came to a gallery to be chic or polite or because he had nothing in particular to do. Describing his reaction, she wrote:

> People came, lifted their eyes to the walls—laughed!
> "You always were one for joking—this is small children's work! Where is your own?" they said. . . .
> Perplexed, angry, they turned away, missing the old detail by which they had been able to find their way in a painting. . . . [They] could not have hurt me more had they thrown stones.[11]

There were many who did like her work, or who at least expressed an openness to it. Emily responded to them for the moment, but afterward they were eclipsed in her mind by the ones she failed to reach. Jealously she watched for small omissions, noticing the way her friends made small talk at the exhibition to cover their confusion. If France had taught her much about the embattled artist, it had taught her nothing at all about detachment. "I feel about my paintings exactly as if they were my children," she once said; "They are my children, of my body, my mind, my innermost being. When people call them horrible and hideous I resent it deeply—I can't help it. I know people don't have to like my pictures, but when they condemn them I feel like a mother protecting her young."[12]

Over the next few months the gap between Emily and the public widened. She had counted on regaining her old job with the Crofton House School, but they refused to rehire her. They told her they had found someone else in her absence; they also let it be known that they disliked her new work.[13] The other schools where she had taught also turned her down. And although she had written in her letter to the *Province,* perhaps with more bravado than truth, that she did not lack for students or buyers, her private classes remained small and sales died down after the opening show. For months her work was out of the public eye. She quarrelled with the B.C. Society of Fine Arts and did not participate in their spring exhibition. According to Maria Tippett, their jury rejected two of the ten pictures she submitted, so she withdrew them all and resigned in a rage from the society.[14] (So the "humiliating" press notices, jeers and insults she remembers from this show in *Growing Pains* could not possibly have happened, at least not then.)[15] She did continue showing her work with the Studio Club, but only through 1912.

By summer she was thoroughly sour on Vancouver, and she could hardly wait to get back to her "silent Indian." Subletting her studio to the conservative eastern artist Wylie Grier, she set off in July on a long and ambitious trip that would take her to the villages of the finest native

artists in the Northwest. Stopping first at the Kwakiutl villages on the east coast of Vancouver Island, she later made her way far up the Skeena River, on the mainland, to the Gitksan (Tsimshian) villages there. Finally she visited the Haida villages of the Queen Charlotte Islands.

It was a considerable undertaking for a lone woman. Pioneer women and missionary wives had penetrated the far north for decades, but always as helpmates and followers, not on their own. Emily was never totally alone on this trip in the sense of being out of touch with humanity (though afterward she implied she was). But her guides and hosts were all transitory and casual, and she had to make her way from one to another as best she could. Her only constant escort was Billie. Everyone she met was helpful, but there were formidable problems: rain, wind, choking undergrowth, the difficulty of tramping long distances (walking was always harder for her after she lost her toe), and clouds of mosquitoes that were only partly defeated by thick gloves and veils.

In the nineteenth century the tribes she visited had brought their traditional art, particularly sculpture, to its highest form. Ironically, it was white traders and hunters, with their wealth and their metal tools, who had helped bring that development about; and it was white missionaries who finally all but killed it. The missionaries arrived fairly late on the scene, towards the end of the century. They took violent exception to native art, which was closely linked to native mythology and religion, and they especially disliked the massive, free-standing poles that stood outside the lodges of persons of rank, proclaiming their descent from various supernatural beings—part human, part animal, part divine.

By the time the missionaries came, in the 1870s and '80s, the natives were very vulnerable to change. The earlier whites had brought prosperity, but they had also brought plagues of truly biblical proportions: smallpox, tuberculosis, measles, flu and whooping cough. Even as native art proliferated, the population was being decimated. Alcoholism and prostitution followed, and widespread venereal diseases crippled the birthrate. The missionaries found the people thoroughly demoralized, and it was not hard to convince them that their art—along with much else they had cherished—was shameful and barbaric. Their old gods seemed to have failed them, and they obediently turned to the new. Carving was vigorously discouraged. By Emily's time a few of the old master sculptors still survived, but the young people refused to learn an art they had been taught to view as pagan.

Emily stopped first at Alert Bay. From there she was able to reach several other Kwakiutl villages: Mimquimlees, Tsatsisnukwomi, Kalokwis, Cape Mudge and Gwayasdums. They were largely deserted, for in the summer the people left to go fishing or work in the nearby canneries. Only a few caretakers, mostly the very old, would be left behind.

In Gwayasdums she found not even this scattering of humanity. A

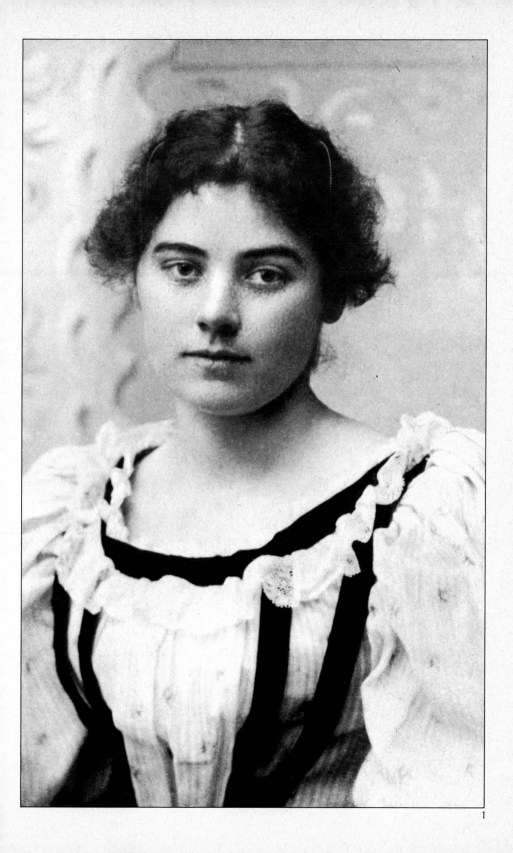

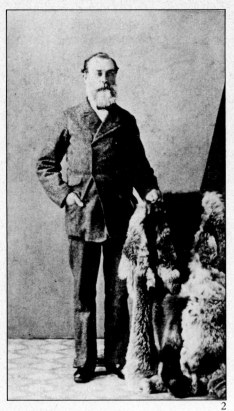 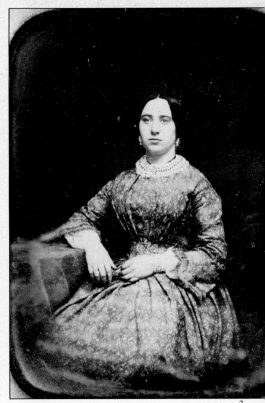

2
3

1. Emily as a young girl. Private collection

2. Richard Carr, 1876. PABC HP93620

3. Emily Saunders Carr, two months after her wedding, 1855. PABC HP93618

4. The Carr house, 1890s or later. PABC HP17811

5. Emily's sketch of her father, c.1880. PABC HP27430

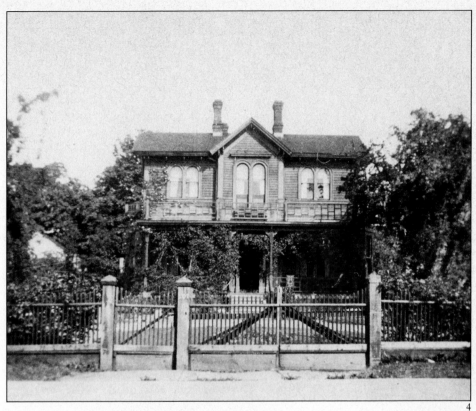

4

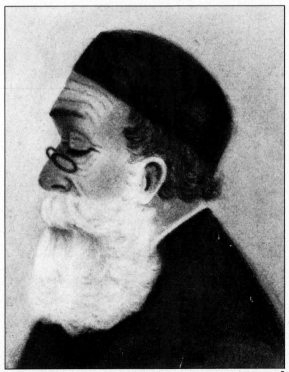

5

6. Emily and Richard (Dick) Carr, c.1891.
PABC HP96100

7. Emily in the Cariboo, 1904. Private
collection

8. The Carr sisters, c.1888: *back row,*
Edith, Clara; *front row,* Lizzie, Alice and
Emily. PABC HP5131

9. Emily in her Simcoe Street garden
with Bobbies, cats Twinkie and Dolf,
parrot and chipmunk, c.1918. PABC
HP51747

10. Kitwancool, 1910. Photo G. T.
Emmons. Special Collections Division,
University of Washington Libraries
NA3498

11

12

11. Emily with Flora Burns at Langford, 1939. Photo Humphrey Toms. PABC HP51765

12. Woo in camp. By permission Edythe Hembroff-Schleicher. PABC HP72119

13

13. Emily and the Elephant, Esquimalt Lagoon, May 1934. PABC HP65557

14. Emily at Beckley Street, May/June 1938. Photo Humphrey Toms. PABC HP93616

14

motor launch brought her there and immediately left, not to return until the next day. The mute presence of the native girl who was with her only emphasized the eeriness of the silence around them. They stood on a narrow, curved white beach of shells and pebbles. Above them were the carved and painted housefronts and the Kwakiutl poles with their fierce, projecting, masklike faces. Everywhere, like some guard left to warn off intruders, grew thick masses of stinging nettles, obscuring the bases of the poles and cascading over the plank walks in front of the houses. Under the nettles the walks were infested with hundreds of thick white slugs and covered with slime. It was impossible to walk without falling. Emily fell, landed among the nettles, and found herself beneath the towering sculpture of DSonoqua, the cannibal wild woman of the woods whose story had terrified generations of native children. Emily backed off as far as she could and sketched the huge red figure with its empty, staring eyes and outstretched arms. It was the first of several images of DSonoqua she would paint over the years.

Gwayasdums was a kind of initiation, as if she were being tested. She stayed awake that night, sitting by the window of the deserted mission house while her companion slept and the mortuary trees outside, their branches bound with coffins, rocked and creaked to the howls of a forsaken, half-wild dog. Beyond her fear—for she was certainly frightened—and beyond her awe at the solemnity of the forest and carvings was a sense of inner triumph, as if she were the privileged guest of giants. The tales she later told of this night are like the tales of a mediaeval quest. Without peril and enchantment no quest is ever worth singing about afterward; and of course the knights of perilous quests have always been men. That too—though she did not allude to it directly—must have been always on her mind.

From Vancouver Island Emily went to Prince Rupert and thence to Port Essington, at the mouth of the Skeena River. There she waited several days for a steamer to take her to the villages of the Gitksan, who lived far upstream. She stayed with her niece Emily English, whose husband, March, was the manager of a local cannery.

The Skeena is a wild, treacherous river, and for many years it had protected the Gitksan not only from their traditional tribal enemies but from most white men as well. A few missionaries had reached the villages by canoe in the 1870s and '80s, and the mining town of Hazelton had been settled as early as 1868. But it was not until the 1890s that steamers began to battle their way past the turbulent rapids, and even now the river wrecked one now and then when it was in a playful mood. Emily found it peaceful enough, though the little engines of her vessel had to roar and puff to make any headway even at low water. Above them she felt the primeval silence arching like a vault, muffling their feeble, passing, human clatter. Bald eagles circled in that silence, waiting for the small inter-

ruption to pass so they could pounce on spawning salmon in its wake. Watching them, one could almost believe that the Skeena was as timeless as they were. But the banks were dotted with mining and lumbering camps and farms, and beyond them lay the new tracks of the Grand Trunk Pacific Railway, which would soon bring the sheltered Gitksan villages within easy reach of the casual tourist.

Emily's steamer docked several miles below Hazelton, and she travelled the rest of the way by canoe. She had come about 180 miles from Prince Rupert. From Hazelton she could easily reach the surrounding cluster of native villages: Kitanmaks, which adjoined Hazelton at the junction of the Skeena and Bulkley rivers; Hagwilget, a village of the Carrier tribe a few miles up the Bulkley; and Kispiox, about ten miles farther up the Skeena. Behind her were Kitwanga and Kitsegukla, which she would visit on the return trip.

At each village she found an old, abandoned settlement clinging to the side of a new one. The missionaries had persuaded the people to build new, European-style houses, but the people had not moved away. They lived close to their old, communal lodges, which were slowly sinking back into the forest. Nearby were their dead: the unconverted, who slept in traditional raised grave houses or in the tops of tall mortuary poles; the converted and prosperous, who slept in the ground under marble tombstones; and those who were either not quite converted or not quite prosperous, whose Christian burial sites were marked by miniature wooden houses, each equipped with the possessions the deceased had most cherished in life. Along the riverbank, among the collapsing ruins of the old houses, Emily found the heraldic poles that had once proclaimed the legendary genealogy of the village nobility. Carved in the massively simple, uncluttered style of the Tsimshian, they ranged from ten to sixty feet tall. Some poles were carved all along their length, some only at the base or top. Some were on the open beach, some half-swallowed by young trees. Some were whole and straight, some split and broken. Some sprouted moss and grass, and many had fallen and lay staring with blurred and softened features at the tangled thickets of salal that hid them from the sky.

The Gitksan were suspicious of outsiders. Like the natives of Ucluelet they resisted having their portraits painted, and they allowed Emily to paint their poles and lodges only after careful questioning. Twice she was summarily ordered to leave a village. At such times she resorted to "a little tact and jollying,"[16] or sometimes a gift of a duplicate sketch. Once she had won their trust she made it clear that it was reciprocal, deliberately leaving her things lying about the village while she was working; she would not, she said later, have dared to be so careless with white children around.[17] She submitted meekly to having crowds of curious natives peer over her shoulder—a liberty she had tolerated only

once before, among the children in Brittany. Before she left a village she would give an exhibition of her sketches, and in general she approached native sensibilities with delicacy and patience.

Sometime in August she left the Skeena and sailed to the Queen Charlotte Islands. This was the ancestral home of the Haida, the tribe that had once been known among the Europeans—with good reason—as "the Vikings of the Coast." A century earlier the Haida had been a wealthy, highly skilled, seagoing people. Blessed with an abundant food supply, slaves to do their menial work and trees worthy of their carvers, they had developed an intricate, sophisticated artistic style unique among the Northwestern peoples. But now they were close to extinction, their population down to a few hundred from an estimated peak of six thousand in 1835. The survivors lived mainly in two missionary settlements at Skidegate and Masset. The old villages were deserted, tucked away among obscure islets and coves and approachable only by sea. No new settlements had been built near them. They were places utterly detached in time, where ancient presences seemed to breathe even in the midst of decay.

After trying the tourist cruise around the islands, Emily left it at Skidegate, where she boarded with a Methodist missionary. His family was away, so for propriety's sake she was chaperoned by a girl from a neighbouring farm, who went along on her sketching excursions: later the girl was replaced by the missionary's own daughter. With the missionary's help Emily found a native couple, Clara and William Russ, who agreed to take her to the old villages in their fishing boat for $10 a day. She came to think of them as friends, and later wrote about them as Jimmy and Louisa in her book *Klee Wyck*. They set up camp, caught and prepared fish, fetched water and cleared brush, and at night they would tell as many of the legends embodied in the poles as they knew, though their own memories, even in the space of a generation, had become vague and confused. The old presences were very much alive for them, and twice they refused to spend the night on the beach and fled to their boat, leaving Emily and her companion to sleep alone among the "ghosts."

Each village had its special personality, recalled later in Emily's writings. Haina, on Maude Island, is probably the place where Emily first made friends with Clara by presenting her (rather grudgingly, for she wanted to keep it herself) with a baby gull stolen from the nest.[18] Tanoo was sunlit and calm, vibrant with memories for Clara, whose grandmother's pole still stood there.[19] Skedans was buried in greenery, a surging tangle of exuberant growth that "linked [everything] with everything else."[20] Cumshewa was "a great lonesomeness smothered in a blur of rain," where Emily sketched a dark, melancholy carved raven hunched against a lowering sky.[21] At Chaatl, barely sheltered from the

full fury of the Pacific, the visitors had to shout to be heard above the roar of the punishing surf. There the campfire stories were full of "ghosts and supernatural things—tomtoms that beat themselves, animals that spoke like men, bodies of great chiefs, who had lain in their coffins in the houses of their people till they stank and there were smallpox epidemics."[22] Not for anything would the Russes sleep on the island. Emily—wakened not by ghosts but by mosquitoes—paced the beach alone that night and watched the first light turn the bay to silver and the poles to soft, pearly grey.

After she left Skidegate she went to the northern tip of Queen Charlotte Island where, based at Masset, she sketched in the villages of Yan and KaYang. Then her summer was over, and she sailed for home. It may be that she had not truly come home from France until now. The summer had been a homecoming in spirit, a return not only to the native people but to what she and the natives shared. Her later accounts, and her insistence that her "sole protection and companion" had been her "old faithful dog," gave rise to the popular notion that she had "lived among the Indians" for long periods—a belief that Tippett has convincingly put to rest.[23] Emily did not, of course, live with the natives but with the white people who surrounded them, and the considerable help they gave her went largely unacknowledged. But it is also true that the ordinary trivia of daily life barely touched her consciousness; they slid off it like rain off the back of Cumshewa's raven. Her mind took what it needed and left the rest, just as it had in France. In that sense she had not only lived among Indians but among Indians who were no longer there.

Good-bye to Vancouver

WHEN EMILY RETURNED to Vancouver, both the *Province* and the *News-Advertiser* welcomed her back. Both reporters (the second evidently filching from the first) noted that Vancouverites remembered "with pride" her pictures hung in the "Paris Salon last year"; one of them expanded the number to "several." "Miss Carr believes in going after new work," the *Province* enthused. "This year she spent in the wilds and last year in the foremost studios of Paris. Last winter her Friday evenings in her delightful studio were an inspiration to art lovers, who considered it a privilege to see some of the work of the new French school. . . . It is hoped that Miss Carr will again this winter throw open her studio . . . and allow her friends the privilege of seeing sketches of some of the remote corners of the northland." The *News-Advertiser,* noting that the native villages and culture were disappearing, added, "It is a matter for congratulation that an artist of Miss Carr's ability should have undertaken to make a record for posterity of these things of grandeur, in an age that is passing."[1] Visitors to her studio were more encouraging about these paintings than they had been about her French work, though they too tended to stress their purely historical value.

Over the winter she finished a number of studio paintings from her sketches, among them a fine watercolour of the Cumshewa raven and the large, well-known canvas of a three-poled housefront at Tanoo, set against a warmly glowing sky. In the best of these works her own style both preserved and transformed that of the native. The native's sense of the tangibility and permanence of spirit, the convergence of man and myth, animal and forest, is enriched by the depth of the painter's understanding and her implicit consciousness of loss. Sky, landscape and sculpture answer one another, and there is silence as well as space in the paintings.

But as recent writers have remarked, and as Emily herself gradually came to realize, the historian inhibited the artist.[2] Travelling backward

with the native through time, she had felt the spiritual resonance that informed his art—not precisely as the native felt it, but with the sympathy of a corresponding need. The wilderness was alive, with many spirits for the native and with one, all-pervasive spirit for Emily. Caught up in the exhilaration of a shared vision, Emily often was unable to keep a firm sense of her own artistic identity. She had gone to France to liberate herself from fact, to learn to transcend it as the native people did. Now she was tied to the new fact of the native himself. And while she tried to paint native subjects in a French manner, with the French vibrancy of colour and disregard of petty detail, she was not able to work with total freedom here as she had in Brittany. Composition and palette were subordinated to the effort to record what she saw. The figures she felt obliged to add to the empty villages were sentimental and unconvincing, and the surrounding landscape was sometimes sketchy. The "riot of color" that had startled her friends the year before was now mostly confined to small landscapes she painted near Vancouver, where she was altogether free of the native.

From the perspective of her whole career, these are minor criticisms. She would eventually climb above the plateau on which she now stood, and while she stood there the air was fresh and bracing. The best paintings of this period, such as *Tanoo, Queen Charlotte Islands* and *Alert Bay,* are strong and enduring; they are landmarks in the development of one of the most distinctive styles in Canadian art. For the moment, Emily felt the need of only two things: money, and a friend who entirely sympathized with what she was trying to do.

Searching for the first, she came across the second. An inquiry sent to Henry Esson Young, provincial secretary and minister of education, trying to interest the province in buying some paintings and funding future trips, brought her an introduction to a leading authority on the Haida. The inquiry itself came to nothing, but her friendship with Dr. Charles F. Newcombe was fruitful and enduring.

Newcombe was a 61-year-old English-born physician who had lived in Victoria since 1889. He was a highly competent amateur botanist, zoologist and paleontologist, one of the founders of the B.C. Natural History Society. By 1912 he had also earned an international reputation in anthropology, drawn into the field by his experiences as a doctor treating the Haida. Reticent and self-effacing to a fault, he had published very little, but in 1901 he had joined J.D. Swanton's pioneering expedition to the Queen Charlottes, and later he had become a field ethnologist for the Field Museum in Chicago. He had collected many splendid Haida poles for museums in North America and Europe, even though he felt the irony of salvaging for the white man what the white man had conspired so energetically to destroy. He had also collected a great deal of material for British Columbia's own provincial museum.

In November 1912 Newcombe was sent by Young to make a scientific evaluation of Emily's paintings. As directed, he sent his report to his friend Francis Kermode, curator of the provincial museum. No artistic evaluation was made; the work was approached strictly as anthropological record. As a scientist, Newcombe was cautiously approving, but it is clear he thought that insofar as the paintings were art, they were inadequate to the purpose. He found the colours "too brilliant and vivid to be true to the actual conditions. . . . At close range it is seen that the materials used have been laid on with a heavy hand. On standing away several feet distance, the colours blend and the roughness [is] lost sight of." He criticized the scale, since "no standard of comparative size has been followed," and he thought figures should be added to future works to throw more life into them. In sum, he thought Emily's work might do as "decorative wall paintings" if the defects were corrected "under proper supervision."[3] This was hardly a ringing endorsement, and the provincial government quietly backed off from any thought of buying Emily's work.

To Emily herself Newcombe was much more encouraging, sympathizing strongly with a feeling for the native people that was so like his own. Probably he did not show her his report, for years later she remembered only praise; she said he had compared her paintings with photos of his own and offered "not a single correction."[4] One suggestion of his she did follow, with results that were not always fortunate, was the addition of human figures to her village scenes. Aside from that, he gave her all the support he could. He bought three paintings on his first visit, and afterward added many more. Perhaps because of his shyness, his friendship with her always kept a certain formality, and he was more of an adviser than a confidant. But she learned a great deal from him and gained confidence from his backing. Later his son William Arnold, who shared his father's interests and knowledge, became a friend who sustained Emily in one way or another throughout her life.

In April 1913 Emily gave a week-long exhibition of her native work, hiring Vancouver's Drummond Hall. There were nearly two hundred paintings, drawings and sketches, some dating back as far as 1899. To go with it she prepared a lecture, drawn partly from readings at the provincial museum library and partly from what Newcombe had told her, but mostly from her own experiences. With only she knew what agonies of nervousness—for she hated speaking in public—she delivered it twice, on 16 April and again two days later.

She began with the bookish parts—explanations of totemism, the clan system, the various kinds of poles—and then went on to personal reminiscence. She explained several of the pictures: *DSonoqua;* the carvings on two Kwakiutl housefronts; the legends surrounding three poles from the Skeena; a mortuary pole at Yan, crowned by a brilliant scarlet-

leafed shrub; a thunderbird with spread wings at Alert Bay cemetery; the graves at Hagwilget (which Emily, with an incorrigibly bad ear but a marvellously British sense for names, pronounced "Hagglegate"). She spoke of the fear and isolation of her nights at Gwayasdums and Chaatl, dramatizing her own courage and claiming she had spent "long days and sometimes nights in lonely villages with no other protection, than the worn teeth of my 13 year old dog." But though she played on the audience's sympathy for herself, she did no less for the native Indian. She talked about the friendliness behind the natives' reserve, their feeling for beauty, their sensitivity to ridicule, their honesty—all traits specifically denied them in the popular mind. Above all she spoke of dignity: the "solemn forsaken loneliness and dignity" of the abandoned villages; the dignity of the shrubbery-crowned tomb at Yan; the Kwakiutl portalled housefront, "so primitive so heathenish and withal so dignified"; the *"great dignity* [of] the Haida people."[5] If she overused the word, it was because no other described so well her feeling for what she had seen, or challenged so well the preconceptions of a white audience. For all her contempt for missionaries, she had become a kind of missionary herself, and she was trying to win converts.

She made two specific disclaimers that have recently been challenged. One concerns expenses: "What I have done I have done *alone* and *singlehanded.* I have been backed by neither companies nor individuals. I *have borne my own expenses* and done my own work." Tippett has discovered an item in a 1912 newspaper, the *Queen Charlotte Islander,* which says that Emily was "on the staff" of the Grand Trunk Pacific Railway. This may have meant that Emily accepted free transportation passes, but there is no hard evidence of this or any other transaction with the company.[6]

The second disclaimer concerns photographs: "I *never use the camera or work from photos;* every pole in my collection has been studied from its own actual reality, in its own original setting, and I have as you might term it been personally acquainted with every pole here shown." There is a wide difference of opinion on this point among recent scholars. (See Appendix 2.) From evidence so far available, it appears that Emily was not being entirely straight with her audience in this matter. The evidence is circumstantial, and the most damaging of it depends on facts not verifiable today. It is clear that the point was important to Emily, or she would not have made such an issue of it, even underlining it in the manuscript. Again we can see her caught in the contradictions of her work; on the one hand she was trying to convince people of the accuracy of her record, and on the other she was trying to win their respect for the artist's vision of the world. Any deference to the camera at this point would have been very damaging.

How successful the 1913 exhibition was is difficult to say. It received a

cordial review in the *Province,* though again the emphasis was on the works' value as historical record rather than art.[7] Judging from Emily's continuing distrust of the public, sales were probably disappointing. It was not easy to talk people out of their strong reservations about native art. They thought it gloomy and savage and queer. It was all very well to go and see it in an exhibition, but one didn't hang it on one's walls.

In any case, this was her last exhibition in Vancouver. She could no longer earn a living by teaching and sales, and she had decided to stop trying. She would move back to Victoria, paint as she wanted to and gain an income some other way. She had no new illusions about Victoria: it was still an "impossible field for work."[8] But it was home, after all, and it was the best place for a new scheme she had under way. Many people in Victoria lived quite comfortably by taking in roomers or boarders, and Emily had decided to build her own apartment house and become one of them.

Except for the fact that she began too late, it was a sound idea. Settlers were pouring into British Columbia, and in the past two or three years real estate speculators had been reaping overnight fortunes. Emily herself had made a profit from the sale of five lots she had bought in Vancouver. Meanwhile, in Victoria, the Carr estate had been much depleted, and in 1911 the sisters decided to sell some land. Unluckily their father had left it all tied up in legal restrictions, and it took a year to sort them out. By the summer of 1912, when they were actually ready to sell, real estate prices had begun to collapse. The Carrs sold some lots for what the market would bring, and the rest of the land was divided among them. Dede rented out the old house and built a cottage at 231 St. Andrew's Street, where the vegetable garden had once been. Lizzie lived with her, turning her lot into a magnificent garden. Alice built a combined house and school at 218 St. Andrew's, moving in the day after Christmas.[9] Emily's lot was at 646 Simcoe, around the corner from her sisters and a stone's throw from Beacon Hill Park.

She moved into her new house in June 1913, after many tedious months of delay. Preoccupied with her exhibition all that spring, she had entrusted the building to an architect, looking in herself only now and then. The architect took liberties with her plans ("mutilating" them, according to Emily)[10] and violated the city building code. The violations had to be fixed later, at considerable cost to Emily's pocketbook and temper. Even after she moved in she had to hire workmen to "make the place livable."[11] Typically, she blamed it all on the fact that the architect was English. She thought he "hated Canada and all her living."[12]

Once she was actually in possession Emily was pleased with the house, if only because it was indisputably her own. It made no concessions to the family tradition of gracious living, and the sight of it would not have warmed her father's heart. Squarish and plain, it huddled next to the

street behind a handkerchief-sized front garden. On the first floor were two four-room flats, each equipped with a fireplace, its own front and back doors, and a scrap of back yard. Originally Emily intended the whole upper floor for herself, and so optimistic was she about her financial prospects that she included a maid's room.[13] But at some point she saw that she would need additional rental income, and she converted half her flat into a tiny, self-contained apartment called the Doll's Flat. This was intended only for hand-picked tenants. The remaining upper rooms, plus an attic, were her own. Also hers was a deep, fenced back garden, planted with fruit trees, shrubs and old-fashioned perennials.

Her sisters were suspicious of both the house and the use Emily put it to. They themselves took in selected roomers, but only by-the-way, as ladies "in reduced circumstances" did. To set about it in cold blood, so to speak, and open one's house to all comers was quite another matter. Nevertheless they were glad to have Emily back on any terms, and she was glad to be there. She looked forward especially to mending the old bond with Alice, who was now the closest friend she had.

It was certainly time to come to rest somewhere. Emily was forty-two, and she allowed herself to hope that the worst upheavals in her life were past. The delicious quiet around her house stirred up half-forgotten childhood memories. She loved to sit at her casement window at night, facing the park, with Sally on her shoulder and Billie's warm bulk at her feet, listening to the familiar sounds of owls and croaking frogs, breathing the cool perfume of a Victoria spring. Between her house and the park, hidden by trees, the old Colonist Hotel stood empty. Soon to become a tea room, it had outlived its bawdy days and would disappear altogether in another decade. Emily may have gloated over it a little on behalf of her father. Almost everything else—the cow yard, the shrubbery, the mossy clearing where she had played "ladies"—was gone. The lily field had been sold, and from now on its fragrance would survive only in her imagination.

Dark Times

ALL THROUGH THE SUMMER and fall of 1913 Emily gave her full attention to her house, planting her garden—her own garden, at last—shopping for second-hand furniture for the flats, equipping them with pots and pans and dishes, visualizing them filled with contented families, proud of the small amenities she bought for them. She found time, too, to build a summer cottage on a lot she had bought in Oak Bay, on the coastal outskirts of the city. Reportedly she built it herself, with the help of a carpenter.[1] She may have intended it as a sketching retreat for herself (Edythe Hembroff-Schleicher, who discovered it, believes so), but in fact she had little time to use it, and it probably brought her a small added rental income.

By December the house was ready for tenants, and from then on she began to discover the real difficulty of what she had set out to do. For one thing, Victoria's ballooning economy settled heavily back to earth. Too many people had built too many apartment houses, and there simply were not enough tenants for them all. The air was thick with the fear of war. British investors were withdrawing their capital from Canada, there were nasty financial and political scandals, and the industries that had promised to draw many thousands of new settlers had begun to slump. Then, in August 1914, war struck. The young men who had come to make their fortunes in farming, mining, fishing and lumbering went to the front instead, leaving their families to struggle along on a soldier's wages. Property taxes rose, and soon the income from Emily's three rental flats barely equalled what she had hoped to make from one.

Landlords scrambled to attract what tenants were left, and Emily's inexperience was a handicap. She still looked younger than she was, though by now she was very heavy and wore her hair pulled up into a tight nubbin on the top of her head. But as with the Studio Club, the problem was not so much in her physical appearance as in her innocent, candid manner. She spoke softly and politely to prospective tenants—as

she habitually did to everyone, except when she was in a temper. She treated them as guests, and visibly shrank from the handling of money. As always, she expected people to recognize her essential vulnerability and respond in kind. There was no middle ground for Emily; there was either honesty or betrayal. Her tenants, with their prevarications, their petty demands and their shrewd bargaining for whatever they could get out of her, inevitably walked on the side of betrayal.

The cosy couples she had hoped for materialized as transients who resisted staying even the month she asked as minimum. Many were unattached women, driven by poverty to cavil over the least expense. Many were unattached men, avoiding military service. A fair number were shady characters of both sexes who were not above skipping out on their rent. Those who were married often brought their own furniture, and then Emily would have to scurry around to move hers out and store it on very short notice. Worst of all, her tenants could not pay enough to cover her expenses. So she filled the house to overflowing, taking people even into her own flat. For a while, beginning in summer 1917, she turned the entire upstairs into a ladies' boarding house, reserving only the attic bedroom for herself. The dining room became a bedroom and the studio a dining-sitting room. She cooked for the ladies and often for the downstairs tenants as well. (She says she became a good cook, but the opinions of her tenants on this point differ.) In the summers of 1917 and 1918 she gave over her whole flat to tenants and lived in a tent in the garden, cooking on a gas ring in the basement.

Meanwhile she tried all sorts of expedients to make ends meet. She sold fruit from her garden and tried breeding rabbits. She set up a brooder in the basement and raised baby chickens. Finally, following the example of native women she had seen up north, she began making hooked rugs from raw wool yarn and the remnants of old clothes, incorporating traditional designs. They found buyers more readily than her pictures did, and they kept alive her increasingly tenuous connection with her art. Painting during the war years became all but impossible for months and sometimes years at a time.

When tenants failed, she simply closed the house for the winter. According to a friend, she spent one winter at a summer cottage on McLoughlin Point in Esquimalt.[2] In the winter of 1916–17 she went to San Francisco, where she found a job painting ballroom decorations for the Hotel St. Francis. She did not work directly for the hotel, but for a couple who owned a handicrafts shop. They hired a storefront workshop in Chinatown, where Emily and a fellow artist spent their working hours. Twice a day Emily commuted by ferry to and from Oakland, where she lived in a women's boarding house. The work was exacting and tiresome, but she liked the boarding house, which was full of "bubbling young things," most of them students, who reminded her of the

fun and comradeship of her days at Mrs. Dodd's.[3] Another old memory suddenly returned one night when, stranded in the city without money for the ferry ride home, she found herself staring at a familiar name on a sign. Mayo Paddon, long since married, had moved to San Francisco, and now she was standing in front of his real estate office. She sent in a note, and presently he came hurrying out, looking a little flustered but very glad to see her. He produced the carfare, along with a teasing reminder that she really should have married him. But Emily was more thankful than ever that she hadn't. "He demanded more than I could have given him. He demanded *worship*. . . . He'd have found me a bitter mouthful and very indigestible and he would have bored me till my spirit died."[4]

In that same year, Billie died. Crossbred though he was, he was all sheepdog to Emily, and trying to fill the void he left she hit on the idea of raising Old English Bobtail Sheepdogs for sale. In 1917 she bought a purebred bitch named Loo, and after some further searching she found Punk, her first kennel sire. Their first litter was whelped in the basement, and later she added to her breeding stock and built a kennel at the bottom of the garden. The "Bobbies" were a saving joy, a never-failing source of humour and comfort during the third and longest dark period of her life. They were also the only one of her new enterprises that paid enough to make the effort worthwhile.

She kept the dogs carefully separate from her tenants, who accepted them with hardly any grumbling. But puppies needed a lot of care, and there were times when, like her old schoolteacher Mrs. Fraser, Emily gave them her full attention and let her tenants shift for themselves. If a bitch had more than six puppies (and they nearly always did), Emily saved the mother's strength by bottle-feeding the whole litter three times a day. Once she was "bottling" a total of thirty pups, all born in a week; it took three hours a day. She almost lost one litter through accidental poisoning, but nursed them all through by spooning milk and brandy down their throats. When a 1919 distemper epidemic carried off fifteen dogs, she watched them through delirium and convulsions, drowning the dying puppies one by one in a garden bucket, shaking with misery at what she was doing. When she ran out of garden space for graves, she put the bodies in the wicker perambulator she used as a shopping cart, wheeled them to the Dallas Road cliffs and threw them into the sea — adding yet another story to the fund of local tales that was gathering about her.

Meanwhile the house that she had hoped would be a liberation became a kind of prison. As the war dragged on she felt her old depression settling in again. Painting had been pushed to the very edge of her existence, and it was her morning romp in the park with the dogs that gave her strength to face the drudgery of each day. As in England and France,

she believed that her career was over; she thought she would be a land-lady all her days. It filled her with rage. Again she felt only "a dead lump . . . in my heart where my work had been."[5] There was no recurrence of the old paralysis: on the contrary, her energy was prodigious, as if it were fuelled by the very combustion of her anger. She flung herself into the fray each morning as if she would wrestle that wretched house— ten-ants, pipes, furnace, coalbin and all—into oblivion. But underneath was the same old feeling of deprivation and hopelessness. And again it was people—not the city this time, but particular human beings with their exasperating individual quirks and their even more exasperating sameness—who had thrust themselves between Emily and her art.

It was the anger of those years, undiminished by time, that gave ten-sion and bite to *The House of All Sorts,* written thirty years later. Humour was the strongest weapon in Emily's arsenal, though it was handier in retrospect than it ever had been at the time. Like most of her writing, *The House of All Sorts* is a funny book. People have chuckled over it for two generations, cheering Emily on and exulting when the meanest of her enemies get their just deserts. But there is a barely controlled savagery in Emily's caricatures of the worst of her tenants. Nowhere are her verbs more violent than in this book, and the vigorous metaphors— brilliant as a sketch by Daumier—often approach the grotesque. She is detached from the humanity of her subjects, describing them in imper-sonal images as animals, things, even points of geography. Here is a crying baby: "The infant's head, as it were, split in two—eyes, cheeks, brow retired, all became mouth, and out of the mouth poured a roar the equal of Niagara Falls."[6] And here the old woman she calls Grannie:

She seemed conscious of her upper half only, perhaps she used only a handmirror. Her leg half was pathetic and ignored. The scant petticoat came only to her knees, there was a little fence of crocheted lace around each knee. Black stockings hung in lengthwise folds around the splinters of legs that were stuck into her body and broke at right angles to make feet. Her face-skin was yellow and crinkled as the shell of an almond—the chin as pointed as an almond's tip.[7]

And a family inspecting a flat:

Both women flopped into easy chairs and lay back, putting their feet up on another chair; they began to press their shoulder-blades into the uphol-stery, hunting lumps or loose springs. Meanwhile their noses wriggled like rabbits, inflated nostrils spread to catch possible smells, eyes rolling from object to object critically. After resting, they went from one thing to another, tapping, punching; blankets got smelled, rugs turned over, cup-boards inspected, bureau drawers and mirrors tested.[8]

There was, of course, another side to her new vocation, for her tenants did come in "all sorts" and those she liked she remembers affectionately. Emily ran her apartment house for twenty-two years, and in that time, especially after the turmoil of the war subsided, there were many tenants who lived up to her early vision of peaceful communal living. There were newlyweds whose infectious happiness spread through the whole house, the nervous young father to whom she brought news of his first-born child, and the young wife downstairs whose friendship "sweetened the sour of landladying."[9] There were bachelors and lonely brides whom she more or less adopted for a while, and mild elderly ladies who would suddenly give notice rather than complain about another tenant. There were children neglected or shouted at or smacked by their parents, whom she comforted with milk, cookies and a tussle in the grass with the puppies. There were women married to brutal, stupid men, and men married to dull, peevish women, who all enlisted her quick and energetic sympathy.

But whether it was sympathy she felt or pure hatred, her emotional life was dominated by her tenants. She could not feel, in the midst of this continual tug-of-war, the detachment that would later transform it into art. Like her painting and her dogs, the house was an extension of her being. "It was mine," she says, "yet by paying rent others were entitled to share it and to make certain demands upon me and upon my things."[10] No matter how she reasoned against it, each tenant was a potential invader. "They had to be very careful not to offend her," the sister of one remembers. "She was very definite about things you weren't to do."[11] She was irritated when she heard tenants rearranging the furniture, sorely affronted when they rejected any of it, shamed when they complained of chipped china or ink stains on the carpet. She hated cleaning up after them when they left, finding their odds and ends in corners, scrubbing their dirty stoves, feeling alien personalities lingering in a place that had, temporarily anyway, reverted to being hers.

Added to all this were the particular indignities of being ordered about and the endless physical labour. She could not afford to hire a janitor, so she fed the furnace herself, rising before dawn each day and groping her way to the basement in the dark. She shovelled snow and mowed the lawn. She cleaned up dog messes and filled holes in the front garden until she got tired of it and banned tenants' dogs altogether. (Her own dogs were kept well out of the way.) She took phone messages, fixed blown fuses, worried over frozen pipes, washed and starched curtains, scoured pots, whitewashed walls and unplugged sinks. She listened, along with fellow sufferers in other flats, to hours of practising on pianos, violins and harmonicas. She took jellies and soups to the sick and mediated quarrels. She hounded rent dodgers and sometimes evicted them with the help of the police. She was cursed at and threatened with an axe. Once

she was physically struck (though she may have brought it on herself; more about that later). And there were other kinds of emotional strain: one tenant, a friend we know only as Ada, committed suicide, and another died of a terminal illness in Emily's flat. It is almost certainly this latter death that is described in the chapter "A Visitor" in *The House of All Sorts*.

Under the multiple load, all the worst of her temper flared up. "I know I hurt my tenants sometimes," she wrote. "I wanted to; they hurt me! It took a long time to grind me into the texture of a landlady, to level my temperament, to make it neither all up nor all down."[12] It did not take a long time; it never happened at all. She could be "very vindictive," according to one ex-tenant, particularly over the heat. (The fireplaces in the flats, intended to supplement the furnace heat, were all inefficient, and Emily replaced her own with a Franklin stove.) "She would turn the water off on you, you see, if she got annoyed," the tenant continues. Or she would "pull the fuses and turn the lights off."[13] A wash left hanging too long on the line would be yanked down and summarily delivered. She once drenched a tenant with a garden hose because (according to one version of the story) he had left his socks drying from a front window.[14] Once, as she herself remembered with satisfaction, she upended a bucket over the head of a woman who refused to pay her rent. It brightened up her whole day, even though it provoked Alice to that familiar refrain, "Oh Milly, I wish you had not."

Her book about those years, like all her writing, is best read as a record of feeling rather than a narrative of fact. It seems beyond belief, for example, that her tenants roused her at six or seven in the morning to demand scouring powder or fresh flowers, or that one of them woke her in the middle of the night because her dog was snoring.[15] In the case of one story, we can see the changes wrought through several reworkings. This is the story of the man who struck her, told in the published chapters "How Long" and "Loo" and the unpublished drafts "Fist" and "Struck." In one version Emily steps on his spectacles, in another she does not; in one she turns the hose on him (perhaps combining this episode with the one involving the socks), in another she does not; in one she has just left the deathbed of her sister Dede, in another her sister is not mentioned.[16] In all of them the man is a permanent resident, enraged because his bathroom tap is frozen. But according to Emily's friend and tenant Kate Mather, the man was a weekend transient whom Emily caught shovelling coal into the furnace. They quarrelled, and she pulled his glasses off and stepped on them. He, in turn, "just gave her a push . . . right over onto the coal heap."[17] The incident did not happen in 1919, when Dede died, but sometime after 1924. Emily has rearranged the facts to make her own aggression appear to be the defence of a help-

less woman against a boorish man, and to further ensure her reader's sympathy she has brought in a dying sister. Yet the seething indignation of the story, particularly in the unpublished versions, is unmistakably genuine. She has used fiction to explain a smouldering accumulation she badly needed to justify, perhaps to herself as much as anyone.

Woven through the stories are the recurring motifs of her private grievances and prejudices. Not since childhood had she lived on close terms with married couples. She minimizes her memory of her parents' marriage (they "died when I was young"),[18] and tries to show that marriages, like people, came in "all sorts"—good, bad and indifferent. On the whole her view of marriage became progressively more grim on the one hand and more idealized on the other, perhaps reflecting her own conflicting childhood memories. The idealized couples, like one young pair in the Doll's House, lived in a traditional, fairy-tale idyll: "She tidied the flat all day and he untidied it all night. He was such a big 'baby-man,' she a mother-girl who had to take care of him; she had always mothered a big family of brothers."[19] For too many of the others, marriage seemed to be a trap held together by habit, religion or economics. Where one partner dominated the other, she identified passionately with the victim, whether it was husband or wife, and thought herself well out of it.

The old conflict between respectability and rebellion, too, became more polarized. Openly contemptuous of her sisters' middle-class scruples, she was herself genteel to the bone: witness her rage over the airing socks, and her horror when she discovered once or twice that she had rented to "unmarrieds."[20] She resented being treated like a servant (though in later life she would prove a tyrannous and demanding employer), and her new identification with the underclass led her to idealize "humble people"—the butcher who sold her scraps for the dogs, a poor cowherd who bought a puppy, the black van-driver who delivered her coal. She liked their straightforwardness, and like the natives and French peasants they seemed free of "sham." She imagined herself one of them. "Gee! I's envy yous," she has the van-driver say in one of her excruciatingly bad bits of dialogue. When she asks him why, he answers, "Because you's kin paint. Seem dat what I want all de life of me."[21]

She wanted to tell him, but did not, that she could not paint either, or at least very little. First of all, she had no time; second—though by ordinary standards her energy was remarkable—she was too tired; third, it was almost impossible to buy paints during the war; fourth (and worst of all), she had no privacy. Even when her studio was not occupied by tenants, people were forever walking in on her. She had reached a point where she could, in fact, paint in the presence of people she knew and liked; but to work in front of strangers was unthinkable: "I was caught there at my easel; I felt exposed and embarrassed as if I had been dis-

covered in my bathtub!"[22] She would quickly huddle a dustcover over her canvas.

Immediately after moving to Victoria she held a studio exhibition. A respectable number of people came, including Dr. Newcombe, who bought eight or nine paintings. There was no review in the press beyond a society notice, which was usual for a private showing. In October she exhibited her work again, entering seventeen paintings—a large number for one artist—in the annual exhibition of the Island Arts and Crafts Society.

Organized in 1909, while Emily was in Vancouver, the Island Arts and Crafts Society provided the only regular art event in Victoria, and by its lights the city's artists sank or swam. The annual exhibition was one of the main social attractions of the year, opened with much fanfare by some important dignitary, usually the province's lieutenant governor. The whole affair would be written up in detail on the women's page of the *Colonist,* with due attention given to the content of the opening speeches and the names of the hostesses who served tea each afternoon. The rest of the article would be divided between the crafts and the fine arts. More than half the exhibits were crafts—needlework, bookbinding, knitting and crochetwork, jewellery and so forth—and it was not unusual for the press to give them priority over the paintings. Flanking the review might be a photo of one of the exhibition's presiding muses, a sturdy dowager in black with simple pearls.

The work exhibited was firmly tied to Victoria's taste. A few of the more daring artists painted in an impressionistic style, which was generally forgiven. The press was benignly democratic, mentioning as many artists as possible and trying to award an adjective to each: "delightful," "charming," "excellent," tumbled down the page like sugar plums. For an individual artist to receive more than a gentle hint of negative criticism was rare; just as in Vancouver the press clearly felt it was their mission to encourage all artistic endeavour. Even more rarely did any single artist receive more than a sentence or two. But both Victoria papers devoted a whole paragraph to Emily's first appearance in the show. The *Times* tried to sound a positive note, though their uncertainty shows through:

> A screen which attracted a great deal of comment among the collection of oil paintings was that on which a number of Miss Carr's decorative paintings appeared. The artist, whose work—of quite a different character, however—was well known here some years ago, has made a number of studies of Indian totems and carvings, which are highly decorative. A picture of a canal at Cressy en Brie and of a peasant's cottage are excellent in composition, while they show also the artist's post-impressionist style in its least aggressive form.[23]

The *Colonist* review was just plain negative, and it matches very closely Emily's memories of her early reviews:

> The pictures which will excite more comment in the exhibition than any other are those shown by Miss M. E. Carr. What is one to say of her work except that it is unlike anything that has ever been in Victoria before. The drawing is beyond reproach, the composition excellent; but the coloring is in a higher key than is vouchsafed to ordinary mortals to perceive. I doubt that even the most patriotic of Irishmen have [seen], even in the West of Ireland, grass as green as that in pictures of Alert Bay and Brittany. The blues and yellows and reds are just as blinding as the greens. One remembers the work of Miss Carr in former years when it was signalized by quiet, sombre tints and beautiful nuances of color, especially in her water-colors. It is to be hoped that this attack of neo or post impressionism will not produce the same effect on her color sense as one was told as a child the result of trying to squint had on the eye, which was to produce a permanent fixing of the eye in the squinting position.[24]

According to Emily, the sneering tone of the review was echoed by her fellow members of the Society, who were "angered into fierce denouncement" and "ridiculed [her] striving for bigness, depth."[25] Just what was said, and who said it, is impossible to confirm. Maria Tippett, who is generally skeptical of Emily's claims of rejection, points out that Emily had some influential supporters, including the daughters of former governor James Douglas and former senator John William Mac-Donald, and that these two women tried to persuade the provincial government to buy some of Emily's pictures.[26] It is significant that the government not only turned them down but never acquired any of Emily's work during her lifetime except for one painting that was presented as a gift.

From accounts of people who knew Emily, one has to conclude that she was right. She may have overreacted to one specific remark or another, but the general current of opposition was strong. "They belittled and ridiculed her," a friend who knew her in the 1920s remembers. "It was worse than just not appreciating her; people made fun of her. . . . She was way, way ahead of her time as far as this part of the country went. . . . The general attitude was that she was pretty queer and her work was queerer."[27] Flora Burns, daughter of one of Emily's few supporters, says her paintings "were just too powerful for Victoria. . . . [The Carrs] had a great many friends and a great many people went to see [her work], but they couldn't understand it, particularly her own family."[28] Another Victoria-born friend ties the resistance to Emily's art to her personal unpopularity: "I suppose if she had been merely strange and odd they would have ignored her, because there are many strange

and odd people in this city. . . . But she happened to be a little sarcastic, I suppose. . . . She offended quite a lot of people, quite a lot. And they didn't understand her work, or what she was trying to do."[29] As late as 1930, according to Victoria painter Max Maynard, it was very common "to damn Emily Carr outright. My brother . . . asserted that [she] had a diseased mind. Well, there were many others who said the same thing."[30]

She could have fought it out, doggedly exhibiting her work again and again until she more or less wore her neighbours down into grudging acceptance. That was the traditional thing to do, as her memories of France could confirm. But the threshold of criticism beyond which each artist can function is not to be judged by anyone but himself. For Emily, whose need for emotional support was unusually strong and always more or less starved, the odds finally became too great. Faced with the enormous physical challenge of simply earning a living, she lost faith—not so much in her art as in its ability to mean anything to anyone outside herself. She turned her back on the public and did not enter her paintings in a group show again for ten years.

Glimmerings

EMILY'S STUDIO AT Simcoe Street was her personal living space. It was a long, narrow room, not very large, cut up by five doors and as many windows. Plain white curtains were hung on rings, so they could be easily whisked open or closed. A skylight let in the north light, and there was a large, stone fireplace, later replaced by a stove. Near it was a sofa for visitors; if there were too many for the sofa, Emily would lower the chairs she kept suspended from the ceiling on pulleys. In an alcove enclosed by casement windows was a massive, leather-topped oak table that had once belonged to the provincial parliament. There she kept her rug frame and wool, a cage of chipmunks or birds, and various supplies. One end of the table was kept clear, and that was where the boarders ate. A huge, black box full of sketches and painting supplies set off the painting area beneath the skylight. Here were two homemade easels, the floor beneath them littered with charcoal and tubes of paint. Another sofa was here, too, a sturdy leather one she shared with the dogs. The general impression most people got was of mess and clutter, but the chaos was ordered, and Emily knew where everything was.

The walls were thick with paintings, "as close together as they could be; they were just like wallpaper."[1] This was pure practicality. The attic and basement were overflowing, and she had no other place to put her pictures. She did not like exposing them; boarders commented on them over dinner, and prospective tenants sized them up while they haggled over the rent. The pictures themselves accused her: "They were always whispering, 'Quit, quit this; come back to your own job!' "[2] And in spite of everything, in spite of her later claim that she did not paint at all for "about fifteen years,"[3] she did paint now and then, visiting Sophie for a day's sketching on the reserve or dashing off a small landscape in her old French style. But this was Sunday painting, a poor substitute for a life's work.

She did not disappear entirely from the public eye. Late in 1917 she

was hired to draw a series of cartoons for the *Western Woman's Weekly,* a feminist periodical devoted to suffrage issues and women's rights. There is no particular significance to this; Emily was still resolutely apolitical, and like her earlier series for *The Week,* these drawings reflect the editors' opinions rather than her own. The editors, for their part, clearly admired her as an example to other women, and it is one of the ironies of this period that they printed a generous article about her in November 1918, holding her up as a model of success while she herself was feeling utterly defeated.[4]

One of the few people who took an interest in her work during these years was the prominent Canadian ethnologist C. Marius Barbeau. Based in Ottawa and working for the Geological and Natural History Survey of Canada, Barbeau was conducting a study of the Gitksan Indians on the Skeena and made almost annual excursions to British Columbia for many years. In the summer of 1915 an interpreter told him of a woman who had visited the Skeena villages three years earlier. Curious, Barbeau asked Dr. Newcombe about her when he stopped in Victoria on his way home. Newcombe, who by now owned at least a dozen of Emily's paintings, answered as a scientist: "He did not seem to think very highly of Miss Carr's achievements," Barbeau later remembered. "He was more interested in the totem poles and carvings of the Indians than in their interpretation by an artist."[5] But Barbeau went to see Emily anyway.

Barbeau's accounts of his meetings with Emily have been questioned. Like many people trying late in life to recall early encounters with Emily, Barbeau's memory betrayed him in details. He said, in an interview recorded in his mid-seventies, that the visit took place in 1916 rather than 1915, and that Emily was making pottery at the time, though he could not have seen her making pottery until his third visit, in 1926. Such inconsistencies, along with indirect evidence from letters and the memories of two other people (also questioned many years later), have led Maria Tippett to conclude that Barbeau never met Carr before October 1926.[6] Like Edythe Hembroff-Schleicher, I prefer to take Barbeau at his word. He was evidently a warm-hearted man of solid integrity, though he could be absent-minded. There is, quite simply, no compelling reason to believe he would publicly tell a large lie, and when questioned about it tell it again.[7]

On this occasion, according to Barbeau:

> She showed me a great deal of her work. She was not herself very confident in its value, and she told me a long story of its being thrown back at her by the people of Victoria; and, in Vancouver, nobody wanted to touch it. She had already given up any hope of ever gaining success. She was a

failure, but she could manage a living otherwise. I then bought from her two canvases of the Tsimsyan Indians, and she gave me a third.[8]

The meeting was not greatly important to either of them then. Barbeau was only casually interested, and Emily was too busy to give him much time. But in January 1921 Barbeau, who by this time was one of the country's leading authorities on the Tsimshian, visited her again. This time he bought two or three hooked rugs. Emily's situation had not changed, and Barbeau decided to try to do something about it. Back in Ottawa, he tried to interest Eric Brown, director of the National Gallery, in Emily's work. But Brown, in the midst of moving the gallery to new quarters, was not in a receptive mood. The three paintings Barbeau had to show him were unprepossessing, and he brushed them aside.

In October of that year Brown received another plea on Emily's behalf, this time from H. Mortimer Lamb of Vancouver. Originally from Montreal, Lamb was a mining engineer, photographer and art collector. He wrote occasionally on art for various Canadian newspapers and for the respected English journal *International Studio*. A friend of many prominent eastern painters, including Homer Watson, Maurice Cullen, William Brymner and A.Y. Jackson, he had published *Studio* articles on Jackson and other members of the new generation of Canadian landscape painters. After he discovered Emily's work in 1921 he wanted to write about her as well. If he had, the whole course of her career might have changed. But he needed photographs, and Emily had none except some "exceedingly poor" snapshots. (Presumably Lamb could have taken some himself, but there would have been a problem with expenses.) The article was never written, though Lamb borrowed the snapshots anyway and wrote about Emily to both Jackson and Brown. The snapshots went to Brown, along with a strong plea for recognition of a western artist of "unusual power." Brown glanced at the photos, wrote a brief, evasive reply, and referred Lamb's letter to the "ethnological branch of the Geological Survey" (Lamb's words).[9] This was Barbeau's department, but he may not have been aware of the letter. In any case, both letter and snapshots disappeared, and nothing more was heard of them. Momentarily defeated, Lamb nevertheless remained a strong advocate for Emily's work. As for Emily, she thought no more about the incident except to harbour a grudge against him for not returning her snapshots.

The eastern art world went its own way for a few more years, and Emily went hers. The Danish writer Isak Dinesen, whose creative life was submerged like Emily's for many years, liked to tell the Danish children's story of the farmer who "saw the stork." Awakened in the middle of the night by a noise, the man blundered about in the dark for a long time trying to find its source, falling into ditches and stumbling over

rocks, until at last he found that the noise came from a breach in a dam. He mended the breach and went back to bed, exhausted. When he looked in the morning at the tracks made by his seemingly aimless meanderings, he saw that they formed a perfect outline of a stork.[10] Isak Dinesen thought her own life was like that: full of pointless pain and blind alleys, which in the end miraculously formed a pattern in which nothing had been lost or wasted. And finally Emily Carr would see her own kind of stork, transposed into eagle or raven or some other indubitably Canadian bird.

Meanwhile, living in Victoria did have its compensations. For one thing, loneliness was no longer a problem. Tallie no longer lived in the city, but the four unmarried sisters were a close family. They saw each other daily, exchanging meals, news and advice. The older ones still mothered Emily in their way, not with the hugs and praise she craved but with practical help. Emily's mortgage was held by Alice, who (on James Lawson's advice) had lent her sister $5,000 rather than investing it elsewhere. When Emily had trouble meeting the payments during the war, Alice extended the mortgage and reduced the interest. Lizzie paid $1,000 on it out of her own pocket, and the sale of the Oak Bay property in 1919 helped pay another $1,000. In 1923 Alice cancelled the remainder altogether. When Emily went away, her sisters looked after her animals. When she had a difficult and not very successful gall bladder operation in 1923, Lizzie moved in with her and stayed for several months.[11]

It was true that for Emily's sisters, having her home again was not an unmixed blessing. Quiet, undemonstrative women all, and still faithful members of the Church of Our Lord, they tried to live useful, inconspicuous lives. Yet Emily made the Carr name a synonym for eccentricity. The sight of her trundling her perambulator full of parcels through James Bay, surrounded by three or four shambling dogs, had become a standard neighbourhood diversion. The pram in itself was not unusual; people did use them to carry home firewood from the beach. But Emily used hers to fetch bones from the butcher for her dogs, and if there was a new litter of puppies she would put them in too. Children would hide behind the ornamental holly trees on Carr Street (now Government Street) and wait patiently for Emily's trip to the butcher so that they could trail behind and perhaps see the puppies. Altogether they made quite a procession. Sometimes Emily would speak to them, sometimes not. Later, as teenagers, they did not make so free, for she often looked "cross as the dickens."[12]

In her person, as in her house, she cared nothing for appearances, only thrift and comfort. She always dressed conservatively on special occasions, in black with gloves, hat and a cameo brooch. But her everyday clothes were homemade smocks, and for outdoors a shapeless wool coat and felt hat. On her feet she wore sturdy laced shoes, or (for walking the

dogs) a pair of old boots, cut down to size. Beginning probably in the early 1920s, she always wore a hairnet with a velvet band around the forehead, under which she tucked her greying hair. It was not unattractive but it was, to say the least, distinctive. Nobody knows why she wore it, but one suspects her hair became thin, possibly after her surgery in 1923.

In spite of not caring how she looked, she was as thin-skinned about ridicule here as she was about her art. She would come home at night after walking the dogs furious because people had laughed at her in the park.[13] Often her shyness was painfully obvious. One neighbour, then a child, remembers what an ordeal it was for Emily to deliver raspberries to the front door. Since the father in this household was a music teacher, Emily might be faced with a waiting room full of pupils and parents. She would thrust her raspberries at the child, whisper hoarsely, "Here are the raspberries. I want my bowl back," and then wait in misery while the child fetched her 50 cents. Released, with bowl in hand, she would almost run down the steps and out the gate.[14]

All this is not to deny that, when she was at ease, Emily was genial and conventionally well-mannered. (Her friend Edythe Hembroff-Schleicher particularly insists on this.) But she was never at ease on public display, and it was her public self that was talked about. It was directly contrary to the image of the elder Carrs, who were, and still are, known universally as "worthy women." They hardly knew how to deal with Emily's reputation. They had no answer to the rumours of her termagant temper, which they knew to be largely true. Lizzie's criticism was constant and vocal; though the others tried to keep silent, Emily felt their censure and gave it a voice of its own. She herself was short on tolerance, especially concerning Alice. She still wanted first claim on her sister's affection, and when Alice lived out as governess with the Hennell family in Oak Bay for about three years and formed close ties with the children, Emily was fiercely jealous.[15] Nevertheless, the fabric of love and loyalty among the Carrs was strong, and it withstood all such minor strains.

By now Alice and Lizzie were in their mid-fifties. Dede, in her sixties, was thin and ailing, and her hair had turned white. In 1916 she and Lizzie moved back into the old house, where Dede continued, as she had for some years, to give lessons in wood-carving, china-painting and jewellery-making. Lizzie had given up on missionary work and become a physiotherapist (in those days called a masseuse). After training at the Rest Haven Veterans Hospital at Sidney, she had built up a successful practice and was well known and liked. Alice, except for her sojourn as a governess, continued running her small private school. She had a gift with children, and many of her pupils were brought to her because they were "difficult" in some way. Some came from a considerable distance, boarding in her house or occasionally with Emily during the school year.

In 1919 the close family circle was broken by two losses. In January their sister Tallie, separated from her husband for several years, died. It was Dede who felt this most keenly, for she and Tallie had shared a childhood long before the other sisters came along. She herself was suffering from undiagnosed pains which may have been aggravated by her grief, and several months after Tallie's death she was told she had terminal cancer. Emily hurried to her when she heard the news, and under the habitual cloak of Carr reticence they made their final reconciliation. "I took [Dede's] hand," Emily writes, "and we both choked. 'Now then,' [Dede] said, 'we won't mention it again.' " And they didn't, except for Dede's request—gently out of keeping with all their past wranglings over dogs, crows and other creatures—that Emily find a home for her beloved pet goat.[16] She died peacefully on 11 December.

Now the family was reduced to three. Only their father, Emily reflected, had reached fourscore and ten. All five who were gone had approached death secretly and alone, leaving those who came afterward no choice but to do the same. "You could not look at the sick one and say 'You are dying, how do you feel about it?' My people had been good living people. It was understood that now that good living would stand them in good stead. Did it? I wanted badly to know."[17] She also wanted to know just what "good living" consisted of, and how far short of it, on some ultimate scale, her own life fell. But despite Lizzie's pleas, she would not let organized religion answer that question for her.

The remaining sisters drew even closer together, yet increasingly Emily began at last to form some intimate, enduring friendships outside the family. The first of these friends was a child.

In general, Emily's feelings about children were mixed. Her descriptions of them are unsentimental, to say the least: "He was most unattractive, a speckle-faced, slobbery, scowling infant. A yellow turkish-towelling bib under his chin did not add to his beauty. In the afternoon glare he looked like a sunset. He rammed a doubled-up fist into his mouth and began to gnaw and grumble."[18] Her tenants thought she hated children, for after several years of filling up holes dug in the yard and listening to roller skates on her floors, she turned away people with children when she could afford to. But once they were there, she was more lenient with them than with adults. Her old art students, Tallie's children (while they were young) and Alice's pupils all knew her as an affectionate, playful big sister, a matchless inventor of games and charades. If she never regretted spinsterhood, increasingly she missed the children she had never had. It was an idealized regret that might have failed the test of reality, but there it was. "Until people have been fathers and mothers," she once wrote, "they can hardly understand the full of life."[19]

Around 1922 Emily became friends with a twelve-year-old child, a summer pupil at Alice's school who probably boarded with Emily.

Carol Williams (later Pearson) had recently moved to British Columbia
from Ontario with her family. She has always dated her meeting with
Emily as 1917, but both Tippett and Hembroff-Schleicher have estab-
lished the probable later date.[20] Unfortunately, Pearson's published
account of her friendship with Emily is extremely unreliable, and there is
no one alive who can verify it. But whatever the specific facts, the emo-
tional tone she describes is true to life. Carol became Emily's almost-
daughter, her "Baboo": Emily was "Mom" to Carol, as indeed she was
to many of her younger friends. They shared the same love of animals
and the same kind of humour and fantasy. They played elaborate
pretend-games together and told one another tall tales. They saw one
another daily, and probably lived together on and off, until Carol
married and moved away in 1926.

Emily did not lack for adult company. She often gave tea parties in her
garden, and every day people dropped in, most of them tenants she had
grown fond of or neighbours she had known for years. For these visitors
she would drop whatever she was doing to talk about local happenings,
animals, the latest crisis among the tenants, or experiences among the na-
tives. She almost never talked about art, unless people showed an un-
mistakably genuine interest in her work: one of her close friends, Madge
Wolfenden, never realized that Emily's pictures were for sale, though she
had known Emily from childhood.[21] With friends her conversation was
like her writing: earthy but not coarse, animated, laced with sly wit. She
was grateful for their company, since she could hardly ever find time to
go out.

Unwelcome callers, on the other hand, would find the studio unac-
countably empty and retreat to hunt for her elsewhere, while Emily—
having whisked her heavy bulk upstairs with surprising speed—peered
down at them from the safety of her attic room. That room, in the south-
east corner of the house, unfinished, with splintery board walls and ceil-
ing, was her final refuge. She did not sleep there always, but she used it
when her own flat was crammed to capacity with tenants. On the slanted
ceiling above the bed she had painted two huge eagles, whose wings
spread from wall to wall. "I loved to lie close under these strong Indian
symbols. . . . They made 'strong talk' for me, as my Indian friends
would say."[22]

Underneath all these human comings and goings ran the steady cur-
rent of her love for her "creatures." From 1913 to 1937 her animal family
included varying numbers of dogs, several cats (the best-known being
the silver-Persian Adolphus), Sally and Jane, cages of budgerigars,
lovebirds and canaries bred for sale, chipmunks, a white rat, and an
incorrigibly mischievous Capuchin monkey called Woo. Of all Emily's
human friends, only Carol fully shared her love for animals. Alice and
Lizzie, fond of creatures in their own way, balked at the white rat but

generally tolerated the others and sometimes looked after them. Other people found the animals captivating, annoying, baffling or frightening, but they could not ignore them altogether. Two men who met Emily in the 1930s later recalled, separately, their uneasiness at seeing Susie, the rat, slither down Emily's neck and disappear inside the bosom of her dress.[23] A Victoria journalist once commented dramatically that "nobody understood" Emily's "frenzied devotion" to animals or her "strange affinity with them."[24] Her childhood friend Roberta (Wolfenden) Robertson recalled that Emily "became animal crazy and had monkeys. She had a little home then, she and Alice, and she'd be sitting and have these monkeys crawling all over her. I believe she slept with the monkeys."[25] Marius Barbeau, describing his first visit to her studio, said "the place looked spooky, full of cobwebs and animal pets. There were sheep-dogs, birds in and out of cages, a cockatoo named 'Sally' and what not!"[26] In fact there were no cobwebs, and Emily certainly never slept with even one monkey, let alone plural monkeys. People made of Emily's creatures what they would, often from highly personal associations: Roberta Robertson, for example, as a child had been terrorized by a monkey. In such recollections one can see the beginnings of a public myth that was quite distinct from the one Emily herself created.

One modern view holds that Emily's love for animals was chiefly a substitute for human relationships; in her loneliness she "turned to Indians and animals and convinced herself that she preferred them."[27] Among her own contemporaries there was no doubt some tongue-clucking sympathy for the poor, repressed spinster who had to nurture puppies instead of babies.

Emily understood very well that her animals fulfilled a basic, womanly need. She knew that through the dogs she expressed "motherliness, most nearly divine of all loves."[28] They allowed her to be compassionate, protective, patient—all the things she could not be in the flawed human world.

And, like her art, they gave her the illusion of omnipotence. "Mine! I shall be his God," she had said as a child when Mrs. Lewis gave her her first canary.[29] Now,

> Whenever the Bobbies heard my step on the long outside stair, every body electrified. Tongues drew in, ears squared, noses lifted. The peer from all the eyes under all the bangs of crimpy hair concentrated into one enormous "looking," riveted upon the turning of the stair where I would first show. When I came they trembled, they danced and leapt with joy, scarcely allowing me to squeeze through the gate, crowding me so that I had to bury my face in the crook of an arm to protect it from their ardent lickings, their adoring Bobtail devotion.[30]

The Bobbies assuaged her sense of powerlessness and offered her an unquestioning, reciprocal and ultimately superhuman love. Her stories about them, collected as *Bobtails,* were published in the same volume with *The House of All Sorts*. Taken together, the books describe Emily's two worlds, the one she was native to and the one where she felt like an exile. In cities and in the apartment house, humanity pressed in on her too closely. Animals took her home, to the mysterious, never-exhausted process of life itself. Through them she kept her art alive, simply because they replenished the idealism that was its source. Surrounded by daily evidence of human venality at uncomfortably close quarters, she saw in animals sentient beings who, however predatory they might be, were incapable of willful cruelty. Without them she might have either turned hopelessly misanthropic or made a peace of sorts with the world—grown up, in a word—and perhaps lost the dynamic, mystical communion with nature that made her paintings what they ultimately became.

She had no patience with the sentimental, anthropomorphizing kind of love many people feel for creatures. She once complained to her diary about a friend who, she said,

> has *the most* irritating repertoire of dog and cat stories—sentimental, mawkish, savoring not the least of the beasts, shoving them up into a human concept of life and missing all the blind animal instinct that is so refreshing in the beasts . . . into a foolish half human. . . . I wonder if I have ever bored folks that way about my creatures. The animals are so far above silly sentiment. It robs them of their dignity.[31]

Like *The House of All Sorts, Bobtails* helped her express her newly found identification with the working class. Unable to do her chosen work, she delighted in seeing that the dogs could do theirs. Nothing pleased her more than to watch a puppy herding hens, or to visit a dog she had sold and find it happily at work, caked with mud and smelling strongly of cow. She took a positive pride in the fact that many of her dogs, though purebred, were not registered. She says she yielded only once to the temptation to buy a dog sight unseen, solely for his pedigree. He turned out to be a neurotic, scraggly creature, a "near-fool." That, she thought, was a kind of judgement on her for "coveting registration."[32] She avoided giving her dogs aristocratic names like Prince or Duke, naming them instead after Hebrew patriarchs: Noah, Adam, David, Moses.

Considering how important the Bobbies were to Emily, one might imagine they were with her for years and years. In fact they were with her only from 1917 to mid-1921, though Adam stayed on after the others. By then the demand for farm dogs was declining, and she

switched to breeding tiny Belgian griffons, which were no less dear to her but less expensive to feed. She already had her foundation sire, Koko, who had been smuggled out of Belgium during the war.

In general, the heavy emotional and financial pressures on her began to ease around this time. Dede's will had provided for the sale of some additional land, with half the proceeds to go to Emily.[33] This added income, along with the Oak Bay sale, Lizzie's help and Alice's final cancellation of the mortgage, lifted a heavy burden from her. She was able to hire a part-time gardener-handyman, and she took some trips, including a six-week holiday in the Okanagan country (though unluckily she spent most of it laid up with the flu). The despairing, chaotic war years and their aftermath were behind her, and the decade ahead would bring the entire province a slow climb back to prosperity. Emily's apartment house would never bring her more than a bare subsistence, but the worst was past.

Creatures and Other Friends

IN OCTOBER 1924 Mrs. Kate Mather, a buyer for Canadian Pacific Railway gift shops in Banff, Victoria and the east, arrived in Victoria to spend the winter and enroll her son in school there. On the way, in the train, she had read a newspaper review of the current exhibition of the Island Arts and Crafts Society. The review

> mentioned a Miss Carr, of whom I had never heard at the time, as one of the exhibitors. It said that her usual atrocities had been exhibited but the people of Victoria weren't exactly persecuted by them because they had been hidden away where they wouldn't bother anybody very much. It meant nothing to me but I thought at the time, "I wouldn't be surprised if that isn't the only person out there that is doing real work, because it sounds like the sort of thing that you would expect." So I thought no more about it.[1]

A few days later, apartment-hunting near Beacon Hill Park, Mather spotted a sign in a Simcoe Street window and climbed the wooden stairway at the rear of the house, looking for the landlady. She knocked at the open door and entered a little vestibule filled with native baskets and cedar-bark mats. She knocked at the next doorway and went on into a hallway that was lined from floor to ceiling with oil paintings. Astonished, she went on more slowly, lingering over the paintings, until she rounded another corner and found herself in a long, narrow studio filled with still more paintings.

> Well, I was just speechless and just looking and looking when all of a sudden, out from nowhere came this person, I should say—that's about all you could call her at that time—dressed in a gunny sack, her hair all tied up with velvet ribbon, her arms akimbo. She just shrieked at me. She said, "How dare you walk into my house like this? What do you mean by walk-

ing into my house?" "Well," I said, "I was so interested in these pictures
and things that . . ." I said, "I'm awfully sorry. I really was looking for an
apartment." I said, "These pictures—where in the world do they come
from?" "Well," she said, "they're mine." "Well," I said, "I know, but
who did them?" She said, "Well, I did them." So then, of course, she told
me what her name was and I realized that this was this Miss Carr that I had
read about.[2]

When Emily had calmed down, and when she had satisfied herself that
the boy would be mostly at school and would be no trouble, mother and
son rented one of the downstairs flats. Kate Mather lived with Emily
only three winters (she spent summers in Banff), but while she was there
she came to know Emily fairly well. Trained in arts and crafts at the Pratt
Institute, she had travelled in Europe and knew something about paint-
ing, and her admiration of Emily's work was genuine, as was her sympa-
thetic indignation on Emily's behalf. An easterner at heart, she had (as
can be seen above) no very high opinion of the west's ability to ap-
preciate its own, and she believed that in Emily Carr Victoria had a far
greater treasure than it deserved. As a tenant, boarder and friend she
knew three sides of Emily: the pleasant hostess, every inch a Carr daugh-
ter, who presided over the communal dinner table; the harried landlady,
whose eye measured shrewdly the amount of butter one took with one's
bread; and the pent-up artist, who came to the Mather flat each night and
worked off some of the day's accumulation of rage in wickedly funny
impersonations of the same tenants she had helped to gravy and potatoes
an hour or so before.
 Mather has left us other brief, vivid glimpses of Emily in the 1920s:
Emily marching home from the poulterer's with a live, struggling goose
under each arm; Emily wrenching pickets from the garden fence to make
picture frames; Emily fixing a special chocolate-nut pudding for dessert,
only to have a nearsighted boarder mistake the nuts for lumps and pile
them all in a little heap on his plate; Emily nearly setting the house on fire
with her basement kiln, and serenely looking on while the firemen
demolished the kiln afterward: "She said, well, that was just fine because
the kiln hadn't been built properly in the first place anyway and she
wanted to build another one—it saved her the trouble of pulling it
apart."[3] (The next one, to the tenants' relief, was built in a shed in the
garden.)
 The kiln was yet another of Emily's money-making strategies. At
Kate Mather's urging, and using local red clay, she made small pottery
ornaments which she decorated with native designs. She felt rather guilty
about it since, unlike her rugs, the pottery did not carry on an established
native tradition. Yet the same people who would not buy a painting of a
Haida pole would venture a dollar or two for an ashtray with a thunder-

bird on it. Emily had no wheel, and her hand-modelled pieces were rather crude, but she sold some of them for as little as 50 cents, and the most elaborate were only about $5. She dug the clay herself from the coastal cliffs, with the help of Kate or Carol. They would haul it up the cliffside with a rope and bucket and wheel it home in the ever-useful perambulator. The kiln took three days to heat and cool; during the actual firing, which took twelve to fourteen hours, it had to be tended every two hours, day and night. The resulting pieces did find buyers. Kate sold some in her shop in Banff, though she could interest nobody in the paintings. A Vancouver gift shop carried the pottery, as did the shop at Victoria's Empress Hotel. Emily herself set up an exhibition case in her studio and held studio evenings for pottery as she once had for paintings—though often the profit barely covered the cost of the tea and cookies she served.

More lucrative, and immensely satisfying, was her new kennel. Emily's Belgian griffons weighed only about nine pounds apiece, and they followed her about like so many bewhiskered minnows dancing attendance on a whale. Old Koko and his ruddy-coated, scrappy son Ginger Pop were Emily's particular favourites. Among the dogs a flock of lesser animals, including Dolf the cat and Sally the cockatoo, were living out their appointed days. (Jane, the parrot, was growing vicious and would eventually be sold.) But the undisputed star of Emily's brood of animals was the monkey, Woo.

Sometime in the early twenties, probably in late 1923, Emily traded one of her griffon puppies for a half-grown Capuchin monkey. Although she felt sorry for the monkey, which was being bullied by its grown companions in a pet-shop cage, she was also exorcizing an old fear. Once, when Emily was nine or ten, the captive monkey that lived on the porch of the Colonist Hotel escaped at night, made its way into the Wolfenden home across the street from the Carrs, and severely bit one of the younger boys about the face. Emily had been very much afraid of monkeys after that, and for a long time she would not go into her father's field alone, for fear the monkey would be there. It was not until she was almost thirty and living in London that she found the courage to enter the monkey house at the zoo, and then she only went so that Mrs. Redden would not laugh at her.

So Woo was brought home, and, because it was winter and the monkey was a tropical animal, Emily made her a wardrobe of doll-size pinafores. Designing them was a challenge, for Woo instantly tore off buttons and hooks, and finally Emily fastened them with sturdy buckles. The dressed-up monkey became one of James Bay's best-known residents, part of Emily's travelling entourage. When she went out with Emily she was fastened with a light chain tied to Emily's belt; in the woods or park she was often chained to Koko instead, which led to pre-

dictable mayhem. (She is still part of the local Emily Carr mythology, often the first thing people remember. Emily's friend Frederick Brand, among others, has pointed out how often people insist that Woo rode around on Emily's shoulder, when in fact she never did.[4] It is somehow necessary to the popular image of Emily for people to *believe* that she did.)

Once installed, Woo became the studio despot. Dolf and Jane, for the sake of their tails, kept a wary distance. So did all the dogs except Koko, with whom Woo established a loving alliance. Emily was altogether captivated, and for Woo's sake she discovered hitherto untapped reserves of patience. The dogs' "spank stick" from the kindling pile rarely touched Woo, whose ingenious talent for destruction usually brought her no worse punishment than a scolding half-smothered in laughter. The cherry tree and its fruit belonged to Woo. So did a particular shed in the garden, where she happily "tore shingles off the roof, smashed her drinking cup through the window, undermined the foundations, ripped boards off the floor hunting for earwigs,"[5] and generally arranged things to suit herself. The shed was her summer quarters. In winter she slept in a cage in the basement. Only once did she manage to undo the latch, and the subsequent chaos—involving, among other things, several pots of geraniums, a barrel of eggs preserved in waterglass, a sack of lime, a box of nails, the contents of every bottle within reach, the ashes from the furnace, and the coalbin—is described in hilarious detail in *The Heart of a Peacock*. Even then, Emily forbore to scold. Woo, she thought, had had herself "one *good time.*"[6]

Still, there had to be some limits on Woo's freedom, and Emily bought her a leather collar and sometimes chained her to one corner of the studio, where the walls were stoutly covered with burlap to protect them from exploring hands. Later she had her own box high on the studio wall, with curtains she could draw at will. At mealtimes she was chained to the dining table, where she entertained herself and everyone else by filching tidbits from the boarders' plates. But generally she ran free, and the progress of her career over the years was marked by a trail of broken mirrors and overturned bottles of ink. Most of the property she destroyed was Emily's, and she never gave the tenants serious cause for complaint. Alice and Lizzie grew fond of her: Saturday-night bathtime for Alice's pupils was something of a circus thanks to Woo, and she cheered up many of Lizzie's more despondent patients. As for Emily herself, it was clear that part of Small lived inside Woo, so to speak, and took great pleasure in it. If Emily couldn't let go and smash crockery, Woo could. If Emily couldn't thumb her nose at the gentry, Woo could insult with impunity the aristocratic swans in the park.

In mid-decade, as Woo settled into her long and obstreperous reign, Emily's circle of friends began to change. In 1924 Dr. Newcombe died,

having caught a fatal chill on one of his excursions north. By 1927 Kate Mather and Carol Williams had both moved away, Kate to live in Toronto and Carol to marry Bill Pearson, an Ontario man. But meanwhile Emily had found permanent friends in three younger Victorians.

One was William Arnold (Willie) Newcombe, the middle of Dr. Newcombe's three sons. Willie is an enigmatic figure, and his friendship with Emily has to be seen in the light of his personal history. Born in 1884, he had been his father's companion and scientific heir, and though he lacked a university degree he had become a skilled anthropologist and biologist in his own right, working for a while for the provincial Fisheries Department. In 1928 his father's old friend Francis Kermode offered him a post as assistant biologist at the provincial museum. Kermode was short-handed and the museum collection was in disarray; Newcombe accepted on the condition that he be allowed to straighten it out. His independent style eventually led to a clash with Kermode, and early in 1933 Newcombe was fired. The official reason given was "economy," but a rumour was circulated that he had been pilfering from the collection. The charge was never made directly. Instead there was a series of petty accusations, including one that he invited a bird-watching club to the museum without permission.[7]

Keenly stung by the whole wretched affair, Newcombe scrupulously prepared a set of notes and memos in his own defence, which probably were never used. Afterward he withdrew alone to his family's house on Dallas Road and became a semirecluse. He kept up a lively scientific correspondence, saw his colleagues and even gave occasional lectures. Victoria, though, knew him only as a painfully shy, unkempt beachcomber with bushy hair and a floppy hat who did odd jobs around the neighbourhood, often without pay.

In these early years he helped Emily a great deal in carpentry and picture-framing out of friendship and good will; by the 1940s, when his help had become indispensable to her, she would insist on his sending her a bill. But their friendship was built of more substantial stuff than scrap lumber and nails. Emily respected Newcombe's knowledge of the Northwest natives, and he appreciated her work to the extent of collecting over two hundred drawings and paintings, many of them salvaged from discards after her death. Probably the strongest bond between them was a shared sense of injustice and a conviction that the world was no better than it ought to be.

Although Emily seemed sharp and bossy to Willie to outsiders (she fussed at him constantly, for example, for not sprucing himself up and buying a set of false teeth), he became one of the necessary people in her life, and she knew it. His serene temperament complemented her turbulent one and served as a kind of emotional ballast for upward of twenty years. "When that blessed Willie comes," she wrote in 1936,

it is as if he tipped the world so it caught more sunshine. It is not that he always does something kind or helpful, mends something broken or straights something crooked. It is not just that. He brings something so wholesome and comfortable. He is so alive and sympathetic. Dear old Willie, I wish he'd got a dear love of a wife and some youngsters of his own. He'd love them so. I'd want to see him get the splendidest woman on earth, not a selfish minx, because he gives so generously.[8]

Another new friend was Margaret Clay, daughter of the Presbyterian minister who had once been mysteriously summoned to the Carr house on April Fool's Day. Margaret had been a small child then; later she had gone to Alice's school, knowing Emily chiefly as the vivacious, inventive leader of games and dances at the annual Christmas party. Now she was a librarian at the Victoria Public Library, and she often chose books for Emily to read and brought them by when Emily herself could not go out. They talked about books, friendship, native people, animals and the woods. And they had some spirited discussions on women's rights, for Margaret Clay was a strongly independent young woman with feminist leanings, and now and then she tried to nudge Emily gently in the direction of the cause.

Those talks generally ended in a friendly stalemate, for Emily's feminist sympathies were still—and always—very much bound up with her art. She had always been acutely sensitive to slurs against her own creativity, or that of any woman. She felt the slightest prick of prejudice there and had learned to see it coming. She was proud of her independence, of having turned her back on marriage and of never (as far as she knew) having played the coquette. In her fifties she wore her excess flesh and dowdy clothes as a kind of badge of honour, a symbol of being beholden to no man.

On the whole, she liked women better than men. She thought that women—unmarried women, whose loyalties were not divided—were the best and most dependable of friends. But she remained too much a private person, too much locked into her own sense of grievance and too wary of the world at large to identify with any political movement. Besides, she was puzzled and put off by much of the new agitation for women's freedom. She clung to the old-fashioned domestic pieties, admiring women who took on the role of wife and mother and made a good job of it. She frowned on divorce. She regarded with a jaundiced eye (tinged with a bit of envy, for she had her vanities) the skimpy dresses, marcelled hair and rouged faces that proclaimed the sexual freedom of the young. Margaret Clay did not fit into that mould. She was a "nice" girl who lived at home and made her own way. In general Emily's view of younger women was influenced by her own historic

conflicts over sex. The new generation seemed too frivolous to deserve the freedom it demanded.

Margaret Clay became one of those stalwarts who would amply justify Emily's faith in the loyalty of women. Another was Flora Burns. Slight, dark and mild-mannered, Flora came from a distinguished Scottish pioneer family. She had grown up in a Dallas Road house built by Emily's brother-in-law, and as a child she attended church with the Carr sisters, though she knew Emily only by sight. When Emily moved to Victoria in 1913, Flora's mother, Mrs. Gavin H. Burns, was one of the earliest supporters of her paintings. She also became a personal friend. After she died in December 1924, her daughter and Emily were drawn together by mutual grief.

Flora had no formal knowledge of art, but like her mother she responded strongly to Emily's work and felt it had been slighted by Victoria. Emily appreciated her support but rarely discussed art with her. Nor—Flora being a very traditional kind of woman—were there any spirited debates on feminism. What the two really shared was an interest in writing. For some time Emily had been surreptitiously writing stories, telling no one about them and hiding them away as she had hidden the bad poetry she had written as a girl. Flora admitted to some tentative, unrealized literary ambitions of her own, and such revelations have a way of being returned. In the fall of 1926 Emily persuaded her friend to join her in a correspondence course in short fiction from the Los Angeles–based Palmer School of Authorship.

(Flora Burns always believed she was the first person to know about Emily's writing, but Carol Pearson says that Emily told her about it in 1926 and asked her to take the correspondence course. The sixteen-year-old Carol was about to move to Ontario, and it was Flora who took the course.[9] A family friend, M. E. Colman, who was not nearly as close to Emily as Flora or Carol, also remembers reading some of Emily's earliest sketches.[10] Emily often kept her friendships strictly segregated, and it was not unusual for each friend to feel exclusively favoured in some way.)

Beginning that fall, Emily and Flora regularly met over supper in Emily's studio, read their assignments to one another and exchanged criticisms. Emily kept on with the course through the spring. Flora dropped out eventually for lack of time. Looking back afterward, she had no great opinion of her own efforts, though in fact she did later become a free-lance writer. But she remembered, with characteristic generosity, that Emily's, "from the very beginning, were remarkable because she used her tremendous experiences of all kinds as material for her stories."[11]

Judging from the few surviving manuscripts, it was her native experi-

ences Emily drew on. Asked to write a descriptive paragraph for her first lesson, Emily wrote about the night she had spent at Gwayasdums, sitting alone by the window watching the mortuary trees creaking and swaying in the wind: she got quite carried away by the gothic gloom of it all and added a human skull illuminated by moonlight, apparently forgetting that she had begun by saying it was raining.[12] Later she progressed to writing fully constructed stories. One of them was "The Nineteenth Tombstone," eventually published in *Heart of a Peacock* as "In the Shadow of the Eagle." Another, never published, was about the friendship between a Vancouver shopkeeper and a native chief, and the shopkeeper's attempt to help the chief's wayward son.[13] Both these stories suffer from faults one might expect to find in Emily Carr's early writing: bad dialogue, sentimentality and a heavy-handed moral message. Both are concerned with the cultural confusion of the natives she knew, who belonged neither to the white world nor to the world of their fathers. Very probably, Emily could not yet feel comfortable with the exposure of writing autobiography, but she was already expressing, through her identification with native people, her childhood resentment at having the alien "civilization" of adulthood forced upon her. The theme of beleaguered innocence is the same throughout her writings, whether the protagonist is native, animal or Emily's heroically defiant, joyously sensuous four-year-old self.

In writing, as in art, Emily's creativity needed to be fed with constant, genuine, almost unqualified praise, and for many years it was Flora who provided it. While the writing course lasted, her encouragement was seconded by the school's associate editor, V. A. Hungerford. The story about the shopkeeper was "excellently handled," he wrote:

> I like your style of presentation which is clear-cut and direct, without useless verbiage. I believe you have a working knowledge of plot construction now, and that you are going, eventually, to write some good stories. It takes practice and patience and hard work and a stout heart, but the reward far more than repays for all this.[14]

But the support Emily got was never enough, and she went through agonies of doubt about her writing. For the first few years she kept her stories out of sight and privately revised them over and over again. Besides being unsure about their literary merit, she was acutely embarrassed by her spelling and punctuation, which had slipped back to elementary-school level. (That is one of the more fascinating minor details in Emily's creative history. It is as if Small, the consciously acknowledged muse of her old age, were emerging now, unrecognized, as a real and separate entity—for Small, of course, had hated every moment of school after Mrs. Fraser's.) Here again she turned to Flora, who

tidied up her manuscripts for her and, in the beginning at least, typed them as well. Later Emily bought a second-hand typewriter and learned (more or less) to type, though until the late 1930s Flora continued as sole copyeditor and chief critic.

She was also a frequent companion on Emily's sketching trips, after Carol left Victoria. The gentle, unobtrusive Flora could be trusted never to hover and peer, and if Emily wanted to go off sketching in the woods or at the Esquimalt reserve, Flora was quite willing to spend the day alone. There were many such trips in the 1920s, some lasting only a weekend and some much longer. Emily now had a maid, Pearl, who could look after the smaller animals, and Alice and Lizzie were always ready to fill in. Sometimes her holidays took her as far from the city as Sproat Lake, about one hundred miles north, where some friends owned a lodge, but usually she rented some tumbledown summer cottage close to home. Once she stayed in a houseboat, moored in the calm waters of the Gorge. Flora visited her there, and at sunset the pair went rowing in the houseboat's little square-nosed dinghy, with four griffons tucked into corners around them, while Woo leaned over the bow, dabbling her hands and kissing her own reflection in the water.

Clearly Emily was continuing to paint, though later, in her need to dramatize the hardships of these years, she would claim she had not. Flora too would recall that "Emily was doing no painting at all" when they met,[15] and at least one other person who knew her in this period has said she was not painting and was very depressed.[16] Yet Emily herself mentioned one painting holiday in a 1924 letter;[17] and in another, in 1927, she said that, from time to time, she had been trying to paint "in the despised adorable joyous modern way."[18]

In 1924 she broke her decade-long boycott of the Island Arts and Crafts show by sending eight paintings to their exhibition. She also entered four paintings in the 1924 Northwest Artists exhibition in Seattle, winning Second Honourable Mention in oil. The following year she showed again with both societies, and in 1926 she had an exhibit of about one hundred paintings in the art section of the Provincial Fair. This time the Victoria press gave her good notices, and the *Colonist* went so far as to say, with more good will than accuracy, that Emily's interpretations of native subjects had "already brought her well-deserved fame."[19]

There was good reason why Seattle suddenly became important to her work. A small group of new acquaintances from that city played a major role in her return to painting and exhibiting. One was Dr. Erna Gunther, a friend of Willie Newcombe's, head of the Anthropology Department at the University of Washington and an authority on Northwest natives. She stopped in to visit whenever she was in Victoria, three or four times a year, and though Emily later called her "noisy and self-opinionated and cocky whoop to busting,"[20] at the time she was a link with native people

and the world outside Victoria. Far more important, in terms of Emily's reviving career, was a group of young artists from Seattle who began to spend occasional weekends and holidays at 646 Simcoe Street in the early 1920s. They were friends of Dr. Gunther, but by a curious coincidence they discovered Emily and the House of All Sorts quite independently, while wandering around Victoria looking for a place to stay. Among them were Ambrose Patterson of the University of Washington, his wife Viola and the shy, peppery young Mark Tobey, who was teaching at Seattle's Cornish School. Emily would put them up in the rooms that had been the Doll's Flat. (Mrs. Patterson remembers those rooms as rather jerry-built affairs, with metal floors that resounded alarmingly underfoot. Emily, ever the vigilant landlady, would scold when Ambrose Patterson's feet shook the floor or when he forgot to turn off the light. She was much harder on men than on women when it came to these small transgressions.)[21]

The Seattle painters were all young, idealistic and full of sympathy for a gifted artist whose career seemed choked off by poverty and neglect. Themselves experimental as artists and open to change, they brought with them the fresh and heady air of possibility. They liked Emily, and though they thought her rather a quaint, old-fashioned little thing, they respected her work. In their casual way they included her in their circle, and if they saw her putting the house before her art, they teased and chided her and told her to chuck the dishes in the sink and get out and paint. Tobey especially took the lead in urging her to put her work first and encouraging her to exhibit. There were picnics in the park and long suppers in the studio, filled with talk about Paris (Ambrose Patterson had studied at the Colarossi) and the special challenge of the Northwest. It was Emily's first full immersion in the company of artists in many years, and it was the first time since Paris that she had glimpsed the international art scene. Their acceptance both shamed and pleased her; she felt abashed at her inactivity compared with their energy. So, with their encouragement, she tried her luck with the public again. She still had no great faith in its wisdom, and she would always distrust the press, even when it praised her, but from 1924 on she exhibited more or less regularly for the rest of her life.

Discovery

IN OTTAWA in 1926 Marius Barbeau, in collaboration with Eric Brown of the National Gallery, began to plan for an exhibition called "Canadian West Coast Art, Native and Modern," to be held the following year. It would be made up partly of native art and partly of paintings by white artists who had worked among the natives. Although Barbeau had not seen Emily in five years, he had not forgotten her. Her three paintings still hung on the walls of his home, and he wanted to see her included in the exhibition. As usual he spent that summer on the Skeena River, and in October he stopped in Vancouver to give a lecture series at the University of British Columbia. He had planned to run over to Victoria to see Emily while he was there, but he did not write to her first, and while he was in Vancouver he received the following curious note:

I had sent to me today a cutting from the Vancouver paper about the lectures you were giving at the University of B.C. I am wondering if you are coming to Victoria. I hope so very much as I would like to hear those lectures *immensely*. I am very interested in the Indians and have made a very large collection of paintings of their villages and totem poles going up North many years ago before they were taken away living among them and painting in their villages. If you do come to Victoria I would be very pleased if you would care to come to my home and see the collection it might be of interest to you would you phone me. My phone No is 2866R. and my house is only a few blocks from the CPR. wharf and the Empress hotel. Walk out Government Street south to Simcoe St 4 blocks turn left up Simcoe I am the last house on Simcoe and my studio upstairs. No of the house 646 Simcoe.

Hoping I shall have the pleasure of meeting you

Yours sincerely,
M. Emily Carr[1]

The note is odd because Emily is clearly addressing Barbeau as a stranger. Although it is dated only by month and day, it was almost certainly written in 1926, and it seems to support Maria Tippett's conclusion that Emily had never met Barbeau before that year. (See p.150, note 6.) Emily herself never mentioned meeting him earlier, but Emily had a way of willfully omitting people's names from her autobiographies, and it has been up to her biographers to restore them. Edythe Hembroff-Schleicher has suggested, plausibly, that Emily simply saw Barbeau's name in the paper without recognizing it.[2] She had a very bad memory for names, and it was even worse if they were not English. At any rate, he did go to see her, told her about the planned exhibition, and persuaded her to bring down a large number of paintings she had stored in the attic. He chose about sixty, from which he said a final selection would later be made. Then he went home and told Brown about her once again, and this time Brown listened.

It was not until almost a year later, in September 1927, that the final choice was made. Brown himself made it, visiting Emily in the course of a western lecture tour. His wife Maud, who was with him, has described the meeting. By implication she confirms Barbeau's earlier visit, though she does not mention the paintings he chose. (Very probably Emily had heard nothing more from him and had put them all away again. One can picture her puffing up and down the attic stairs, carrying a few at a time, muttering imprecations against people whose promises came to nothing.) Brown selected paintings from those already hanging on the walls. In his wife's words,

> As soon as we reached Victoria we made an appointment and paid her a visit. She showed us her hooked rugs and pottery with their excellent Indian designs but told us she had stopped painting because nobody understood her work. Fortunately there were plenty of her sketches hanging on the walls. These were so powerful and original that as soon as Eric saw them he assured her that they would be appreciated in the East. Before our visit was over plans were already under way to feature her pictures of Indian life in an exhibition of West-Coast art which the gallery was arranging.[3]

Brown asked her to send some rugs and pottery as well, assured her the shipping costs would be paid, and offered her a free railway pass if she wanted to come east for the opening. At first she refused, saying she could not leave her house and her dogs. But her sisters took over the house, a friend in Vancouver took in the dogs, and on 8 November Emily left for Toronto.

She was going to Toronto first, rather than Ottawa, because Brown had suggested she meet the Toronto-based group of landscape painters

called the Group of Seven. Embarrassed, she had had to confess that she had never heard of them. In that case, he said, she should read a new book about them, *A Canadian Art Movement* by Fred Housser. She bought the book, and in Vancouver she met one of the group, Frederick Varley, who had recently come west to teach at the School of Applied and Decorative Art. The meeting was cordial, though no real sparks were struck on either side. But Varley was impressed enough to wire ahead to his friends in Toronto, asking them to open their studios to the painter from Victoria.

The afternoon of the tenth found Emily crossing the Rockies, staring out her window at the soaring, silver-grey peaks, heavily mantled with autumn snow and flushed with a warm, declining light. She had not seen the mountains in sixteen years, and they moved her to a kind of reverie her younger self had rarely known. "I should like," she wrote in her journal, "when I am through with this body and my spirit released, to float up those wonderful mountain passes and ravines and feed on the silence and wonder—no fear, no bodily discomfort, just space and silence."[4]

Recorded in her journal too—and excised by the editors when it came to be published—were her half-tolerant, half-caustic appraisals of her fellow passengers: a bullying husband and his meek, religious wife; a German family with a wailing baby; a "lanky female" (one of that younger generation Emily had little use for) who spat grape seeds in the aisle and displayed her "undies" to the whole car; an "old pair of Johnnies" whose false teeth were not equal to the task of demolishing a whole chicken.[5] Emily's teeth were false, too, and she was rather smug about having sense enough not to make a spectacle of herself in public. Yet the food she had brought, peanut butter sandwiches and apples, seems only a little less treacherous than the food she was criticizing.

As the mountains fell behind, she turned to Housser's book and began to read about the Group of Seven. They could have had no better spokesman than Housser, who spiritually was one of them. A Whitman scholar, theosophist and personal friend of the group, he shared with them an aesthetic vision that owed much to nineteeth-century transcendentalism, modern mystical religion and a passionate Canadian nationalism. All of the group were familiar with the writings of Emerson, Thoreau and Whitman, and they saw that the challenge of artistic emancipation faced by their young country was much like that faced by America a century earlier. Like Emerson, the Group of Seven tried to free themselves of Old World tradition, or at least as much of it as would not survive a rigorous transplantation. Like him, they looked for a native art, tough and fresh and vital, growing naturally from the interaction of man and nature in the New World. Canadian art, they felt, would never thrive as long as European technique was imposed on Canadian subjects.

It had to be a living process, in which technique and style grew spontaneously from the artist's communion with his own landscape. For the Group of Seven, the only truly Canadian art was landscape painting. It was the physical presence of Canada, her shaggy forests and rough mountains, her brilliant foliage and clear air, that would shape Canadian art.

All of them went this far with Emerson. Several of the group and their friends went further, sharing his sense of landscape as a continuing revelation, instinct with divine life. The tendency towards mysticism was strongest in Lawren Harris, who like Housser was a keen theosophist. For Harris the whole visible universe was the living body of an inexpressibly beautiful and benevolent spiritual force. Among the other artists, Arthur Lismer too was interested in theosophy, while Frederick Varley held to his own individual brand of spiritualism. J. E. H. MacDonald was an authority on the American Transcendentalists and had named his son, Thoreau, after one of them. And it may not be irrelevant that Eric Brown, who consistently supported the Seven over the years at some risk to his own career, was a Christian Scientist.

Diverse as these persuasions were; they had in common a belief in the immanence of spirit. There was a feeling among the group that Canada was especially touched by God, or at least that here God's touch had not yet been dimmed by the heavier hand of man. Their painting expressed not only the visual beauty of the wilderness but their exhilaration at participating in it, discovering it, becoming part of it. In this respect the Group of Seven belonged to an existing Edenic tradition in North American painting. In feeling, though not in style, they were close to the Luminists and the less theatrical members of the Hudson River School. What they painted, and experienced, was a vision of Adam in the New World, a Garden rough and unpruned but essentially innocent, a fresh page in the battered book of Creation. And the same sense of privileged wonder was at the very heart of Emily Carr's love of art and Canada. As Emily read Housser's lyrical celebrations of the union of God, man and nature, she must have recognized, with growing excitement, her own deepest feelings clothed in another's words.

In their search for the very soul of Canada, the group had probed those corners of the wilderness they could reach, camping and painting together and freely sharing ideas and technical mastery. Like Emily, they made small, rapid sketches on the scene. Theirs were in oil on wood panels—concentrated masterpieces of vibrant colour that remain, quite apart from the studio canvases that were later painted from them, among the more remarkable treasures of Canadian art. In the early days, before the war, the group had mostly confined their travels to Algonquin Provincial Park and the area around Georgian Bay, though Harris and MacDonald had painted in Nova Scotia as well. After the war they had

ranged farther west, to the Algoma country and the northern shore of
Lake Superior. Still later some had reached the Rockies, and in 1926
A. Y. Jackson had visited the Skeena River with Barbeau. (But it was his
native province, Quebec, that brought out the best in Jackson. Already
something of a legend there, he was known as Père Raquette, from his
custom of travelling the rural back country on snowshoes with his paint-
ing gear strapped to his back.)

The Group of Seven had never been a formal organization, only a band
of like-minded painters, some of whom had drifted away over the years
as others had come in. There was a constant core of five: Harris, Mac-
Donald, Jackson, Lismer and Varley, who was himself, even now, be-
ginning to drift away. In 1927 the other two members were A. J. Casson
and Frank Carmichael. Their backgrounds were various; three were
British-born, none were westerners, and none had had as much formal
art training, in years, as Emily. Yet the philosophical kinship between
the group and Emily was remarkably close, and as she read about these
painters she had never met she felt her years of isolation melting away.
Others had shared with her those feelings of exaltation that had moved
her as the grand procession of the Rockies marched past her train
window. One can imagine the shock of recognition when she came
across passages like these:

> The North . . . demands the adapting of new materials to new methods.
> Brush skill and draftsmanship are not enough. A suitable soul-equipment
> and great powers of creative expression are essential. . . .
>
> This task demands a new type of artist; one who divests himself of the
> velvet coat and flowing tie of his caste, puts on the outfit of the bush-
> whacker and prospector; closes with his environment; paddles, portages
> and makes camp; sleeps in the out-of-doors under the stars; climbs moun-
> tains with his sketch box on his back. . . .
>
> For Canada to find a true racial expression of herself through art, a com-
> plete break with European traditions was necessary; a new type of art was
> required; a type of sufficient creative equipment to initiate a technique of
> its own through handling new materials with new methods; and what was
> required more than technique was a deep-rooted love of the country's nat-
> ural environment.[6]

On behalf of the group, Housser disowned the modern European tra-
dition: "Painting in Europe, since Cezanne, has become a business of
research and experiment. . . . Always in Europe, 'tradition,' that beauti-
fully powerful despot, gets into the saddle of the soul and curbs at least
for a time the freest spirits."[7]

Here Emily surely recognized her own distrust of "art jargon," her
largely unconscious resistance to Masters old and new, and her commit-

ment to the "silent Indian." She differed from the group in that she frankly acknowledged the debt she owed to the "new way of seeing" she had learned in France; but she joined them in a common need to transform and transcend the European experience.

Startlingly familiar, too, was the story of the group's struggle for recognition. Like Emily's, their early work (except for A. Y. Jackson's) had met with encouragement, and like her they had later met with a few scattered but virulent attacks—far nastier and more numerous, one must add, than anything she experienced. Like Emily, they reacted to hostility with a certain measure of contempt: in Peter Mellen's words, they "cultivated the image of themselves as valiant heroes overcoming the ignorant philistines." Like Emily too, they would afterward consistently misremember the dates and circumstances of the attacks, and "seemed to remember all the bad criticism and little of the good."[8] They too were extremely thin-skinned, given the amount of praise one can document now. But Mellen points out that the worst attacks may have been verbal, not written. That was certainly true of Emily. In both cases, no one except the artists themselves knew for certain how much abuse they were subjected to.

There were some significant differences between Emily and the Seven. For one thing, none of the group had had to go entirely outside the field of art to earn a living, and so none of them had had his faith in himself shaken as severely as hers had been. The fact that they were all males, and working in a more open and sophisticated climate for art, must have also helped to fortify their spirits. Strength led to strength: the Group of Seven had never given up on their public as Emily had. Quite the contrary. They had joined together in their own studio building, learned from one another, cheered one another on, and zealously defended one another in the press. They had exhibited together, too, though not formally until 1920, when they held the show that gave them their name. They had courted the public when it was friendly, argued with it when it was not, needled it when it seemed to be forgetting them altogether. Above all, they had not let it alone. Where Emily had turned away, the Seven had rallied. Where she had fled from attack, they had sometimes gone out of their way to provoke it.

Housser told the group's story with fervent sympathy and an instinct for high drama. The Group of Seven, he believed, would do for Canadian painting what the epic poets had done for the nations of Europe.[9] On the whole, his version of their fight for acceptance was too highly coloured. They had not, as he claimed, "set their conviction against the entire press of the country."[10] But they had set it against the Royal Canadian Academy, much of the art-buying public, and assorted powerful conservative critics, led by Hector Charlesworth of *Saturday Night*. By 1927 the worst attacks were over, at least those against the group itself.

But Eric Brown and the National Gallery, who had consistently supported the group over the years, would have the die-hard conservatives of the art world snapping at their heels as late as 1933.

Kate Mather was now living in Toronto, and when Emily reached the city on 13 November she went straight to her friend's home. Later in the day she checked in at the Tuxedo Hotel and met the members of the Women's Art Association, who would be her guides and hostesses. To her delight, one of them was Bess Housser, who was "wife of the book,"[11] a painter in her own right and art critic for the *Canadian Bookman*. On the following day, with Bess and another woman, Emily went to the Group of Seven's studio building on Severn Street to meet A. Y. Jackson.

Born in Montreal of Anglo-Canadian stock, Jackson had studied in Paris and painted in Brittany as Emily had, and his early post-French paintings were remarkably similar to hers. Selling them in Montreal had been uphill work, and in 1914 Jackson had come to Toronto to join the group that was forming around Harris and MacDonald. He had lived there ever since, but his ties to Quebec were strong, and it was his paintings of lonely Quebec farms, huddled under layers of subtly shadowed snow, that would say "A. Y." most strongly to coming generations of Canadians. Jackson was the most down-to-earth member of the group, a man's man and a lifelong bachelor. He left metaphysics to the others; he himself simply loved the outdoors and painted it as he saw it. He was an old friend of Mortimer Lamb and had been with Barbeau on the Skeena the previous year, so Emily's name was not unfamiliar to him. Now she sat in his studio amid a group of students, while Jackson brewed up tea and passed refreshments on the lids of cake tins. His canvases were scattered around the room. Emily's reactions, written afterward in her journal, show her making a generous, thoughtful and on the whole accurate comparison between his work and her own. She says she

> loved his things, particularly some snow things of Quebec and three canvases up Skeena River. I feel a little as if beaten at my own game. His Indian pictures have something mine lack—rhythm, poetry. Mine are so downright. But perhaps his haven't quite the love in them of the people and the country that mine have. How could they? He is not a Westerner and I took no liberties. I worked for history and cold fact. Next time I paint Indians I'm going off on a tangent tear.[12]

The next day she visited Arthur Lismer at his garden studio—"lanky, enthusiastic Lismer, good as any tonic."[13] The English-born Lismer had emigrated in 1911 and joined the early nucleus of the group. But his heart was in art education, and in 1919 he had become vice-principal of the Ontario College of Art. There his radical theories had brought him into

conflict with the conservative principal, George Reid. Recently he had resigned to become educational supervisor of the Art Gallery of Toronto, and from there he would go on, throughout a life of teaching and lecturing, to virtually revolutionize art education in Canadian schools. Emily was not the only person to find his buoyant idealism a "tonic." Like Harris, MacDonald and Varley he was a visionary, and Emily sensed immediately that he was "more poetical" than Jackson.[14] Because he gave so much time to teaching, he had few works to show her. But those were impressive, executed in the richly coloured, decorative and rhythmic style that was, in its several manifestations, a hallmark of the group. His two most recent canvases, especially, left Emily with "a feeling of exhilaration and joy."[15]

Shy, reticent J. E. H. MacDonald was, at forty-seven, the oldest member of the group. He too was dividing his time between painting and teaching, and Emily did not meet him when she visited his studio that Friday. She did meet his son Thoreau, himself a painter and very much his father's spiritual heir, "a boy all spirit, almost too fine to stay down on this earth."[16] Looking at MacDonald's work, Emily was again stirred to admiration, though as before it was not unqualified. She did not respond to these paintings as strongly as she had to the others, and she thought MacDonald's colours were sometimes "a little hot and heavy and earthy."[17] She wanted to see his work again, and being too shy to ask was glad to discover afterward that she had left her glasses behind. Unluckily Thoreau delivered them himself and spoiled her excuse.

Admiration, a kind of Rip-Van-Winkle bewilderment, self-doubt, chagrin at the thought of all the years she had spent overseeing a boarding house while these men were steadily working—all were part of the emotional turmoil of these Toronto days. Yet the people she met saw only a stout, self-deprecating little woman who spoke in a well-modulated, ladylike voice and seemed very unlikely, on the face of it, to produce work of originality and passion. None of them had seen her work, which was in Ottawa, but everywhere she went she was welcomed as an equal. Overwhelmed by all this attention, she was a little incredulous. She wondered if she really belonged in these distinguished ranks. For her own part, she felt an immediate kinship, as if she were among old friends between whom all the important things had long ago been said. Yet she felt too that her work was not quite up to theirs. She was "way behind them in drawing and in composition and rhythm and planes."[18] Above all, her work was too tame. The fidelity to fact that she had once been proud of now troubled her. She felt her work belonged more to the native Indian than to her. If these men felt something was lacking when they saw it, perhaps they were right—for the moment. She had a lot of catching up to do.

She could not help wondering, too, if Jackson and Lismer did not feel a bit condescending towards her as a woman. There had been no evidence of it that she could put her finger on, but all the same the suspicion lodged in her mind. At first glance, there seems little justification for it. The Group of Seven, like other liberals, were hospitable towards women in the arts. Although there were no women among the Seven, women would join their successor group, the Canadian Group of Painters. Meanwhile the Ontario Society of Artists and the Toronto Art Students' League had long welcomed women in their ranks, and there was a rising young group of women painters—among them Prudence Heward, Anne Savage, Pegi Nicol, Lilias Torrance Newton and Sarah Robertson—who were gaining critical recognition in the 1920s. On the other hand, these women were a new breed, and they were often regarded as talented amateurs.[19] Until recently the history of art in Canada, at least as perceived by historians, had been thoroughly male, and writers of the day tended to consign "women painters" to a separate category. Women were not admitted to full membership in the Royal Canadian Academy, and even in liberal circles there was an informal tradition of exclusion. The Arts and Letters Club, which had played a crucial role in the early history of the Group of Seven (as well as the Toronto Symphony and other cultural groups), was a private men's club. Grip, Ltd., the firm where most of the group had met and worked before the war, was *de facto* male. The outdoor aesthetic of the Seven, the communal experience from which their painting grew, was perforce a male experience. So the liberal convictions of these men went against the grain of their own personal tradition, not to mention the larger social tradition. And with the best will in the world on both their side and Emily's, she was right to perceive that to them she was an outsider, not only as a westerner but also as a woman.

So she vacillated between pleasure at what they said and defensiveness at what they might be thinking. Of all the group, only Lawren Harris welcomed her warmly enough to dispel her doubts. He told her what she wanted to hear: "You are one of us."[20] And, on balance, her meeting with him on 17 November was the most significant of her life.

Harris was the leader and chief catalyst of the group. A member of the prominent Massey family, he had never had to worry about money, and it was largely because of Harris and his friend Dr. James MacCallum that the studio building had been built. But it was Harris's remarkable personal qualities that meant most to the group. Energetic, boyishly ebullient (his speech was peppered with the innocent slang of the flapper era: "Golly!," "Swell!," "Gee Whiz!"), he had often carried the others along through the sheer momentum of his optimism. Yet those who knew him well knew that he fought his own private battles with despair, and that

his apparently unshakable serenity was rooted in his theosophical faith. For Harris the universe was a living organism, infused with spirit. Art stripped away the surface dross and made the spirit visible, so that the creation of a work of art was a sacramental act. In that respect he would have felt philosophically at home in the New England or the English Lake Country of a century before. But from the twentieth-century theosophical movement Harris drew an eastern belief in the progress of the soul through karma, and because of it he had a rare ability to put himself above time, without in the least abstracting himself from the present moment. There was nothing cold about Harris, but he took a cosmic view. As a person he had an extraordinary sense of balance. As a painter he saw nature in its simplest and most elemental forms: soaring, sharply sculpted peaks; massive piles of clouds; the dark, humped forms of islands, floating in a boundless expanse of sky and water that glowed with cool fire like irradiated ice. Above all, Harris painted light. It was characteristic of his canvases that they almost seemed to generate their own.

The two reproductions of Harris's work in Housser's book had not prepared Emily for the impact of these paintings, particularly the monumental *Above Lake Superior*. She was swept back to the sense of freedom and infinite peace she had felt among the mountains. Literally struck speechless, she sat

> like a dumbfounded fool. The woman who had taken me did the talking. He must have thought I was a fool. I could not help it. I had not any words. Neither in England, Paris, nor anywhere had any work touched me so deeply right to the very core. The whole idea of it was new to me. Not like Mr. Gibb's modern things had been strange and new. This newness was a revelation, a getting outside of oneself and finding a new self in a place you did not know existed; getting a glimpse in those pictures into the soul of Canada, away from the prettiness of England and the modernness of France, down into the vast, lovely soul of Canada, plumbing her depths, climbing her heights, floating in her spaces.[21]

When she left the studio she was exhausted and emotionally drained, and she spent a wakeful night, shaken intermittently by violent spells of weeping. She left for Ottawa three days later, determined to visit Harris again on her way back.

There was nothing transcendental about her trip to Ottawa, and her description of the local YWCA speaks for generations of hapless female travellers:

> The acid virgin behind the desk looked me up and down, decided she could give me a room and asked my business. It is clean, immaculately so,

but everything is plastered with "Don'ts," every wall and tap and door and radiator a "Don't do something" on it. There's a *public* wash room. I cleaned my [dentures] with four females looking on. There's no apparatus in my room only a glass that holds a teaspoon. The lights are fixed thoroughly uncomfortably at the door so you can't read in bed, nor sit close to the light. There is a roaring battle downstairs, some game playing I should say.[22]

She fled the next morning and found another room, and from then on she was enveloped in hospitality. Led by the Browns and the Barbeaus, the Ottawa art community "took her up," as the contemporary saying went, and invitations flooded in as fast as she could accept them. She listened to Marius Barbeau sing native Indian songs till midnight and had long, satisfying talks with the Browns on art, England, Paris and Canada. She saw Jackson and Lismer, who had also come to Ottawa, and she met several other leading painters—among them Nan Lawson (later Cheney), who would become a close friend in the 1930s. She watched the hanging of the exhibition, politely curbing her impulse to do it herself. ("Men," she fretted, "talk and squint and haggle so long over hanging.")[23] She designed the cover for the exhibition catalogue and gave a highly dramatic description of her travels among the natives and her previous neglect to a reporter for Toronto *Star Weekly*.[24] And whenever she had some time to spare she roamed the corridors of the National Museum, sketching from the native collection.

When the exhibition finally opened on 2 December, Emily was disappointed.[25] The crowd was small, she complained to her journal, in part because the invitations had been sent out too late. The rooms were "almost empty," the Browns were "a trifle too forced in their gay humour," and Barbeau's face was "set and hard." The whole thing was a "fizzle."[26]

She brooded sourly over the rejections in the basement, which included "four beautiful canvases" by other artists as well as "half of the things they had me send."[27] But she really had no cause for complaint. Besides her rugs and pottery, there were twenty-six of her oil paintings on the walls; no other artist was so generously represented.[28] People said "grand embarrassing things" about them, and though she answered modestly that she had only copied the work of the natives, now that she saw her paintings hanging among the others she felt they did have something the others lacked. She "knew the people and the places and . . . loved them more than people who had gone out west and given them a swift look over . . . who were really much better artists than I."[29]

The reviews in the Ottawa press were enthusiastic, and it is some measure of her nervousness and fear of failure that they seem not to have

touched her. "Canadian Art History to be Made in Ottawa," exulted the *Citizen* before the opening. "This is the first exhibition of its kind ever put on in the world." And of Emily,

> Emily Carr, of Victoria, B.C., has shown part of one of the most notable collections of Indian studies ever discovered in this country. She is a real discovery, for, although her work remained unnoticed for many years in her own province, it was heralded last summer by officials of the gallery of the National Museum as being the greatest contribution of all time to historic art of the Pacific slope.[30]

According to the same paper, the opening was a "splendid success . . . exceeding even the most sanguine expectations of those responsible." Emily's work was mentioned again: "Working for fifteen years or more without recognition as she has, it must be a source of keen gratification to her and everybody interested in the preservation of Indian art that she has at last been discovered and [her] work given the attention it deserves."[31]

After the opening Emily went to Montreal for an overnight visit, mostly to see the Group of Seven paintings in the Royal Canadian Academy show. While she was there she found time to have lunch with Flora's younger sister Patricia, meet three women painters—Anne Savage, Mabel May and Sarah Robertson—and visit the studio of Edwin Holgate, whose work was also in the Ottawa show and who had been with Jackson and Barbeau on the Skeena in 1926. From Montreal she journeyed to the little town of Kinmount, north of Toronto, where she spent three days with Carol and her husband, Bill Pearson. But she could not get Harris's paintings out of her mind, and she could not relax until she had seen them again. On 10 December she left Carol wondering at the scantiness of her visit and hurried back to Toronto.

Once she was there she found herself paralyzed by shyness. Asking Harris for still more of his time seemed an imposition; not asking him was out of the question. She spent a long Sunday morning battling with herself, feeling cross and generally out of sorts, before she finally summoned the courage to pick up the phone. He was as warmly cordial as before, and not only asked her to the studio on Tuesday but to supper that night. She went, and spent a memorable evening with Harris and his wife, whom Emily instantly liked. After supper, as if they were indeed old friends who could pay each other the high tribute of silence, Harris played a symphony recording on the gramophone while Emily sat quietly, bathed in music and in the radiant tranquillity of the paintings on the walls.

Two days later, on her fifty-sixth birthday, she went back to Harris's studio. Patiently he pulled out all his canvases once more, while Emily,

her shyness permanently overcome, unleashed all the questions and ex-
clamations that had been milling about in her mind. Mostly she wanted
to find the key to what lay behind those paintings. Harris helped her as
much as he could. He showed her some techniques he used to give more
vibrancy to his colours, and suggested that she jot down notes on a sub-
ject before she began to paint it. He gave her the titles of some books to
read, but warned her to "pitch them away and forget them" afterward.[32]
When she fretted that her work belonged more truly to native people
than to her, he answered, "Go ahead, find your own way to express your
own material."[33] But when he tried to explain the most important ele-
ment in his work, its theosophical base, Emily was only bewildered.
From what little she could understand, theosophy seemed arcane,
esoteric and probably anti-Christian. All the same, she thought she
should find out more about it.

When she left Toronto she was carrying two of the books he had men-
tioned, Clive Bell's *Art* and P. D. Ouspensky's *Tertium Organum*.
Presumably she had no trouble with Bell's classic discussion of
"significant form," though to Emily it may have seemed like just one
more example of art theory chasing its own tail. The other book, written
by a Russian theosophist and mathematician, was an impenetrable
treatise on the limitations of positivist thought and the need for cosmic
consciousness. Because it hinted at answers to the questions Harris had
raised, she struggled with it valiantly, and for the most part hopelessly,
during the journey home. But it was thrown into shadow by the
memory of Harris's paintings. That, she wrote, was "a never-failing
joy." She felt "as if a door had opened, a door into unknown tranquil
spaces."[34] Even after she had returned to the bustle of Christmas and the
clamour of tenants and pets, she had only to think of them and the petty
distractions of her life receded. She felt it was possible to breathe again,
and most of all to work. In a very real sense, then, Harris's paintings said
to her what he himself had tried, and probably failed, to tell her
in words.

North Again

THE CANADIAN WEST COAST ART exhibition opened in Toronto on 7 January 1928 and in Montreal on 17 February. Public interest was high in both cities, and Marius Barbeau gave an address on native Indian arts and traditions to an overflowing crowd at the Art Gallery of Toronto. Reviews were sparse, but the Toronto *Star Weekly* ran a major article on Emily, based on the interview she had given in November.[1]

Emily fretted over the lack of news and complained that nobody ever told her anything. Barbeau did his best to keep her mollified, sending photos and clippings and reassuring her of the keen interest on the street. "The people like your paintings greatly," he wrote two days after his lecture. "Several people have told me, including Lawren Harris himself, that this is the best exhibition they ever had in the Art Gallery of Toronto and it is a revelation to most people who don't know British Columbia and the West Coast."[2] Harris, whose first view of her work she had awaited with some trepidation, sent high praise. Her paintings were "impressive—more so than Lismer had led me to believe." He had no criticism to offer:

> I feel that you have found a way of your own wonderfully suited to the ex-
> pression of the Indian spirit and his feeling for life and nature. . . . The
> pictures are works of art in their own right, individual, finely plastic and
> having creative life in them. I have nothing to say—save this—don't be in-
> fluenced by anything or anybody. Shun everything but your own inner
> promptings, your own pure reactions—like the plague.[3]

A few days later Brown wrote to confirm the success of the Toronto show and to tell her he had framed ten of her watercolours and would hang them, along with two paintings from the West Coast show, in the Third Annual Exhibition of Canadian Art at the National Gallery later

that month. She was, he assured her, "at the very height of [her] powers," and with renewed public interest and recognition would go on to do "lovely things."[4] In March he sent word that the National Gallery had bought three of her watercolours at $75 apiece for their permanent collection. Emily was "fearfully excited," not only because of the prestige but because she was painting at full steam, buying "gallons of paint and lots of canvas."[5] And already she had plans in hand for an extended trip north that summer, which depended very much on the National Gallery purchase and other sales in the east.

Meanwhile her eastern success did not go unremarked in Victoria. As far back as September 1927, when Eric Brown chose her paintings for the West Coast Show, the *Colonist* had given her a front-page write-up under the headline, "Victoria Artist is Outstanding. Mr. Eric Brown, Director of Canadian National Gallery, Ottawa, praises Miss Carr's work." Brown had done his best to wake Victoria up about Emily Carr: "You have here in Victoria one of the most interesting painters in the whole of Canada. Miss Carr's work is quite extraordinarily good, as good as any that is being done in the country, and I am trying to arrange for her pictures to show in the National Gallery at Ottawa."[6] Some months later, while the show was in Montreal, there was another long article, "Victoria Artist Honored by Director of Canadian National Gallery," with statements by Brown and Barbeau on Emily's unique contribution to the exhibition. "Emily Carr," the *Colonist* writer concluded, "has placed Victoria on the map, artistically speaking."[7] For the time being, Emily was popular in her home town; but the deference to eastern opinion was conspicuous, and often Victoria's celebrations of Emily's fame would seem like the tail wagging the dog. A whiff of praise from Toronto, the States or London would always bring Emily predictable headlines in Victoria. She had a point when she remarked in 1933 that "people here don't like my work, it says nothing to them, but they like what is *said* about it in the East. In other words, they like the 'kick up' not *it*. That's the hurt."[8]

In Ottawa the tireless, ebullient Barbeau, out of sheer good will and his own strong belief in Emily's work, became a kind of self-appointed promotional agent. He himself bought the oil *Bear and Moon Totem* for $100, exchanging it for a smaller one he had bought previously. He persuaded his own institution, the National Museum, to buy a small oil and a friend to buy a watercolour, negotiated the sale of a rug and some pottery to another friend, and arranged for the sale of two more rugs and a large quantity of pottery to the Canadian Handicrafts Guild in Montreal. Other prospects—among them a sale to the Department of Indian Affairs and one to the prominent collector F. N. Southam—eventually fell through, but not for any lack of effort on Barbeau's part. In April his

novel *The Downfall of Temlaham* was published with a reproduction of *Bear and Moon Totem,* bringing Emily some wider exposure plus the small, standard fee of $25.

Meanwhile there were stirrings of interest in other corners of the art world. Inquiries came in from Edmonton, from Calgary (where a watercolour was sent and sold) and from the Women's Art Association in Toronto, whose projected solo show for Emily was given up because it would have competed with the West Coast show. There were requests for the West Coast show from two American galleries, one in Rochester and one in Buffalo, and while they did not pan out in the end they contributed to the general hubbub of optimism that made itself heard, mostly through the medium of Barbeau's letters, in Emily's Victoria studio.

Stimulated by all the encouraging reports, and especially by Harris's unqualified praise, Emily had once again put her work at the centre of her life. Having screened off her studio for more privacy, she rose at six every morning in order to have a few precious uninterrupted hours. She was delving into her 1912 sketches, painting with the concentrated energy of many lost years. "I really don't know half the time if I am here, or in the northern village, when I get working on those old sketches," she wrote to Brown.[9] By February she was already wondering how soon her watercolours would come home so she could use the material in them for canvases. And already she had made up her mind to go north that summer if she could afford it: "I just thirst to get back," she told Barbeau, "even if the poles are gone I want to get the feel of the places again."[10] Barbeau and Brown both responded with help. Brown obtained free CPR steamer and rail passes to Prince Rupert and the Skeena villages. Barbeau sent suggestions on where to find the best material and put Emily in touch with Walter E. Walker, manager of the Arrandale Cannery on the lower Nass. Walker invited her to stay at the cannery free of charge; her only expenses would be meals, at about 35 cents apiece.

So her summer plans took shape, while the spring went by in a flurry of hope and activity. The apartment house with its everlasting problems somehow became mere background; she barely seems to have noticed it. She was not only painting but preparing canvases (which she did entirely from scratch, beginning with making her own stretchers), hooking rugs and digging clay. In January she made three new rugs from designs she had found in the National Museum. In February and March she prepared three shipments of pottery: one for a new shop in Victoria, one for the National Gallery and a final, large joint shipment for the National Gallery and the Montreal Handicrafts Guild. That one took up three crates, and she was glad to see the last of it. By then she was feeling rather frayed

around the edges and, as she put it to Brown, "not at all up to the mark."[11]

This exhilarating, productive spring had had its rough spots, and Emily was weary in more ways than one. To begin with, she had been very worried about Alice, whose eyesight had begun to fail some time earlier. There had been some fear that she might lose it altogether, but in March it unaccountably improved and—for the time being, anyway—the spectre of blindness receded.

Then too, even the cheerful letters from Ottawa were a mixed blessing. They came in thick and fast from various harried and distracted correspondents, each of whom probably thought the others were keeping Emily better informed than he was. In general, Brown was concerned with exhibitions and Barbeau with sales, while H. O. McCurry, the secretary of the National Gallery, tried to keep up with the accounts. They all wrote to Emily separately, and inevitably bits of information fell through the cracks. It was not until late April, for example, that she learned that a casual reference by Barbeau in March to "a picture gallery in the west" had meant the sale of a picture to Calgary.[12] For a while she was not sure just when the West Coast show went to Montreal, how long it would stay, or whether her pottery had gone with it. There was a muddle over a rug she wanted to give the Browns, which she feared Barbeau had sold to someone else by mistake. She had understood that some of her work would be in the Group of Seven show in February, but had heard nothing about it by the time the show opened. (In fact none of her work was hung. Apparently Harris, who was going to choose something, found nothing he liked well enough among the paintings that were not already being exhibited.) And when Barbeau made his arrangement with the Handicrafts Guild, he did it in such an offhand way that Emily did not know which pieces had been sent, nor whether they had gone on consignment or been bought outright. The large shipment she sent to the guild via the National Gallery was held there for several weeks ("Barbeau wanted to keep [the pottery] to show to some people," Brown explained), while the guild manager in Montreal bombarded Emily with questions on their whereabouts.[13]

Barbeau kept referring to sales, but the proceeds were so slow in coming that Emily began to wonder if they were disappearing—not through any malfeasance, but through sheer confusion—into an indeterminate limbo somewhere above Ottawa. The result was a rather tart exchange with McCurry, in which Emily demanded to know just how things stood and McCurry (who had had to tend to many of the petty details of Emily's sales himself) reminded her icily that "a fair measure of appreciation and gratitude might go far to smooth out any seeming difficulties which at present appear to loom so large in your thought."[14] The quarrel

was patched up, but Emily never quite trusted McCurry afterward, though eventually he became director of the National Gallery.

Another sore point developed over her watercolours. She had sent twenty, and what with the Canadian Art exhibition and the hope of possible sales, they stayed in Ottawa for about five months. Emily wanted to work from them and fretted all spring for their return, but on the other hand she was happy to sell five, and would have been happier still to sell them all. When the remaining fifteen finally came home in April, eight had been stained by the waxed paper in which they had been packed. At first Emily shrugged it off: "You need not worry over it," she wrote to Brown, "I want them mostly to work from."[15] But one has to agree with Edythe Hembroff-Schleicher that Emily was "sly" in this instance.[16] The paintings had been insured, and Emily sent them back to Ottawa for the insurance company to ponder over. Meanwhile she did some pondering of her own and soon convinced herself that what was due her was the full sale value of the pictures. In October the company paid her $200. As Brown pointed out, the sum was not unfair under the circumstances. But Emily felt she had been cheated, and two years later she was still grumbling that she had received "a mere pittance on *six* and the rest were a dead loss."[17]

In the end, all these misunderstandings—and there were several more besides—paled in comparison with the invigoration Emily gained from her new eastern friendships. Nobody knew that better than Emily did, despite her testiness. Although she was irritable, and uncharacteristically shrewd over the insurance payment, it was because she was eager to expand her work into the new spaces that had suddenly opened before it. She fussed over money and badgered McCurry because the thought of having to give up her summer trip for the lack of a few dollars was unbearable. But by June there was no doubt that she could go: her eastern sales had so far brought her about $600, with another $100 to come, and thanks to Brown and Walker her main transportation costs and part of her board would be free. With the help of Barbeau and Willie Newcombe, she framed a two-month itinerary that would take her to Alert Bay, Fort Rupert and the surrounding Kwakiutl villages on Vancouver Island; then to the Skeena and Nass rivers and finally to the Queen Charlottes. William Halliday, the Indian agent at Alert Bay, sent information on the remaining material there, and her old friends William and Clara Russ wrote from the Queen Charlottes, inviting her to stay with them and offering guide service at $12 a day. On 27 June, having rented out her flat, Emily toted her gear and Ginger Pop's travelling box aboard a steamer, and set off.

According to two unpublished stories, she began by spending several days at Fort Rupert, on Vancouver Island's northeast coast. She writes of lodging at the village store with two sisters-in-law, one half-native and

one full-blooded (who would appear, slightly rearranged, as Jenny and Bessy in "The Hully-Up Paper"), and of spending long, drowsy days sketching on the pebbly beach, lulled by the cries of the birds and booming, sighing melody of the surf. An earlier generation of Victorians had known Fort Rupert as a "fierce, wild place." Now the only thing fierce about it was its herd of wild cattle, who came upon her one day as she lay sleeping in the sun on a grassy bluff. Ginger Pop broke into a fusillade of barks, and Emily woke to find a ring of long, wickedly curved horns surrounding her, a "fringe of danger between me and the sky." Native cattle were as wild as buffalo; the natives killed them by tracking them down and shooting them. They had no love for people, and still less for dogs. Ginger Pop, quivering with excitement, was ready to fight them all, and they probably would have obliged had not a boat, entering the bay just then, tooted its whistle and frightened them off into the bush. It was only later that Emily learned from the native women just how narrow her escape had been.[18] This time her fiery little dog, of whose spirit she was enormously proud, had almost brought disaster on them both. But she was no less proud of him for that. Of all her companion-dogs, Ginger Pop had the most individual character, and his particular blend of pugnaciousness and absurdity would captivate everyone she met on this trip and ease her past more than one awkward moment.

She soon moved on, and the first week in July found her on the mainland, travelling by rail up the Skeena River. She found the villages there much changed since 1912. Many of the poles had rotted away or gone to museums, and those in Kitwanga had suffered a particular kind of indignity. Kitwanga was now a routine stop on the CPR and a major tourist attraction, and the federal government and the railway had launched a joint project to "restore" the finest of the remaining poles. In 1912 they had stood where the natives had originally put them, facing the river. Now most of them had been cut down, coated with a protective layer of grey paint, painted with gaudy commercial colours on top of that and set on concrete bases in a neat row, with their faces towards the incoming trains. Jackson had been distressed when he saw them in 1926,[19] and Emily, writing to Brown in August, lamented the loss of the soft colours of weathered wood and vegetable dyes, all for the sake of the "beastly tourist."[20] Still, there were twenty-six poles (including houseposts) left in Kitwanga, and she found similar numbers, still in their original settings, at Kispiox and Kitsegukla. But the high point of her stay on the Skeena was her five-day excursion to Kitwancool.

Kitwancool was the northernmost village of the Gitksan. It lay on the Kitwancool River several miles from Kitwanga and was accessible only by a steep, narrow mountain trail, a trade route used by generations of natives. Emily had wanted to visit the village in 1912, but had been scared off by tales of the natives' violent hostility to intruders.[21] Even

now, in 1928, she was warned that they had recently threatened a party of surveyors with axes. But, urged on by her own curiosity and encouragement from Barbeau, she managed to persuade Chief Douse of Kitwancool, his son and two other men to take her to the village on their lumber wagon.

Her reception was cool, but not really hostile. A torrential storm lengthened her intended stay of two days to five, and after the first night she was given a place to stay in the lodge of the Douse family. Once she had been accepted by Mrs. Douse, who held the rank of chief in her own right, Emily was accorded the status of guest. Meanwhile, among the dogs, Ginger Pop made himself the village boss with some dispatch, while the suspicions of the natives melted into laughter. Emily sank thankfully into the easy rhythm of native life, which never failed to bring her back to some lost and precious corner of calm inside herself. "There was no rush, no scolding, no roughness in this household. When anyone was sleepy he slept; when they were hungry they ate; if they were sorry they cried, and if they were glad they sang."[22] All the same, there were some differences that could not be bridged: Mrs. Douse, though unfailingly kind, maintained the reserve befitting her rank; and Emily fenced off her corner with a tent fly for privacy and refused—as she always had—to partake of any native food, even when her own supplies dwindled to hardtack and raisins.

Rain had been her constant companion on the Skeena, and at Kitwancool it chased her into half-ruined grave houses and abandoned lodges, which she shared at least once with a herd of damp, jostling ponies. She had to take her views of the poles as she found them, through windows and chinks, and she could hardly do them justice. Still, she gave them the best she could, for these poles, which Barbeau thought the finest anywhere, were well worth any amount of trouble. Even though the carvings were clearly very old and in "shocking repair," Emily sensed an intimate, living connection between them and the faces she returned to every night. "They might have been family portraits," she wrote Brown, "and probably some were."[23] The resemblance was especially strong among the women, and many of the carved figures were mothers holding babies, their "big wooden hands . . . so full of tenderness they had to be distorted enormously in order to contain it all." Two of the poles belonged to Mrs. Douse, and Emily afterward made copies of her sketches of them as a gift. She kept as a lasting record of her visit her portrait of that stalwart, vigilant matriarch. "Womanhood," she wrote, "was strong in Kitwancool."[24]

Working in the Skeena country required all her ingenuity. The rain threatened to ruin her watercolours; when she tried working in oils instead, the wet pigments tended to smear. The worst discomfort, though, came from the mosquitoes, which had driven more than one Skeena visi-

tor to near-despair. Emily devised a sack to wear over her head, with a pane of glass inserted for her to see through. With that, plus two pairs of gloves and a pair of heavy canvas trousers, she managed to foil all but the most determined of them. But moving about in such a costume, let alone painting in it, was a challenge in itself.

Around the first week of July she left the Skeena and made her way via Prince Rupert to the Arrandale Cannery, at the mouth of the Nass. There Walter Walker and his family made her welcome, and true to his promise Walker gave her a cottage of her own. But daily tea with the Walkers was no substitute for sketching, and it was a week before the busy cannery could spare a man to take her up the river to Greenville. Lakalzap, the village at Greenville, had no poles, but it was within easy reach of two old villages, Gitiks and Angida. Here again, though, transportation was difficult. The only human beings in Greenville at this time of year were Lazarus Moody—an old man, one-eyed and half-crippled with lumbago —and his wife and small grandchild. It took Emily two or three days to persuade Lazarus to take her to the two villages in his rowboat. She had a day in each, or at least as much of a day as she needed, since the undergrowth had almost obliterated the poles. The rest of her week on the Nass was spent in Greenville.

It was not the experience she had come for, but it had its compensations. The first was the conquering of her own fear, which essentially meant getting past the limits of the plump, middle-aged, white Anglo-American female she usually was. That required a different kind of courage from the kind she had needed at Kitwancool. At Greenville she was alone, as she had been (essentially) at Gwayasdums many years before, and what she was afraid of was nothing in particular—only absence, vacancy, the suspicion that nature was a vacuum which evil rushed to fill. When she entered the deserted schoolhouse that was to be her quarters, the desolation of the place struck her almost like a physical blow. Not even a match could live in the stagnant air. In panic Emily left the place immediately to find the Moodys, who lived at the far end of the empty village, and postponed her meeting with whatever had reclaimed the building weeks before, when the schoolteacher's steps had faded down the path. Later, though, returning after dark, she had to make her peace with it, re-establishing a human presence there with small rituals: boiling the kettle, setting the clock, turning the calendar pages. The first night was long and wakeful, as she lay "in that smothering darkness . . . not knowing what was near me—what I might touch if I reached out a hand."[25]

The power of Emily Carr's art owes much to such experiences, and to the ambiguity which the native himself felt towards the potent, unpredictable natural forces surrounding him. The native joined them to himself, made of them spiritual allies, and celebrated his union with them in

his art. He did not flee them or defy them, nor did he diminish his awe of them by sentimentalizing them. Instead he made of them an extension of his own humanity. Fear exists in native art as one component among many, including sheer aesthetic joy, reverence and the pride of belonging in such company—of belonging, if you will, to the gods. Many North American whites have known the native well enough to plumb these depths with him, but few, perhaps none except Emily Carr, have brought them to full artistic expression.

In the paintings of the next few years Emily's interpretation of the dialogue between forest and totem deepened and darkened. She was able to realize on canvas the emotional tension she had felt many times over the years, at places like Greenville and Gwayasdums. In major canvases like *Totem and Forest* and *Big Raven* the central subject and the forest assume an almost palpable weight and mass. The heaviness of the forms, the depth of the shadow and the brooding solemnity of the totems can be felt as oppressive, and many people, especially in Emily's own time, have found her work disturbing, sinister, full of foreboding. In paintings like *Strangled by Growth* and *Guyasdoms D'Sonoqua* the menace is plain and open. But in general, fear is not a dominant theme in her work. It is the white, urban viewer—feeling, as Emily did at Greenville, that moment of utter vulnerability in the face of whatever dark forces man has held at bay with myth and song and icon—it is that white viewer who has magnified the feeling of supernatural threat, sometimes until he can see little else.

Although fear was not an overriding theme in her art, Emily did believe it was a necessary element. She could not achieve a full realization of the vitality of the western forest without confronting death and the dread of death. Ever since her early trip to Ucluelet, she had worked under a vague sense of being constantly watched from the forest by something indefinably hostile, and she had come to accept and even welcome it. Without it her work, lacking tension and complexity, would have lost its unique power. "You have got to go out and wrestle with the elements, with all your senses alert," she would write a few months after this trip. "You have got to hold your nose against the smell of rotten fish, and you've got to have the 'creeps.' "[26] Much of the strength of her mature native paintings lies in their ambiguity, in the balance between terror and affirmation, between the malevolence of a DSonoqua and the titanic gentleness of the totem mothers at Kitwancool.

So what Greenville gave her, finally, was not so much fresh material for her painting (for even the poles at Angida and Gitiks were so hedged about with nettles, salal and bracken that she only saw parts of them), but simply the chance to personally conquer fear once again, emerge once again on the other side and rediscover the quiet, inexhaustible vitality that lay beyond it. The desolation of Greenville was an illusion.

The village was not empty; it was filled with the sheen and murmur of the river, the rank fragrance of gold-green skunk cabbages, the cries of eagles, the shadows of clouds and, of course, the insistent serenade of hungry mosquitoes. Emily compared mosquito armour with Mrs. Moody, or laughed with her over Ginger Pop's absurd abbreviation of a nose. They had no common language, but by now Emily was well practised in her all-purpose, international pantomime. Between visits she sketched in the village or looked in on Lazarus's boat shed, where he worked in a haze of smoke to fend off mosquitoes. A half-dozen starved, abandoned dogs, who had greeted Emily with snarls when she arrived, now followed her everywhere and suffered her to pull festering porcupine quills from their noses. At night, or when the weather was impossible, they waited patiently outside her door as a sort of honour guard. Then the schoolteacher's room would become a studio, where Emily worked by lamplight while Ginger Pop snored near the stove and a neighbouring squirrel scampered and munched in the woodshed.

Greenville marked the end of the mainland portion of Emily's trip. By early August, after a stopover in Prince Rupert to overhaul her gear, she was staying with the Russes in their new, modern house in Skidegate. They made her very welcome, and even though the weather was still wet and gloomy she managed to sketch in Alliford Bay and on Maude Island and "did quite a bit."[27] But reaching the outlying villages of Skedans, Cumshewa and Tanoo was very difficult. William Russ could not spare the time to take her as he had promised, and it was some time before she found a man who agreed to take her on a four-day tour for a flat fee of $50.

It was dawn when she and Ginger Pop climbed aboard the man's fishing boat to set off. Her guide and his young son and daughter were there to meet her. Emily had high expectations of this trip. She expected to do her best work in the three villages, which had slept almost undisturbed through the sixteen years since she had seen them. But the summer's pattern of accidents and disappointments was still with her. The morning mist thickened to rain, and the wind and seas rose steadily. The party reached Skedans safely, and Emily went ashore and even managed to do some sketching. But Skedans was a bad harbour in a storm. The boat, moored far out, began to drag its anchor. By the end of the afternoon Emily's guide had narrowly escaped being drowned and the helplessly drifting boat, with Ginger Pop aboard, was almost driven onto the rocks. Luckily a seiner happened by at dusk, and its Norwegian crew rescued the party and towed the boat to Cumshewa Inlet. There Emily was transferred to a Japanese fishing boat and later to a moored Canadian scow. She had been violently seasick, but thanks to the sequential gallantry of all three captains and crews she had had berths to rest in and warm food when she could face it. By the next day, with Ginger Pop

safely restored to her, she felt well enough to do a little sketching ashore at Cumshewa. She did some more at South Bay, where she was taken that night and where she remained until she went home. As far as sketching was concerned, her $50 had bought very little.[28]

But, as before, she was remarkably cheerful about her assorted mishaps. Writing to Brown on 11 August, she was not really downcast, only rueful:

> I had $50.00 worth of experiences but oh I *did want my work.* Travel round these Islands really is terrific. Well I should be thankful I have my life, for [if] the engine had gone bad before we got to land in that awful sea we'd have all been lost. And in spite of everything I have quite a bunch of work to keep me busy this winter from my sketches.[29]

She had, in fact, thirty large watercolours, a goodly number of notes, and some oils which, though smeared, would be useful as source material. But most of what she took away from this trip was intangible. Her rich memories of people—the Douses, Lazarus Moody and his wife, the Russes and Clara's sturdy, redoubtable old mother, Mrs. Brown—would slowly ripen in her mind until they re-emerged in the stories of *Klee Wyck.* So would the "feel" of the places, not only their physical details but the emotional climate of each. And finally, there was the adventure of it all, and the pride of having come through it in high fettle. More than once over the last winter she had wondered if her strength would be equal to the demands of her rejuvenated career. She was fifty-six, and far too heavy; she did not (as she often reminded herself) come from a long-lived family. But now, far from being depleted by her two months of knocking about, she felt reinvigorated and eager to work. On 16 August she went home to get on with it.

New Growth

IN 1957 THE AMERICAN painter Mark Tobey, speaking to a reporter from the Victoria *Times,* proclaimed flatly that "there would have been no Emily Carr if it hadn't been for me." When he first met her in the early 1920s, he remembered, he had been struck by the spectacle of this "greatly gifted woman," frittering her time away on ashtrays and suchlike. (That was true enough, and Tobey had been one of the Seattle group who tried to get her to set her priorities straight.) She had become his pupil, and he had undertaken to teach her the principles and concept of form, which she came to accept only "after a great struggle." Never a man to make light of his own accomplishments, Tobey was convinced that he had singlehandedly transformed an artsy-craftsy landlady into a great painter: "It simply is not possible that a woman living her circumscribed life, could have developed as she did, to conceive the great swirling canvases, the wonderful tree forms, unless there had been someone to indicate the way for her: I was that someone."[1] He wrote much the same thing, at almost the same time, to Donald Buchanan of the National Gallery.[2] Among the handful of people who claim a major role in the making of Emily Carr or have had that claim made for them, nobody else is anywhere near so brash and self-congratulatory as this.

With the help of Ina D. D. Uhthoff, an energetic Scottish-born artist new to Victoria, and George Napier, who was a student of Emily's, Emily arranged to have Tobey teach a master class in her studio. He came to Victoria in September 1928, two or three weeks after Emily returned from the Queen Charlottes. According to Maria Tippett, he used Ina Uhthoff's studio as well.[3] Emily said later she invited him to come because he was "out on his uppers"; Tobey claimed he came to help Emily out.[4] In any case, Emily worked under him for three weeks and sent a glowing account to Brown: "I think [Tobey] is one of the best teachers I know of," she wrote. "I felt I got a tremendous lot of help

from his criticisms. He was very keen on my summers work, and his crits. I feel will be very useful in the working out of many problems connected with my summers work, which I hope to do this winter."[5]

During the weeks he worked with Emily, Tobey did contribute much to a remarkable evolution in her style. But, as Doris Shadbolt suggests, the change was already under way.[6] Tobey's criticism accelerated it and gave it focus. In the watercolours Emily painted in the north she had begun to move towards a bolder, more simplified, deeply sculptural style. The change was still tentative; it was not yet the "tangent tear" she had promised herself in the east. But it owed a great deal to the work she had seen there, especially Harris's. Her life was no longer "circumscribed," though it may have seemed that way to Tobey. She was struggling hard to break free of an old style that had become too confining, and Tobey appeared precisely when she needed someone to reach out a hand and give a hefty pull.

All this is not to take away from Tobey's very considerable gifts. In his seven years at the Cornish School he had earned a reputation as a dynamic teacher. He himself had had very little formal art education, and like Emily he had a towering contempt for educational dogma. "The imagination can be murdered without sentence; done away with while learning to embalm," he once wrote. "The walls are hung with painted corpses. . . . Why don't art schools have classes on how to remain aware?"[7] There were other strong ties between them: Tobey admired and collected native art, and like Emily he detested cities. A follower of Baha'i, he was something of a mystic, though unlike Emily and Lawren Harris he put mankind, not nature, at the centre of his faith and art. And temperamentally Emily and Tobey were much alike, shy on the surface and underneath volatile, humorous, hot-tempered and stubborn. They fought, and one can well believe that Emily had a "great struggle" accepting a radical new point of view from this cocky, red-haired American male nineteen years her junior.

Tobey's claim to have been the "someone" in Emily's career rests on the slim foundation of the 1928 master class and scattered earlier visits. After 1928 he and Emily kept in touch, but he apparently did not visit her in 1929. In the summer of 1930 he spent three weeks in her studio while she was away on a trip, and when she returned she was annoyed to find he had made free with her painting supplies without her permission. She visited Seattle in November of that year, and a few weeks later the friendship fell apart. Emily asked Tobey to come to Victoria and give her a criticism, and she even sent him $5 towards the trip. Tobey waited three weeks to answer, and then he sent some lame excuses (without, apparently, returning her $5). Emily fired off a curt note in reply, saying she had a guest coming and cancelling the invitation. She was furious with him, but her fury was mostly channelled into her journal.[8] Tobey

moved to England a few months later, possibly without ever realizing the full depth of his transgression.

By the time the rift came, Emily really had little need of Tobey's tutoring. She had worked through the problems that had baffled her in 1928, and was far more secure that she had been then. Her final comments on Tobey's work, even though she wrote them in the heat of anger, show a disenchantment that probably would have come about in any case. In 1928 she had been exhilarated by Tobey's experimental, off-the-wall approach; in 1930 it struck her as rather cold-blooded. "He is clever," she wrote, "but his work has no soul. . . . He knows perhaps more than Lawren, but how different. He told me to pep my work up and get off the monotone, even exaggerate light and shade, to watch rhythmic relations and reversals of detail, to make my canvas two thirds half-tone, one third black and white. Well, it sounds good, but it's rather painting to recipe, isn't it?"[9]

Time and time again in Emily's life, when she was at the verge of some critical breakthrough, there appeared some catalytic figure like this whose strength and confidence gave an extra spur to her own. Sometimes the support was only in the form of encouragement and unqualified praise, as in the case of Flora Burns and Kate Mather. Sometimes, as with Marius Barbeau, there was tangible, practical help as well. The strongest figures lent psychological support, not only directly but through the example of their own powerful self-assurance. Harry Gibb, Lawren Harris and the Group of Seven, Tobey and later Ira Dilworth were among these people; with the exception of Frances Hodgkins, they were all men.

There was also an unfortunate pattern of discarded friendships, and it is true that Emily can be accused of using her friends. That happened with both men and women: with Tobey, the Seattle painters and two young, local painters she would meet in the 1930s; and to a lesser extent with Brown, Jackson, Barbeau, Lismer and Mather. There would be a peak of early excitement and mutual affection, built on praise for her work; then, as the praise began to flag, there would be the pained reaction, the acid comments, the retreat and the slammed door. People she had welcomed initially with open arms suddenly became "fools" and "muttonheads" who "gave her the pip." By 1930 the pattern was an old one, beginning with her uneasy relationships in England and continuing through her angry withdrawal from the art community in Vancouver and Victoria. By the end of her life the list of people she had alienated, or who had alienated her, far outnumbered the friends who had remained in her good graces. She herself was cheerfully conscious of what she called her "intolerance," but she never seriously tried to overcome it. She simply said she inherited it from her father and laid the responsibility for it on his head.

To various disgruntled ex-friends, including Tobey, Emily was mean-spirited and egotistical. It was not egotism that made her ride roughshod over people; it was the very opposite. Lacking the inner confidence necessary to carry her immense talent, Emily resorted to a defensive bravado. Few artists have the inner strength to create in a vacuum, but Emily's need for praise and encouragement was all but insatiable. It was like a chronic ache, assuaged often but never for long. It helped to drive her into illness in youth and embittered isolation in middle life.

That lifelong, incurable need was rooted in time, place and family, but also undoubtedly in the circumstance of sex. If Emily was still, at the age of fifty-seven, the sturdy child who had sung to the cow and roamed the fields for wildflowers and birds' nests, she was also still the daughter who "should have been the boy." She never thought much about it, except to bristle when someone praised her for painting "like a man," as if she had measured up to some improbable standard. No matter how brave a face she put on it, Emily always had to struggle to believe in the possibility of her own success. As a child she had been a tough, feisty little girl who was given a great deal of liberty, for a girl. But less was always expected of her, and even the praise she gained had a different shade to it, as if her abilities, remarkable though they might be, were not truly relevant to the real business of life. It was her little brother, frail and not particularly gifted, who was always meant for boarding school and university. And, outside her own family, it was evident enough that the boys were always the real heirs. They were the ones whose sensible clothes were made for active bodies, who swarmed all over the picnic wagon, climbed trees and walked slippery logs over the sea. They were given the world to choose from, and when they grew up they seemed, like Tobey, to assume their birthright as naturally as breathing.

With a talent as strong as that of any man she knew, and with equal endurance and discipline, Emily still had to contend with a nagging self-doubt that had nothing to do with *who* she was, only with *what* she was. It was so much a part of her that she never really looked at it squarely. But it made her turn to male friends like Tobey at certain significant points in her life, when she was facing some obstacle and needed to fortify her own inner faith. They lent her some of their own reserve of confidence, and most of them lent it as she borrowed it, unconsciously. (That was not true of Harris and Dilworth, who understood Emily's insecurity very well.) But there were times in each relationship when that same unthinking, careless male self-assurance could become a threat. Then it would seem to Emily that things came all too easily to the princes of the earth, and she would turn against them. The same vulnerability that drew her to her friends could make her drive them away.

Of course, there was a great deal more to Mark Tobey than his boundless self-confidence. His own preoccupation with mass and volume, as

well as a tendency to experiment more widely and freely than Emily had for many years, had a significant impact on her work. In 1928 Tobey was caught up in his personal discovery of the concept of cubism, which he said he discovered while watching the path of a fly through space. It might be argued that that particular phenomenon seems more related to his later, highly linear style than to the late 1920s. Be that as it may, his interest in mass and volume of that period does show up in paintings like his stark, stripped-down *Middle West* (1929). Emily's works from around this time also show a sharply increased sense of the depth and solidity of objects, along with a more selective, concentrated composition and a marked departure from the faithful realism of her earlier work. Shapes become more simplified and weightier, and there is a definite shift towards abstraction.

Emily may also have temporarily derived from Tobey a certain visual restlessness that was essentially foreign to her art. Tobey's cluttered, aggressively claustrophobic painting *Emily Carr's Studio* was apparently done during his 1928 visit to Victoria. That picture is all jumble and jagged edges; one has the feeling the whole assemblage is about to fall on one's head. There are a few of Emily's paintings and drawings from around this period (though it is hard to date them precisely) that strongly resemble Tobey's study of her studio. Shapes are fragmented or tumbled together, the outlines of trees and mountains are harsh and jagged, and the aura of space, normally characteristic of Carr's work, disappears or becomes compressed and even turbulent. One of the most striking, an undated charcoal sketch now at the Vancouver Art Gallery, is a semi-abstract composition of jagged tree forms and horizontal bands, from which two fiercely staring, disturbingly detached eyes emerge. The theme of the latent violence of the forest, usually so strongly contained in her later works, is overwhelming in this sketch, and like one or two others of the same period it shows her losing the emotional balance that was generally a primary hallmark of her work.

Ultimately, Emily's explorations with form led her away from this kind of turbulence, and from fragmentation and abstraction. She was not interested in breaking down and recombining shapes, but in enhancing the integrity of each. Cubism probably helped her continue to simplify the forms of the burgeoning, unmanageable western forest. Space, and attention to the full significance of each separate form in space, are necessary to that ordered, brooding calm that Emily achieved in the finest works of this period. And actually the transcendent equilibrium of these works suggests a greater debt to Harris than to Tobey. In the end, though, her work is so powerfully individual that all the cavilling about "influences" is by the way. What Tobey and Harris both gave her was the key to yet another portion of her own genius.

After Tobey left Emily settled into one of the most productive periods

of her life. In the beginning there were a few unavoidable distractions. Two of her flats were empty, for one thing, and so she had to suffer constant interruptions from the phone and doorbell, however much she wanted to request all intruders, "politely, but firmly to go to the devil. . . . How I wish," she wrote to Brown, "I had *nothing else to do but painting.*"[10]

For her new work she was drawing on all the source material she had. When her new sketches fell short, she supplemented them with those from 1912. She begged Brown to return her damaged watercolours, which at that point were still held by the insurance company. And, fearing that there might be more delays in the future, she asked him for a written guarantee that the oils remaining at the National Gallery would be returned immediately, insured and express prepaid, whenever she asked for them.[11] She tried to put her request as tactfully as possible, but the misunderstandings of the past year had shaken her trust in Brown and the National Gallery, and there was really no way to hide it. Brown, clearly miffed, immediately sent watercolours, insurance cheque and oils to Victoria, and for a while there was a chill in their relationship.

Emily exhibited twice locally that fall, once with the Island Arts and Crafts Society and once in her own studio, where Willie Newcombe gave a talk on the Haida and the village of Kitwancool. Again, as with the West Coast show earlier that year, the coverage in the local press was abundant and highly approving. The *Colonist* review of the Island Arts and Crafts show gave a full paragraph to her three paintings, concluding that "Canada must some day be greatly endebted to Miss Carr for her unique contribution to historical art."[12] A month later both the *Colonist* and the *Times* covered her studio show, the *Colonist* ending with a nod to "the National Museum at Ottawa, which had an exhibition of her work during the present year."[13]

After the excitement died down, there was the long winter, given over to working through the challenges of a rapidly changing style. It was a difficult struggle, in which Tobey's recent encouragement and the euphoria of a new public image quickly faded behind the intensity of solitary concentration on her work. In March 1929, feeling depressed and tired, Emily exhibited for the first time with the prestigious Ontario Society of Artists in Toronto. Lawren Harris's letter on her two canvases, *Skidegate* and *Totems, Kitwancool,* was a salutary dash of spring tonic:

> The consensus of opinion—best opinion—is that they are a very great advance on your previous work. I am as sure as I can be that that is *true*. They are as good, perhaps better than anything in the show and its a big exhibition. It is as if your ideas, vision, feelings were coming to precise expression yet nowhere are the works mechanical, labored or obvious.

Having dealt with the specific, he went on, with typical insight and sensitivity, to deal with the universal:

> For goodness sake dont let temporary depression or isolation or any other feeling interfere with your work. Just keep on working, and do just what you feel like doing most. Try and remember . . . that there is a rhythm of elation and dejection and that we stimulate it by creative endeavor, by an acceleration of vision or work—we stir up life, essential life, and if we permit it it will take toll of us and at times we may wish we were hum-drum, lethargic, dull and normal (?)—anything to escape the see-saw of real living that must somehow temper us, deepen us, expand us. The only way it seems to me is to go ahead.[14]

Encouragement came in the form of dollars as well as words. In May *Totems, Kitwancool,* a large, dramatically spare canvas of two female totems seen in profile against a background of village and sky, was bought by Hart House of the University of Toronto. At $175 it was the most substantial single sale Emily had yet made in the east, and it was the first in the style of her full maturity.

From now on she produced a succession of works which would securely establish her place as one of the leading Canadian painters of this century. She did not realize that, of course, and the quiet, solid power of her work betrayed no trace of the cycles of elation and despair that went into their making. Emily rarely dated her canvases, and she would always resent any reference to "periods" in her work or that of any artist. That was pigeonholing, and moreover it implied some kind of progression that, if one thought about it too much, belittled the importance of whatever one was working on at the moment. But she had reached a level where the term *period* implies no judgement, only a self-evident fact. The works of the next three or four years would never need any justification. Her style changed dramatically later on, but each painting would always succeed or fail on its own terms, and the finest works of these years are as arresting and as commanding now as they were then.

Art historians use the term *formalistic* to describe these works. One is struck by their superb economy, by the way she has stripped the recognizable forms of pole, village, forest and sky down to their very essence, so that they seem to come forward, demanding not only to be seen but to be felt and known. These paintings are like Harris's in their insistence that we shut out all superficial detail and enter a more elemental universe, that we pay attention to what Emily called the inner reality, the very things in themselves. From here it is but a short step to abstraction, and Harris would eventually take that step. But although Emily did venture into abstraction a few times, she was not comfortable with it. For her the

marvel lay precisely in the vision of the familiar as something rich and strange.

The affinity with Harris is unmistakable, not only in purely visual terms but in the spiritual enhancement of each object. In some ways, though, the two artists are diametrically opposite. Where Harris's canvases opened ethereal vistas of pale light, suggesting an impersonal cosmic order of ice and grey rock, glowing skies and shimmering water, Emily's delved into the darker, more complex universe of earth and living things. Harris's work affirms a permanence and order beyond individual life. Emily's work affirms permanence and order as well, but it focusses on the order within nature, on life persisting side by side with death, indeed on life drawing its very identity and substance from death. One becomes airborne in a Harris landscape; in Emily's paintings one must stand on earth and meet head-on the giants that walk there. "The deeper down you burrow into *earth* things," she believed, "the more of spirit you find."[15] The forest is always present, even in paintings like *Big Raven* or *Totems, Kitwancool* where, visually speaking, there is little of it. Emily makes us see that the totems themselves embody it; the carved beings are its visible face, and the wood of their substance is balanced between birth and decay.

In paintings like *Totem and Forest, Indian Church* or *South Bay, Skidegate* the forest presses against the frail limits of the canvas in great waves of resurgent foliage. The colours are the deep tones of sepulchral evergreens, aged wood, damp soil, and skies heavy with impending rain. Technically they confined Emily to a narrowly restricted palette, stimulating her to increased use of complementary colours and deep chiaroscuro to effect her dramatic contrasts in tone. Light glows from within these canvases as from Harris's, but it is a subdued light, often a warm one. The works of both painters are austere and rather static, requiring us to cross a certain distance and shed certain impedimentia before entering their world. Both are ambiguous, suggesting a solitude that can be either liberating or disquieting, depending on what you bring to it. But Emily's titanic western landscape challenges one to enter that dialogue of fear and affirmation mentioned earlier. It suggests an infinite calm beyond the dialogue, but it will not allow one to escape the dialogue itself.

Emily's involvement was at a different level from Harris's; she was earth-bound and earth-intoxicated. The question rises—and nowadays it is a touchy one—whether there is a particularly female aspect to her vision. Certainly, for better or worse, women painters have historically concerned themselves with the human, the personal and the here-and-now. That has changed since the advent of abstract expressionism, but in Emily's day and for centuries before, very few women were drawn to pure landscape painting. Emily Carr's extraordinary empathy with

living things extended beyond sentient beings to the very cellular level of the most immovable trees. There was nothing cerebral about it. It was immediate, physical and direct, and in that sense it was sexual, even maternal. I am not suggesting that women painters in general are bound to follow that pattern, or that male painters are excluded from a vision of landscape as intimate and all-encompassing, in its way, as Emily's. Nor am I dabbling in crude pseudo-Freudian theorizing that would define a whole career as a sublimation of biological drives. But I think that Emily's impulsive reaching out towards the natural world, which began very early and gathered intensity as she grew older, expressed the side of her that belonged to womanhood in general and to her mother in particular. Setting aside the eternal debate over biology versus environment, we can say that Emily's love of living things was spontaneous and sensual from early childhood. It was not enough to see a chicken or a flower; she had to hold it, feel the life of it, know its texture, experience the animating force that distinguished it from all other, identical chickens and flowers. At the very end of her life she would still insist on touching the flowers people brought when she was sick; and if no one brought her flowers, she would ask for any ordinary living twig with leaves on it.

Emily's need for direct, physical contact with other living things was basic and lifelong. The landscape was not merely a subject to be painted; it was a breathing organism, an extension of the life in herself. In that sense it was different only in degree from the animals she always kept around her, for the tenderness she showered on them was an expression of her tenderness for all life. If that specifically physical, personal feeling for life can be called female, then Emily brought to her art a distinctly female strength. One can see it in the solemn, formal paintings of the late 1920s and early 1930s, and one can see it in the swirling, expansively joyous landscapes of her later years.

Nootka and Port Renfrew

IN THE SPRING of 1929, at the request of someone in the east, Emily wrote an article for the June issue of the *Supplement to the McGill News*.[1] Written in a typically crisp, conversational style, it is an interesting sequel to the talk she gave at her 1913 Vancouver exhibition. Here again she focussed on the native Indian artist's interpretation of the western landscape. She reminisced once more on her own travels among the natives, implying that her only companion was her faithful sheepdog, Billie. (For the sake of unity, Billie was resurrected to take the place of Ginger Pop in one story from her 1928 trip.) She made a new plea to the western public to shed its provincialism and scolded it for the hostile reception it had given a Group of Seven show in 1928.[2]

The main difference between this article and the 1912 talk is that Emily is no longer a deferential step behind the native Indian. She is up there beside him, urging other artists to catch up with her. The native was the first modern artist of the west. He "searched beneath the surface for the hidden thing which is felt rather than seen, the 'reality' in fact which underlies everything."[3] The very wood he carved was part of the thing he was trying to express. He was anonymous, working only for the sake of the art itself. And though Emily is appropriately modest about her own work (it is "humble enough, and it falls very far short of what I wish it could be"),[4] she is writing as one who has also found the "inner reality" of the west, who can set an example for others to follow. With the help of the native, she has freed herself from an outworn tradition. If other British Columbian artists want to shed the "borrowed plumes" of Europe, they must come to know the west as deeply as the native does, and as—by implication—Emily herself does.

Describing her own experiences among the natives, she seems to be addressing not only her fellow artists but the outgrown ghost of her younger self:

You have got to go out and wrestle with the elements, with all your senses alert, to see and hear, and feel; there is no luxurious travel and accommodation. You have got to hold your nose against the smell of rotten fish, and you've got to have the "creeps." You must learn to feel the pride of the Indian in his ancestors, and the pinch of the cold, raw damp of the west coast, and the smell and flavor of the wood smoke, and the sting of it in your eyes, and the awful torment of the mosquitoes, and the closeness of mother earth and the lonely brooding silence of the vast west.[5]

The words are much like Housser's, and they would have had a familiar ring to many eastern readers. But she was not writing for easterners, she was writing for the west. Moreover, when Housser or one of the Seven wrote such words it was understood that male was speaking to male; there was a kind of we-rugged-brothers-around-the-campfire tone to them, as if the wilderness were an exclusively male preserve. Emily may not have consciously intended to change that, but simply by being who she was, she spoke to the sheltered, conventional young woman who perhaps painted studio portraits or flower studies: the one who had never fully tested her courage either artistically or physically, who was comfortable enough but vaguely dissatisfied with her work, and who was a little uneasy walking in Stanley Park by herself.

Emily wrote of the advantages of isolation for the native artist. His "very obscurity and freedom from personal recognition" allowed him to "work free and unfettered . . . for the sake of the thing itself."[6] Emily's own desperate need for praise, and the long years of bitter resentment against an indifferent public, are set aside, for the moment. She has come through, after all, and has earned the right to dispense wisdom:

We may not believe in totems, but we believe in our country; and if we approach our work as the Indian did with his singleness of purpose and determination to strive for the big thing that means Canada herself, and not hamper ourselves by wondering if our things will sell, or if they will please the public or bring us popularity or fame, but busy ourselves by trying to get near to the heart of things, however crude our work may be, it is liable to be more sincere and genuine.[7]

Many years after she wrote this article, Emily recalled that she had "stopped grieving about the isolation of the West" around this time. She said she believed she was glad she was cut off.[8] The article confirms it. She could not value the isolation of the west until she had broken it.

In general, the *McGill News* article has some of the same authority that she had achieved in her painting. Reading between the lines, we can see Emily making sense of her life, drawing success out of seeming failures

and finding coherence where once she had seen only confusion. The long years of loneliness, the years of dependence on native art, the energy poured into senseless, menial chores, the ridicule and incomprehension she had met, have become part of a unified pattern. The voice is that of someone who knows where she is, and who—to go back to Isak Dinesen—is beginning to "see the stork."

Emily went north twice in 1929. In early May she and Koko travelled up the west coast of Vancouver Island to the cannery community of Nootka on Nootka Island. There she stayed in a hotel on the waterfront, a queer, ramshackle affair run by a young woman who was a widow (or maybe, Emily muttered to herself, she was "just widowed on and off").[9] The place seemed utterly comfortless and strangely empty: there were only a few sticks of furniture—no carpets, pictures or curtains, no hint of food past or present in the kitchen (though the woman said she would cook one meal a day), no hint of fire past or present in the fireplace, and no other human occupants that Emily could see. The landlady gave her a minimal greeting, quoted a high rate, announced that the power went off at ten, showed her upstairs and strode off down the echoing corridor, banging the door behind her. There was nothing in the room but an iron bed, a chair and a table, a row of hooks on the wall and a bare light bulb that winked out, leaving the room lit by moonlight. But the sheets on the bed seemed clean, and Emily slept well.

She soon found she was not the only guest, though she was the only woman. The others were men who worked for the cannery, and they came in all types and nationalities, an old-fashioned western miscellany of people. Nearby were the settled communities of workers, grouped by nation—Norwegians, Japanese, Chinese. Farthest out was the native village, a row of houses with a plank walk built over the mud flats, all painted the same shade of cannery-issue dull red, with white trim. From their chimneys pale smoke drifted downward, mingling its fragrance with the familiar scents of cedar, seaweed, tidal debris and salt fish. Along the plank walk the villagers moved as quietly and deliberately as if, like the people in one native legend, they were living at the bottom of the sea. From the shelter of one of the houses, Emily watched them through a rainy Sunday. The wooden walk was slippery, and most of the feet that paced along it were bare. There were the tough and calloused feet of old women and the supple feet of small children, whose toes clung "like limpets." There were a few shod feet as well, the feet of young men in rubber hip boots and young women in "pitiful highheeled uncomfortable things." They all walked with the same "lingering unhasteful gait. . . .

Why hurry? The sun doesn't, neither the moon. There are plenty more days and nights. Those who gulp their wine can't taste it. Shins—knees

—hips—corsetless bulk show steady beating hearts, motherly shoulders, built to bear heavy burdens and solid papooses wrapped in plaid shawls red and green and blue, heavy brown faces age [?] early with kind soft eyes that observe all but appear to notice nothing. The very name "Indian" cannot be uttered without a drawl. . . .[10]

When she was not sketching in the village she sketched in the forest. There was a single path, leading nowhere that she knew of, and she would follow it until she found a spot to set up her easel. She was working there one day, enveloped in the usual silence and half-conscious of the usual prickly feeling on the back of her neck, when she saw Koko tense and heard a rustling and clanking behind her. She turned and saw a curious apparition, a bearlike man all bedecked with packages and tin cans dangling from strings, and carrying more parcels in his arms, for all the world like St. Nicholas and a Christmas tree combined. He was just as astonished as she was. He stood there for a moment, visibly struggling for words, until the few he needed burst out: "One lady, she paint this wood?" She told him huffily that she did indeed (adding to herself, her fear having entirely vanished, that she was "as indigenous to these woods as a pine tree").[11] That silenced him. He stood there nevertheless for several minutes, staring at her while she worked in growing discomfort. Then he suddenly turned and went on. Emily told no one about him, and a few days later she left Nootka.

Two miles south of Nootka was Friendly Cove, the site of Captain Cook's 1778 landing. Yuquot, the tiny native village there, was connected to Nootka by a path. Otherwise, it was accessible only by sea. No white people lived in Friendly Cove, though a priest visited regularly to say Mass in the tiny church, the successor to the first Catholic church in British Columbia. But directly opposite the village, on a headland at the end of a tidal peninsula, was a lighthouse—a "strange, wild perch" on a "nosegay of rocks, bunched with trees spiced with wild flowers."[12] There Emily stayed for a week or more with the lighthouse keeper, Tom Fish, his wife and their son, Bert. "It is wonderful, clean, spacey," Emily wrote in her journal. "There is room to breathe, space to feel out into and think."[13] The family gave her their newly married daughter's room and seemed glad to have someone to fill the empty space among them. On fine days young Bert took her clambering over the rocks, or ferried her in his motorboat to Friendly Cove and other sketching sites along the shore. On stormy days the lighthouse became a sanctuary of light and warmth in a howling maelstrom of sea and sky. On one such day Mr. Fish took Emily up into the lighthouse tower so that she could sketch. But the familiar world had disappeared, except for the wraithlike shadows of the great trees on the shore, bent like saplings underneath the wind and all but lost in a tumult of rain and pounding surf. She could

only lay down her brush and watch, "every sense . . . burden[ed] to ca-
pacity,"[14] while the huge light and the foghorn sent their blinding, blar-
ing, life-giving pulses out into the whirling nothingness outside.

Before she left the Fishes she met the apparition of the woods again.
He turned out to be an elderly Russian farmer who lived by himself in a
lonely farmhouse on the shore. One Sunday Emily, Koko and the Fish
family took a picnic lunch and motored across the bay to visit him. He
was fishing in the little creek beside his house, and when he saw them
coming he put down his pole and came to greet them. Koko was sitting
in Emily's lap, and when the Russian saw him he held out his arms and
called. The shy little dog went to him immediately, and before Emily
recovered from her surprise the Russian was halfway up the path, croon-
ing to Koko and leaving his visitors to follow when they could. Emily
was not used to having her beloved dogs forsake her for strangers, but
her annoyance melted before the gentleness of the old man, who kept
Koko close to him all day. He showed his visitors over his garden and his
old-worldly, meticulously kept house, and after lunch he opened a bat-
tered, metal-bound trunk and showed them pictures of his family in Rus-
sia, "speaking of them in a soft loving way caressing Koko's ear all the
while." Emily was "very touched by him. . . . His surroundings were so
immense [and] primitive his ways gentle. He did not strike one [so]
much as foreigner to Canada as foreigner to the world. . . . I could al-
most have cut Koko in two when we came to leave and he gave him back
to me only that would [not] have done . . . Koko the Russian or me any
good."[15]

The Russian came to the lighthouse once before Emily left, bringing
gifts of cabbage, rhubarb and fresh eggs. That was the last she ever saw
of him, though he and the Fish family gave her some untypically affec-
tionate memories of white people in the north. Emily rarely spoke or
wrote of the whites she met on her native trips. Although she was not
unkind about them (except for tourists and a missionary or two), they
had no real substance for her. Yet she was struck by how warm these up-
landers were to one another. Snappish and mistrustful herself, wincing at
the sound of one more pair of stranger's feet climbing her stairs and one
more set of knuckles rapping smartly on her door, she could only marvel
at people whose human contacts were so rare that each one was a gift of
chance.

Except that there were no more lighthouse sanctuaries and saintly Rus-
sians, Emily's second trip that year was a natural successor to the first.
Between them they made a pair of peaceful counterweights to the hectic
summer interval between them. In mid-August, some three months after
her return from Nootka, Emily boarded the *Princess Maquinna,* the
steamer she had probably taken on her earlier trip. This time she went

only as far as the first stop, the little settlement of Port Renfrew, about five hours out of Victoria.

At first sight, as she walked down the gangplank at dawn, the place seemed to be nothing more than an eerie collection of ruins. This was not the kind of desolation she had found at Greenville or in the slumbering, decaying villages of the Haida. These were the ruins of white enterprise gone wrong. Beside the rotting wharf an abandoned cannery listed perilously over the water; beyond that was a vacant shed, its door wrenched off and tossed among the litter inside. In the half-light Emily made out the hulk of a factory that had once made boxes, and the blackened beams, rusty stove and twisted bedframes of a hotel that had burned the previous year. She walked past them, and past a scattering of houses whose empty windows stared inward at darkness. The whole place seemed steeped in hopelessness, and she was tempted to climb back on board the steamer while she had the chance.

That would have been a mistake, for a bit more walking brought her to the real life of Port Renfrew, the native village on the cliff above. The rising sun, disentangling its beams from the dark spires of the trees, poured light on the open doors of houses, on the graceful forms of beached canoes, on fishermen setting out to sea, on flocks of children skittering like seabirds over the gleaming sand, dogs making futile forays at wise, teasing crows, and women hanging out clothes that fluttered and played in the wind like so many bright pennants. Behind the village was a fully mature British Columbian rain forest of hemlock and amabilis fir.

Emily's delight in Port Renfrew can really be expressed only in her own words:

Joy, joy how splendid it is to be alive to feel the sting of the fresh salt spray to smell seaweed and clam flats. . . . How arrogantly the pines toss their wind battered tops against the sky. The sun and the wind are in fierce battle as to who shall predominate, and these two great elements clean up the little village on the cliff eating up waste and offal, and driving the smells far out to sea. Even the village bulls the great red brute with the white face and the old sour black are careering with lumpish sportiveness and tails up . . . along the sand while a dozen village curs give joyous chase. And with head well up and back plumb straight Sophie[16] barefoot walks stately[?] up the hill thro the village past Chief Toms house with the big whale[?] pole in front and Jimbo's[?] pole and Chief Johnny's big bear and the three community houses, where 5 families live in each, and there is still ample room for their hens and dogs and cats, and the cow has been know[n] to enter but was not favorably received. And the fish racks and tin cans and beach drift and refuse and the grass grown streets with no swifter a vehicle than a wheelbarrow to which is hitch[ed] old blind Jake.

And rope is tied to each arm and his old lame wife clutches her crutch in one arm and with the other hand stacks the load of wood upon the barrow and guides Jake by his roped arms, and so they take the beach wood for their fire to their little shanty behind the community house. And there is the clip clop of Jerry's tool finishing a canoe of cedar. A boat comes in and spills a glory of silver fish upon the sand and the women with their knives and boards come trooping down to clean them and hang them on the racks by the doors to dry in the sun and wind. It's a gloriously peaceful hubbub not the mechanical rasping clank of the city but the mellow ring of nature knocking against nature, realities holding their place steadily in the universe. And dont forget the bitter sweet cry of the gulls, and up above all the bald headed eagle circling pridefully king of them all.[17]

Here is the place itself, and Emily in the middle of it. Fragments of it would surface in a later story, "Two Bits and a Wheelbarrow" in *Klee Wyck*. But the finished story is slight, as is a poem she composed about Port Renfrew in her journal. If we really want to know the village as she knew it, we have to go back to the passage quoted above.

Emily had kept occasional journals since childhood. She had burned the very earliest for fear her sisters would laugh at them. Her adult journals, for many years, were quite guarded. Written mainly as travel journals, they were often sketchbooks supplemented with scraps of prose or doggerel verse. But when she took her 1927 trip east, nothing less than a full-scale, traditional diary could hold all her feelings and impressions. It was then she began to hit her stride as a journal writer. After she got home in 1927 she put the journal aside. She did the same with the journal quoted above. But in 1930, without the excuse of any journey except the one she had been on for almost sixty years, she would begin a diary that would continue, more or less regularly, through the rest of her life.

It cannot be entirely accidental that Emily achieved a new fluency with words at the same time as she reached full mastery as a painter. The year 1927 marked a point of inner liberation; something inside her was set free, and it manifested itself in writing as well as painting. Words had always been her medium-in-reserve, necessary both to feed her art and go beyond it. But from 1927 on it is interesting to see the different ways she used them. Emily's fiction was lean and crisp almost from the beginning. She kept the sentences short and the rhythms light, as if the printed page were a formal garden and she, like her father, felt obliged to tidy up its gravel paths. The journals, in comparison, were open fields. They gave her space to lope along at full speed, heedless of syntax or punctuation, until she found a rhythm that matched the full abundance of the words singing in her head. If they have a presiding literary spirit, it is Whitman, for Emily was a devotee of the American poet, especially after she met Housser. They are not all long, singing cadences, of course, for like most

journals they have their plain, workaday moments, as well as their moments of self-pity and rancour. But in passages like the 1929 paean at Port Renfrew, we can see her finding the sheer, untrammelled joy of using words for their own sake, presumably without thought for anyone's ear or eye but her own. The result, unlike her verse, is often very close to poetry.

CHAPTER
23

Banner Year

BY 1929 MARIUS BARBEAU'S work on the West Coast was winding down, and he stopped in to see Emily that fall for what would prove to be his last visit. Still her most faithful patron, he bought two paintings before he left. One was a pure landscape, a scene painted from her 1928 sketches of South Bay. Barbeau was surprised to see several others like it, paintings of forest and shore that left the native out altogether. He liked the change, and he liked to think his old friend Ambrose Patterson had had something to do with it. But by now the Seattle group had fallen into disfavour at Simcoe Street. As Barbeau discreetly put it, they were "in the habit of going [there] for a vacation and . . . enjoying themselves and drinking a bit. She was getting tired of the job of giving board to outsiders."[1] And even in the early days, when the friendship had been easy and free of strain, their advice had probably not carried enough weight to bring about such a far-reaching change. Now the only American she really listened to was Tobey, who had indeed told her it was time to leave the native behind.

Yet the voice she heard most clearly these days was Lawren Harris's. In a pair of letters written the previous spring, before she left for Nootka, he had urged her to consider "leaving the totems alone for a year or more," to explore what she herself called "the tremendous elsewhere that lies behind."

> Don't give up anything just push it all further and more searchingly. The reason I mentioned the totem is that it already in itself is a definite artistic form and if you did too many you might become dependent on them. Whereas if you do boats, villages, trees, rocks, sea, bays, skies, anything else, you will create your own form and can go back and handle totems with greater surety.[2]

Coming from anyone else, advice like this might have set off a small

explosion. Emily did balk at it a bit, but she and Harris were on a very
solid footing. Her early admiration of his work never soured into rivalry,
partly because of the genuine sweetness of his character, partly because
he was very sensitive to her wariness, and partly because he was so
benignly detached from his own ambition. When Emily wrote in 1944
that Harris's "work and example did more to influence my outlook upon
Art than any school or any master,"[3] she was not being sentimental over
a friendship of some seventeen years; she was simply stating a fact. His
surviving letters to her are a sustained essay on the artist's battle against
depression and inertia, and on his need to keep faith with himself in
hostile or indifferent times. Written probably for his own sake as much
as for hers, they sound much as his conversation must have: highminded,
colloquial but slightly archaic, laced with theosophy, old-fashioned
romantic idealism and plain common sense. Almost all Emily's letters to
him are gone, but for several years he was the one person to whom she
felt she could say anything, or at least anything she could admit to her
own consciousness. There was no hint of sexual intimacy about their ex-
changes, which took place mostly on the rarefied plane of art and reli-
gion. Yet for Emily the medium of letters, safely disembodied as it was,
permitted an intensity of feeling that would not have been possible face
to face. Except for Ira Dilworth many years later, Harris came closer
than anyone else to re-creating her early relationship with her father. The
demands of that role might have been overwhelming at close quarters,
but in his letters he was able not only to accept it but to carry it off with a
good deal of grace.

Usually Harris's support was more general than specific. He rarely
made direct suggestions like this one about the totems, and when he did
Emily usually took them to heart. In this case his words were very well
timed, for Emily was half-apologetic about how much her work owed to
the native, and at this point in her career she needed very much to take
full possession of her art. In her 1929 and 1930 sketching trips she spent
more and more of her time working in the forest, out of sight of the na-
tive villages. Most of these forest sketches were done in charcoal, a me-
dium she had come to fully appreciate only in the past year. It was light
to carry and easy to use in the rain, and its clean line and deep tones trans-
lated smoothly into the dramatic, simple forms of her canvases. It was
also around this time that, following another of Harris's suggestions, she
began to carry a little notebook in which she jotted down impressions of
a scene before she began to sketch it.

For Emily 1930 was a banner year. We can get some idea of it just from
the number and variety of her exhibitions. Besides two local shows (the
Island Arts and Crafts Society show in Victoria and the Palette and
Chisel Club show in Vancouver), she exhibited in Toronto with the
Group of Seven and the Ontario Society of Artists, as well as with the

Fifth Annual Exhibition of Canadian Art at the National Gallery, the 16th Annual Exhibition of Northwest Artists in Seattle, and an exhibition of Contemporary Canadian Artists that opened at the Corcoran Gallery in Washington, D.C., on 9 March and travelled to several American cities. She had three solo shows: a small one at the Canadian National Railway office in Ottawa, a major show at the Crystal Garden in Victoria and another at the Art Institute of Seattle. The year saw several firsts: her first time as an invited contributor with the Group of Seven, her first solo show (except for studio shows) in her own community, and the first significant U.S. exposure of her work.

In spite of any contretemps Emily may have had with some of her Seattle visitors, she became quite active in Seattle art events from 1928 to 1931, and Seattle was a logical setting for an American one-man show. In 1928 she served on the jury of the Northwest Artists' Exhibition, and in 1929 she was a judge. She entered her own work in the shows of the next two years, winning a first prize in 1931 for her watercolour *Zunoqua*. It was immediately after the 1930 show, which took place as usual at the Fine Arts Institute, that she was given a solo show in the same building.

All this began at the height of her friendship with Tobey, who was probably the main impetus behind it. But it also coincided with her friendship with John Davis Hatch, who was director of the Art Institute from 1928 to 1931. Hatch was a friend of Tobey's but met Emily independently, through Erna Gunther and Willie Newcombe, in 1928. Thereafter he came to see her now and again, usually for tea or dinner and usually alone. He was very young, only twenty-one when he took the Seattle job; he was a stranger to Seattle and had no family to look after him; and he had a high opinion of Emily's work. That was quite enough to establish him in her good graces. They were never close enough to be on a first-name basis, but Emily gave Hatch many of her sketches and wrote to him now and then for the rest of her life. It was Hatch who arranged for her Seattle show, which ran from 25 November 1930 to 4 January 1931.

The reviews in the Seattle press and the American art journals all emphasized the controversial nature of Emily's work. Apparently Emily saw none of them, and at first she alternately raged and mourned over the supposed failure of her show. Hatch was away, though he did send some hurried reports, and another Seattle acquaintance confirmed them. Both said the show had stirred up some spirited debate. "People are either decidedly for or against it," Emily wrote in her journal. "No one comes and goes without saying *something*."[4] That mollified her a bit. Nevertheless, she was still furious with Hatch for not keeping her better informed, and she sent him a blistering reprimand, typed "so's he would not miss one word."[5]

The best review of the year came from eastern Canada. Writing in the March issue of the *Canadian Forum,* Jehanne Bietry Salinger singled out

Emily Carr and the Montreal painter Prudence Heward as the "two glories" of the Canadian Art exhibition at the National Gallery. Emily's *Indian Church,* a picture of the little Catholic church at Friendly Cove, was "the most daring painting of the whole exhibition."[6] The *Canadian Forum* was closely tied to the Group of Seven and its praise was no surprise, but Harris made the most of it. Jehanne Salinger, he told Emily, was "the best person of all 3 sexes writing on art in Canada today. . . . I don't know whether we can make any inroad on [your] innate modesty but the weight of the best opinion in the country on art (sure, I include myself) ought at least to increase your desire to work or to give you more joy in it."[7]

The only serious opposition Emily encountered after 1927 was in Vancouver, where art criticism in the late 1920s was both reactionary and hopelessly naive. Emily sent the Vancouver *Sun* review of the 1928 Palette and Chisel Club show to Eric Brown, who sent quick commiseration: "The kind of criticism from Vancouver of your work in a recent *Palette and Chisel* exhibition is pathetic and I am not surprised you don't show much of your work there."[8] "Pathetic" was indeed the best possible word. About Emily the reviewer wrote,

> A picture by Miss Emily Carr entitled "Sunlit Shops, Port Hope," is a very ambitious subject but the panes of glass have no reflected lights and are too opaque. In other words, it does not give one the impression of being glass. [A study] of a girl by the same artist has a very awkward left thumb and the foreshortening of the left forearm is faulty.[9]

It is possible that this incredibly inept, unsigned review was written by John Radford, a reactionary critic who four years later vigorously supported a drive to oust Eric Brown from the National Gallery.

Similarly minded, and of a similarly limited vocabulary, was the critic "Diogenes" of the Vancouver *Province*. In his review of the 1928 Palette and Chisel show, "Diogenes" showed his dislike of Emily's work simply by ignoring it.[10] But in 1929, when Emily showed her work with the B.C. Society of Fine Arts for the first time since 1910, "Diogenes" zeroed in:

> I have scarcely seen Miss Emily Carr since she lived in Vancouver and was a well-known contributor to the exhibitions of the society in the years before 1912. She has several eminently striking pictures in the present show; they seem to me rather bewildering. It is perhaps because I have not had the opportunity that Miss Carr has enjoyed of becoming thoroughly imbued with the aboriginal way of looking at things.[11]

The antagonism of this reviewer was very strong, and it intensified in an article written the following year. It is interesting that he remembered

Emily from before she went to France; he was probably one of the people who ridiculed her work in 1912, and he may have been an original member of the BCSFA.

For the time being, any work Emily showed in Vancouver was virtually certain of being attacked or ignored. That, plus a general mistrust she felt towards the new Vancouver Art Gallery, caused her to withhold her work from BCSFA shows for several more years, until 1936. She did show at least twice more with the Palette and Chisel Club, a far smaller, less prestigious show.

In Victoria the press continued to bask in her accomplishments like a proud parent whose child has heaped honour on the family name. But the man on the street was not so easily won over, and many people still thought it good sport to make fun of her. Emily took particular exception to the gallery comments—or pained silence, as the case might be—at the Island Arts and Crafts shows. For better or worse, this was Victoria at its most honest. People did not feel the need to echo eastern pundits at this show, nor to pretend to like art that made them uncomfortable. It was Emily's very perception of this honesty that made her angry. In 1930 both friends and press greeted her new work in total silence. "It was just *awful*. Made one *sick*," she complained afterward in a letter to an eastern friend.[12] This was the ordeal of "tea and gossip" she remembers in *Growing Pains,* where her sisters cap the whole wretched afternoon in their absolutely characteristic ways: Lizzie takes one terrified look at Emily's work and flees, while Alice compliments the only thing she really likes about the pictures: their frames.[13]

Nevertheless, Victorians had turned out in force the previous March, when the Women's Canadian Club gave Emily her first solo show in Victoria outside of her own studio, at the city's new Crystal Garden convention centre. Much of the impetus for the show came from two foreigners, the American writer Kathrene Pinkerton and a Dutch painter, temporarily living in Victoria, named Lodewyck Bosch. They joined forces with Margaret Clay and other members of the Women's Canadian Club to bring about the exhibition, and Pinkerton somehow talked Emily into giving a speech on modern art.

Two days before the show Bosch wrote a piece for the *Colonist*, scolding Victoria for neglecting Emily Carr and patronizing Canadian art in general. "How staggered we were," he wrote,

> when our eyes first fell upon her pictures. . . . We could not overcome our astonishment and emotion. We could not believe it possible that a country in this enlightened time could have remained so totally ignorant and indifferent to such powerful and really inspired work. In Europe Miss Carr would have been acclaimed as one of the greatest artists of her day. State

and community would, with reason, have been proud of having her as a native of the country and would have done everything to honor her.[14]

This was laying it on a bit thick, especially for a foreigner. There may have been an element of stung pride, as well as a good deal of curiosity, in the large turnout for Emily's show; in any case, interest was so high that the exhibition, originally scheduled for only one day, was held over for two more.

Facing some five hundred women and clutching Ginger Pop for moral support, Emily delivered her talk on modern art on the opening day, 4 March. Later published under the title *Fresh Seeing,* it was a concise, unpretentious and altogether convincing appeal on behalf of modern art, one that could still be used today to initiate the timid and fortify the uncertain. Then the club presented her with daffodils and took her to tea at the Empress Hotel. She accepted a request to speak again on 10 March before the Kimtuks Club, another women's group.

The Victoria press was admiring, as usual, but in Vancouver "Diogenes" used Emily's show as an excuse to launch a full-scale attack on modern art in general. This time he was really offensive, and not only to Emily:

To the most conservative ideas of those who think about art, and about its development through a sane process of evolution[,] it will still be a question whether the best way of establishing a new Canadian art is to saturate oneself with the barbaric efforts of the aboriginal. Emily Carr's wide knowledge of the Western Indians, and her deep study of their ways of thinking, make us wonder what would have been her artistic career had she remained in England, where she was born? There are examples to prove that prolonged residence among aboriginal races, whether in Africa or India or Australia or South America has tended to make an Englishman resemble those with whom he has been for many years in contact.[15]

He capped this by remarking, offhandedly, that he had seen "three photographs" of Emily's pictures; apparently they were *all* he saw of the exhibition.

Altogether, "Diogenes" notwithstanding, March had been a triumph for Emily. She felt she had passed a milestone, and so she had, though it would be some years before she received this kind of local attention again. At the end of that month, still glowing over her success, Emily took her second trip east. Taking Koko with her, she went first to Ottawa, where she stayed with the Barbeaus, saw the Browns and other old friends, and visited her small solo show at the CNR offices. Then she went on to Toronto, where the Group of Seven show opened at the Art

Gallery on 5 April, hard on the heels of the Ontario Society of Artists show in the same building.

The Group of Seven show had special importance for Emily, for though her works had hung with the group's at the OSA and in other shows, they had never been in one of the group's own exhibitions. This year, as one of many invited contributors, she had six major canvases on the walls.[16] Nervous at first, ready to defend or excuse them if need be, she began to relax as everyone she spoke to remarked on the new depth and authority in her style.

At a party after the opening she found her *Indian Church* gracing the wall of Lawren Harris's dining room. Jehanne Salinger had not been the only easterner smitten by this picture. Harris had liked it so well when he saw it in Ottawa that he had arranged for it to be sent to the OSA show, where it was hung at the last minute, too late to be listed in the catalogue. It was, he crowed to Emily, "the best thing in the show,"[17] and afterward he, Jehanne Salinger and the Art Gallery of Toronto jockeyed delicately for the privilege of buying it. Harris won out, and he was so fond of it that Emily, who always hated hearing her earlier work favoured over her later, would finally forbid him to say another word about that "beastly church."[18] But for the moment she was immensely pleased with it and with herself.

The next few days were partly given over to visiting the Pearsons, who now lived in Oshawa with their baby son. There were trips into town with Carol, to shops, the museum and the zoo; and there were teas and excursions with Toronto friends. Emily was enjoying herself thoroughly until Harris, who had just come back from a trip to the States, threw her a challenge: New York was only a stone's throw to the south, she had never been there, and why didn't she go now and see the new spring exhibitions? Emily said it was out of the question. Toronto was all the city she could cope with, and even Toronto had elevators, a modern torment she would go to any lengths to avoid. New York's elevators would be higher and faster, and New York itself would be foul, rude and suffocating: turn-of-the-century London compounded many times. But she was ashamed of her cowardice, and in the end she decided to go. She wired ahead to some old friends, the Coziers, who managed an estate on Long Island, and when she arrived at Grand Central Station Nell Cozier met her and instantly whisked her out of the city. On the island all was peace and spring greenery, and Emily was astonished that the monster's black breath had not blighted the countryside. She spent a week there gathering her courage, and then—probably on 21 April, the day after Easter—she left Koko with the Coziers, boarded the train and headed for the dragon's lair. Nothing happened. New York was only a larger Toronto, full of space and easy civility. There were slums and soup kitchens and people jumping out of windows, but Emily never saw

them. Modern New Yorkers can entertain themselves with a vision of the city as she found it: "clean, the traffic wonderfully managed and the people courteous."[19] The clerk at the Martha Washington hotel found her a room one flight up. It was small and dim and it overlooked an air shaft, but it had its own bath and there were no YWCA prohibitions on the walls.

East and West

EMILY SPENT A WEEK in New York. Nell Cozier came in and went sightseeing with her, but most of her time was given to galleries and museums. There is a partial list of them on a surviving scrap of paper: the Wildenstein and Reinhardt galleries on Fifth Avenue, the Dudensing (Valentine) gallery on 57th Street and the Roerich Museum on Riverside Drive.[1] The exhibitions she saw included, among others, works by the early Cubists and Kandinsky. There was a show of Charles Burchfield's early watercolours at the Museum of Modern Art through 23 April, and at Alfred Stieglitz's gallery, An American Place, she may have seen the Arthur Dove exhibition that closed 22 April. She certainly visited the gallery, where she met Georgia O'Keeffe. The two women had a little talk, and Emily seems to have liked O'Keeffe's work, for she was puzzled by how dissatisfied the painter herself seemed with it. Katherine Dreier, whom Emily met a few days later, put that down to excessive ambition: O'Keeffe, she said piously, "want[ed] to be the greatest painter" and would not settle for being just another singer in the "grand, great chorus" of art.[2]

In the doorway of the Roerich Museum Emily ran into Arthur Lismer, who was visiting New York with a student and an art teacher from Toronto. They went through the museum with her. Afterward they all went on to the De Hauke Galleries, where they saw Duchamp's *Nude Descending a Staircase* and works by Picasso, Braque, Léger and Juan Gris, among others. That show was, mercifully, on ground floor; as they made the rounds of other galleries, Lismer would gallantly intercede with each elevator operator on Emily's behalf. There was an enormous quantity of art on view in New York that week, and it was probably due to Lismer's guidance that Emily saw much of the best of it.

Abstraction, she had told her audience at Crystal Garden, was art in which "only the spiritual remains."[3] A lot of what she now saw, including the Duchamp, did not meet that definition for her. But some

works—the joyful organic kind, perhaps, like Dove's and Kandinsky's—moved her as powerfully as any art she had ever seen. She had put a good deal of careful study into her Crystal Garden talk, but in fact had seen almost no major abstract art before, except in reproduction. In effect her week in New York was a crash course in modern art, including some that had been produced in Paris while she was there. It must have been a queer experience, rather like meeting for the first time close kin that have been raised in foreign parts.

Harris had given Emily an introductory letter to Katherine Dreier, and after a few missed signals they managed to meet two hours before Emily left the city. For many years Dreier had been at the leading edge of the avant-garde in New York. A painter herself, she was best known as a tireless lecturer and writer, and with Duchamp and Man Ray she had founded the Société Anonyme, forerunner of the Museum of Modern Art. She lived in a posh townhouse, attended by a bevy of footmen, maids, clerks and assorted functionaries, all of whom so thoroughly intimidated Emily that she allowed herself to be conveyed upstairs in an elevator without a murmur. Dreier put another appointment aside and was hospitality itself. But Emily was always half-frightened, half-envious of great displays of wealth and knowledge, and in her description of the visit one can feel her unease at being once again the "colonial," the outlander from the provinces. She played the part to the hilt, as she had in England years before, and took a sly pleasure in making a particularly jejune comment on one of Dreier's own paintings. ("Please, Miss Dreier, why is that carrot stuck through the eye?")[4] It was the verbal equivalent of slurping her tea and eating too much cake.

She was grateful that Dreier had been so "extremely nice" to her, and she dutifully promised to read Dreier's *Modern Art and the New Era* so that she could learn more about abstract art. But after all it must have been a relief to board the train, lean back, close her eyes and know that she was heading back to familiar ground. Dreier had awed her; it is doubtful that New York had. What New York had given her was a wider context for her art than she had known before, spanning everything from Cubism to Social Realism. The diversity she had seen was far greater than any she had known in France, or for that matter in Canada, where art since the early 1920s had been dominated by the Group of Seven. Its impact on her work is not really measurable, though the fluidity and freedom of her later style may have owed something to her memory of these days. And perhaps the example of artists as varied and individual as O'Keeffe, Kandinsky, Burchfield and Dove helped confirm her faith in the power of her own vision. At any rate, she came home believing more strongly than before that isolation was important, even necessary, to her art.

Back in Victoria the quiet fabric of her life rewove itself around her:

her sisters, old friends like Willie Newcombe, Flora Burns and Margaret Clay, and a coterie of little old ladies, very old-fashioned and very English, childhood neighbours and family friends who gathered about her like the straggling swallows of some lost summer. One of time's little ironies was that Emily herself, for all her anglophobia, was turning into a little old English lady. Her soft voice, the accent she had kept while vowels were flattening all around her, even her eccentricities and her humour reminded people who met her of their long-lost grandmothers and aunts in the Old Country.

And there were also some new threads in the pattern, young people who added colour and texture. One was Frederick Brand, a young assistant professor of math at UBC who met Emily in 1932. That year Brand's sister and brother lived in the Doll's Flat, and Frederick often came to visit them, staying in Emily's flat. In 1933 he spent the whole summer there, preparing for graduate work in the east. Since he was home studying, he and Emily spent much time together, lingering over lunch on the veranda or talking long into the evening in the studio. Except for one sharp quarrel over the bathroom, their friendship was tranquil; so much so that Brand, recently asked to describe it, at first remembered nothing but "pleasantness and calmness, I would even say peacefulness." It was only afterward that he recalled the "turbulence that was always there in her character," and the temper which was never unleashed directly at him.[5]

Brand tried hard over the years to further Emily's career, by arranging for her work to be shown at the university and by reading her stories to his students and showing them to a prominent literary scholar, Garnett G. Sedgewick. In 1934 he married one of her closest friends.

Brand was one of several young bachelor tenants who enjoyed Emily's particular favour. Another, Henry (Harry) Rive, lived with her several years and was the original of the "big, pink and amiable" bachelor in the story "Lower West."[6] Like Brand's, his friendship with Emily was unruffled, and it included his wife when he married and became a permanent neighbour in James Bay.

Another favourite was Philip Amsden, the bachelor of "John's Pudding."[7] Amsden moved in in 1929, at the age of twenty-three. He stayed six years, throughout the worst of the Depression, often taking meals with Emily and generally enjoying being clucked over, for he was homesick for England and his mother. When he lost his job she lowered his rent and promised him that whatever happened, he would not be out on the street. In return he donated his worn-out trousers for her rugs and helped with small odd jobs. He was a comfort to have around in those years, when many of her tenants seemed like throwbacks to World War I: meaner and leaner than those in normal times, and a shade less honest.

Two other young men, who passed through briefly but left a lasting

impression, were German tourists who showed up at her door one day in 1929 with an introductory letter from a New York acquaintance. After they met Emily their two-day stay in Victoria lengthened to two weeks, and there were frequent excursions and picnics, when the three of them would sit on the grass and read Whitman aloud. Emily always remembered the pair with tenderness, and even at the height of the Second World War would carefully separate her hatred of Hitler from her wish to think well of Germans in general.

It has often been remarked that Emily could be very stiff and cold to young men, but all these friendships belie that claim. What she could not tolerate in young men was direct competition. That thorny issue did damage her friendship with three other men in their twenties, all from Victoria. The first was Max Maynard, a schoolteacher in the process of becoming a painter. He had known Emily's work casually for some time, but nevertheless when he walked into the Crystal Garden show in 1930 the impact of it hit him almost like a physical blow: "I was bowled over. . . . I'd never been so moved by paintings in my life."[8] The next day he was back with two companions, Ira Dilworth and Earle ("Bunny") Clarke, who taught English and art, respectively, at the high school. Neither of them could see what Maynard was so excited about. Clarke, aping the standard Victoria response, made a great show of shielding his eyes with his hands. Dilworth, who a decade later would become a central figure in Emily's life, was clearly indifferent to the pictures. Maynard did not care what Clarke thought, but Dilworth was a close friend and a cultural touchstone, as he was to many young men in Victoria, and Maynard tried hard to argue him around. It was no use; the noisier Maynard became, the more Dilworth resisted, and finally he left, unconverted, with Clarke in tow. Maynard, lingering behind, found himself confronted by a stout little woman dressed in homemade clothes, her wispy grey hair done up in a net. She had been following and listening, and now she introduced herself as Emily Carr and invited him to her studio.

For a while they got along very well. Maynard came once a week or so, and Emily always was ready with a fresh store of boarding house tales and a new canvas or two to show him—a privilege still accorded to very few. Later he brought two other young men, friends, Jack Shadbolt and John McDonald. Shadbolt, at twenty-one, was a serious painter but had no formal training. McDonald was an art-lover and a close friend of the other two. They all became thoroughly swept up by Emily's work and thought her the most original artist working in the province, and they acknowledged her influence in their own art. They were, in short, the kind of fresh, dedicated, independent young painters she had called for publicly more than once.

It was their independence that undid the friendship, that and the fact

that they were men. With minor changes, it was Mark Tobey all over again. These men had that same careless, male confidence; and since they were only boys—"young puppies," Emily called them—the problem came down to their presuming an equality she was not ready to grant. At their age Emily had still been an apprentice, a modestly competent art teacher with years of study still ahead of her. Confronted with Harry Gibb's work at the age of thirty-eight, she had been tongue-tied for fear of showing her ignorance. But Maynard, though he had never studied and rarely asked for criticism himself, was quite ready to criticize Emily's work after he had known her a short time, and he was genuinely puzzled and hurt when he was "cut back, cut down, very sharply."[9] The same was true with Shadbolt and McDonald, and once when Emily caught McDonald peeking at a canvas without permission she ordered him out of the house. Later on, when she began to detect signs of her influence in the work of the men, she would convince herself that they were stealing from her. Another artist Emily's age might have been flattered, but she simply could not believe, even now, that she could afford to be generous.

All this happened over a period of several years, so that it is hard to say just when a definite chill set in. Looking back later, Maynard thought he had sensed hostility from the very beginning: "Emily didn't accept men readily. She resented them, in my opinion, and in particular, she resented younger men who seemed to show any sign whatever of talent."[10] That was true enough. On the other hand, it did not help matters that Maynard, who was very literary, often affected a pontifical manner; or that Shadbolt tended to intellectualize about art and, as Emily would put it, "spout art jargon." Nor did it help that Maynard announced to Emily his low opinion of women painters in general, to which he was graciously inclined to make her an exception.[11] She was not particularly grateful for that distinction, though she did try to take a larger view: "Sometimes I think I won't ask him to come over any more but if he can take anything out of my stuff (and he does use my ideas) maybe it's my job to give out those ideas for him and others to take and improve on and carry further."[12] But as time went by her resentment won the upper hand. It was no great compliment, after all, to be thought a freak of nature, rather like one of Dr. Johnson's women preachers. (Of whom the good doctor said, "A woman preaching is like a dog's walking on its hinder legs. It is not done well; but you are surprized to find it done at all.")

Later, like Tobey, Maynard would be surprised at the bitterness against him that surfaced in Emily's journals. He took it as something peculiar to her, part of her eccentricity. Yet the difference between them was more cultural than individual; Emily came up against the assumption of male superiority many times, and how she dealt with it depended,

in the long run, on whether she perceived it as a direct threat or just a general nuisance.

One man whose attitude resembled Maynard's was John Davis Hatch. In a letter written in 1934 he compared Emily's art to the writing of Gertrude Stein: both had "a certain vigor—solid and honest stuff." But as for women artists in general, "I do not or did not believe women were made to be truly great creators—The entire field of painting produces only Berthe Morisot, Le Brun and Mary Cassatt—all have a distinctly feminine quality of charm in their work though basic stuff is at the foundation (with the exception of Le Brun)." As for writers, "Mme de Stael alone had an intellectual contribution."[13] Emily let this slide by and remained friendly. Hatch was not a painter, and by 1934 he lived thousands of miles away. Maynard, on the other hand, was trespassing on her own turf, and she reacted accordingly.

Unlike her fitful friendship with the three men, Emily's friendship with the painter Edythe Hembroff ran smoothly. Edythe herself has told the story of their meeting many times: how Emily saw a newspaper notice about Edythe in 1930 and, struck by parallels between Edythe's art studies and her own, called her up. They met first at one of Emily's garden parties, always very mild and proper affairs, if one discounts Woo filching the odd sandwich.[14] It was not until later that Edythe saw the paintings—the power and originality of which she immediately recognized—and came to know the full complexity of Emily's nature.

On the face of it, theirs was an unlikely friendship. Edythe was only casually fond of animals (though she had a dog) and as indifferent to native people as most Victorians her age. She had little feeling for nature, preferring to paint portraits and still lifes, and did not give much thought to religion. She was gregarious, attractive and fond of clothes—all traits which often put Emily off. Coming from a thoroughly conventional, middle-class home, she was unsettled at first by the perpetual clutter of Emily's studio and the unmistakable animal smell that wafted from corners.

But after a while, Edythe hardly noticed Emily's eccentricities. She thought of her as a proper, old-fashioned lady at heart, and she was surprised that this woman who was rumoured to be outrageous was really so very "normal."[15] A mild-mannered person herself, she never provoked the full force of Emily's temper, though she saw it directed at others. She responded to Emily's humour and honesty and tried to follow her exemplary artistic discipline. Emily, for her part, needed a friend who cared about art but would not compete with her, and if the friend was someone she could play "Mom" to, so much the better.

For about three years, except for Edythe's occasional absences, the two worked together almost daily. For courtesy's sake they tried each other's kind of subject: Emily spent two winters painting studio portraits with

Edythe, and in summer Edythe would follow Emily to the woods and
obligingly try to develop a rapport with trees. As Emily grew fonder of
Edythe, she grew more and more critical of Maynard and Shadbolt.
They all belonged to the same societies and competed in the same exhibi-
tions, and Emily kept a sharp eye on their progress. If Edythe won a
prize and the men did not, Emily crowed loudly. If the men won instead,
or if they failed to take proper notice of Edythe's work, she flared up.
"My advice is to just leave them *alone,*" she fumed after one real or imag-
ined slight. "Let them know you are paddling your own canoe and it's
too full with good stuff to take them aboard. How I do rant on! But, I'm
sick of those three."[16]

Like Fred Brand, whom she married in 1934, Edythe actively pro-
moted Emily's work. In 1933 she participated, along with Emily and
Maynard, in an exhibition at the UBC Library, arranged by Brand
mostly for Emily's sake. In 1934 and again in 1938, she and Brand ar-
ranged for Emily's work to be shown again at UBC;[17] the 1938 show
was a solo exhibition. A few months after she met Emily, she organized
and collected a public subscription—no easy task in the Depression—to
present Emily's *Kispiox Village* to the provincial government. The pic-
ture was the first Carr work owned by the government (and the only one
till after Emily's death), and the $166 it brought allowed Emily to go to
the Chicago World's Fair that fall.

After the Brands married in 1934 they moved to Vancouver, and the
friendship was carried on through letters and occasional visits. There was
a sharp falling off in the early 1940s because of Emily's jealousy of
Edythe's family. But while Edythe was in Victoria she became the only
artist Emily ever worked happily with on a sustained basis, and by the
time she left, the two had taken three summer sketching trips together.

But before they began Emily went back north by herself once more. In
mid–August 1930, four months after her return from New York, she set
off for northern Vancouver Island. She went by way of Vancouver, in-
tending to spend an afternoon with Sophie.

Sophie was not there when she arrived. The house was deserted, the
gate nailed shut. The man next door said that Sophie and her husband
Frank were off picking hops, but Emily was worried. She waited a while
in the Catholic church next door and finally called on Sara, Sophie's
rheumatic, semi-invalid aunt, to see what she could find out. "We'd a
great talk," she told her journal, "and then we spoke of Sophie the news
is bad. Sophie is drinking and worse. Tho [Sara] is Sophie's aunt she has
nothing to do with her now. I wondered how much was true." Later the
village priest confirmed it all, "only worse. Sophie is a prostitute. She is
drinking hard. . . . Sophie that told me that she loved me like a sister and
that I loved and believed it. . . . She has lied so hideously and sunk so
low and there is nothing one can do."[18]

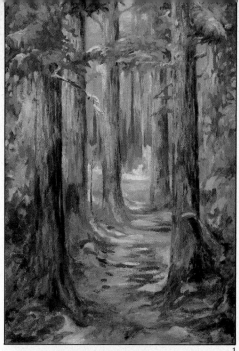

1. *Winter Moonlight* (*Stanley Park*), 1905–10, oil on canvas. Collection of Glenbow Museum, Calgary, Alberta. 56.7

2. *Landscape with Tree,* c.1912, oil on canvas. Collection of Glenbow Museum, Calgary, Alberta. 56.23.5

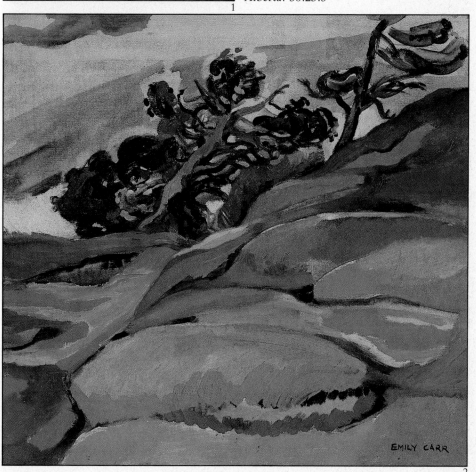

EMILY CARR

2

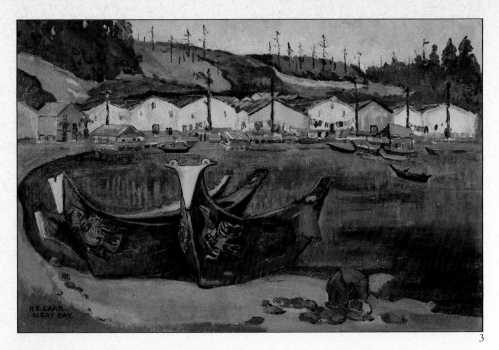

3

3. *Alert Bay*, 1912, oil on canvas. Private collection

4. *Totem Mother, Kitwancool*, 1928, oil on canvas. Emily Carr Trust. Collection of
Vancouver Art Gallery

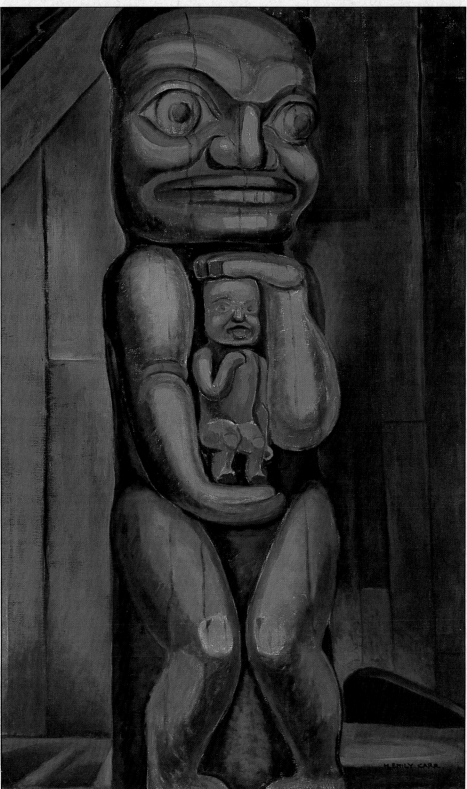

5 6

5. Untitled, 1928–29, charcoal. Emily Carr Trust. Collection of Vancouver Art Gallery

6. Untitled (Tree), 1931, charcoal on paper. Emily Carr Trust. Collection of Vancouver Art Gallery

7. *Forest, British Columbia,* 1931–32, oil on canvas. Emily Carr Trust. Collection of Vancouver Art Gallery

8

8. *Forest Landscape II,* 1931–32, oil on wove paper. National Gallery of Canada 5042

9. *A Rushing Sea of Undergrowth,* 1935, oil on canvas. Emily Carr Trust. Collection of Vancouver Art Gallery

EMILY CARR

10. *Strait of Juan de Fuca,* c.1936, oil on paper. The McMichael Canadian Collection. Gift of Dr. and Mrs. Max Stern. 1974.18.1

For all Emily's revulsion against sex and her genuine pity for her friend, it was the lie that stung most. For eighteen years she had seen Sophie as a kind of native Madonna, all stoic tenderness, bearing and burying her babies as regularly as the seasons. She had seemed so strong and balanced, accepting life and grief alike without denial, as smooth and symmetrical as one of her own baskets. It was that wholeness Emily especially loved, seeing in it all she most admired in native people. Now Sophie was only another human being, as fragmented as anyone, and for the moment Emily was brought up hard against her own ideals. But if Sophie had lied to Emily, Emily had at least conspired in the lie out of her own necessity. In the end the friendship survived, and Emily always spoke and wrote of Sophie afterward as if nothing had happened.

The trip that followed was a kind of farewell to the native. In future years there would be no more rigorous, lonely excursions north. Not only was Emily's own art changing, but the last of the poles and old villages were disappearing. She revisited Alert Bay and then travelled around the tip of Vancouver Island to the villages of Quatsino Sound, where she had never been before.

Somehow Emily's voyages always seemed to begin and end at night. She arrived at Quatsino at night, sitting on a mail sack on the deck of an asthmatic little mail boat with her back against a barrel and Koko on her lap, fighting nausea and headache, wondering about the letters in the sack and the people who sent and received them, and worrying about the faltering engine, the darkness of the night and the competence of the drunken engineer. Presently the soft thump of bow against pier told her they had reached the landing. Emily gathered her things, paid her dollar fare and followed an old man up a steep bank and through a cow gate to the hotel, where a plump, friendly woman showed her to a room. It looked clean enough (though in the morning she would find that someone had been sick behind the bureau), and after making Koko comfortable on her oilskin coat she lay down on the bed. Her head was still throbbing, but someone had left three books in the room, and she took an aspirin and nodded off over a copy of *A Vindication of the Life of Lady Byron*.

As usual, transportation was hard to come by in the sleepy summer season, and Emily spent a lot of time waiting on piers and beaches for boats that were coming "Bye'm'bye." But she had one memorable, almost surrealistic experience. It tied in oddly with her first trip among the Kwakiutl, in 1912, when she had watched the night out at Gwayasdums and encountered, for the first time, the figure of DSonoqua. That figure, terrifying and frankly meant to terrify, had special significance for her. She had looked for other versions of it many times, but had seen only one. Now she thought she had found another in a single figure, a house-post of a burned-out lodge in a deserted village. In fact, the figure was

not DSonoqua at all and was not even female,[19] but it pleased Emily to
think so, because it was a DSonoqua transformed. There was a dignity
and serenity to this figure that balanced out the horror of the legend and
brought it to a peaceful resolution. She saw in it the other face of the
witch-figure, a "singing spirit, young and fresh . . . graciously fem-
inine."[20]

The village itself belonged mostly to the old DSonoqua: "creepy,
nervy, forsaken, dank, dirty, dilapidated,"[21] oozing a stench of nettles
and rotting wood. And it was full of cats. Emily, of course, loved cats,
but to come upon a small army of them in this wild, deserted village,
curling and purring about the very feet of the legendary woman of the
forest, was an uncanny experience. Native cats usually learned the fine
art of making themselves scarce very early, but these—there were six at
first, eight when she returned the next day—were aggressively friendly,
rubbing against her ankles, tripping her up when she walked, pressing
close to her when she sat to sketch. On the second day they were joined
by two hens, a speckled pullet and a large, fussy matron whose chicks,
Emily guessed, had made a quick meal for the cats.

Koko accepted them all, and when Emily beat her way into the woods
to sketch, the whole troop straggled along, demystifying the forest,
tweaking the hem of its dark robe, making this corner of it into a harm-
less barnyard annex where a hen could stretch out in the sun and take a
dust bath. It was eerie and touching and a trifle absurd, as if some fixed
order of things had gone awry and some ancient balance of terror had
been tipped ever so slightly in favour of the comic. And always the real
forest hovered at a little distance, "full of unseen things and great si-
lence,"[22] harbouring the panther as well as the deer, harbouring
whatever had given rise to the original fierce, lawless image of the
Gwayasdums DSonoqua.

In a series of sketches and paintings of the village, Emily tried to ex-
press the weird, solemn comedy of those two days. In the canvas *Zuno-
qua of the Cat Village,* the heads and eyes of cats emerge here and there
throughout the dark, surging waves of underbrush, while the totem,
half-turned to the left, gazes at some far-off point that has no reference to
either the picture or the viewer. It is an oddly disjointed painting, neither
fantasy nor reality and lacking the coherence of true surrealism. In a sec-
ond painting, *Strangled by Growth,* the cats are gone and the mood is
melodramatically evil. The figure, reverting to the true DSonoqua,
glares malevolently through writhing, semi-abstract bands of foliage.
Like *Cat Village* this is an untypical painting, an attempt to realize an
extraordinary experience and an attempt, too, to test once more the
limits of an established style. Both may reach back to her experiments
with Tobey or to paintings she had seen in New York. But the work of
the coming decade would take her in quite a different direction.

CHAPTER
25

"My Aims are Changing"

"MY AIMS ARE CHANGING," Emily wrote as she worked on the Cat Village series. "I feel lost and perplexed."[1] The early 1930s would be years of inner struggle and expansion on all fronts—spiritual, artistic and emotional. She painted the last of her best-known native canvases, among them *Big Raven, Vanquished* and *Blunden Harbour,* and the first of the rhythmic, swirling landscapes of her later years began to emerge from her brush.

Spiritually she plunged into a time of intensive religious searching that brought her suddenly back to Christianity. From scorning all worship in churches (unless they were empty ones) she became an exemplary church-goer, though the churches she chose were a far cry from those she had been brought up in. Victoria offered a surprisingly wide range of unorthodox places to worship, from the Pentecostal Assembly to the British-Israel Association. There was also a succession of lecturers who spoke on the application of Christian thought to problems of everyday living. Emily attended several of these series, and through a friendship with Dr. Emma Smiley of the Victoria Unity Centre she was especially drawn to services and speeches there. She regularly heard W. Newell Weston, LL.M. (billed as "Metaphysician, Educator, Author"), who spoke at the centre several times a week in 1932–33. Nondogmatic, practical, emphasizing the sense of an all-pervasive divine spirit, the beliefs of Smiley and Weston helped reconcile Emily's native mysticism with the personal, comforting elements of Christianity she needed to keep.

Her new piety gained her no credit with Lizzie, who did not see why, if Emily was going to make amends to God, she could not do it with the Episcopalians. To Lizzie, the kind of Christianity Emily brought home from the Unity Centre hardly deserved the name. It was all mixed up with bits and pieces of paganism and, except for a kind of born-again, Southern-Baptist fervour, was hardly different from Unitarianism. Emily seemed to like it because it put God among the trees (and among

the pigs and chickens, if it came to that); Lizzie held that God was in Heaven, where He belonged, and that after creating trees on the third day, and pigs and chickens on the sixth, He had left them very much to their own devices. To confuse the Creator with the creation, as Emily did, was close to blasphemy. When she said as much to Emily, Emily retorted that Lizzie's God was "small and mean" and not worth all the fuss that was made over Him.[2]

What Emily gained from Weston and others was a wide-ranging, liberal kind of Christian transcendentalism, a faith centred on the individual's communion with the divine and open to almost any means, from meditation to vegetarianism, that might contribute to that end. In a broad sense it was not very different from theosophy, and it did not, in itself, set up any division between Emily and her theosophical friends back east. But it was explicitly Christian, affirming a God both pantheistic and personal, a God who heard (even if He did not answer) petitionary prayer. Christ was divine, yet divinity in the world did not stop with Christ; he himself was evidence of an extended, universal Incarnation.

Outwardly Emily was much the same as always. She did not go about proclaiming her new faith to everyone, if only because that was exactly the sort of thing Lizzie had always done. But one has only to look at the devotional passages throughout the journals of this period to see that the inner effect was profound. All the old contradictions seemed resolved, and she did not have to deny the spiritual presence she found in nature in order to talk to God as freely and as confidently as a child. God was in the trees, in herself, even (though it was hard to remember) in her tenants; God could be depended on for practical help, like the strength and patience to get through spring cleaning.[3]

Her reading began to include devotional titles like *Christ in You* and *In Tune with the Infinite*. She steeped herself in Emerson, Blake and (always and especially) Walt Whitman, whose earthy, athletic sexuality did not offend her, possibly because she managed to construe it as something else. (D. H. Lawrence, on the other hand, offended her mightily, though for a while she was drawn to his celebration of a universal life force.) She was reading on art as well, copying down passages that especially touched on her own experience, like this one from Horace Shipp: "Aesthetic pleasure is our joy in [the] assurance of a universe harmonious beyond the power of accident, united in rhythm, which finds echo in our own minds and feelings. It is our appreciation of the thinness of the veil between the finite and the infinite."[4]

Art and religion, which for Emily had always been joined in feeling, now were joined in thought as well. God was the Father and God was the spirit upon the waters; God was, in fact, whatever she needed Him to be at the moment. Everything seemed miraculously explained, miracu-

lously simple, and art was what she had always felt it was:

> Art is worship—all life is God manifested, or the Christ. Art is a seeking
> for the Godlikeness, the symbols of God. Beauty, strength, light, love,
> breadth, sweetness, abundance, substance, these and more working to-
> gether to make a complete, satisfying whole. It is the Soul seeking after
> God to worship him in spirit and in Truth.[5]

Her customary meditation before a sketching subject, which had
chiefly meant waiting for the scene to visually clarify itself, now became
a spiritual communion:

> Method of working—Sit quietly and silently acknowledge your divinity
> and oneness with the creator of all things. Enter the silence and feel your-
> self pivoting on the one source and Substance God. When you are
> permeated with this feeling of oneness with the creator regard that which
> is before you till some particular phase of it arrests your attention and then
> form your Ideal, thinking deeply into it, seeing God in all, drawing the
> holiness of his Idea to you and absorbing it till you become one with it, and
> at home with your subject. Relying on your intuition, which is the voice
> of God to lead you and to tell you step by step how to proceed. The work-
> ing will come through the Spirit.[6]

A passage on rhythm in Mary Cecil Allen's *Painters of the Modern Mind*,
which she might have slid right over a year or two earlier, now spoke of
universal correspondences (the emphasis is Emily's):

> Art is a *symbol of the changing continuity of visible things*. The painter has to
> endow everything *with life* and how to do it is his constant problem. He
> *draws no distinction between animate and inanimate life*, to him *everything IS
> alive* and he calls this life *RHYTHM*. . . .
> 　The *sensation of rhythm is brought about by the undulations of line which even
> in its most intricate windings must maintain a seemingly inevitable series of
> changes from one curve to another. It must appear organic*. . . .
> 　*Rhythm is brought about by a mental grasp of the INEVITABLE RELA-
> TIONSHIP OF ONE ELEMENT TO ALL THE OTHERS, not by the
> cunning and forcible piecing together of different elements which is the function of*
> [mere] DESIGN. *It creates a* SYNTHESIS so *closely knit and so organic that
> it obliterates the impression of the several parts or movements and presents ONE
> COMPLETE AND LIVING STRUCTURE*.[7]

All this fed into the development of a new style, altogether different
from the controlled, formalistic style of 1928–30. Rhythm becomes the
most important, most recognizable element in Emily's pictures. The

solidity and mass of her earlier work dissolve under light, spare, feathering brushstrokes that unite everything in one continuous flow of movement. Space becomes a different kind of space, no longer carved out by the objects it surrounds but merging into them and lifting them into its own, living momentum. For a time the two styles existed side by side: the earlier style continued unchanged in her native works right through *Blunden Harbour,* while the newer one began to emerge in her 1931 Cordova Bay sketches and the many studies she did of young, vibrant, second-growth forest. Occasionally both were brought to bear on the same subject, as in the reserved, monochromatic *Grey,* which looks back to 1929, and the relatively unbuttoned *Little Pine,* which looks ahead to the mid-1930s. Sometimes they were joined uneasily in the same painting, and a stand of busy young pines would be swaddled into tight, rigid little cones, like children squirming in last year's castoffs. The most successful of these transitional paintings were the "tree trunk" pictures she painted in 1931: sombre, graceful studies of the cedars at Goldstream Park, they unite the depth and mystery of her best native work with the softer, subtler, more fluid line and colour that lay ahead.

If religion was at the centre of her new style, there were other forces at work as well. One was Emily's discovery of a new sketching medium that answered beautifully to what she was trying to do. She was still working in charcoal, and her sketches at Goldstream are among her most impressive in that medium. But in 1932 she also began sketching with oils on paper, thinning her pigments with gasoline and using high-quality housepaint for her whites, sometimes combining paint and charcoal in one sketch. For paper she used plain manila, bought in big sheets and torn in halves or quarters. From now on the spontaneity and vigour of her sketches often outshone her finished canvases, and she would never, even in the hardest times, be cramped by worry over how she would pay for materials.

Another change was the nature and frequency of her sketching trips. The physical hardship and brooding immensity of the north was behind her, and instead there was the intimacy and freshness of the local woods, which became the primary subject of her art instead of a kind of understudy that filled in on odd days. Here religion and circumstance dovetailed perfectly; for circumstance had been nudging her towards her own woods for some time, while religion suddenly lit them up like revelation. Added to that was the pure fun of having at last, in Edythe Hembroff, someone she trusted enough to camp with: someone who could talk art with her, who was rugged enough for the backwoods, who would respect her privacy when she was working, who was easygoing, humorous and resourceful, who did not mind the dogs and at least tolerated Woo and Susie.

In 1931–32 Emily took five local sketching trips, three of them with

Edythe and two alone. The two solo trips were the least successful. In the fall of 1931 she sketched in the Sooke Hills near Victoria as the guest of an old girlhood friend, Maude McVicker. Maude had formerly run an antique shop in Victoria, where she had sold Emily's pottery, and here in Metchosin she and her husband raised purebred sheep. A good deal of the wool in Emily's rugs had come from the McVickers' farm. Emily never could stand to be long in her old friend's company; they were no sooner in the same room than they quarrelled. This time, however, Emily was lodged in a cottage separate from the main house, and for that reason she was able to work. She could not help overhearing the scraps between Maude and her husband, though, and for that reason came home feeling edgy and tired, reflecting (with an irony that completely escaped her) on how hard it was to put up with other people's "hideous uncontrolled tempers."[8]

That was the first solo trip. In June 1932 she spent a few days in a farmhouse near what is now Mount Douglas, but the weather turned very wet, Emily caught a cold, and she gave it up.

The three trips with Edythe were all happy and fruitful. Except for one minor clash over where the teaspoons were kept,[9] the two camped together in harmony, sharing their quarters with five dogs and Woo. For their first trip, in early May 1931, they shared the Hembroffs' comfortable summer cottage at Cordova Bay. The second trip, in September 1931, took them to a not-so-converted garage at Goldstream Park, where the glory of the giant trees nearby made up for the bleakness of their shelter. For the third, in May 1932, they accepted the use of Maude McVicker's hunting lodge on Braden Mountain in the Sooke Hills. (See Appendix 3.)

None of these sites was more than a few miles from Victoria, yet each had a distinctly different character. The Hembroff cottage was set among hemlocks in a straggling summer colony overlooking the Juan de Fuca Strait. Emily worked in the woods, but they were a bit too domesticated for her, and it was the fine, curving beach, cluttered with silvery driftwood left by the winter's storms, that produced her best sketches, most of them probably done later in her studio.

On the third trip, at Braden Mountain, the two friends found themselves high above sea level, enclosed by silence and the sleepy sounds of insects and birds, by the rounded shoulders of the Sooke Hills and by dense, shadowy forest. Edythe recalls that Emily made the sketch for her well-known monochromatic painting *Grey* on this trip.[10]

At Goldstream Park the busy, shallow little Goldstream River has cut a narrow valley between steep, fir-covered hills, and on the flats beside the stream grows a magnificent grove of giant cedars, their warm red bark veiled here and there with silvery-grey lichen. Sunlight filters through their shaggy branches and kindles a crown of ferns here, a nurs-

ling tree there, and hummocks of velvety, emerald-bright moss. From their garage shelter up the road Emily and Edythe would walk to the grove each morning and spend the day sketching, picnicking at noon on the riverbank while the dogs dozed in the shade and Woo dug among the roots for grubs. A footpath meandered through the trees, never out of earshot of the river, which was as full of music and sunlight as the trees were full of shadow and silence.

All these factors converging in her life at once—friendship and the sketching trips, a new medium, a religious consciousness such as she had never before experienced—contributed to a view of art that was, finally, as exalted and serene in its way as Lawren Harris's. Yet the styles of the two painters, once so similar, now began to diverge. By the mid-1930s there would be no visible parallels left. Although Harris shifted from landscape painting to abstraction, his style remained essentially the same. Emily, staying within landscape painting, achieved a final, radical transformation that sharply distinguished her late work from her own earlier work and from that of any other painter.

What she never did achieve was the kind of selfless benevolence that Christianity seemed to call for. She tried to harness her ambition and make herself a perfect instrument, just another voice in that "grand chorus" Katherine Dreier had spoken of. "Cast out the personal," she commanded herself,

> strive for the spiritual in your painting. Think only of the objective. Desire only that the consciousness of the presence of God may show and speak, not as accomplished by you, not as your work, not as having anything to do with you, but being only a reminder and an explainer of the manifested Father, the Christ. You yourself are nothing, only a channel for the pouring through of that which *is* something, which is all.[11]

But however close she came to realizing this ideal in her painting, she never came anywhere near putting her lively, pugnacious ego under lock and key. She strove hard for "right living and a right attitude towards my fellow man,"[12] and told herself she would never "get in touch with, in tune with, the Infinite" without them. She scolded herself roundly for her lapses of temper:

> Damn I'm always . . . bursting forth making enemies instead of friends whirling round in a muck of rage muddying everything and getting all wrought up—how can I ever see straight and clear and search for the good the true and the beautiful when I'm such a wild beast—and yet if I go on just swallowing everything seeing things go wrong and rotten then I ferment inside and that's worse. One must be calm and happy to accomplish. [Amédée Joullin in San Francisco] used to purposely aggravate and badger

me to get the best work out he said. Maybe it was more live work but that is not what one wants. It is deep pure *good* emotions that should underlie our best work, not mean snappy ones—I shall never paint anything *good* I'm just dead bones and venom.[13]

So she would scourge herself into an appropriate state of meekness and quietude, which would dissipate the moment she sensed another slight on her work: the supposed failure of her Seattle show, or Barbeau's report that A. Y. Jackson had called her new paintings "monotonous, uninteresting, dull etc."[14] One particularly sore point was the National Gallery's refusal to buy her paintings. In spite of Brown's encouraging letters, and in spite of the fact that he regularly placed her new work in exhibitions, the only Carr paintings in the National Gallery were the three 1912 watercolours bought in 1928. Brown pleaded hard times, but that excuse began to wear a bit thin after several recent canvases found their way into private eastern collections. At the thought of those twenty-year-old watercolours, all Emily's new, hard-won humility would instantly collapse.

In 1931 Emily's work was hung in several exhibitions, but it was not until December that she showed any of her new forest studies. Three of them were among the paintings she sent east for the 1931 Group of Seven show. Before they left she held an open-house and tea at her studio, not bothering with invitations but simply putting an ad in the paper. Many people came, and to her surprise they seemed to like her new work. "Of course some hated it," she wrote Nan Lawson (now Cheney), "but on the whole many expressed interest."[15] When the canvases arrived in Toronto it was two forest paintings, *Red Cedar* and *The Little Pine,* that drew the most comment from her friends. As usual, the praise reached her chiefly through Harris's letters, and it was Harris who helped her most whenever the thought of her sixty years became too much for her:

You say "Your best work is done before it even got the chance to be good"—that is precisely the feeling of every artist worth bothering about. With you it is not that it is . . . actually true but having started a somewhat new direction in your tree subjects, you, nor any[one] else can hardly expect that you will achieve a complete fullness of expression immediately. . . . Then you say "you guess you're through"—what nonsense. You're just beginning a deeper search into the fundamental life in trees and forest and nature in her deepest, most secret moods and meanings and to expect to perfect in terms of paint a complete equivalent of your deeper approach short of years of on-going slugging is to ask too much. . . . Now, again and again, no one in Canada or anywhere else is doing what you are doing. . . . For goodness sake, do keep on despite any temporary discouragement or anything else.[16]

Harris himself had reached an impasse in his painting, which he fought by doggedly reworking old subjects. When he admitted as much to Emily, it was her turn to send words of comfort ("a noble letter," said Harris "[that] moved me much").[17] She was also worried on her own account, for Harris was such a solid bulwark that if his spirit failed she thought hers would as well. But neither of them failed. Harris painted very little in 1932, though eventually he would emerge from his crisis as an abstractionist. Emily too painted little that year, not because of Harris's block but because she needed, as she put it, to "swim underwater" for a while.[18] And as it turned out, the Depression left her very little time for painting anyway.

Emily began to feel the financial pinch in 1931, when she was forced to lower rents. The house was almost her sole source of income now. She had given up her annual pottery sales, and she was letting her pictures go to friends and neighbours for $5 or $10 apiece. She had almost stopped breeding griffons, though an occasional litter of puppies still brought in a few extra dollars. Thanks to Philip Amsden, she had a tiny, steady income, though even he paid less rent than he had before. She took tenants into her own flat when she could, but renting the two main flats downstairs became more and more chancey, until in 1932 she was unable to rent them at all. They stood empty all summer and fall, giving Emily a very high-priced vacation. But she had had an idea germinating in her mind for some time, and now she decided to do something about it.

She wanted to open an art gallery—not an ordinary commercial gallery, but a natural extension of the park next door, meant for the families who walked there, people of "all classes, all nationalities, all colours."[19] She saw it as "a warm quiet nook to drop into on these dull winter days when no band plays. A place one could sit and rest and look at pictures which would be changed every few weeks." On weekdays a small fee might be charged, on Sundays admission would be free for everyone, and Saturday mornings would be saved "specially for the children."[20] There could be short lectures and study groups, and a special effort might be made to help young, unknown artists. Above all, she wanted it to be a gallery for people who normally were a little afraid of galleries.

The "People's Gallery" campaign is fascinating because it was so very untypical of Emily. Here she was, the lifelong iconoclast, the queer grumpy lady on Simcoe Street with the monkey, suddenly throwing herself heart and soul into politicking and fund raising for the good of the common man. Economics was the spur that set her going, for if the gallery could be funded at $95 a month, she would be almost free of land-ladying. But the vision itself meant a great deal to her, and the reasons were various. Probably religion had something to do with it. Emily was very well aware of her shortcomings as a Christian, and to do something for the public good would help balance the scales a little. Then there was

the old grudge against her own class, her own family, her father and her sisters: the People's Gallery idea was a calculated slap at one potent symbol of all that, the Island Arts and Crafts Society. There was no place for muddy boots and dirty fingernails at the Arts and Crafts exhibitions, and Emily had always liked to think (from a safe distance, anyway) that people with muddy boots and dirty fingernails were the only *real* people around, except for children and natives.

In December Emily publicly launched the gallery idea with the energetic help of a number of friends, including Edythe Hembroff, Max Maynard and Jack Shadbolt. She began by installing a connecting door between her two empty flats and holding an exhibition on 14 December. She hung her own works in one room and the two kitchens. The other three rooms were given over to three other painters, all safely conservative so as to draw in a moneyed crowd. One was Annie Bullen, a granddaughter of Sir James Douglas, who had just returned from England with a portfolio of English cottage scenes; one was Robin Watt, a portraitist; and one was Lee Nam, a young watercolourist who had walked into Emily's studio off the street one day and introduced himself.

At 8:15 in the evening of 14 December, the day after Emily's sixty-first birthday, some forty people met to view the exhibition and consider the gallery idea. Among them were several city councillors. Emily made a short speech, asking for donations, "moral support and mothering,"[21] and a committee was formed to look into financing and administration. The Victoria press gave the project full and sympathetic coverage, and the next day Emily wrote to Eric Brown in high spirits: "People were pleased with the rooms and the exhibition and it looks to me as if it may go through. . . . A lot of people came and [for Victoria] were *quite keen* really enthusiastic and *want* it."[22] Brown quickly replied that if Emily could get her gallery, the National Gallery would "do everything in its power to help it along by sending it exhibitions and so on."[23]

During her campaign Emily approached all the municipal heavyweights she could think of: the mayor, the superintendent of parks, the lieutenant governor, the Women's Canadian Club. The exhibition was reopened for three days in late December and two more meetings were held, but by mid-January it was clear that although there was plenty of interest, it was not, as Emily put it, of " 'pocket' intensity."[24] It was heartbreaking to see the early enthusiasm crumbling, for if fewer than two hundred people or groups had pledged $6 a year the plan would have gone through, and Emily would not have had to beg from the heavyweights. As it was, the heavyweights sat themselves firmly on their wallets. For good measure the lieutenant governor pointed out that if only the plan called for a new, fireproof building on a city lot, "he *might* be willing to lend us a set of 'Dürer drawings' he had—He knew at least 20 people in Victoria who would subscribe $500.00 each."[25]

So even though times were hard, there was money around for selected worthy causes. But one had to know how to prove one's worthiness, and the thought of Emily, all done up in her best homemade black, perched demurely on a plush chair and trying to woo some portly burgher into parting with his money, is sad and more than a little ludicrous. It was the only political effort of her life, and she stuck with it until it was absolutely beyond hope. Then she put it quietly behind her. Enough new tenants showed up to keep her from bankruptcy, and the connecting door downstairs was closed up.

It was around this time, partly in hope of making some extra money, that Emily began to go a bit more public with her writing. Flora Burns was still her main critic, but increasingly she asked for comments from Lawren Harris, Fred Housser, Kathrene Pinkerton, Margaret Clay, Edythe Hembroff, Fred Brand and others. Harris learned of her writing for the first time in the spring of 1931 when she sent him "In the Shadow of the Eagle." He urged her to do a book on her experiences among the natives,[26] and two years later he suggested a complete autobiography, "a book of nearly three hundred pages written whenever you feel like it. . . . Let it moil a bit in your head and see if it doesn't suggest something, take shape and demand doing."[27] Emily did not commit herself directly, though after 1931 she began to branch out from native stories to animal stories, and in 1934 she wrote the first story about her childhood, "Cow Yard." By now she had no hesitation about reading her stories to her sisters, who heard "Cow Yard" over tea two days after it was finished. If they objected to her portrayal of them, they were too polite to say so. They said they wanted to see it in print, but they—or Lizzie, at least—took it for a child's story. And of course they missed the point: Emily thought she had written about maternity, the miraculous renewal of life, the terror of death lurking in the ivy tree; Alice and Lizzie only saw a collection of memories centred around Emily and her love for a large, smelly, scary cow. "I guess I failed entirely," Emily lamented. "Well, chuck she goes into the failure drawer, done with."[28] The "failure" of successive drafts was part of the ritual of writing for Emily; a month later she resurrected the story and sent it off to Harris and Housser.

Sometime in the spring of 1934 Emily had a talk about writing with Nellie de Bertrand Lugrin (Mrs. E. B. Shaw), a professional writer whose father had edited the Victoria *Daily Colonist*. The two women had known each other casually for upward of thirty years, and in a 1927 article on women potters Lugrin had given Emily her first notice in a national magazine.[29] According to Lugrin, Emily said she had taken a writing course but had "met only with rebuffs" (which of course was not true). She asked to take Lugrin's summer course in short-story writing at the Provincial Normal School, and Lugrin agreed.

The course ran for a month in July and August, and there were eleven

other students, all teachers. Emily, who took her seat the first day with a typically "defiant look" at her classmates, soon became comfortable and ended up taking top honours. Her story "The Hully-Up Paper,"[30] a fashionably sentimental piece about a native mother and her daughter, was voted the best in the class. She read it, clearly and with no sign of shyness, before an audience of several hundred at the school's closing exercises.

The story is not one of Emily's best, and we can guess something about Lugrin's literary perceptions from the fact that she preferred it to "Cow Yard." She was not geared to Emily's kind of writing, and she regretted that though Emily had "had many interesting experiences which she might have woven into fine romantic tales" (presumably on the order of "The Hully-Up Paper"), she "did not make much use of [them]." Luckily Emily held her ground; she "did not like criticism. She thought that, in spite of her spelling and grammar, there was sufficient merit in her work to find a market."[31]

Emily took another course with Lugrin that winter, this one an adult education course at the high school, but the class lacked the verve and motivation of the teachers and the sessions were so dull that Emily could hardly stay awake. She tried joining a group calling itself the Authors' Association, which turned out to be "mostly old women . . . like me, and a sprinkling of the ugliest men I ever saw."[32] But she was writing steadily, and her craft was perfecting itself from the inside out.

Emily had never approached a publisher except once, in England in 1899, when she tried to interest the firm of Frederick Warne, Beatrix Potter's publisher, in some of her work. Brusquely turned down, she had not tried again.[33] Now, encouraged by Margaret Clay and others, she began to send her stories to magazines, among them *Maclean's, Saturday Evening Post, Atlantic Monthly* and the British *Countryman,* and asked for criticism from something called the International Correspondence Criticism Service. The magazines sent rejection slips, and the criticism service told her her stories were unmarketable. She was only temporarily discouraged. With her writing, as with her painting, she maintained a healthy contempt for the public taste: she didn't "*want* to write that popular mechanical twaddle. . . . Blood and thunder, sex and crime, crooks, divorce, edgy things that keep them on the *qui vive* wondering which way the cat is going to jump and hoping it's the *risqué* way. I can't write that stuff. I don't want to learn."[34] In any case, writing involved a lot less pain than painting. Rejection slips were so impersonal they hardly hurt at all; she would rather have a whole mailbox full than endure a single opening at the Arts and Crafts Society. Besides, writing was giving back to her precious odds and ends of her own life, and (though she did not admit it) allowing her to rearrange them to suit herself.

Elephant Days

EXCEPT FOR HER operation in 1923, Emily had enjoyed over two decades of robust health. It was as if she had gathered together all the petty sicknesses of half a lifetime and suffered through them all at once, in England and France. Even now, in her early sixties, she still kept to the same demanding daily routine, did all the minor repairs around the house, went to writing classes and found time almost daily for an outdoor sketch and a studio sketch. Her annual spring cleaning was impressive. Around February, when she was bursting with impatience to get outdoors and the damp spring still loitered and shivered outside her windows, she would mix up a batch of whitewash and clean and whiten her own walls and those of any vacant flat. Then she would scrub the floors and, if they needed it, scrape them down and varnish them. Curtains were washed and ironed, shelves emptied, stoves, pots and pans scoured, dust kittens in closets ruthlessly hunted down. It was a time for neighbours and visitors to literally "stand from under," for old furniture, used utensils and other heavy discards would come hurtling out the attic window, to be burned or carted away. She did it all more or less alone, though an elderly Chinese handyman helped with the lifting and carrying. Afterward she would collapse in an aching heap of weariness and contentment, which these days demanded a day or two of recovery in bed. There was a delicious satisfaction in tackling and finishing a job with her hands, especially if her painting had been going badly.

Clearly she was almost as tough and sturdy as ever, but there were a few ailments that reminded her of her age: a rheumatic hip, persistent backaches, digestive upsets and sudden, inexplicable moods of depression that she blamed on her liver. In very cold weather or sometimes when she climbed stairs she was bothered by chest pains, the beginnings of angina. She accepted it all without fuss, yielding to the waves of bone-weariness that followed overexertion, though always wary of the fine line between rest and procrastination. Every now and then she fasted for

a few days, living on nothing but fruit juice. It was as much a spiritual remedy as a physical one. She thought it was good for minor aches and pains, and mentally she always came out of it feeling new-washed and light as air. The lightness was all in her head, for her fasting never had any visible effect on her weight.

She had grown a bit deaf. It came in handy sometimes, when visitors came to her studio and made clumsy compliments about her paintings that she much preferred not to hear. But sometimes she really worried about being deaf. Lizzie had no patience with her deafness, and that led to scenes. And Emily feared that her deafness might grow until it shut her off from other people. There were moments when she thought total deafness would be more lonely even than blindness, because it seemed to irritate people so much. Luckily her deafness never grew to be a real handicap, though it was one of several intimations of mortality.

She thought of death more often now, sometimes with a flicker of fear but usually with calm speculation, as a reunion with people and creatures she had loved. "I do not think we shall meet those others as we left them," she mused on the eve of her sixty-second birthday. "I do not think we shall know each other in the flesh, only in the spirit. It will be those who have been akin in spirit here, more than akin in the flesh that will meet and rejoice together."[1] In spite of a growing distance from theosophy, she would always half-believe in reincarnation; it did not seem particularly un-Christian to suspect that she had lived on earth before and would again. She did worry that her work would be cut off before it reached its height, and that fear especially plagued her in the very early 1930s, while her style was still in transition and nothing she painted seemed to satisfy her. The pressure only drove her to more painting, so that in spite of aches, fatigue and growing economic troubles these were gloriously productive years.

Her spiritual calm, even happiness, in the face of death found expression in the growing joyfulness and vibrancy of her paintings. "Movement is the essence of being. When a thing stands still and says, 'Finished,' then it dies."[2] In both substance and spirit, she was painting life itself, affirming it with more intensity and abandon as she grew older. At the same time, the late beach and sky studies, with their great, arched vaults of moving light and space, seem to say as much about death as about life. She sketched on the cliffs at Beacon Hill almost every evening, staying until that mysterious, fleeting time between sunset and dusk when sky, water and beach are suffused with an even glow that seems to have no source but itself.

Paint could be too earthy for what she was trying to express; the single most frequent complaint she had against herself was that she ruined the subtlety of a promising sketch by "loading on paint." She admired the airiness and delicacy of Lee Nam's watercolours, and when he asked her

to teach him replied, with perfect honesty, that he had as much to teach her as she had to teach him. Lee Nam was a part-time artist, without much formal training. His paintings, though rather conventional water-colours of flowers and birds, had an exquisite Oriental economy that Emily could approximate only with a great deal of labour and luck. She has sometimes been accused of patronizing Lee Nam, and it is true that in one sense he was just another of her waifs. But he also had achieved something that was still beyond her, and she respected him for it.

She gave herself more and more time away from home. All through the 1930s and into the '40s she had friends with cars who would drive her into the country on day trips. Philip Amsden and the Brands, among others, cheerfully put themselves and their vehicles at her disposal. Some drivers, mostly the younger relations of close friends, were more or less commandeered: Edythe Brand's younger sister Helen, whose dislike of Emily was cordially returned, was enlisted at least twice.[3]

In the spring of 1933 Emily travelled by rail deep into the mountainous mainland Interior, to the far end of Seton Lake. She visited her niece Lillian Rae at Brackendale, stayed at the Lillooet reserve at Anderson Lake, and enjoyed an unexpected reunion with Sophie, who was visiting Brackendale with her husband. It was a happy trip for the most part, though there was grief in the middle of it when her beloved old Koko failed and had to be put down—shot, in fact, because there was no vet available. Emily threw herself hard into work and brought home a sheaf of sketches, one of which became her canvas *The Mountain*. The painting gave her enormous trouble, more than anything else she ever did. Intellectually she believed the mountain was instinct with life, like all God's works, but she could not feel it. The thing was too cold and solid. It sulked on the canvas like a "great corsetless woman or a sitting pillow":[4] it was nothing but a "bad, horrid, awful, mean little tussock."[5] After months of struggle she sent it to Toronto for exhibition, but it retained a certain lumpish quality.

Immediately after her return an old childhood fantasy came true. As a child she had dreamed of travelling in a covered wagon, like story-book gypsies. Now she suddenly had a chance to buy a metal caravan or trailer, canvas-topped, broad in the beam and a little the worse for having been hauled over the Rockies. She saw it sitting by the road with the For Sale sign, went home and did some careful calculations, and went back the next day and bought it. It became more personage than thing, and she called it the Elephant. Willie Newcombe helped her fit it out with a row of dog boxes down one side, a monkey-proof corner, a built-in table and a shelf for books. Furniture was separate: a bed for Emily, another to set up outside for visitors, three chairs and a hammock. Chinks were tightened and the canvas top newly painted, and on 17 August she had it hauled to Goldstream Park. So began a period of absolute

freedom on her sketching trips, when she no longer depended on the vagaries of landlords and the dubious shelter of tumbledown cabins that nobody else wanted to use. There were, of course, some limits on where the van could be settled, and for that reason it was always beside a road. But people were generous about offering land, and though the van spent each winter out in the country by itself nobody ever disturbed it.

Launching these excursions was an exercise in patience, for the Elephant was only barely movable. Hauling day would begin with Emily, her gear, bedding, food boxes and assorted furniture all sitting on the sidewalk, while four or five dogs milled about underfoot and Woo shrieked and bounced in her cage. Only Susie the rat was calm, safely stowed in the van in an oatmeal carton. Invariably the haulers would be late. Emily would wait with a native's patience, while the faces of wondering neighbours materialized at windows and the milkman, iceman, bakery man and mailman all gave her good morning, chirped at the monkey and picked their way through the obstacles and the friendly melee of dogs. Once the truck came, the business of hauling and jacking up the van took the rest of the day. Then Emily would stow everything away, put up a canvas lean-to, fetch water from the nearest tap or well, gather kindling and saw logs, and build a stove out of scrap metal and rocks. She was especially good at that, finishing it off with a stove pipe finely tuned to the wind. She seldom failed to get a fire going, even with damp wood, though in a thoroughgoing rain she would retreat inside with a smelly little kerosene stove. Woo's cage would be secured in a nearby tree; at Goldstream it was a hollow cedar, a veritable monkey palace complete with earwigs for snacks. By bedtime everything would be set to rights and the animals bedded down, and if weather permitted Emily would enjoy the luxury of an open-air bath by starlight.

She tried to interest friends in joining her for the first trip, but the only person who wanted to come was Henry Brand, Fred Brand's twenty-year-old retarded brother, who was living with his sister Edith in Emily's house. He stayed two weeks with Emily, sharing her delight but also distracting her from her work, until a heavy rain forced her to send him home. Then she turned her full attention to sketching. The great, shaggy, patriarchal cedars were curiously elusive this time; they had not changed since her earlier trip, but she had. She wanted continuous movement, swirling rhythms, universal coherence, yet the patriarchs made everything around them seem irrelevant. They belonged more to the depths and silences of her earlier style. Although she was disappointed in her sketches, the well-known *Red Cedar,* now at the Vancouver Art Gallery, probably dates from this trip and shows that she achieved far more than she knew.

Camping trips in the Elephant were sociable affairs. Emily later claimed she did not encourage visitors, but in fact she had many, espe-

cially on weekends, and she seems to have enjoyed them as long as she had working hours free. She liked to show people how homey and civilized her makeshift arrangements could be. And she always got to know her temporary neighbours. At Goldstream she made friends with "Mrs. Pop Shop," the portly, amiable woman who ran the park food concession, and later with her successor, Mrs. Hooper. There were visitings back and forth with Mrs. Giles up the mountain, whose children played with Henry.

That was all comfortable sociability. Sundays, though, brought massive invasions of tourists that made camp life a torment: "smart automobiles and workmen's trucks, wheezing Lizzies and boys on bicycles. They whooped and yelled and picnicked everywhere."[6] Work was impossible. Emily improvised a studio out of hanging blankets and fallen logs, and people seemed to think her camp—which was right next to the park gate—was a kind of public entertainment. They poked their heads under the blankets, clambered over and around the logs, and endlessly demanded to know who she was and what she was doing. If she left the van unguarded, they took over her campfire and helped themselves to her dishes and her table. The dogs worked themselves into hysterical fits of barking and had to be locked in the van. Woo knew enough to keep well out of sight, hiding behind a little hummock on the riverbank or lying motionless along a willow branch. But that was boring, and one Sunday she amused herself by downing yet another dose of paint. The next day was almost as hard on Emily as it was on Woo, and by now it was clear that the next campsite would be well off the beaten track.

In May 1934 she camped next to Esquimalt Lagoon, in a field full of wide daisy patches and sweetbriar roses, loud with bird songs by day and the croaking of frogs by night. Two weeks later, when a steady rain had made the field too wet for comfort, she moved to the nearby Metchosin Road, where a kindly Scottish farmer offered her a sheltered spot next to his own house. There was "wide happy peace" in John Strathdee's field, and "behind was a great stretch of second growth land, fuzzy young firs with brilliant new yellow tips to every bough, all upward curves and circles."[7] That was the "frivolous wood." Across the road was the "solemn wood,"[8] dim and cloistered, carpeted with deep moss and pale clumps of Indian pipe. The wood sloped down to the sea, and there were "mountains here and mountains there, close ones fir-covered and green, far ones cloud topped and blue as the Heaven that met them."[9] Puppies were born in the van, and black-faced sheep grazed near the wood, beyond the range of the dogs. An unidentified friend stayed with her for two days at Esquimalt, and Alice came with a flock of ladies, bringing letters, cake and cigarettes. Every Saturday John Strathdee's sister Elsie joined Emily for tea after her weekly stint of tidying "brither's hoose." On fine days

Emily was out from sunrise to sunset. On rainy days, or when a keen wind rocked the Elephant and scattered her saucepan lids like thistledown, she would tuck up in bed, her feet warmed by a hot brick in a biscuit tin, and read or write, with long, refreshing draughts of sleep in between. She returned for another month in September; altogether John Strathdee's field gave her forty or fifty sketches, several stories revised or newly written, and eight solid weeks of restful work.

The following year she camped about three miles farther on, at Albert Head, a place of high skies and wide seas, with dense forest nearby. She spent part of May, all of June and most of September there. Her health slowed her down a lot this year, especially in the fall, and she was much bothered by headaches, aggravated by wind and rain. On those days when she felt "liverish" she would paint near the van, from the cliffs or in a little wooded hollow. Edythe came out to sketch with her now and then, and her neighbours the Morleys from James Bay dropped in during some particularly dismal weather. The local people visited, bringing a succession of small gifts—puddings, vegetables, plums and even a lamp wick. It was an isolated place. The early generation of settlers and their children had moved on, and their abandoned farms, worn grey fences and overgrown orchards gave the place a castoff, melancholy air. But on the slopes above the road the woods were lush with greenery, a tangle of salal, briars and infant pine that yielded a harvest very different from that in the sour, parched gardens below. It was a "great, dry, green sea" that would "sweep over and engulf you";[10] it was also "perfectly ordered disorder. . . . A robust grandeur, loud-voiced, springing richly from earth untilled, unpampered, bursting forth rude, natural, without apology. . . . The air calls to it. The light calls to it. . . . There are no words, no paints to express all this, only a beautiful dumbness in the soul, life speaking to life."[11] She sketched it there, despaired, tackled it again and again in her studio. Eventually the complex rhythms of her "jungle sketches" began to find their own harmony. People would not like them, she was certain. But for herself, working alternately on sky and jungle sketches seven months later, she was "keen as pepper."[12]

In any case, by 1936 she had almost freed herself from caring what people liked and did not like. She was amazed at how detached she had become; it was a kind of bonus that age had handed her. Ironically, the praise that she had so desperately needed ten or twenty years before came showering over her now, though mostly she distrusted it or shrugged it off. Even if it seemed honest, she worried that it might make her complacent. Laudatory "write-ups" depressed her. They seemed hopelessly shortsighted and sickeningly sweet. When Shadbolt and McDonald wrote from New York in 1934 offering to try to arrange an exhibition for her there, she turned them down, wanting neither the publicity nor the bother. A similar offer from Mrs. Leopold Stokowski in 1936 met

the same response, as did Mortimer Lamb's suggestion of a show in London. There were exceptions, of course. When the Vancouver painter J. Delisle Parker, fresh from Paris, proclaimed her work "magnificent," she was elated almost in spite of herself.[13] A highly complimentary article by Graham McInnes in *Saturday Night* made her blush. Her paintings, he wrote, were "so striking, so vivid, so full of the real *furor poeticus,* that they are unforgettable." She was "a great artist . . . who is, in her own way, as *possessed* with the creative urge as that powerful and tragic figure of the last century whose name was Vincent Van Gogh."[14] Emily tried not to let it turn her head. "Those things are never *quite* straight," she told herself. "There is a little stuff, and a lot of froth and sentiment."[15] (Mortimer Lamb also gave her an intelligently appreciative article in *Saturday Night,* in 1933.[16] It is not clear what she thought of Lamb's article, or if she knew that Graham McInnes, one of Canada's leading critics, was anything more than a man who had once visited her studio.)

It was still the praise of ordinary people that moved her most. In 1933 and 1934 she had the rare satisfaction of seeing Alice and Lizzie respond to her work with genuine feeling. That meant a great deal, though it does not seem to have lasted. She cared about what Lee Nam said, in his broken English, and she had reserves of time and patience for sympathetic studio visitors. But anyone who was the least bit pompous or condescending, or who pretended to some knowledge of "The Arts," still got short shrift. So did the discreetly silent. Such people drove her to mischief: she would set the clock ahead or turn the rat loose, or she would simply confront them with her most recent, most uncompromising work and scare them off with a "swift eyeful."[17] Yet she might give hours to a beginning painter looking for advice, or to an elderly couple perplexed by the mysteries of modern art.

CHAPTER
27

Consolidation

FOR MORE THAN five years Emily had looked to her eastern friends, especially Lawren Harris, for encouragement and advice. Harris himself had constantly urged her to beware of false prophets and learn to put more faith in her own judgement. Now she really began to stand alone, both artistically and emotionally, and that led to a drift away from everyone in the east, and finally from Harris himself. The process was gradual, but one important step came in the spring of 1933, when she sent a batch of sixteen sketches east for criticism. At that point she was still very uncertain about the direction her work was taking, and she worried that perhaps she was past her peak. Bess Housser took the sketches to a meeting of artists and friends and afterward showed them to several others before passing them on to Arthur Lismer. The comments from the meeting, quickly noted by Bess and sent to Emily, were mostly positive but necessarily brief. Harris, from whom Emily had expected much, was vague:

> [The sketches] are very vigorous, alive and vital. . . . Personally I do not feel that your sketches are subject to criticism. They represent vital intentions and one can only say—"I like this one" or "I don't like it"—and that has no value. They are so unusually individual and so saturated with what you are after perhaps more so than you realize.[1]

The general tone of the letter was enthusiastic, but Emily was floundering and wanted specifics, and she was disappointed. Lismer's comments, sent separately, showed a definite lack of understanding. The sketches were fine "as studies of mood," but he felt they were too large, and that the brush was used "in an accidental way." The very lightness and freedom that Emily strove so hard for seemed to baffle him. "In some of them the world goes to pieces—the ground is not solid. The rocks are spongy and the foliage is wraith like." He complimented their

"big feeling" and their "feeling of power and courageous attack," but it was clear he had strong reservations.[2]

That marked a decisive point in Emily's relationship with the Group of Seven. The group itself was in the doldrums. J. E. H. MacDonald had died the previous year, Lismer's teaching drew him more and more from his painting, and Harris was temporarily blocked. Apart from all that, none of them had ever significantly changed his style. When Emily sent them her sketches they had just dissolved the Group of Seven and formed a new organization, the Canadian Group of Painters. Emily was a charter member, but she would never feel the same about it as she had about the old group. The freshness and daring of the twenties was gone, and what was left was the group's own kind of orthodoxy. Still looking backward themselves, it may have been hard for them to accept significant change in the style of one they regarded as a protégé, and a female protégé at that. In any case, they were clearly out of sympathy, and Emily decided not to ask them again for support. She set Lismer's comments angrily aside, and afterward looked back on that gesture as a "milestone" in her development.[3]

In writing, too, she began to go her own way. Both Harris and Fred Housser had been sending criticisms on her stories, and Housser's had been especially helpful—tough but not bruising. But in 1934, when she sent them "Cow Yard," she got a very lukewarm response. Emily had a strong emotional investment in "Cow Yard," and her sisters had only recently thrown cold water on it. So when Harris simply dismissed it as "fine," and Housser said nothing at all for two months, she reacted much as she had over her paintings. In fact, both men were involved in acute emotional crises. Emily knew nothing of that. She only knew that she would no longer "diddle round as to what this and that one thinks," but rely on herself from then on.[4]

Nevertheless, she had a warm reunion with her friends when, in the fall of 1933, she made her third trip east. Lawren Harris had sent glowing accounts of the international art exhibition at the Chicago World's Fair, and when he wired to tell her that the fair had been held over an extra month Emily, who had been hesitating over the cost, suddenly decided to go. It was expensive, but Lizzie gave her $20 and Alice probably matched it, and Edythe had raised $166 through her drive to buy *Kispiox Village* and give it to the province. On 30 October, after some strenuous preparations that included tying all her valuables around her waist with a corset string and buying an absolutely indestructible hat, she set off.

When she reached Chicago she was profoundly disappointed to find that the art exhibition had been suddenly closed the day before. Pleas to the Chicago Art Institute were in vain; she could not get past the stony phalanx of secretaries at the door. She made the best of it by lingering in the city for six days to take in the sights and the rest of the fair. Then she

fled to Toronto, where she spent nine days as a guest of the Houssers before returning home.

This was the last of her eastern visits, the last time she would enjoy these friendships without any of the shadows that later fell over them. Artistically she had already begun to separate herself from the east, but personally this was a "joyful affair,"[5] for as usual Toronto made a tremendous fuss over her. Bess and Fred gave two large teas, and there was a dinner at Isabel McLaughlin's[6] and a Fritz Kreisler concert afterward. She sat in on Lismer's classes at the Art Gallery of Toronto, had dinner with the Harrises and three long talks with Lawren in his studio, and went home with the gift of one of his Arctic sketches.

There were two trouble spots. One was the sight of her two pictures, *In a Wood, B.C.* and *The Mountain,* hanging in the Canadian Group exhibition at the Art Gallery of Toronto. Emily had always flinched at the sight of her paintings hanging next to the Group of Seven's. She would belittle them to herself and then wait for someone to talk her out of it. This time was different in two ways: first, no one *did* try to talk her out of it, at least not very hard; and second, although she was overwhelmed for the moment by a feeling of failure, she rallied very quickly and did not allow it to gnaw and rankle as she once had.

The second problem was a long discussion with Lawren on theosophy, one that left her sleepless and weepy. What was said in detail can only be guessed, but Lawren was very persuasive, and for a night and a day afterward Emily was utterly miserable. She felt robbed of God, Christ and prayer, alone in an immensely cold and mechanical universe. A talk with Fred Housser the next day soothed her fears, and by the time she left Toronto she was half-convinced there might be something in theosophy after all. Some months earlier Lawren had recommended Mme Blavatsky's *Key to Theosophy,* and it was probably now that Bess gave her a copy and she began to read it.

Once home, away from the powerful ambience of three people who always had influenced her strongly, she began to revert to her own beliefs. Mme Blavatsky's elaborate blueprints of eternity first bewildered, then enraged her: she flung the book half-read across the room and later burned it. To Lawren she wrote mildly enough in December, telling him she simply "couldn't swallow" theosophy whole, though she did "see the big grandness of much of it."[7]

The following month A. I. Raja Singh, of the India Christian Mission, lectured and preached in Victoria for two weeks. A Gandhian Christian, he was "educated and vital, big, broad and spiritual. . . . When he got through you loved him and Gandhi both."[8] Emily heard him eight times, and he came to see her at least twice. By the time he left Victoria she was more solidly Christian than ever. W.N. Weston was no longer at the Unity Centre, but in the next few months Emily became a follower

of the charismatic Dr. Clem Davies, whose ministry at the City Temple ("Where Religion Cheers") had been drawing large crowds for a decade. The City Temple was not a church at all, but the old Royal Victoria theatre, pressed into service in order to accommodate Davies' large and enthusiastic congregation. There "Dr. Clem" preached on a variety of subjects, from psychic phenomena to politics, in a flamboyantly populist, free-wheeling style that somehow appealed to Emily's love of "straight talk." There was something of Elmer Gantry in Davies, and Emily chose not to believe the spicy rumours that circulated about his personal life. He was not, in short, the kind of preacher that a Carr would ordinarily listen to. And for that very reason, among others, he became Emily's spiritual anchor, at least through the rest of the 1930s.

As soon as Raja Singh left Victoria Emily wrote again to Lawren, and to the Houssers as well, reaffirming her faith in Christianity. Then she steeled herself for what she thought would be a complete rupture. There was none. "So you think we'll suddenly become frozen up because you have found a new happiness," Bess wrote. "Bless you darling what a funny dear you are."[9] "The most important thing for anyone," wrote Lawren, "is to *stick to what yields you the fullest inner life.*"[10]

Emily later believed that these religious differences opened up an impassable gulf between herself and her friends. It is true that they continued to send her theosophical books, which made her angry. But in fact there was only a gentle divergence of views, which might not have mattered if there had not been a far more serious division. That summer Emily learned that Lawren and Bess were divorcing their respective spouses to marry one another, while Fred Housser planned to marry the painter Yvonne McKague. Emily was thrown into a turmoil of moral condemnation and unacknowledged jealousy, and a meeting with Bess in Vancouver in July only served to heap coals on the fire. She was especially angry that all three had been involved in the affair while they were trying to convert her to theosophy a few months earlier. And her prudish sexual standards did not allow for this kind of divorce: the very thought that people could fall in love outside of a peaceful marriage was "disgusting." Altogether it was "a tumbling down of ideals and idols,"[11] and though she eventually took a calmer view she felt that her last ties to the east had been broken. Lawren and Bess married late that year and moved to Hanover, New Hampshire, where Lawren became an unofficial artist-in-residence at Dartmouth College. In 1938 they moved to Santa Fe. Emily continued to write to them, but the old intimacy was gone. She wrote occasionally to Fred and Yvonne until Fred died in 1936.

Meanwhile other ties loosened one by one. Her correspondence with Marius Barbeau had quietly limped to a halt. She never forgave Lismer for his comments on her sketches, despite some frank talk when he came west in 1935. A. Y. Jackson's slighting comments on her work in 1931

were not forgotten, and her old suspicions of him deepened; she was sure he despised her "for a *woman* artist."[12] Later on that suspicion would extend to the other members of the group, except Harris.[13]

As for Eric Brown, his strong support for the People's Gallery did not outweigh a long list of grievances Emily had stored up by 1934. She was irked that nowadays he requested pictures through the provincial selection committee in Vancouver instead of directly from her. He had not kept her informed of the whereabouts of five watercolours travelling for over a year in exhibitions. Worse, he had ignored a request of criticism of her new work, and she had heard on "pretty good authority" that some canvases sent for general exhibition in 1932 had been briefly hung and then taken down as "too *modern*" for the National Gallery. Worst of all, the National Gallery still owned no works of hers except "those two miserable old watercolours done more than *twenty* years ago."[14] All this she recited in a letter in October 1934, which she began by demanding the immediate return of her watercolours. Brown sent them promptly with a reproachful note, and there was a long silence between them.

Although these were all separate quarrels, one cannot help but see how neatly they coincided with Emily's need to free herself of influences she now felt as negative. At some level they were one big family quarrel, a re-enactment of old dramas and old tensions in Emily's own head. Once again she had declared a violent emancipation, magnifying indifference or half-hearted support into real and tangible opposition. It was still necessary to Emily's art that she grow by a dialectic of extremes; there was no quiet median, or if there was it held the threat of mediocrity and stagnation. In this instance, at least, the damaged friendships caused no real harm. Emily's temper was legendary by now, and the people involved took their brickbats from whence they came. Some of them would come back later, renewing their friendship on a different basis.

Partly because of her growing estrangement from the east, and partly because she could no longer afford to ship her paintings to exhibitions, she began to concentrate on showing her work in Victoria. One important exception was a 1935 solo show at the Lyceum Club and Women's Art Association in Toronto, her first solo show at a major eastern gallery; it inspired the Graham McInnes article in *Saturday Night*, further widening national recognition of her work. Another was a 1933 group show at the University of Alberta in Edmonton, where Emily was represented by twelve canvases and twenty-five sketches. But in general she was content to keep her work close to home. Victoria was mellowing towards her work, now that it had gained some international standing, and Emily softened in her turn. She had boycotted the Island Arts and Crafts Society entirely in 1931, and might have written them off for good. But in 1932 Max Maynard, who was vice-president that year, persuaded the society to reserve a separate section for the "moderns," and Emily en-

tered work along with Maynard, Edythe Hembroff, Jack Shadbolt, Ina Uhthoff and a gifted young pupil of Maynard's named Ronald Bladen. This venture was not popular with the rank-and-file members, some of whom, according to Maynard, "made a point of avoiding the Modern Room altogether. Many genteel ladies, I recall, came to the door, sniffed and turned away. The men, for the most part, were more positive: they entered in groups and made sarcastic comments to each other in loud voices."[15]

There was no offer of a modern room the following year. Emily withheld her work in protest, but in 1934 she capitulated after the officers offered to waive the usual entry fee. She showed with them again in 1935 and 1937. The Island Arts and Crafts Society might be a living monument to the past century, but it remained the main outlet for exhibiting on Vancouver Island.

She also returned to her old practice of holding shows at home, either in her own studio or in the downstairs flats, which were empty all too often these days. There were four shows at Simcoe Street in 1934–35, including an ambitious six-day retrospective show in April 1935. For that one Emily hung an entirely different group of paintings each day, so that people who came several times—and there were surprisingly many—saw a selection of work that spanned her entire career. In general, the turnout for these shows was large, and the compliments so profuse that she hardly knew what to do with them. "It's funny how little I care what they do say," she wrote after an invitational show in 1934. "All that 'goo' trickles over me and runs down the other side. . . . Oh, I'm sure I wasn't nice, not a bit nice to people tonight. They liked my evening and me in spite of me not because of me. I'm a cat."[16]

Presumably she had not become entirely indifferent to praise, for even with Willie Newcombe's help the effort she put into these shows was prodigious, and it would have been easy enough to withdraw entirely into her own cocoon. But there is no doubt that she meant it when she wrote that she was not working for the sake of exhibiting, but "just to squeak ahead a little" towards her own personal goals.[17] And exhibiting was important for other reasons besides praise. For one thing, religion had strengthened her belief that her talent was only lent to her and that she had a duty to share it. And for another, her exhibitions helped soothe her qualms about the "selfishness" of art. When she looked back at her life, she sometimes saw it as one long, greedy clamour for self-expression. Her sisters seemed "so high and unselfish and worthy" by comparison, "doing things for people *all the time*."[18] In such moments, for her own peace of mind, she needed exhibitions to point to as concrete evidence that she was giving something to the world. It was hard to be matched for life with the inexorable goodness of Lizzie and Alice, who were so imbued with social conscience that they thought it wrong to eat

their Christmas dinner without sharing it with someone—not necessarily someone poor or lonely, just someone.

If Emily could never aspire to those heights (she especially resented sharing Christmas dinner with outsiders), neither was she as self-centred as she thought she was. She might scour the city by streetcar, looking for a cheap, halfway pleasant flat for an old woman in straits, offer a dog to someone who seemed alone and down, or arrange an exhibition for a gifted teenaged artist. Her kindness to Henry Brand was not an isolated case, for she was also friends with Harold Cook, a retarded, partly crippled man in his early forties who lived in the Wilkinson Road Mental Hospital. Emily had known Harold in Kispiox, where he had lived most of his life, and after he came to Victoria she did her best to ease his frantic rebellion against confinement. Aside from a sister, Emily seems to have been his only link to the outside. She visited him regularly, brought him small gifts and talked with him about animals and about the Skeena country they both loved. Harold was only mildly retarded; he wrote autobiographical stories in imitation of Emily's, and he kept a bulky file on the progress of her career. Emily gave all her clippings to Harold; it gave her almost as much pleasure to get rid of them as it gave him to collect them.

Harold was one of the many people she gave sketches to around 1933. Others included John Davis Hatch (to whom she sent one a year), Edythe and Fred, Flora Burns, Lee Nam, Gerhardt Ziegler, the Houssers, and Harry Adaskin, first violinist of the Hart House Quartet.[19] She had always enjoyed giving away her paintings, rugs and pottery, and part of the fun of her new paper sketches was that she could afford to be prodigal with them.

Her local friends, for their part, were busy looking out for her welfare. The UBC shows arranged by Brand in 1933 and 1934 brought in sales and provoked interest among the faculty. Meanwhile, also in 1933, Margaret Clay and the Victoria Business and Professional Women's Club arranged to have *Vanquished,* a late painting of Skedans, sent to an international show in Amsterdam, where it was well received.

In October 1935 Emily was asked to give a speech before the literary society of the Provincial Normal School. Published as *The Something Plus in a Work of Art,* it was concerned with identifying the "something beyond the literal content of the picture, something that distinguishes the great work of art." Emily spoke of it variously as an "Ideal" and as what the Japanese call *Sei Do,* or "the transfusion into the work of the *felt nature* of the thing to be painted." It was the spiritual connection between the artist and his subject; without it art descended, as it had in the nineteenth century, into mawkishness and commercialism. Now the "brave fierce rebellion" of modern art was bringing it back.[20]

Like all her talks, this one reflects the place she had reached in her own

life. It is about the final insufficiency of craftsmanship, criticism and example—the ultimate solitude of the artist, the mystery of his communion with his subject. It is also, incidentally, strongly transcendentalist in spirit. Emerson, whom she paraphrased at one point, would have approved.

Edythe and Fred Brand married in 1934 and moved to Vancouver, and around the same time Philip Amsden married and left Simcoe Street. Emily still saw them all now and then and wrote often to Edythe, but she missed Lawren, or more precisely she missed the role he had filled in her life, and increasingly she felt the old longing for a fully understanding, supportive and forgiving friend, one who met the complicated and exacting need for soulmate, colleague, parent and lover. She would never forgive Bess Harris, though she could not admit her jealousy as such to herself, much less begin to understand it. She was jealous of Amsden's marriage as well, and of any close relationship that deflected the feeling between herself and those she loved. The fact that, jealousy aside, she herself often drove her friends away through sheer cantankerousness only lent an extra sting to the resulting loneliness: "It must be my fault somewhere, this repelling of mankind and at the same time rebelling at having no one to shake hands with but myself and the right hand weary of shaking the left."[21]

At such times her creatures were especially important to her. The numbers had stayed more or less constant, though the cast came and went. Ginger Pop died suddenly in 1931, and Dolf the cat, after eighteen years with Emily, curled up in a dog's box one night and with his usual lack of fuss went permanently to sleep. The irrepressible Woo, despite four separate meals of paint (each of a different colour), careened merrily on from year to year. The number of dogs more or less stabilized at four, and after Koko's death his son Pout gradually became Emily's favourite. Puppies arrived and were bottled, wrapped in blankets and nursed through illness. They filled the van or studio with squirming, clamorous new life for six or eight weeks before being claimed by their new owners. There was still a chipmunk cage on the studio table, and there were bantams in the garden and small birds on the stairway landing.

Emily was especially fond of Susie the rat, partly because nobody else liked her. Lizzie and Alice had long ago accepted Woo, even though she stole Lizzie's cufflinks and once kept Alice cornered for hours in the back yard shed. But a rat was a rat, even if it was a white one, and it took a long time before the sisters could even tolerate her anywhere near them. They refused to look after her when Emily was away, so often Susie would go along, stowed in an oatmeal carton in Emily's handbag. "Millie let the thing crawl around her neck and lick her throat," Alice told a journalist years later. "How could she?"[22] In fact, Susie was a mild little beast who moved so entirely within Emily's orbit that she could be

left in the van with the door open and never think of venturing out. When Emily sketched outdoors Susie nestled inside the collar of her jacket. At home she lived in a basket on the studio table, where she devoted herself to endlessly shredding paper for nests that were never filled. Emily felt guilty about that and once went so far as to provide a mate, but Susie turned out to be a determined virgin after all and the bewildered male was taken back to the pet shop.

Susie's affection for Emily was so strong that, unless the studio door was firmly shut at night, she would laboriously make her way up the stairs and up the bedpost and wake her mistress at one in the morning with a brisk scurry across the pillow. When she died in 1935 Emily found her in the morning on the studio floor with her nose resolutely pointed at the stairs. Emily buried her in the garden and missed her as a "companionable little nip of *life*"[23] whose portion of the world's intelligence and feeling, minute though it was, was surprisingly complete.

Early in 1934 the Carr sisters were drawn closer together by the discovery that Lizzie had a severe heart condition. There was very little said about it, for like Dede before her Lizzie would not have her illness discussed. But there was a new element of tenderness among them, and Lizzie went so far, in the first moments of disclosure, as to ask her sisters for help.

Tenderness did not necessarily mean patience, and Sunday dinners continued to be "a bit perilous," with Emily and Lizzie "both such high explosives. It's like two little boats setting out on a rough sea."[24] It was a marvel to Emily that such dissimilar souls could have come from the same family; on second thought, she decided they were not dissimilar at all, and that they all owed their "abominable narrow autocratic intolerance" to their father. At Alice's table, surrounded by small children perched on dictionaries and telephone books, she would give rueful thanks that they three sisters were old maids, so there were "no unfortunates to bestow the taint of our pecky natures on."[25]

At Eastertime 1935 the sisters gathered twice in the old house to read their father's diary. From Emily's comments it appears that she, at least, had never seen it before. Although it brought back all her fear and hatred, it also gave her an "entirely new slant" on him, and it was then that she began to make a kind of peace with his memory. The diary covered the years 1836 to 1876, from before his arrival in America through the family's settlement in Victoria. Emily thought he seemed "a fine young man, strong and brave, honest, kindly and energetic, plenty of perseverance and plenty of pluck."[26]

It was in 1935 that Emily came to a decision about her house, which was becoming an insupportable burden. After two decades of hard use it needed major repairs that Emily could not do herself and could not afford to pay to have done, and the Depression had driven away her ten-

ants. Lowering rents did not help, and sometimes people who did move in would afterward go on relief, and Emily would be forced to evict them. One family of four adults bargained for $5 off their rent in return for help with chores, but the "help" was pretty much at their discretion. After a year or two it had dwindled down to bringing in the wood; Emily finally lost patience and gave them notice. People seemed shifty and mean, as they had during the war years, and Emily's rage steadily escalated:

> Oh this renting business it goads the life out of one. The long epochs when the house stands sullenly empty. The short sudden spurts when there are enquiries, when men and women come and look, *de*-testable people who treat your things like garbage, jeer, find fault, scorn, demand, Jew, then tell you about all the other *wonderful* places they have seen and *so cheap*. Ask why they did not take them and they start to wriggle, [and] finally out comes some mean blemish—location, bath, rent, landlady, heat or something or other. They demand every luxury and modern convenience yet they would beat the rent to a nickle with no shame. They would crush the pride out of you and force you to meet their unreasonable extortions. They would grind you, crush you, starve you. When you do not pulverize before them they turn on their heel and depart. Oh why must bread earning be so bitter?[27]

(Incidentally, Emily was both anti-Semitic and anti-black, but only intermittently. Her prejudices came into play against people she did not know or like. Railway porters were "niggers," but in this same year she spent $15 she could not afford to hear lectures by a visiting black preacher, Garland Anderson. Harry Adaskin's Judaism was all in his favour, but that of her next-door neighbour, who gave loud parties and entertained "painted hussies," definitely was not.)

For months the house was on the market for sale or exchange. Agents and potential buyers came and peered into closets, thumped pipes and exclaimed over the chairs and the monkey while Emily fidgeted and shot baleful looks from the background. She in turn looked at tidy cottages crammed with knick-knacks and and at not-so-tidy, homely farms inconveniently far out of town. Finally, on 21 January 1936, she arranged a trade for a small house on Oscar Street in the Fairfield district of Victoria. She did not intend to live in it herself, but she had no trouble renting it out for $25 a month. For herself she rented a rundown little place on Beckley Avenue, only a few blocks from her sisters. The rent was only $12, leaving a tiny but crucial profit.

She wondered what the house would be like without her. It would be more peaceful, certainly, for Mrs. Findlay, the new landlady, was an obliging soul. The future of the studio did not bear much thinking about,

for the Findlays would use it for a sitting room and their taste ran to paper flowers and dim engravings of waterfalls. She wished she could leave one painting hanging permanently on the wall. She would miss the garden, the attic room with its painted eagles, the sound of rain on the roof at night inches above her head. But she really had no other regrets. She had grown into a successful painter here, yet the house was saturated with evil memories. She remembered the wrangling architect, her friend's suicide, her jealousy when Alice refused to live with her, her long illness after her operation in 1923, the petty bickering of the ladies' boarding house, the cheats and bullies she had had to deal with during the War and the Depression. She had no doubt it was part of some divine plan, designed to season her and break her stubborn will. At any rate, it was over, and at sixty-four she looked forward to finally having a home that was—in all but name—her own.

CHAPTER
28

Beckley Avenue

BECKLEY AVENUE in James Bay was a homely little unpaved street lined with shabby bungalows where people without much money were raising large quantities of children. The back yards were given over to kitchen gardens, so the children played in the road, which was perfectly safe since automobiles rarely used it. The air was full of their shouts all day, mingling with the barking of many mongrel dogs, the cackling of hens, the squeaking of clothesline pulleys and pram wheels, and now and then the rumbling of a wheelbarrow bringing up a load of driftwood from the beach. Fifty years earlier this neighbourhood had been part of Armadale, the showplace estate where Flora Burns's grandfather, Senator William John MacDonald, and his wife had raised their family in discreet splendour. A little corner of it still survived, wild and overgrown, its gnarled trees somewhat battered but still standing, its much-trodden paths littered with candy wrappers. Emily went there sometimes to sketch or dig the moss that lined her chipmunk cage.

Emily's cottage at No. 316 had six rooms: sitting room, bedroom, dining room, kitchen, bath, and a tiny studio that Willie Newcombe had converted from the old dining room. Sunlight and sea air flooded in through the high windows, and in the back yard grew apple and plum trees, one of which Woo appropriated for her own. There was a shed and a chicken house, and the whole was surrounded by a sturdy wooden fence, behind which shy rows of children gathered to pay their respects to the monkey and the dogs.

Emily came to love this place more than any other, but there were a few weeks of painful adjustment at first when, tired from her move and missing the bustle of people and her old daily routine of chores, she wandered aimlessly from room to room like a castaway, fit for nothing in particular and least of all for painting. The combination wood and coal range in the kitchen sulked, partly because the wood was wet. The pipes were corroded, so that the taps yielded only a little weeping trickle of

water. Emily wept along with them, cursing her lack of foresight in leaving her own dry woodpile in the Simcoe Street basement. But the former inhabitant of the house came and taught her how to humour the stove, and after a few months she had a plumber clean the pipes. Willie came often, bringing a backpack full of dry wood each time, and together they would stoke up the fire and have a comfortable talk beside its warmth. Alice and Lizzie came, and Flora Burns and Margaret Clay, and other old friends one by one, each of them helping to push the strangeness of the place a little farther out, until after a month it was entirely gone and Emily was working in her studio with all her old zest.

Outdoors Woo's perch in the plum tree was hidden by a froth of blossoms, and up and down the street the back gardens bristled with sticks labelled "cabbages," "beets," "onions," while a few odd wallflowers and daffodils bloomed uncertainly around doorsteps. Emily went back to Simcoe Street just once, to dig some plants from her old garden. The house was pretty much as she had expected: Mrs. Findlay was tired and kind, and there were artificial roses in the studio of a most improbable colour. One thing she had not foreseen: "the *FRONT PORCH UP-STAIRS* was full of *WASH!*"[1]

Of all the grateful influences she felt those first few weeks, Willie's was the strongest. It was now—or rather, from now on—that his friendship really came into its own: "Willie has made me a wonderful wheelbarrow. I am as proud of it as if it were a limousine and want to wheel it . . .";[2] "Willie brought me a back load of dry wood . . .";[3] "The engineer who set the whole works going was Willie. Those kind, keen eyes penetrate into every corner, sum up needs, set things to rights. In the avalanche of dirt and cold stone I'd have been snowed under but for his help a million times."[4] She quickly made friends with Mrs. Hudson, a solid woman who was to be her helping-neighbour, the one who could be relied on for borrowed cups of flour and mutual plant-waterings during holidays. And there was really no one on the street she did not know, from the two-year-old across the street whose father was tubercular, to the retired charwoman who, at ninety-one, painted her own fence and complained that she was getting too old to scrub the ceiling.

The neighbourhood children, of course, were drawn to Emily's animals like bears to a honey tree. They were not allowed inside the gate without permission, and Emily could be snappish with them: more than once she heard herself sounding like the tiresome Mrs. Drake of her own childhood.[5] But Phyllis, Mrs. Hudson's six-year-old daughter, would not be kept at bay. She began by waving from her kitchen window or her tree house every time she caught sight of Emily, and shortly—as a treat following a bout with measles—she was invited in to watch the dogs being bathed. From then on she was an indispensable presence, boisterous and endlessly curious, but affectionate and as quick to feel a

slight as Emily herself. She was always underfoot, tugging at the pup-
pies' legs and riling the adult dogs, tracking up newly washed floors,
swinging on the front gate and forgetting to close it behind her. "And
withal," Emily wrote on one particularly trying day, "such a merry note
in the house it would be desolate without her indeed."[6] Like Carol Pear-
son before her, Phyllis made up her mind to live with Emily—not right
away, but when she grew up and made "lots of money."[7]

In June Emily had the Elephant moved to a cliff about three miles
north of its previous site. She was in another sheep field, surrounded by
space and light. Ant-hills made the place look like a miniature city, and
behind the van were the uprooted stumps of two gargantuan trees. A
dense wood lay some distance down the road. Across the bay the lights
of Victoria winked companionably at night, and directly below her lay
the immense gravel pits of the Producers Sand and Gravel Company.
There was a tiny cluster of work buildings, and a toy trestle that ran out
into the sea, and minute moving figures no bigger than flies. She heard
whistles at noon and five and a distant chug of engines, but otherwise she
was alone.

Towards the beginning of her stay she had eight solid days of rain,
which she tried to turn to advantage by writing. When that palled she
would visit the Spencers, owners of the site and her only neighbours. In
moments of desperation she would sing to the beasts. That raised her
spirits some, if only temporarily, and later the rain gave way to a brazen
summer sun. Then she buckled down to sketching sky and sea, pines and
gnarled stumps, and the gigantic golden-grey bowls of the pits. Two
pairs of acquaintances camped briefly nearby, and Edythe and Fred came
to visit her. So did Humphrey Toms, the newest of Emily's flock of
young male friends. A tall, good-looking teacher who was the nephew
of her old Vancouver employer Jessie Gordon, Toms was a faithful visi-
tor until he left for the army in the early 1940s. He often chauffeured
Emily to campsites in his car or came wheeling out to visit her on his
bicycle.

When Emily went home it was to a manageable little pile of chores
rather than the mountain she had always faced before. There was finan-
cial ease, too, in the form of $195 in sales and the enrollment of two
middle-aged ladies as sketching pupils. But her comfort was brief: in
early August Lizzie died quietly after a brief hospitalization. There was a
formal four-day mourning period, held at the request of Lizzie's pastor,
during which Emily and Alice had to condole with scores of tearful visi-
tors in Alice's sitting room. They hated it and sneaked away to Alice's
garden whenever they could. They themselves were dry-eyed, and for
the moment could only be glad that Lizzie had slipped out of life very
easily. Tears came later, when they had to sort through her belongings
and feel the almost physical pang of absence. Then all sorts of things

came into sharper focus for Emily: the inevitable guilt she always felt at having disappointed her family; the peace that had illuminated her sister's anxious face after death; the full force of a love that was no longer clouded by bickering; and a fury, surprising in its force, at the heaps of religious tracts and Bibles that somehow represented the emotional waste of a life lived entirely by rule.

The two younger sisters had made a point of formally deferring to Lizzie as head of the family. Now it would have been absurd for bossy Emily to pretend to defer to mild Alice, and in any case Emily felt protective towards her sister, who seemed increasingly frail. After Lizzie's death they rented out the old house for a year, and the job of landladying fell on Alice, who loathed it. Her eyesight had failed until she now could barely see at all at night, and her daytime vision was poor. Yet she kept her school going, or perhaps it was the other way around. The number of pupils was small and constantly changing. "She's like an old hen," Emily thought, "always stealing a nest and bringing out a new brood — speckled, blacks, browns and whites. Just now they're speckled."[8] It was a delicate balance: when Alice had too many pupils she was pale with weariness, and when she had too few she was depressed. But in fact, as time would prove, Alice was made of very sturdy stuff indeed.

The two major transitions in Emily's life this year, her own move and Lizzie's death, brought her to a kind of summing up. Always introspective, she found in the old letters, photos, diaries and mementoes in both houses a host of half-forgotten memories, and they in turn spurred her to fresh writing. Among the stories she wrote in 1936 were "D'Sonoqua's Cats," "White Currants," "Unnamed" ("One Crow") and "Mrs. Drake" ("Mrs. Crane"). In May she met a "girl" who offered to criticize some stories in return for a sketch.[9] This was Ruth Humphrey, who taught English at Victoria College and who became Emily's main source of literary help for the next year. She was a discerning critic, understanding both Emily's strengths and weaknesses as a writer. Where Emily's editors-by-correspondence had demanded classic plot construction and a tidy dénouement, Ruth encouraged the mood and character sketches that came naturally to Emily. She warned against sentimentality and awkward dialect, and urged Emily to lighten her touch and "let the reader use a little more discretion and common sense himself — in short, write *between* the lines more than *on* them."[10] Emily accepted her advice easily and they had a good working relationship. It is likely that much of Emily's ability to "peel" a sentence, which so impressed her later editor Ira Dilworth, was learned from Ruth Humphrey.

Her painting too was going well. She had another week of sketching in the Elephant in September — not more, for the weather was cold and Lizzie had only been gone a month — and afterward felt that she had definitely "lifted a little" that year.[11] Always searching for signs that her work

was beginning to "dodder" and grow "feeble," she honestly could find none. In April 1936 she entered a B.C. Society of Fine Arts exhibition in Vancouver for the first time since 1929 and won a favourable notice in the *Province,* which was no longer dominated by "Diogenes" and his acid pen.[12] Four sales resulting from that show won her back as a regular exhibitor with the BCSFA. She had also shown with the Island Arts and Crafts Society, and in November she held a successful invitational evening at home, which Willie hung for her. In the east she was given a solo show at Toronto's Hart House early that year, and she was represented in the Canadian Group show and the international Southern Dominions show. Visitors to her studio included Mrs. Leopold Stokowski, who came just before or just after the Beckley Avenue move and bought a painting. In December Emily received a request from Charles S. Band of Toronto to send some paintings on approval. Normally suspicious of all such requests, she agreed because Band came well recommended. A director of the Art Gallery of Toronto, he soon became an influential supporter in the east. Among the paintings he eventually acquired was *Indian Church,* bought from Lawren Harris in 1936.

January 1937 brought one of those bitter cold snaps that Victoria suffers once or twice a year, when the Arctic sends a forcible reminder of just how close it is. The wind buffeted the flimsy Beckley Avenue cottages and pounced in ambush on anyone who ventured outdoors. Emily's angina always grew worse in this kind of weather, and on 9 January an unusual attack of severe, steady pain forced her to call the doctor. On 14 January she was taken to St. Joseph's hospital, where she remained for a month.

The physical pain of her heart attack soon subsided under medication, but for a while the psychological shock was profound. She would have to give up her newly won solitude and independence and rely on a live-in housekeeper. Camping trips were out of the question for that year anyway, and in future she would never be able to go alone. For the rest, she would probably be able to return to painting but was not sure how much she was physically capable of. That uncertainty was a torment: no one could predict just how much of an invalid she would be. She made up her mind not to "moan in self-pity,"[13] but it was hard to stick to that resolution, especially when the "hypos" ordered for heart pain brought on a side effect of teary depression. Nevertheless, she did gain ground steadily from the beginning. That was chiefly due to her native spunk, but it was helped by the swift response of everyone who knew her.

When it came to the test, crusty Emily Carr had a great many friends. Immediately after her attack flowers, which were not so much an amenity as a necessity to Emily when she was sick, arrived by the armload. Letters followed, among them several from Lawren and Bess

Harris, Eric Brown and Charles Band, all saying they could not imagine her anywhere but in the woods, painting. Visitors were carefully rationed, though Alice came daily and Willie Newcombe and Ruth Humphrey often as they could. Among the others was a "dear neighbor woman" who brought a gift of six oranges, each carefully wrapped in a screw of paper.[14]

Word of her illness galvanized her old friends in the east, and there was a sudden, unprecedented surge of interest in her work. The ground had already been laid in 1935–36, with her two solo shows and Charles Band's support. Now Eric Brown arranged to have Eric Newton, art critic for the Manchester *Guardian,* choose fifteen paintings for possible sale to the National Gallery or others and for inclusion in the exhibition, "A Century of Canadian Art," to be held in England in 1938. Newton, who was in British Columbia on a lecture tour, spent 29 and 30 January in Emily's studio and, with the help of Willie and Ruth, made his selection. In the middle of the first day he went to see Emily, who was so agitated at the thought of meeting him that the head nurse almost forbade the visit at the last minute. But Emily's Dr. MacPherson intervened, realizing that it would do her far more harm to miss Newton than to see him. They had half an hour together, long enough for Newton to communicate his keen enthusiasm over the paintings. Later he would write of meeting "that solitary genius, Emily Carr . . . and of spending two astonishing days in her studio surrounded by hundreds of her sketches and paintings of giant trees and virgin forests. The effect was of stumbling on a well-stocked library of books on a new theme and written in a new but easily legible language."[15]

Afterward when Emily saw the list of his selections she thought it rather strange; but within the small number allowed him and a size restriction (which was later lifted), he did try to include work from every phase of her career. About the fate of the paintings she was typically skeptical. She did not trust Brown, and she suspected that the whole arrangement was "just one of [the Gallery's] borrowing spasms."[16]

In fact the National Gallery atoned for past sins by buying the sketch *Sky,* from Newton's selection, as well as two major canvases (*Blunden Harbour* and *Heina*). Other sales followed. Charles Band quickly assembled and hung a small solo show at the Art Gallery of Toronto through March and April, inspiring another strongly favourable *Saturday Night* review by Graham McInnes.[17] The Art Gallery itself bought three paintings, Mrs. Stokowski added a second to the one she owned, and the prominent eastern collectors H. S. Southam and J. S. McLean each bought at least two. Charles Band bought *Nirvana* immediately and *Grey* some time later, and in September he came to Emily's studio and selected three more paintings on approval. Meanwhile Lawren Harris, who had

bought a canvas in 1936, sent $200 for another in March. And in the west the Vancouver Art Gallery, which Emily had regarded with some wariness up to now, bought a major native canvas, *Kitwangak*.

Altogether, including several sales from her own studio, Emily's pictures brought her over $3,000 in 1937 alone, which was a substantial hedge against medical expenses. After this high point her art income subsided, but sales continued to make a critical difference. Emily's basic income was only about $50 a month. Of this, $35 came from stocks, bonds and the rent from her Oscar Street house; the balance was a $15 allowance from her niece Una Boultbee, formerly paid to Lizzie and accepted by Emily only with great reluctance.[18] Out of this she paid $15 in rent to Alice and $20 to $30 to a maid, plus her own living expenses and taxes and upkeep on the Oscar Street house. Obviously, without the few hundred dollars a year her paintings earned, plus her publisher's advances in later years, she would not have been able to pay her bills. Even so, one wonders how she managed.

All the sales and attention were exhilarating, to say the least, but in the first weeks after her heart attack Emily was still very anxious over the future of her painting. What helped her most then was her own decision, encouraged by Ruth Humphrey and Dr. MacPherson, to write a series of "little short Indian incident fragments" based on her own experiences.[19] She began to compose them mentally in the hospital, and once she was home she wrote them down with amazing speed. Ruth, Flora and Margaret Clay all helped with criticisms, and though Ruth soon left for a year abroad Emily kept in touch by mail and sent her manuscripts now and then. Mrs. Chapell, a stenographer from Victoria College, volunteered to help with typing until Emily insisted on paying her. Between March and the end of July Emily finished seventeen stories about the native Indians—over three a month. These stories, with some additions and subtractions, became the book *Klee Wyck*. Despite Emily's claim that she wrote them early in 1937, it has sometimes been thought that she really wrote them years before and simply polished them up during her convalescence. But the journal passage cited above, as well as a letter to Ruth Humphrey,[20] clearly indicate that almost all the stories were new. The journals before 1937 do not refer to any except "D'Sonoqua's Cats."

Emily was allowed to go home on 15 February. She found her animal family diminished. One griffon had been given away, and her bantam rooster Cockydoo had died. Woo had gone to Vancouver's Stanley Park Zoo, where she would peacefully live out the remaining year of her life. Of the three remaining dogs, one would die that spring, leaving Pout and Matilda as permanent dogs-in-residence. Small birds and chipmunks were temporarily absent but would be replaced, and by August there was a new blue parakeet, Joseph, who was probably the least active pet Emily ever had but very tame and beautiful.

House, creatures and Emily were all in the hands of Mrs. Hassack, a brisk, capable practical nurse Alice had engaged for a month. Mrs. Hassack ran a tight ship; Emily submitted meekly and took some pride in belying her reputation as a crank. Dr. MacPherson laid down a strict regimen: breakfast in bed at eight, writing in bed till ten, up till noon, lunch, rest, up for a while, down for a while, supper, perhaps an hour in a chair, bed. It was terribly confining for someone as normally active as Emily. She had all she could do to sit on a stool and watch a neighbourhood boy plant a few flowers she herself could have put in in half the time; and afterward she had to listen to him groan with weariness.

But there were visitors in the afternoons, and soon she found advantages in having her working time regulated and screened from distractions. Her morning writing time was very productive, and as she grew stronger she began to use the evening for typing drafts. And she found that after all there was no reason why she could not paint. A new rack for her sketches, built by Willie while she was in the hospital, helped her keep her work in order and boosted her morale. By 20 April she had not only finished several *Klee Wyck* stories but had four canvases simultaneously under way.

In August she was immensely flattered by a visit from Lady Tweedsmuir, wife of the governor general, who appeared with an entourage of chauffeur, equerry and lady-in-waiting and bought a sketch. "I think it was very gracious of her to call on me," Emily wrote to Edythe. "She was very nice, dignified and kindly."[21] Emily suffered much anxiety over the appearance of scruffy little Beckley Avenue on this occasion, and nothing betrays the lurking residue of "ultra-English" in her character more than the fuss she worked herself into. (By contrast, she set almost no store by Mrs. Stokowski's two visits and once even refused to speak to that lady on the phone, dismissing her as "a fool.")[22]

Alice finally consulted a doctor about her eyes, and in late April she underwent surgery to try to save what was left of her sight. Another operation followed in August, and several years later there were one or two more. There was no real improvement after this first one and she had a good deal of pain, but the doctor thought she at least had a good chance of maintaining the status quo. Emily worried about her a great deal and managed to bring on a setback in her own recovery by visiting her sister in the hospital. Yet in the long run, her anxiety for Alice increased her own determination to get well. Alice seemed so isolated, hemmed in by "perpetual twilight,"[23] and yet she was "very difficult":

> She is so lavish in her giving and so stingy in taking . . . grudges everything she receives. Obstinate as an owl, ungracious of efforts to help her. If only there was something one could do instead of lying here helpless, yet for her sake I've got to do that, got to molly coddle and mamby if I hope to

get well and help her. How much more use Lizzie would have been, yet she'd have worried A. more. We seem to have got very near to the end of everything, or is it near to the beginning?[24]

She thought that in the end the only way she could help Alice would be to move in with her, perhaps as early as that winter. The thought made her wince. Whatever others thought of the perpetual clutter she lived in, Emily was proud of herself as a homemaker; she thought of homemaking as a test of womanliness, and by her own standards she passed it very well. She never, for example, allowed anything to go unrepaired. Alice, on the other hand, lived for years on end with a multitude of small defects she could not see: broken front steps, a back door that stuck, smoky paint and peeling wallpaper, couches torn by the dog, a front-hall view of the toilet. She bristled at any suggestion of change and seemed "stubbornly determined that it shall be just as it is for ever and ever."[25] How Emily could bear to live there she could not tell, but she was sure she would have to some day. By the end of the year, though, with Alice no better but no worse, she pushed the idea aside for the time being.

Mrs. Hassack left at the end of a month. Emily was glad and sorry to see her go: sorry because she was so efficient, and glad because she was very reserved and no company at all. That was the crux of the absurd, marathon series of crises with "help" that now began. Emily wanted someone who would really be a part of her life, someone to chatter and giggle with, but she also wanted someone deferential, someone she could hold off at arm's length. She had very fixed and antiquated notions about the "place" of domestics, notwithstanding her fantasies about the "common people." And for their part, the women she interviewed had certain expectations of their own:

A smug Christian Scientist applied today but we did not like her she wanted to companion me she wanted 2 nights and a day out she must have a clothes closet in her room well, she supposed she'd have to try and manage to keep the dust from her trousseau with curtains, but those creatures (pointing to the pups) will track in a lot of dirt and she did not like stoves and she hoped we'd meet each other in consideration and she was accustomed to more wages exit her *WOW!*[26]

After several false starts she finally found a placid farm girl, Louise, whom she grew very fond of and who stayed with her almost a year. But then it was all to go through again, and many times over after that.

The journal passage quoted above is one of many left out of the published journals, *Hundreds and Thousands,* and since the journals are such an important source perhaps the published version should be compared

with the original. *Hundreds and Thousands* was edited after Emily's death by her publisher, William H. Clarke, and her editor, Ira Dilworth; after Dilworth in turn died Clarke completed the task, with nominal help from Phylis Dilworth Inglis. The title was not Emily's own, but was taken from a collection of miniature autobiographical sketches, separate from *The Book of Small,* which still exist in manuscript form.

In general, the published journal follows the manuscript. Spelling and punctuation have been corrected, and dates have been moved or added, sometimes without clear substantiation; occasionally they have been deleted, even when the manuscript date is clear. Beyond these small variations, the editors took out passages that were redundant (for example, there are many more entries on God in the landscape than appear in the book), or maudlin, or spiteful about people she knew, many of whom were still alive when the journal was published. There are also a number of passages that reveal her corrosive dislike of people-at-large. Such passages are often a bit incoherent, as if the force of her feelings muddled her thinking, and they are often full of sexual jealousy; what they almost invariably share is her fury at any form of phoniness or sham. They got more virulent as she grew older. Tea at the Empress Hotel and a turn around the conservatory provoked one typical outburst in August 1938:

> The "I'm itness" of the ill bred moneyed tourist—horrible clothes horrible manners horrible looks. Dumpy little women sitting in outsize stuffed chairs, feet dangling and turned in, frightful hats, geranium gashes for mouths, acting up, not one bit themselves, simpering at men, overacting . . . waggling themselves insolently behind, disdaining to admire frankly the honest loveliness of flowers in pots everywhere and racing through the conservatory after tea, chasing the exotic and scornful of everyday flowers.[27]

She softens this particular passage with a rhetorical question at the end: "Am I like that too? Are we all like that?" But it is clear enough that she feels herself safe from comparison.

Negative words have been deleted here and there throughout, even where the context is very general. On the abdication of Edward VIII, for example, *Hundreds and Thousands* reads, "All for the love of a woman Britain's King has abdicated."[28] Emily actually wrote, "All for the love of an unsavoury woman Britain's King has abdicated," and like many of her countrymen she went on to speculate on Mrs. Simpson's "thwarted plans to be queen."[29] Other, more understandable deletions have to do with visitors to the studio: women who "drivel footle," a "young man particularly crazy about himself . . . unspeakably bumptious and self-opinionated," an "old girl with popping eyes, skittish manner and hysterical voice."[30]

On the other hand, several affectionate entries on Willie Newcombe were edited out, perhaps at his own request. Several of the passages on Phyllis Hudson are gone, though the delicious one on dressing up and hunting bumblebees is there.[31] Mrs. Hudson is present but in somewhat attenuated form, so that we miss, for example, the homely detail that when Emily caught flu in 1936 Mrs. Hudson, herself convalescing, brought dinner in daily and stayed to have Emily rub her aching back.[32]

Other omissions concern church services, her feelings towards her pastor and the depth of her commitment to Christianity after 1930. During the crises of 1936–37 she gained a lot of strength from listening to Dr. Clem Davies. When she was housebound she listened to his sermons twice a day on her radio, and before and after her illness she always attended Sunday morning services in the old Empire Theatre, where they were now held. Davies does not seem to have been a pastor in the usual sense: he did not visit her when she was sick, nor did she ever go to him for personal advice. And he was an odd sort of preacher to turn to for comfort, for his sermons nowadays revolved around the gloomier Old Testament prophets and the conviction that events in Europe heralded the beginning of the Apocalypse. Emily found comfort in them nonetheless, partly because Davies held that death—which she felt so close now—was but a short prelude to the great, universal resurrection, when everyone would be transformed at once amid general rejoicing. Davies took the loneliness out of death, which for Emily was all its sting. And so, "as an interpreter of the Bible and as an expounder of death Clem [meant] very much" to her.[33] On the Sunday after Lizzie's death Emily refused to go with Alice to Lizzie's church, where people would want to "clasp us and slop tears." Instead she went to hear Davies, who was "full of Armageddon" as usual, but confident "in the promise of God for that time."[34] She thought so much of him that, in a carryover from theosophy, she sometimes believed she saw an aura around his head when he was preaching.[35]

Obviously much of what is missing from the published journals is trivia, and from a literary point of view it made sense to delete it. For the rest, one cannot blame the editors for removing passages that Emily herself would have been embarrassed to show the world. But we should be aware that the Emily Carr of *Hundreds and Thousands* has been tidied up and made presentable, rather like Small before a birthday party. The Emily of the original journal is more complicated: she is nastier in anger, more generous and expansive otherwise. She is more intensely religious and more neurotically misanthropic than the Emily of *Hundreds and Thousands*. She is also less isolated from the people around her, and more involved in the constant murmur and clutter of ordinary daily life.

Klee Wyck

"WHAT SHALL I DO with this absurdity," Yeats asked in his seventy-first year, "Decrepit age that has been tied to me / As to a dog's tail?" It had nothing to do with him, but there it was; and to ignore it was to run the risk of becoming ridiculous, of being "derided by / A sort of battered kettle at the heel."

Like Yeats, like most people, Emily Carr was caught more or less un-aware by age. She was depressed by its ugliness, and she tried to avoid looking in mirrors. But where Yeats was angry, Emily—who had been angry at so many things in life—was calm and resigned. If she had to tug along any battered kettles, she would keep them behind her where they belonged. The evil that she feared most, the slow, insidious mental decay that one recognized in other people and never in oneself, did not materi-alize. Physical debility sharpened her tongue, which honed its edge on a succession of teenaged maids. But she kept her sanity, if not her temper, and she kept on working. Her last years did not bring the proverbial well-earned rest, though out of necessity she rested far more than she wanted to. Rather they began a positive new phase of growth that was, in its way, as dramatic as anything that had gone before.

She recovered quickly from her 1937 illness. The heart attack that had threatened to ruin her career, if not her life, rumbled into the past like some brief and violent storm, leaving only mutterings behind. She would always be burdened with angina pains and with occasional attacks of cardiac asthma, but the uncertainties lifted; she knew what she could do and what she could not. She accepted her new restrictions without protest. The doctor ordered her to spend one full day a week in bed, fast-ing on tea and orange juice, and even on ordinary days she stayed in bed all morning, writing stories and letters on a board propped against her knees. Afternoons were given to painting and puttering, and as she got better the "puttering" might include, for instance, a whole afternoon

spent (with Alice and a handyman) "lugging trash out of the cellar" of the Carr house, which was about to be sold.[1]

One wonders if the doctor got wind of that day's work; at any rate, seeing that she was doing well, he said she could resume her sketching trips the following spring. They had to be modified, of course, like the rest of her life. She had to take her maid along, and she had to stay in a proper house with a good roof and a stove. She sold the Elephant in the spring of 1938 and used the $15 it brought to rent a comfortable six-room cottage on a dairy farm. Altogether she had four such trips to the woods between 1938 and 1940, each a green oasis in a life of grey semiconfinement. She brought home a collection of sketches from each: joyous, tenderly wrought studies of young trees, their very lightness a challenge to the shadow of war and to her own increasingly untrustworthy body.

On 30 March 1939, while she was in the midst of mounting one hundred sketches on board for upcoming exhibitions, Emily had a second heart attack, this one far more serious than the first. She spent a month in the hospital, her convalescence saddened by word of the death of both Eric Brown and Sophie Frank. She herself recovered much as she had before, so that by the end of the year she was back to her old regimen. But in June 1940 she suffered a stroke that impaired her speech for a while and weakened her left leg. That really slowed her down, at least physically. It was months before she could walk steadily, and she got around the house on a "scoot box" made from an old butter crate. Except for an occasional outing in a friend's car, she was virtually housebound for over a year.

She continued to paint, though more sporadically than before, and her work still appeared regularly in exhibitions. During her 1937 illness Eric Brown wrote to Nan Cheney, who had just moved to Vancouver, suggesting that Nan try to arrange a solo show for Emily in Vancouver.[2] Nan spoke to A. S. Grigsby, the director of the Vancouver Art Gallery, and a solo show was arranged for October 1938. Emily was delighted and instantly forgot her previous distrust of the gallery. The show was one of the most successful of her career. She made eleven sales and afterward a selection of the pictures was sent to the University of British Columbia, where they were hung by Edythe Brand.

Aside from enthusiastic press notices, her VAG show brought her

> many lovely letters from various people. . . . It was my most *recent* work, mostly woodsy, and the letters all said the same thing in different ways, viz., their own country had spoken to them, made them feel our big woods in a new way. This made me very happy, happier than if people far off had praised their mechanics or the historical side of the Indian stuff.[3]

The 1938 show was invitational, but after that she had a show at her own expense in the Vancouver gallery every year except 1942. She was

not able to hang them herself or even visit them all, but Nan, Edythe, Lawren Harris and other Vancouver friends hung the pictures and sent her news.

Meanwhile her reputation continued to grow elsewhere. In Canada a major solo show was scheduled for September 1939 at the Art Association of Montreal, though unfortunately it had to be cancelled at the last minute because of the war. In the United States there were Emily Carr paintings in two exhibitions, at the 1939 World's Fair and at the 1939 Golden Gate Exposition in San Francisco. In England she was represented in 1937–38 in the so-called Coronation Show, an exhibition of works by artists throughout the British Dominions.

A major milestone was the "Century of Canadian Art" exhibition at London's Tate Gallery, which opened almost simultaneously with her 1938 VAG show. The whole exhibition was well received by the British press, and the four Emily Carr works were especially noticed. The London *Times* critic thought *Indian Church* "one of the most interesting pictures in the exhibition," while Eric Newton praised Emily's work as "utterly convincing and completely free of any tradition, Canadian or European."[4] A few months later, in the *Canadian Forum,* Newton enlarged on this at some length:

> [Emily Carr] is at her best when she is working on a big scale. And her best is magnificent. If the word "genius" (a word to be jealously guarded by the critic and used only on very special occasions) can be applied to any Canadian artist it can be applied to her. She belongs to no school. Her inspiration is derived from within herself. Living among the moist mountains and giant pines of British Columbia, a country climatically different from the rest of Canada, she has had to invent a new set of conventions, a personal style of her own. Where the Eastern Canadians have been content to stylise the outward pageantry of the landscape, she has symbolised its inner meaning, and in doing so has, as it were, humanised it. Her trees are more than trees: they are green giants, and slightly malevolent giants at that. The totem poles she often paints are haunted by the Indian deities they represent. Her art is not easy to describe, and indeed her power can hardly be felt in the four works shown in London. It happens that I saw over a hundred of her paintings when I was in Victoria. To see them was rather like reading an epic. Four short quotations cannot adequately represent the cumulative effect of the whole.[5]

At the end of that year, 1939, Emily's landlord suddenly decided to sell the Beckley Avenue house. Having just recovered from her heart attack, Emily was feeling relatively well, and to say the least she did not welcome the news. But after the first shock wore off, she picked herself up with her usual resilience and decided that now was the time to move in

with Alice. The school was finally closed, and there was plenty of room for her. She had thought the whole thing through long before, and it seemed the only logical choice. She told herself she would be the staff of her sister's old age, but of course she was also fulfilling an old childhood dream that Alice had never really shared. According to Flora Burns, Emily did not consult Alice at all. She simply "announced" that she was moving in.[6]

Certainly Alice was abundantly displeased. She consented mournfully to Emily's taking over the old dining room and schoolroom, and listened in dismay to a long list of proposed renovations. For all her mild exterior, Alice guarded her independence just as jealously as Emily did, and her schoolhouse had been her private domain for a quarter-century. If it was rundown, that was—so to speak—at her own pleasure, and when Emily went beyond the obvious necessities and tried to spruce up the entire house, Alice was livid. Each coat of paint or mended step was a battlement stormed and taken, and at each blow she would retreat inside the silent fortress of her wounded pride. Emily sputtered and fussed over the whole affair in her journal, making resolutions to respect Alice's sensibilities, breaking them, repenting and making them again. Alice, with far more explosive feelings to deal with, compressed all her indignation into six tight little words: "Feb. 6, 1940. Workmen began to alter my house."[7]

By March, when Emily moved in, Alice was resigned to having her there. But the underlying tensions remained, part of the many differences in style and personality that divided the sisters. Emily's stroke happened in Alice's kitchen three months later, amid a sickening welter of heat, smells and general messiness that Emily suddenly, and quite literally, found past bearing. Afterward, of course, Emily's whole rationale for moving in was altered, and it was Alice who looked after her instead of the other way around. Then there was a good deal of sympathy for "poor, gentle Alice," much as there had been for Dede in the old days. But it was as misplaced in this case as it had been then. Alice was no helpless martyr, and her weapon of injured silence was a potent foil to Emily's noisiness. Emily's Dr. Baillie,[8] who saw relatively little of Alice, once surprised Emily by shrewdly observing, in a departure from his usual discretion, that Alice was "one of those negative personalities who rather enjoy being a little miserable."[9] Although it is true that Alice was much put-upon, she could be every bit as difficult to Emily as Emily was to her. When she was piqued over some offence—if Emily wanted to read or listen to the radio in the evening, for instance, rather than chatter—she would refuse to speak for days on end. Difficulties developed over meals (Alice was a vegetarian), and it did not help that by 1943 both sisters were quite deaf.

Nevertheless, for all their differences, the sisters formed a strong al-

liance against loneliness and infirmity, and the advantage was not all on Emily's side. As time went on a fairly even balance of give-and-take developed between them, enlivened (in calmer moments) by a healthy sense of absurdity. One such moment is an account of a joint shopping expedition, as told in 1942 by Small, Emily's childhood persona. The spelling and punctuation belong to the piece and have not been changed. It begins in Kresge's five-and-dime, with Emily "blind talking" for Alice:

E. would pass slowly up the aisles making rumbling comments. "Here's potatoe parers, there are handkerchiefs 5 cents and *very* ugly—castors, screws, gimlets, knives, string, wool, shoe polish, tooth paste, glue, saucepans, underwear—now lets find hose-menders (the new pipes have bust all our combined garden-hoses) (three busts to 1 foot)

Here are duckey childrens sun-hats little rosebuds all over but *very* poor quality—pretty teacups oh? 49 each rather heavy but good floral design—some pink some yellow: so old Emily rambled on & on about the *use & looks & strength* of everything & if she moved more than 3 steps A. would loose her & fall into a lamp shade or butt into the candy cases. After they had filled a bag with junk such as cant be telephoned for & A. had bought household trifles that sounded useful or ornamental rolling off E.'s tongue the old girls decided they were hungry & tired, so they braved the "stop-go's" and got over . . . View St. and A. decided on Spencers basement next for 3 bls [sic] of butter. But, E. stuck at the stairs & a whole block of underground walking before they got to butter counter.

"Couldn't you *phone* for the butter?"

"I like to see butter and *carry* it home I'll meet you outside Teerie's [Terry's]." But as A. always went to wrong doors & missed meeting even when she had 2 eyes full of sight E. did not want the risk of chasing round & round between Terrys 2 doors. So A. went into a fury and then dumb. They went to Terries *early* to avoid "lunch-rush." In the middle of the floor a mean little bunch of waitresses (all new & in misfit smocks & caps left behind when their predesisors went military) were fighting as to whose tables were whose, while hungry people waited When E. had sat A. in a boothe & read her the menu the top half of E. kept oozing from their stall trying to arrest one of the wait-persons who occasionly came to the booth looked at them as if they were a managery & went away again At last E. took to shouting her order at the back of each waitress but *nothing* happened except that A. got madder & said "there is no rush, Millie!" Instead of all waitresses bringing all the orders E. had shouted the meanest rattiest of them all brought us 5 paper table-napkins. E. asked if they might not have a glass of water to go with the napkins & the girl then offered a menu. When E. asked the "wait" "which food went with which (to make what was called "the club luncheon") the creature always began with "I

immagain this" E. over-boiled & (I think she'd done *well* to keep *under the lid that long*) she roared "I want to eat *not* immagain!" So A. & E. came home hungry & *without* butter.[10]

It was in the year after she moved in with Alice, as she approached her seventieth birthday, that Emily formally launched her writing career. In a sense, the timing was perfectly in keeping with the rest of her life; her art career had not been truly "launched," in the sense of public success, until she was fifty-six. It was not really a success yet, if by that one means a popular triumph. It remained for her writing to bring her that connection with the common man that had always eluded her.

Emily's painting was both universal and specifically, passionately nationalistic. Seeing the Canadian landscape as a unique spiritual expression, she wanted to translate that vision so purely that any Canadian, seeing her art, would instantly recognize the shaping forces of his own land and his own identity. That was why spontaneous letters from strangers, or the comments of Lee Nam or a baker's delivery boy, meant more to her than formal reviews. She wanted desperately to be a popular artist, and much of the anger and resentment she had built up over the years sprang from the rejection of the man on the street.

But of course she could not be a popular artist. For one thing, her vision was too personal and too complicated. And besides, the mystique of art—that "art jargon" she had always instinctively hated—got in the way, aweing people so that they could not see what she thought she had plainly set before their eyes. She was also handicapped by being a pure landscape painter. Many people were almost as alienated from nature as they were from art, and they were even more put off by the native people's stark and (as they thought) superstitious melding of the human and nonhuman.

Emily's writing, fine as it is, is unquestionably a lesser art than her painting. Yet in her stories, particularly in the vivid evocations of the native and the forest in *Klee Wyck,* she would finally touch that wider public imagination her painting had failed to reach. Immediately loved and understood, at least on the narrative level, Emily's writing set the public on her own ground. For the more thoughtful readers it formed a bridge to the less accessible world of her painting. For the others, who were content to rest where they were, it became part of the national character and physiognomy and made Emily Carr's name a household word in Canada.

Although Emily had been writing stories for years before her 1937 heart attack, it was that illness, more than anything else, that turned her into a serious writer. The long hours in bed had to be passed somehow, and the fears of permanent uselessness and vacancy had to be assuaged. Writing was a strong antidote to depression. Besides, she loved rounding

out her past and making sense of it; it was exquisitely satisfying to see one's life as a finished whole, and not to have to stumble out of it at the end like some sleepy, befuddled child.

Nearly all of Emily's published works, as well as some unpublished ones, were finished in draft form between 1937 and 1941. *The Book of Small* took shape slowly during these years, building on a base begun in 1934. *Klee Wyck* was mostly written in 1937–38, and it was followed by *The House of All Sorts*. *Pause* was written in 1938, *Woo's Life* in 1940, *Bobtails* in 1941. The first version of *Growing Pains,* the story of her painting and writing career, was begun in 1938 and probably finished in 1939. (The second, published version, composed from scratch without reference to the first, was written in the early 1940s.)

Her illness aside, her writing was spurred on by outside help and by her first realistic chance of publication. Here again, as so often happened in Emily's life, her friends played a crucial part. By 1937 Emily had had enough of rejection slips; left to herself, she would not have risked receiving any more of them. But Ruth Humphrey wanted very much to see Emily's stories published, and she prodded and coaxed her friend to try again. In April 1937, while Emily was still very ill, Ruth showed a group of childhood sketches to the Shakespearean scholar Garnett G. Sedgewick, who was head of the English department at UBC. Sedgewick was not unfamiliar with Emily's writing, for Fred Brand had shown him some stories a few years earlier. Now he immediately agreed with Ruth that the sketches should be offered to Macmillan in Toronto. If Macmillan accepted them, Sedgewick would edit them and write an introduction. The manuscript was sent off, and Ruth also sent the story "D'Sonoqua's Cats" to *Blackwood's* magazine in England. In May she left for an extended trip abroad; in her absence, Margaret Clay took over as Emily's liaison with Sedgewick and Macmillan.

In June Sedgewick came to see Emily, who was working hard on finishing her native stories. He asked to see them, and though he kept her waiting five months for his opinion, it was unequivocal when it finally came. The sketches were fine just as they were, and "certainly should be published for the benefit of those who have eyes and ears. They aren't likely to have a large audience. The select few will be appreciative."[11]

That was an exhilarating boost for Emily's confidence and helped her keep on writing. But then, for about a year, it seemed as if nothing more would happen. Although Hugh Ayers of Macmillan met Emily in October 1937 and praised her childhood sketches, the firm rejected them for publication, claiming they lacked mass appeal. *Blackwood's* not only rejected "D'Sonoqua's Cats" but misaddressed the envelope so that it was lost in the mail. Twenty native stories, sent with six others to Ryerson Press in 1938, were also rejected and also lost, though Ryerson did locate and return them the following year.

All this was no worse than Emily had expected. She almost took a kind of gloomy pleasure in seeing her predictions fulfilled. But around December 1938 the indefatigable Ruth Humphrey, now back from her travels, introduced Emily's stories to Ira Dilworth, regional director of the CBC.

Dilworth had known Emily by sight since boyhood. Now in his midforties, he had come to James Bay with his family at the age of fifteen, and shared the neighbourhood memory of the funny fat lady with the monkey and the baby carriage. During and after World War I, still living in James Bay, he had been one of Victoria High School's most innovative and charismatic teachers, almost a cult figure to the brightest students. In 1926, after graduate study at Harvard, he became principal of the high school, and later he taught English at Victoria College and UBC before finally accepting the CBC post.

A plump, fair man with a fussy manner, Dilworth was called Dilly behind his back by his high school students. But he was a brilliant teacher. "Dilly was always part of his class," one of them said later. "He didn't hold us at arm's length the way many teachers do."[12] In a time when Victoria was still virtually a cultural desert, Dilworth's English classes included long intervals of classical music, played on a Victrola brought from home. When he was principal, and later as a college teacher, he held regular evenings of music and poetry at home, attended by a half-dozen or so students and ex-students, among them Max Maynard, Jack Shadbolt, Fred Brand and Roy Daniells. Later, when he worked for the CBC, he inspired a similar kind of loyalty among his employees there.

He had first seen Emily's paintings at Crystal Garden in 1930 and had been less than overwhelmed. Art was not his strong suit; literature was. He was immediately enthusiastic over the stories. The first thing he did about them was to ask his friend Sedgewick to read several over the air. The two readings, carried by the local CBC station, were delayed somewhat by the war but took place early in 1940. They were followed in 1940–42 by other broadcasts, sent over the national network with Dilworth himself reading.

Meanwhile, in June 1940 (just after Emily's stroke), Dilworth took several stories east to the Oxford University Press in Toronto.[13] Initially William H. Clarke, manager of Oxford, and his editor King Gordon liked the stories but, like Macmillan before them, doubted they would sell in book form. Dilworth persisted, though, and eventually he won them over. By October Emily—now living at Alice's and slowly regaining her strength—could tell Nan Cheney there was *"something* in the rumor you heard (stories) but nothing definite yet. So I do not say anything."[14] The decision was finalized in March 1941, when Clarke and his wife, Irene (who was a working member of the firm), came west and had several visits with Emily. Oxford had accepted not one Emily Carr book

but two. *Klee Wyck* was published in October 1941, and *The Book of Small* followed a year later.

Ira Dilworth's role had barely begun. He became Emily's editor and permanent emissary to Oxford as well as a loved and trusted friend. Living in Vancouver with his mother and two adopted daughters, Dilworth was leading a full life when he met Emily. He had a demanding job, requiring much cross-continental travel, and when the war began his already heavy responsibilities were greatly increased. He was a sociable man, a gourmet cook and director of the Vancouver Bach Choir. His mother's health was frail and she needed looking after. Nevertheless, he undertook to make frequent trips to Victoria to go over Emily's manuscripts with her and take the latest batch home for criticism. He advised her not only through the publication of *Small* but throughout the rest of her other works. He was always under considerable pressure from Emily, who could not really allow for any demands on him but her own.

Emily always insisted that she could not write without him, and that by itself her writing was just "a flout of drift."[15] She was so vociferous about it, and so fierce in claiming a share of each success for him, that one is tempted to suspect her work was not entirely her own. But many of Dilworth's written comments survive, and there is nothing in them to suggest that he ever overstepped the bounds of editor. He corrected spelling and punctuation and helped her organize and polish her material, and he was firm about judicious cuts. But the style is entirely Emily's, easily recognizable to anyone familiar with her letters and journals.

Publishing an unknown writer in wartime Canada was an especially risky venture because so few trade books could be published at all. That being the case, the contrast between William Clarke's faith in the stories, once it was established, and the faintheartedness of earlier publishers is striking. "I cannot tell you how thrilled we are at the discovery of this material," Clarke wrote a few months before *Klee Wyck* appeared. "We believe that it is the greatest find in Canadian literature since 'Maria Chapdelaine,' and we shall be tremendously disappointed if, both here and in the United States, her work does not receive adequate attention."[16]

Klee Wyck was never successful in the U.S., but by December it was clear that, at least as far as Canada was concerned, Clarke's hopes were justified. Emily's first book became an instant classic. War-weary Canadians fell upon it in bookstores and emptied the display racks, and booksellers who had ordered only a few copies were caught short. The nationwide weekly *Saturday Night* provided trumpets in the form of two successive articles by Dilworth,[17] and the reviews were uniformly enthusiastic. " 'Klee Wyck' is one of the show pieces of Canadian bookmaking in 1941," wrote the reviewer of the Toronto *Globe and Mail,* "and I think it will be extensively read for its charm and deep feeling."[18] Blair Fraser

of the Montreal *Gazette* predicted that the book would win Emily a wider public than her painting ever had, adding that "her rage burns as hot as any Indian's, when she sees their ancient ways forgotten, their ancient arts lost, and their inner integrity destroyed by the fatal touch of the white man. . . . Out of her anger, her love for these humble people, and her painter's eye for the beauty of a strong wild country, she has made a fine book."[19] The Victoria *Colonist* reviewer welcomed it as a "great book" and a "valuable piece of Canadiana."[20] "[Emily Carr's] pity is great," said Robertson Davies in *Saturday Night,* "but the severity of her irony is like the slash of a razor. She writes like a woman who has led a lonely life, far from the pretences and flatulent enthusiasms which bedevil literary folk. There is nothing to be said in dispraise of her work; it is the product of a fine mind complete and strong in itself."[21] A few months later *Klee Wyck* won the Governor General's Award for the best book published in Canada in 1941.

For some weeks after the book came out Emily would not believe in its success. She kept a strict accounting of which friends wrote to her and which did not, took each delay as a sign of doom, and suspected Dilworth and Clarke of giving the truth a little kindly doctoring. But as the volume of letters and clippings coming through her mailbox steadily grew, she began to understand what it was to be a national celebrity and allowed herself to bask and expand a bit. She even went so far as to paste her clippings in a book Flora gave her for the purpose.

Yet along with the proliferation of intelligent criticism in the forties came a lot of mindless, gossipy publicity focussing on Emily's personal oddities. That kind of article reached its peak after her death, when all sorts of people who had known her slightly felt obliged to add their mite to the growing mountain of print. But the trend was an old one, and Emily herself had occasionally encouraged it. The interview she gave in 1927 for the Toronto *Star Weekly,* published under the coy title "Some Ladies Prefer Indians," is a notable example.[22] In 1940 she did it again, giving an interview to Elizabeth Ruggles of the Victoria *Daily Times,* who afterward minutely described her studio and wrote of how she had "penetrated by canoe waterways known only to the natives to sketch the vast untouched forest depths," and so on. The article often mentions Emily's sharp manner, and in fact sometime during the interview Emily, realizing it was all a mistake, snapped "I hate reporters" at Ruggles, who of course dutifully wrote it down.[23]

An article written the following year by an ex-classmate from the 1934 writing course was equally infuriating, using the publication of *Klee Wyck* as an excuse to write a purely personal reminiscence.[24] Almost as offensive in a different way were the fulsome appreciations written by the *Province* critic J. Delisle Parker, a painter and sometime friend of Emily's. Parker was given to rhapsodical prose. He praised the

"symphonic quality" of her paintings, opining that "the influence of Turner and Van Gogh [is] obvious,"[25] and he was not above such gratuitous folksiness as this:

> One can imagine the three griffons, including the now-deceased Coco—who has become a legend among Miss Carr's friends—seated side by side on a couch with the wicked Woo looking in from the outside of the big studio window, and Susie the favorite white rat in the background, all gazing at their beloved mistress while she painted.[26]

Understandably, this sort of stuff got Parker, one of Emily's keenest fans, consigned to the ranks of "muttonheads."[27] Emily did not hate all reporters, but she immediately spotted and loathed the kind who sensationalized her private life or used her work as an excuse for flights of literary fancy.

On Emily's seventieth birthday the University Women's Club, which had made her an honorary member three years earlier, gave a party to publicly acknowledge her achievements. Emily was terrified. For weeks beforehand she tried to keep the whole thing out of her mind. She did not believe even her best friends would come, and she was astonished when Alice surmounted her shyness to accept an invitation. Ira told her he probably could not attend, and she braced herself to face the public alone:

> My party is dated for Saturday next. The poor dears mean well—I'm to be carted to the function by the President, who is a complete stranger to me as are all of them except Ruth and Margaret Clay (if they are there). Well, nothing for it but to attire myself in the dress I split in Vancouver and all the courage I can muster, and *forget* about it till Saturday morning.[28]

It turned out to be an extravagant affair. Most of Victoria's civic organizations were represented, and there were letters or flowers from, among others, the premier, the lieutenant governor, the Indian Commissioner of British Columbia, the Indian Agent of Vancouver Island, the mayor of Victoria and the Canadian press. Emily sat next to Alice on a sofa, surrounded by flowers, while Ira (who of course had come) read aloud from *Klee Wyck*. Afterward she managed to blurt out a short speech of thanks. Driven home before she became too tired, she suffered no ill effects except insomnia. By the next day she was sitting up in bed composing the first of twenty thank-you notes, which she duly sent out within a week as her mother had taught her. She had to check with Ira about forms and titles, and some of the higher dignitaries she was afraid were too lofty to be addressed at all. ("How about the Lieutenant Governor and Premier surely not?? or how???")[29] The excitement brought on

an inevitable reaction, and three days later she was feeling "like a leaf flit-
tered to earth and flat and sodden after the spin whirl through the air. I
believe I'm *glad* to be earthed again. The leaves must feel a little that way
after having *sat* all their lives."[30]

Soon her life was back to its usual placid tempo, and she was making
Christmas candy and grumbling about the neglect of old friends, notably
the Group of Seven: "I rather expected to have heard from some of the
artists, Lismer Jackson etc.," she wrote Ira. "They resent me a little—I'm
a woman."[31] She was still fully armed; it was too late for her to change a
lifetime stance of waiting for the next tiger to come out of the shadows.
All the same, the tigers from now on were all made of paper. She could
never again feel truly isolated and ill-treated, and she was well on her
way to becoming a national heroine.

Last Years

"THE BOOK OF SMALL" came out in the autumn of 1942. It was actually two slim volumes in one. The first part, which gave the book its title, was made up of twelve stories of Emily's early childhood. They all take place before the Carr family was broken up by the death of the parents; the telling of the misery that followed, and Emily's long and turbulent rebellion against her older sister, was left for the posthumously published *Growing Pains*. *Small* is more reticent and more perfectly crafted than the later book. Light and funny and vivid, it is first of all pure entertainment, a nostalgic evocation of a simple, sleepy time and place that contrasted poignantly with the war-blasted realities of 1942. Turn-of-the-century Victoria, with its upright matrons, its natives and Chinese and pioneers, its flower-scented streets and meandering cows, is brought to life in the second half of the book, which Emily called *A Little Town and a Little Girl*.

Light though it is, *Small* is an angry book, though the anger is so delicately sauced with humour that it is rendered into something slight and charming, the petulance of a little girl. Richard Carr dominates its pages, even when he is not there. The opening chapter describes his Sundays, with their punctilious regimen and their banished books and toys; and one can detect his spirit and his minions throughout, in sanctimonious Lizzie, scolding Dede, lugubrious Auntie Hayes and the cold, censorious Mrs. Crane. As himself, pompous and self-righteous and always "very particular about everything being just right,"[1] Emily's father is always a little ridiculous. Emily took her revenge, finally, by laughing at him. She herself did not realize that; she thought she had simply unburdened her hate by forgiving him. She did not even realize "how much of Father there was in the book" until it was published, and then she said she hoped her portrait of him had "made people respect and honor" him.[2] But though there was real affection in the writing, the net effect was to reduce her father and Victoria itself to words on paper, creatures of her

own devising. Acknowledged or not, it was her way of disarming the tyrant whose power over her childhood had been absolute; and at the same time she got back at the town whose gentility, however picturesque, had cramped and chafed a growing spirit.

Alice's reaction to *Small* is difficult to assess, for we have only Emily's account of it. To Emily directly, Alice was decidedly negative. She was acutely sensitive to any criticism or ridicule of her family in Emily's stories. Emily once wrote Nan Cheney that when she read Alice the early chapters of *Growing Pains,* Alice was so furious that she did not speak to Emily for weeks.[3] She had seemed to like "Cow Yard," the earliest of the *Small* stories, but she would not listen to Ira read "Sunday" on the radio, and Emily read her only bits and pieces of the rest of *Small,* those that were least likely to upset her. Ultimately, the only books of Emily's Alice genuinely seems to have liked were *Klee Wyck, Bobtails* and *Pause,* all of which were safely remote from herself and the family. On the other hand, she was anxious to see *Hundreds and Thousands* published after Emily's death, out of purely generous motives since the royalties had been willed to Dilworth.

Commercially and critically *Small* was a success. The first printing of four thousand sold out in three months. In England it was the only Canadian book to be published in wartime. In Victoria it was enthusiastically hailed by both the *Colonist* and the *Times.*[4] Margaret Clay assured Emily that the public library could not keep up with the demand. But Emily also noticed that Bishop Cridge's daughter, who came to see her some weeks after the book was published, said nothing whatever about it,[5] and that seems to have been true of many townspeople. If they were offended, they were too well bred to complain directly to the offender. Still, Emily suspected she had stepped on some toes. She kept her copy of *Small* out of sight and never spoke of it to visitors unless they spoke first.

From mid-1942 on Emily's illnesses multiplied. Before the end of her life she had a third heart attack, two more strokes and several acute attacks of cardiac asthma. There were four rush visits to the hospital and a dreary six-month incarceration in a nursing home. Finally, in 1944, she begged not to be sent to the hospital any more, and her sympathetic doctor agreed. She had a stroke that year, but she recovered from it at home in her own bed, with her work, her radio and her remaining animals around her. Although two nurses came in then for a while, generally all the care she had was from her last maid and friendly enemy, the inimitable Mrs. Shanks.

She had days and weeks of near-despair, when she felt "like a country road rambling on and on with twistings and *no* lights."[6] One would expect any chronicle of these years to be depressing, a tale of the inexorable decay of a brilliant human being. It is not. It is sad, certainly, and full of

suffering too large to be comprehended through anything less than a day-by-day reading of her letters. But those letters—and they are voluminous, by far the richest source a biographer has to draw on—move and breathe with such intensity of feeling, and such feistiness and humour, that the chronicle is one of living, not dying.

She wrote a great many letters, for she had never had more friends than she had now. Nan Lawson Cheney, whom Emily had first met in 1927, had renewed their friendship during a summer visit to Victoria in 1930. In 1937 she married and moved to Vancouver, where she was a great help during Emily's recovery from her first heart attack. Cheney helped alert the art world to Emily's illness, initiated the 1938 solo show at the VAG and personally hung it. She visited Victoria once or twice a year, staying with Emily or with an aunt, and on one of those visits painted the portrait of Emily that is now in the National Gallery. Emily in turn stayed with the Cheneys in Vancouver in 1938 and occasionally thereafter. The friendship was not particularly deep, but it was sprightly, and after Emily became housebound it gave her one of her most regular correspondents. Others in Vancouver included Ada McGeer, an old Victoria friend who now worked for Ira Dilworth; Roy Dunlop, another employee of Dilworth's; Walter Gage of the University of British Columbia; and the radiologist Dr. Ethlyn Trapp, who visited Emily often in the early 1940s and named her house Klee Wyck in her honour. Letters went out to Edythe Brand—though not as many as had gone a few years earlier—and to Victoria friends like Ruth Humphrey and the young painter Myfanwy Spencer Campbell, who became the last of Emily's surrogate daughters.[7] There were letters to the Harrises, the Clarkes and Carol Pearson. Carol was still Emily's "Baboo," and in these last years, herself very ill, she came west twice to see Emily. Emily sent her the fare at least once, in 1942. It was $100, which was an astonishingly large chunk of Emily's resources. Clearly she wanted badly to have Carol near her at this time, when she was ill and lonely and many of her young friends had been scattered by marriage, careers or the war. For a time it seemed that the whole Pearson family might move west; but economic reality prevailed and the plan fell through.

The greatest number of Emily's letters, by far, went to Ira Dilworth. With her other correspondents, in varying degrees, Emily kept some part of her inner life in reserve. But with Ira there was really nothing she could not share. Their friendship was always based on "straight talk," and Emily's feelings towards him were deep and complex. He was father, son, priest, psychiatrist, mentor, comrade and lover. She credited him with endless sympathy and understanding and trusted him absolutely, and although she must have tried his patience severely (he said as much, at her funeral), he never seriously disappointed her. She deluged him with letters, scolding him for overworking one day and for not

reading her manuscripts or answering her letters promptly enough the next. She herself nearly always wrote on Sunday after his CBC poetry reading, and generally once or twice in midweek. Her letters, scribbled in pencil on scrap paper, were largely innocent of punctuation except for underlinings and exclamation points that rival Queen Victoria's. Occasionally she offered some apology for them, but only to confirm her contempt of rules: "Such notepaper! I'm no lady!! Whatever is handiest when I write! being particular stunts thought—sorry—brains limited."[8] Usually they were two or three pages long and dangled long tails of codicils. Loving, playful, malicious, ingenuous, flirtatious, full of pain but often very funny, they were basic Emily Carr, freed of all restraints.

Although they worked closely together on *Klee Wyck* and on all her subsequent books, it was *The Book of Small* that set the tone of Emily's love for Ira. Ira's sympathy for the child Small was, to Emily, an acceptance of the young, obstreperous self that respectable society had driven into hiding decades earlier. She dedicated the book to him and in her will she left the manuscript, along with all her others, to his care. He became Small's "Dear Guardian," and as Small gained reality in the book, she emerged as a third person in their friendship. An invisible Tinker-Bell elf, she wrote her own letters, hung up cobweb stockings at Christmas and surveyed the world from Ira's waistcoat pocket. She scolded and coaxed Emily out of depression and fits of temper and was not above tattling on her to Ira. It was all a game, of course, but it was also in real earnest. Small was at once Emily's liberated childhood self and her muse, and without her Emily might have lost her stubborn hold on work and life. Without Ira, in turn, Small would have ceased to exist.

Under all Emily's affectionate banter with her friend was the tacit recognition that he was the son she had never had and the father she had lost very early, long before the actual death of Richard Carr. He was, too (though Emily never said as much), the man she could have loved forty years earlier. The notion that there could be any trace of sexual feeling between herself and this man thirty years her junior was so foreign and repellant to her, and seemed so patently absurd, that she dismissed it out of hand. But she could allow herself to express, through Small, a degree of love that was the privilege of small children and old women. It was Small who wanted to hug Ira, but then Small was a spirit-child who wanted to hug a dearly beloved father. Ira was not a demonstrative man, and Emily would apologize for Small's effusions and promise to try to teach her manners; whereupon Small might observe, in a codicil to Emily's letter, that nobody had ever succeeded in teaching her any manners whatever.

Ira was also her confessor. The consuming demands of her art, her lifelong failure to mesh smoothly with the people and place into which she had been born, the implacable virtue of her sisters, the friends she had

hurt and continued even now to hurt, and the old, cruel accusation that she had hastened her mother's death, all puzzled and shamed her still. Her writings eased that ache, but only partly, and she suspected that *Small* would offend many Victorians and that it had already offended Alice. She badly needed someone to say "Go in peace" even though she could not promise to sin no more, and the continuing creativity of her last years owed much to Ira's unspoken absolution.

Along with the manuscripts, Emily left to Dilworth the royalties from her books, which eventually passed to his heirs. She briefly considered leaving the royalties to Alice, but decided against it because she expected (rightly) that Alice would not live many more years and she wanted Ira to have some reward for the monumental effort he had put into her books. She never had any inkling of how substantial the reward would become. In later years Ira asked Alice to legally confirm his rights to the royalties, which she did, provoking some private criticism of Dilworth as self-seeking. Yet it is clear that Emily intended him to fully enjoy a return for his help; and Alice, who left an estate worth about $10,000 when she died, was not in financial want.

Ira was the centre of what Emily called her "posey of grand men."[9] "How nice men are," she wrote in 1942, "so much nicer than I thought, once long ago. I used to be a man hater once. Now I have far more men than women friends. . . . I seem to get closer and deeper to them than to women??"[10] It was not true that her men outnumbered her women, but by now they outweighed them. Her old women friends, as well as some new ones, stuck loyally by her; yet she did "get closer and deeper" to men. None of them except Lawren Harris were artists, but it would not have mattered much if they had been. She was fairly detached from her art now, and her competitiveness and defensiveness had softened. She did not have to worry any more about men shouldering her aside and patronizing her, nor about sex. Consequently she was thoroughly comfortable with men and ingenuously pleased to confess that she had, on the whole, misjudged the sex. Among the men who meant most to her were Bill Clarke, who visited her several times in these years and always left her "brisked"; Willie Newcombe; her lawyer Harry Lawson, son of her childhood guardian; and Dr. Baillie, who respected her need for work while delicately navigating her through the shoals of illness. What she perhaps appreciated most about Baillie was that he never lied to her; in recognition of that she dedicated *Pause,* her book about the "San," to him.

The revelation about men was not, generally, retrospective; she had been flatly ungracious about several men who had tried to help her, notably Mortimer Lamb and (lately) Charles S. Band, and she never fully acknowledged her debt to Eric Brown or Marius Barbeau. But she did come to a renewed appreciaton of Lawren Harris. The Harrises moved to

Vancouver in 1940, and Emily resumed her old friendship with Lawren. It was not on the same plane as before; they avoided talking about religion, and Emily was still critical of Bess (though not to Lawren). But in the course of writing the final version of *Growing Pains* she reread Lawren's old letters from the 1930s and saw how much he had helped her career:

> He was marvelously generous to me from the start of our friendship, round about 1929–1930 opening the rich cupboards of his heart stored with art knowledge that I had never even dreamed of, riched with his own perception, his inner struggles, his bigness, his love of lovely things, his . . . hopes [and] high aims, patiently encouraging, showing, lifting the despondent failure of western me out of the slough me and my thwarted Art were wallowing in. . . . Those letters are *worth* more than *my whole* Biog.[11]

She found too that the "Biog." itself traced back to a letter of Lawren's written in 1933:

> I found something I had forgotten, viz., Lawren tried to persuade me to write a biog: practically the thing I *am* doing. I remember jeering and saying "Who'd want to read it?" and "What had *I* to write about?" and dismissing it from my thoughts. Maybe it did not register *then,* maybe it sowed the idea, I don't know. I *thought* it was *really* because Eric Brown asked me to [in 1938], said if I wouldn't someone else would.[12]

She gave *Growing Pains* to Lawren to read in 1943, added some forty pages of manuscript at his suggestion, and dedicated the book to him. Throughout the rest of her life he continued to line up exhibitions and buyers for her, just as he had in the old days, and after her death he shared with Willie Newcombe, and later Ira Dilworth, the trusteeship of the art in her estate.

The question of the final disposition of her paintings began to trouble Emily in the early 1940s. She did not want to leave them to Alice, for various reasons: there would be a large inheritance tax on them; Alice had never shown the slightest interest in them and indeed could not even see them any more; and after Alice's death they would go to Tallie's children and grandchildren, several of whom Emily disliked. In July 1941 she resolved the problem by establishing the Emily Carr Trust. Originally made up of forty-five oil paintings, the Trust was increased informally, both before and after Emily's death, until by 1966 it included 170 works. During the war the paintings were sent to the Art Gallery of Toronto for safekeeping, where in 1943 many were shown in a major retrospective exhibition. After the war, according to Emily's wishes,

they were sent to the Vancouver Art Gallery, where they remain today. (See Appendix 4.)

Emily's worst invalidism began in August 1942. The early months of that year, those just following her big birthday party, were a golden time. *Klee Wyck* went into a second printing, *Small* was waiting in the wings, and Emily was happily involved in preparing a show for the VAG. She had a new puppy, a sweet-tempered Australian terrier named Sara, and she was feeling flush enough to hire a taxi now and then and take Alice on little excursions around the city. She even ventured twice out into the woods for sketching, with the taxi leaving her and picking her up. In June she had a three-week visit in Vancouver with the Dilworths, and before she left she announced she was going back to the woods that summer for a good long stay, and neither her friends nor her doctor could talk her out of it. She put it off for a month so that Carol could come for a visit, and at the end of July she went.

She rented a wooden shack at Mt. Douglas Park, a steep, heavily wooded preserve overlooking Cordova Bay. She had no one with her, but the park tea house was next door and the proprietor, Mrs. Billy Edwards, brought her breakfast each morning and kept a motherly eye on her. "Goodness she's a kind soul," Emily wrote,

> . . . gives me such loving care yet never intrudes on my work. This cabin is BLISS, tar paper and shiplap—scenery peeking in through the knotholes and windows—door never shut—occasional yaps of iced agony from the bathers below.[13]

A few days later Small reported that Mrs. Edwards had ordered Emily to bed after some "longish" walking, and Emily was "meek." There were "cedar trees for nurses—delicious nurses—who don't rustle starch, and chatter."[14] Although there must have been several such days, Emily brought home fifteen large sketches of the blue-green, sweeping cedars of Mt. Douglas, as well as several smaller ones. Among the manuscripts she wrote or revised was the chapter on her mother in *Growing Pains,* which she thought "perhaps the tenderest most loving bit of writing I have ever done."[15] She came home on 7 August in high spirits, but unable to move without heart pains. She put herself to bed, thinking a few days' rest a fair price for ten days of pure joy. But on 14 August she had a severe thrombosis that knocked her unconscious for three days.

When she was out of danger she was transferred to the Mayfair Nursing Home, where she stayed until March 1943. She had four solo exhibitions that year, in Montreal, Toronto, Vancouver and Seattle. The one in Toronto, the so-called Trust Show, was one of the high points of her career. It took place in February 1943, when her health and spirits were at an absolute nadir, and she hardly noticed the glowing reviews. Even so,

sick as she was, she was writing. She had three books under way, plus the unpublished miniature sketches. The last book to be published in her lifetime, *The House of All Sorts,* came out just before her birthday in 1944. Into it she packed some twenty-odd years of drudgery and bitterness, along with the languid ladies and the blustering men, the tyrant furnace, the frozen pipes, the battle of the hose and the battle of the pail. As comic art, with all the misery and the sheer weight of years leached away, the entire middle of her life did not quite fill a volume. *Bobtails,* the story of her first dogs and the sane balance they gave her days, filled out the rest.

The House of All Sorts is one reminder of how often in her life Emily kept herself going through sheer contentiousness. She did still, but she sometimes had a hard time finding anyone to contend with. Her friends wrote, sent flowers and visited when they could, and the worst she could accuse them of was a few weeks here and there of inattentiveness. For a while, in the nursing home, she jousted with the owner, Mrs. Clark, who was a tempting target because she was so *"dreadfully* English."[16] But after Emily went home she was lonely and depressed. There were periods when she was too ill to write or even to read. There were long, terrifying nights spent sitting up because she could not breathe when she lay down, and there were days of uncontrollable weeping, the side effect of the injections Dr. Baillie gave her for her heart. The year 1943 was wretched, with no sweetness and very little spice to it; such spice as there was came in the innocuous person of an elderly housekeeper, Mrs. Shanks.

Mrs. Shanks (or just plain Shanks to Emily) was a widow whose kin, evidently almost as exasperated with her as Emily came to be, had pretty much left her to fend for herself. She was the only maid who ever came to Emily's house who did not fret to leave it, either to marry or to "better herself." She instantly made the cramped little flat her home and Emily her family, and could not be persuaded to leave even for Christmas, since she had nowhere else to go. Emily was sorry for her, and fond of her in a crusty sort of way. But as a helpmate Shanks was a disaster because she was both stubborn and chronically, almost pathologically, absent-minded. Nevertheless, Emily had nowhere else to go either, for wartime help was scarce; and so the two were stuck with one another. After almost two years Emily finally tried to fire her, but Shanks's replacement caught flu at the last minute and Shanks stayed on.

Emily wrote the daily saga of Shanks in her letters to her friends. It comes out sounding something like the part about the duchess and the cook in *Alice in Wonderland.* But where the cook was fierce, Shanks was vague and fluttery, and where the cook was liberal with the pepper, Shanks was liberal with anything that came to hand. Emily's appetite was dampened anyway as a side effect of her medication, and Shanks's

culinary excesses made the food inedible. So Emily took custody of the cloves and paprika and hid them in her clothes closet, and the onions soon followed them. Saucepans were hung above the bed and doled out one by one, "because [Shanks] *would* use wrong ones for *wrong* things and ruin both food and saucepan. She was awfully shamed to have the Doctor see a saucepan hanging on my bedroom wall and, I *believe* has not used it for wrong purposes since."[17] For a while, before the doctor forbade it, Emily got out of bed each day and cooked her own meals and Shanks's too. When that was not possible, she ate only porridge, which she said was the only food in the world Shanks could cook.

Of course Emily lost her temper regularly. Then (by her own account) she would roar "Mrs. Shanks!" and hurl pillows, spoons, towels or whatever on the floor. Shanks would momentarily shake herself together and promise to reform, but the effort never lasted more than a day or two. "[It's] the worst thing possible to upset my fool heart," Emily grumbled, and that was probably true.[18] At the same time it was high comedy and good theatre, and very much like a replay of certain moments in her boarding house days. One can feel the gusto with which she dramatized her own rage, and the way she drew life and spirit from the telling of it. Later Shanks began to fight back, and then there was real wrangling. But the only physical harm Shanks did was not to Emily's heart—it was to her already failing appetite. When Emily was hospitalized in September 1943, Dr. Baillie said it was "partly due to starvation."[19]

Emily's work continued to appear in group exhibitions in her last years, though she gave up on the Island Arts and Crafts Society after 1937 and did not send directly to the Canadian Group of Painters after 1939. She sent several paintings almost every year to the B.C. Society of Fine Arts shows in Vancouver, and with the help of Lawren and Willie she continued her annual solo shows at the Vancouver Art Gallery. They were made up largely of forest sketches, though in 1941, under the stimulus of *Klee Wyck,* she did a series of paintings of native subjects. These were based on the same material as her earlier native works, but the resemblance is only superficial. In the late paintings there is little of the stark contrast and severity of form that characterized the earlier ones. The sense of space and lighter palette of the intervening years transformed the new works, and their drama was more subtle. The *Skidegate Pole* that led the new series showed its massive, slightly tilted subject set on a bare hill and open to the sky. The shadowed forest setting was gone, and with it the metaphysical dialogue between tree and totem. This pole was lit by the flat, evenly diffused light that illuminated all her late canvases. The painting was notable for its strict economy and for the way she excluded any shape that might distract from the simple unity of pole, hill and sky.

Those paintings, and the Mt. Douglas sketches two years later, stirred up some faint echoes of the old controversy. One Vancouver reviewer alluded to the "gloomy formlessness" of the works at her 1941 show, and Jack Shadbolt, who gave a talk on those paintings, was consistently interrupted by a heckler—though the man apparently objected to Shadbolt's criticism of the paintings and not to the paintings themselves.[20] But in general it was now considered philistine, at least in educated circles, to sneer at Emily Carr. "There is something courageous and remarkable," wrote the critic and painter Mildred Valley Thornton, "in the spectacle of this woman, no longer young and in poor health, painting with such profusion and with growing power at an age when many are laying down their tools and slackening in mental concepts."[21] Needless to say, Thornton got no thanks from Emily for commenting on her age and infirmity; nevertheless the article expressed what many people felt.

Of all Emily's late exhibitions, the most important, and indeed the culminating show of her career, was held at the Dominion Gallery in Montreal in 1944.

Except for one brief experiment with a Vancouver dealer, Emily had never had anything to do with commercial galleries. She was unwilling to entrust her work to them or to part with the standard one-third commission. Ever since the mix-ups with the National Gallery in 1928 she had hated sending her work out to strangers, though for the sake of prospective sales she would grudgingly part with them "on approval."

In late July or early August 1944, the Montreal dealer Dr. Max Stern came west to acquaint himself with the work of western artists. Originally from Düsseldorf, where his father had owned a gallery, Stern had fled Hitler in 1934 and set up a gallery in London. In 1940 he arrived in Montreal, where he and a partner, Mrs. R. Millman, established the Dominion Gallery. Four years later it was probably the most comprehensive gallery in Canada, carrying works by the best-known Canadian and European artists. The Canadians included the Group of Seven and the new generation of Quebec abstractionists, among them Alfred Pellan and Jacques de Tonnancour. The Europeans (carried at some expense to the gallery, for Montrealers seldom bought them) included Chagall, Ernst, Feininger, Grosz, Kandinsky, Kokoschka and Rodin.

Stern had been commissioned by a Montreal collector to buy a painting by a western artist. When he protested that he knew none, his client mentioned Emily Carr. Accordingly, when Stern reached Vancouver he asked Lawren Harris about Emily, and through Harris and Dilworth he arranged to go to Victoria and see her the next day.

He arrived in the late afternoon and found her sitting on the veranda, wrapped in a blanket, with her Siamese kitten on her lap. She took him

inside and began to pull out paintings from the hundreds that were stacked in racks along the studio walls. Stern had seen only a few before he realized that here was a major talent, very different from any he had seen before. He persuaded Emily (who was panting for breath but thoroughly enjoying herself) to sit down, and took over showing the works himself. When she tired he left, but he came back twice more, and before he left Victoria Emily had given him two paintings and sent another to Mrs. Millman. She had also tentatively agreed to send him a large number of works on consignment for a year and to let him hold an exhibition that fall.

After consulting Ira and Lawren, Emily shipped eighty-seven paintings (oils, sketches and watercolours) to Stern in mid-August. Out of these he chose fifty-nine paintings for the Dominion Gallery exhibition, which opened on 19 October and ran a little over two weeks. The gallery assumed the cost of framing, and eventually the cost of crating and shipping as well. The works chosen spanned Emily's entire career, from France onward. They were arranged chronologically in four rooms, with the magnificent late forest and sky studies at the end.

Nobody, except perhaps Stern himself, expected much of the show. Arthur Lismer, whose advice Stern's partner had asked in the beginning, had warned that there would be no sales, and given the general art climate in Montreal that was a fair guess. A small show of Emily's work at the Art Association of Montreal the year before had had a short but favourable review in the *Gazette,* but had not been widely noticed.[22] Now Montreal suddenly ignited over the Dominion Gallery show. Forty-six of the works were sold, bringing Emily a total of $1,260.67.[23] At an average of about $27 per painting to the artist, they were shockingly underpriced, but the volume exceeded anything Emily had ever known before. She was very pleased and promised to try to send more paintings, but a third stroke in September forced her to postpone that task. For the Canadian public, this was the beginning of a devotion to Emily Carr's art that has lasted forty years, despite the vagaries of fashion.

Emily made a successful comeback from her stroke, and by November was "painting a bit and writing too."[24] Stern pressed for another show in 1945, but she wanted to have one more show in Vancouver first. She did send him another large consignment of watercolours in January, and then she threw herself into preparing her VAG show, touching up her sketches and mounting sixty of them on plywood. The effort exhausted her, as did the endless bickering with Shanks, and she was worried about Alice, who was interrupting her own sleep at night to check on her sister. In February 1945, with no specific complaint except weariness, Emily checked into the newly opened St. Mary's Priory nursing home, com-

fortably nearby on Government Street. There she was delighted to re-
ceive word that UBC planned to confer on her an Honorary Doctor of
Letters degree that spring.

She had finished preparing her show, seen her third book into the
world, left her art to the west, completed all her manuscripts and
entrusted them to Ira's hands. Although she had another show in mind
and unpublished manuscripts next to her bed, all her major work was
done. "I used to wonder," she once wrote Ira, "what people who were
uncertainly facing death thought about it. They seldom mentioned it and
I often wished they would. (We are rather cowardly about that thing.)
Now I look on it very much as I used to look . . . on going out into the
woods in the van in the old days, busying myself in the preparation of
leaving things as straight as I can, and leaving the new camp to be itself
when I get there."[25] On 2 March 1945, in the middle of the afternoon,
she got there.

Ucluelet, 1899

THE DATE OF EMILY'S trip to Ucluelet can only be established indirectly. She definitely did not go when she was fifteen, as she claims in *Klee Wyck* (p. 3). The year 1898 has generally been accepted, but without firm evidence. There are several sources that strongly suggest April 1899.

First, May's sister Lizzie Houston Armstrong, who was at Ucluelet from 1897 until July 1898, vehemently denied that Emily visited there then, said she had never met Emily and that her Ucluelet stories were "the darnedest lies I ever heard" (Lizzie Houston Armstrong, AHP).

Second, an entry in William Locke Paddon's diary, dated 7 April 1901, says it is "two years today since I first knew Emily" (Diary of William Locke Paddon, 1901, Emily Carr Arts Centre). In two of Emily's stories, she recalls that Paddon fell in love with her either on the way home from Ucluelet or just afterward ("Martyn," PABC; GP, 80).

The month, April, is confirmed by Paddon's diary and by Emily's 1913 statement that she arrived at Ucluelet "on a cold misty morning in early spring" (Lecture on Totems, 1913, PABC). Moreover, if she had gone in summer as is sometimes suggested, she would not have found the school in session.

APPENDIX
2

Photos

THE PHOTO CONTROVERSY began when Maria Tippett came across seven photographs in the British Columbia Provincial Museum that appeared to have been taken by or for Emily. Some bear a strong resemblance to three of Emily's paintings. Emily herself, or someone like her, appears in one, and an easel appears in two others. The inscription "M. E. C.," not in Emily's hand, appears on all of them. On this basis, Tippett stated flatly in a 1975 article that Emily Carr "had begun to take her own photographs" on the 1912 trip, and that she used them as sources for paintings ("Emily Carr's *Blunden Harbour*," 33, 37). The point reappeared in her full biography (MT, 106, 108).

Edythe Hembroff-Schleicher hotly disputes the charge in her 1978 book. She dismisses out of hand the idea that Emily could have taken the photos. The equipment would have been far too heavy to carry (five of the pictures were printed from glass plates), and in any case Emily's ineptitude with machines was famous among her friends. She also cites dissimilarities between the photos and the paintings allegedly taken from them, and explains the general resemblance by the fact that totems and housefronts "have to be reproduced from one particular vantage point for maximum effect." But she does acknowledge that at least five of the photos were taken by one of Emily's party in 1912 (H-S, 235–40). It follows that Emily must have known of their existence and may have had access to them.

The question is also raised in a 1978 article by Trisha Gessler, curator of the Queen Charlotte Islands Museum. Here again, except for one photo-and-painting pair, Hembroff-Schleicher's objections apply. The exception is Chief Gold's House, at Pebble Beach near Skidegate. There is a painting of this house dating from c. 1913, but Gessler states that the house itself had "fallen into ruins" and was "gone" long before 1912 (Gessler, 31, 35). Presumably this is from an eyewitness account at the time, and the only question I would have is whether it was so far

demolished that even an artist's eye could not reconstruct it in imagination. (The moon crest over the door was certainly missing, but Emily had an exact copy available to her a few miles away, at Skidegate.) If the house was indeed totally demolished by 1912, then Emily would have had to copy, from scratch, the photo taken by Richard Maynard in 1884, which she could have found through Newcombe or the provincial museum.

Yet another writer, Doris Shadbolt, believes that three much later paintings, *Kitwancool, Heina* and *Totem Village* (all c. 1928), were based on photographs (Shadbolt, 72–75, 203). Here again, the evidence is circumstantial. In the case of *Kitwancool,* the only evidence is a date on the back of the painting, not in Emily's hand and probably incorrect (see page 216, note 16). The case for *Totem Village* rests on an unidentified inscription on two drawings, not on the painting itself. *Heina* does indeed closely resemble an 1884 photo, and according to Tippett an X-ray has revealed a "literal copy" of the photo underneath the present painting (MT, 120). Moreover, Shadbolt observes that by the time of Emily's second visit to this village, in 1928, it had deteriorated so badly that she could not have seen it as she painted it. All one can say in Emily's behalf is that she *had* seen it in 1912, and had sketches to refer to.

The dispute on whether or not to take Emily at her word is enlivened by the fact—which nobody denies—that the famous painting *Blunden Harbour* (c. 1930–32) was definitely copied from a photo. This is a unique case, though, because this seems to be the only village Emily ever painted that she had not actually visited. Hembroff-Schleicher caught Emily copying the photo, and recalls that Emily was none too happy about it (H-S, 273). Emily wrote another, implicit denial in an unpublished account of her first meeting with Dr. Newcombe:

> My drawings were very authentic. I thought, Now this is history and I must be absolutely truthful and exact, and I worked like a camera. Dr. Newcombe who was a great authority on Indian stuff came to see my things. He bought three and said would I mind his comparing them with his photos of the same poles and possibly adding more detail. "The camera can't take artistic license," he added. But when we came to compare them there was not a single correction. My sketches gave a clearer interpretation than the photographs. There was however one bird which lost a wing between the time of his photo and my sketch and this I painted in for him (J., 1937–40, early draft GP).

Here she suggests that she knew of no photos except Newcombe's. Yet the photos in question were almost certainly taken in Emily's presence, probably by William Russ, and it is hard to believe she had not seen them. And in fact, as we have seen, Newcombe did question the ac-

curacy of Emily's paintings, though perhaps not of the three he bought himself.

There is really no way to resolve the question on the basis of existing evidence. Hembroff-Schleicher's argument that Emily did not take any photographs herself seems, to me, absolutely convincing. But the point Gessler makes about Chief Gold's House is also persuasive, as is the X-ray of *Heina*. One has to conclude that Emily probably knew about the photos, even if she did not take any herself, and that she may have referred to them, and possibly even copied two of them line for line—one in 1913 and one in 1928. Both instances, obviously, would have postdated her 1912 disclaimer. Her statement that she was "personally acquainted" with every pole remains true beyond doubt. And it is equally true, as Hembroff-Schleicher reminds us, that she had plenty of her own sketches to work from.

Sketching Trips, 1931–32

EMILY AND EDYTHE HEMBROFF took three sketching trips together: in May 1931, to Cordova Bay; in September 1931, to Goldstream Park; and in May 1932, to Braden Mountain.

Tippett (*Emily Carr,* p. 296) has questioned two of these joint trips as described by Hembroff-Schleicher in *M.E.* (pp. 27–35) and *Emily Carr: The Untold Story* (pp. 125–27). In both cases she cites seeming conflicts in Emily's journals. But in my interviews with Hembroff-Schleicher, she has vehemently confirmed that the trips took place.

The May 1931 conflict concerns a series of lectures given by Prof. Harry Gaze in May 1931 (J., 22 May 1931). Tippett believes that this series, which Emily definitely attended, would have interfered with the May trip to Cordova Bay. In fact, Gaze gave three lecture series that month in Victoria, and Emily attended the third. I have not been able to locate a specific press notice for that third series, but if it followed the pattern of the others it ran nightly. Emily attended the fourth of a five-lecture series on 22 May. She had ample time for a two-week trip beforehand.

The September 1931 trip to Goldstream is impossible to document, aside from Hembroff-Schleicher's recollections. Tippett believes it took place in June because of a June entry in Emily's journal headed "Goldstream" (H&T, 28). In addition, Emily's September journals show that she stayed at the McVickers' Metchosin farm that month, and there is no similar entry for Goldstream. Nevertheless, Hembroff-Schleicher is certain that they went to Goldstream together in September, and that Emily went to Metchosin after she returned. It was not unheard-of for Emily to take two trips in quick succession if she got the chance. She did so in May–June 1932.

The June 1931 Goldstream entry, which is for one day only, was probably made during a day trip to the park. Emily's friends often took her on day trips in their cars, and Edythe's younger sister specifically recalls taking her to Goldstream, though she does not remember the date (Interview, Mrs. Helen Hembroff-Ruch, Nov. 1984).

The Emily Carr Trust

IN JULY 1941, at the suggestion of Lawren Harris and Ira Dilworth, Emily had her lawyer Harry Lawson draw up what has come to be called the Emily Carr Trust. It was revised, but only slightly, in November 1942. In it she set aside forty-five oil paintings to be held in trust by Lawren and Ira. The works were identified by the words "Emily Carr Trust" on the back of each canvas, and a list was made ("Pictures in the Emily Carr Trust," n.d.; Indenture, 1941, Newcombe papers, PABC).

At their discretion, the trustees were to select some of the forty-five as a permanent collection; the remaining works could be sold as needed for the upkeep of the core group. Any money left over was to go towards the education of Canadian artists. Emily wished the collection to be housed in the Vancouver Art Gallery, partly in gratitude to its director, A. S. Grigsby, for his kindness during her solo VAG exhibitions, partly because Victoria was unable to house them, and partly no doubt as a parting shot at her native city.

Towards the end of 1941, Emily had second thoughts about the size of her gift. Harris told her that a minimum of thirty pictures was needed to make up an exhibition, and that left only fifteen to sell. She decided to add more paintings, but informally, so as not to bother everyone with more legal technicalities. By the spring of 1942 she had added thirty-five, making a total of eighty works in the trust: forty-five permanent and thirty-five to sell. This is the number Emily used in letters to friends, and it is the number used in public announcements of the Trust (*Province,* 29 April 1942; H-S, 150, 152; EC to Walter Gage, [May 1943], PABC). These paintings too were marked "Emily Carr Trust," or "Ira," but no formal list was made at the time. Later, probably in 1943, the trustees made a list of forty-seven "permanent (not for sale)" paintings. It is impossible to reconcile with the 1941 list, in part because some of the titles changed, but also because some of the original works may have been sold

or replaced (H-S, 146–47; typed list headed *Emily Carr Trust,* n.d., New-combe papers, PABC).

As can be seen, the Trust was originally a very casual affair, a semi-legalized agreement among friends. Not only were the additional paint-ings left out, but the document itself was very loosely worded. For ex-ample, Emily certainly intended to give her works to her own province. In her letters she spoke variously of giving pictures to "the Nation, that is to British Columbia" (H-S, 152); to "Canada (West)" (RH, 6 July 1941); or to "the West" (ID, Sunday morn [23 Nov. 1941]). The fuzzy language reflects her own fierce provincialism; as far as she was con-cerned, the rest of Canada barely existed. And perhaps for that reason, it never occurred to her or to anyone else to specifically name British Columbia in the Trust. There was no legal restriction on selling paint-ings outside the province.

Then too, Emily left the selection and the number of the core collec-tion entirely to the trustees. Only they knew which were permanent and which were not. Emily trusted Ira and Lawren completely, and she loathed legal red tape. She was also, by now, fairly detached from her work. "Beloved Trustors," she wrote before she shipped the pictures, "do *whatever you see fit* with your wards. As Lawren told me of the Klee Wyck crits, [it is] no business of mine. My job was *the making*. They have their own infinitesimal part to play in things" (ID, 9 A.M. Sunday [23 Feb. 1942]).

In November 1942 Emily revised her will. In it she left all her real and personal property, including over $8,000 in securities and insurance, to Alice. She had already given her sister a large canvas. All her remaining pictures went into a second trust. Lawren Harris and Willie Newcombe were the trustees of this trust (Willie later resigned in favour of Ira Dil-worth). Again, the trustees had absolute discretion to sell the works or give them to a public gallery. The proceeds were to go towards the teaching of art in B.C. and towards a scholarship fund for B.C. art stu-dents (Last Will and Testament, 30 Nov. 1942, Newcombe papers, PABC).

The several hundred paintings in the estate were separate from those in the Emily Carr Trust, but the trustees were the same, and in the year af-ter her death they added ninety works, including watercolours and draw-ings, to the Trust. Hembroff-Schleicher has determined that they later sold six pictures, including three from the 1941 list, to public galleries in Alberta and New Brunswick (H-S, 146).

From the time of the formation of the Trust in 1941 until its termina-tion in 1966 the composition of the permanent collection is impossible to trace, though Hembroff-Schleicher has made an exhaustive effort to do so. Records were kept informally, if at all, and decisions were made

casually among the trustees. It should be remembered that they were
fully empowered to revise the core collection. Nevertheless, on behalf of
all British Columbians, Hembroff-Schleicher has taken both the trustees
and the Vancouver Art Gallery sharply to task for not properly identify-
ing and protecting the core collection, and particularly for the six sales
(H-S, 145–67). It is difficult for me as a foreigner to share her indigna-
tion, given Emily's faith in her "beloved trustors," the generous number
of works they added to the Trust and the continued availability of the
pictures to the public. But certainly it would have spared many people
today a lot of grief and hard feelings if Harry Lawson had insisted that
Emily spell out in so many words just what it was she wanted.

Notes and Bibliography

Brief references in the Notes can be found in full in the Bibliography. In addition, the following abbreviations have been used:

AAA: Archives of American Art, Smithsonian Institution

AGO: Archives Collection, Art Gallery of Ontario

AHP: Aural History interview, Sound and Moving Images Division, Provincial Archives of British Columbia

BS: Emily Carr, *The Book of Small*

Colonist: Victoria *Daily Colonist*

ECAC: Emily Carr Arts Centre, Victoria

Folk Studies: Marius Barbeau Collection, Canadian Centre for Folk Culture Studies, Canadian Museum of Civilization, National Museums of Canada

GP: Emily Carr, *Growing Pains*

GP ms: Handwritten autobiography, Provincial Archives of British Columbia

H-S: Edythe Hembroff-Schleicher, *Emily Carr: The Untold Story*

HAS: Emily Carr, *The House of All Sorts*

H&T: Emily Carr, *Hundreds and Thousands*

ID: Letters from Emily Carr to Ira Dilworth, Provincial Archives of British Columbia

J.: Emily Carr, unpublished journals, Provincial Archives of British Columbia

KW: Emily Carr, *Klee Wyck*

M.E.: Edythe Hembroff-Schleicher, *M.E.: A Portrayal of Emily Carr*

MT: Maria Tippett, *Emily Carr: A Biography*

NGC: National Gallery of Canada

PABC: Provincial Archives of British Columbia

Paddon Diary: Diary of William Locke Paddon, Emily Carr Arts Centre

Peacock: Emily Carr, *The Heart of a Peacock*

Province: Vancouver *Daily Province*

RC Diary: Diary of Richard Carr, Provincial Archives of British Columbia

RH: Ruth Humphrey, "Letters from Emily Carr"

Times: Victoria *Daily Times*

UBCL: University of British Columbia Library

VAG: Vancouver Art Gallery, Library

Notes

INTRODUCTION

1. Shadbolt, *The Art of Emily Carr;* Tippett, *Emily Carr: A Biography*
2. Hembroff-Schleicher, *M.E.* and *Emily Carr: The Untold Story*
3. Taylor, 166

4. ID, 14 Feb. [1942]; Stern, in an interview with the author (July 1978), spoke of the "masculine power" of Carr's painting.
5. Burns, "Emily Carr," 225

CHAPTER 1

Except where otherwise noted, entries in this chapter are from the Diary of Richard Carr, PABC.

1. 31 May 1837
2. 25 July 1840
3. 11 Jan. 1839
4. 31 Aug. 1839
5. 10 April 1861, 12 April 1863. That two of the Carr sisters appear to have

had the same name (Eliza and Elizabeth) makes one suspect that one of the parents married twice and that some of the siblings were not full-blooded relations.

6. 2 Oct. 1848
7. MT, 283, n.2
8. 25 Feb. 1862
9. 20 March 1863

CHAPTER 2

1. RC Diary, 5 July 1863
2. BS, 8
3. BS, 11
4. "Roses and False Fat," PABC
5. BS, 3
6. BS, 14
7. BS, 8
8. J., [Dec. 1934]

9. *Camas Chronicles,* 35
10. BS, 150
11. BS, 35
12. BS, 103
13. ID, Friday [c. Feb. 1944]
14. Mrs. Duncan Robertson, taped interview, AHP

CHAPTER 3

1. BS, 68
2. GP, 6
3. GP, 6
4. "The Littlest Bridesmaid," PABC
5. GP, 4
6. ID, Tuesday [Nov. 1942]
7. GP, 4
8. "Father's Temper," PABC
9. "Father's Temper," PABC
10. BS, 68
11. GP, 4
12. "Letters to Topsy Tiddles," "Small's First Lock and Key," PABC
13. "Tibby, Tabby and Tot," PABC
14. "First Snow," PABC
15. "Father and the Moon," PABC
16. BS, 13
17. GP, 4
18. BS, 11
19. BS, 26
20. BS, 6
21. GP, 3. Emily was not four, as she claims. She was baptized in 1879, a few months before her eighth birthday.
22. Taylor, 158
23. "Mother's Work Bag," PABC
24. "Conscience," PABC
25. BS, 4
26. Richard Nicholles, taped interview, ECAC

CHAPTER 4

1. BS, 15
2. BS, 17
3. BS, 15
4. BS, 15. There were actually two cows, a Guernsey and a Jersey, but the Guernsey had such a particular hold on Emily's memory that she obliterated the Jersey altogether.
5. BS, 18
6. BS, 20
7. BS, 33
8. GP, 8–9
9. GP, 4
10. "I Am Much More a Lady When Alone," PABC
11. ID, Friday [Aug. 1943]
12. J., [Dec. 1934]; J., [1944]
13. BS, 159
14. Mrs. Duncan Robertson, taped interview, AHP
15. BS, 9
16. BS, 61–62
17. BS, 92
18. BS, 17
19. BS, 53–54

CHAPTER 5

1. Pethick, 117
2. BS, 116
3. "Mint," PABC
4. J., frag. [1942?], PABC
5. J., frag. [1942?], PABC
6. J., frag. [1942?], PABC
7. "Snob Children," PABC
8. With the exception of Mrs. Fraser, whom I have not been able to positively identify, all the adult friends Emily describes in *The Book of Small*—Mrs. McConnell, the Mitchells, the Gregorys, Bishop and Mrs. Cridge, the Lewises and Dr. Helmcken—were in reality very much as she described them. So were Mr. and Mrs. J.C. Bales, of the unpublished stories "Compensation" and "Adoption" (PABC). I have been able to find only one person whose name was actually changed in *Small,* and that was Mrs. M.W.

Tyrwhitt-Drake, who became
"Mrs. Crane." But the Drakes'
beautiful house and garden near the
Point Ellice bridge are faithfully
described in Emily's story.
9. BS, 156–57
10. "The Littlest Bridesmaid," PABC

11. "Father's Temper," PABC
12. BS, 138
13. BS, 137
14. BS, 127
15. BS, 68
16. "Martha's Joey," PABC
17. BS, 127–29

CHAPTER 6

1. BS, 157
2. GP, 7
3. ID, Tuesday [Nov. 1942]
4. MT, 14
5. J., Easter Monday [1935]
6. J., Easter Monday [1935]
7. GP, 7
8. Perhaps the lilies were blooming only in Emily's mind because of their significance on this day. The wild lilies bloomed at Eastertime, but the mock orange, spirea and daisies she also mentions bloomed later in the season.
9. GP, 8–9
10. "Happy, Happy Children," PABC
11. "The Family Plot," PABC
12. GP, 12. Ira Dilworth, who probably knew Emily better than anyone else, doubted her sister thrashed her with a whip; so does Hembroff-Schleicher. But Emily was quite insistent on this point, mentioning it in her journals as a punishment even before her mother's death, and in at least one unpublished story ("A Stroke," PABC). Whipping was hardly an unusual punishment in that time and place, and it seems likely that Dede accelerated an existing family custom after her mother's death in an effort to enforce her second-hand authority.
13. GP, 13–14; *Peacock*, 8–21. The name Piddington is probably genuine. It appears in unpublished manuscripts in which other names are unchanged.

Emily did change it in the *Peacock* story, "One Crow," where it becomes Smith.
14. GP, 14
15. J., Easter Monday [1935]
16. GP, 12, 15
17. GP, 15
18. Colman, "Emily Carr," 29–30
19. "A Three Girls Drawing Class," PABC. The girls are identified by Tippett, MT, 17.
20. GP, 15
21. Tippett believes Emily went to San Francisco in 1891 (MT, 283–84). The evidence is tenuous either way, but Emily always claimed she spent three years in San Francisco, and I believe that claim is credible if one does not take her memory of specific time periods too literally: if, for example, one substitutes "four" for the five summers she says she spent with the Greens, and "a year and a half" for the "year" she says elapsed before her sisters came to San Francisco. One supporting point is that she seems to have spent two summers in San José with Auntie Hayes (GP, 57; "Aunt," PABC). These would have been the summers of 1891 and 1893. The third was spent in San Francisco with her sisters.

The records of the California School of Design, which would settle the question, were lost in the 1906 fire.

Chapter 7

1. GP, 17
2. GP, 29
3. Despite his name, Joullin was a native-born San Franciscan, though he too had studied at the Julian and was a member of the French Academy.
4. J., 28 Sept. 1939
5. GP, 46–47
6. GP, 35
7. GP, 24
8. GP, 22
9. GP, 27–29
10. GP, 35–38
11. "Aunt," PABC
12. GP, 55
13. GP, 65
14. GP, 68
15. GP, 68
16. Emily says that Nellie McCormick also died suddenly, driven to suicide by her tyrannical mother (GP, 69). But this cannot have happened early in 1894, when Emily says it did, for Nellie probably visited Emily at least once in Victoria (ID, 9 A.M. Sunday [23 Feb. 1942]), and Tippett has confirmed that she was alive as late as 1895 (MT, 284).

Chapter 8

1. GP, 76
2. GP, 75
3. Nicholles, "The Real Emily Carr," 12
4. Interview, Edythe Hembroff-Schleicher, Nov. 1984
5. Flora Hamilton Burns, taped interview, AHP
6. "Smash," PABC
7. Awarded to "Miss E. Carr." Hembroff-Schleicher points out that there is a chance the prize went to Edith rather than Emily (H-S, 80–81). Three prizes awarded the following year to "Miss M. Carr" certainly went to Emily.
8. Nicholles, "The Real Emily Carr," 12
9. Margaret Clay, taped interview, AHP
10. ID, 9 A.M. Sunday [23 Feb. 1942]. Tippett believes Mac may have been Nellie McCormick (MT, 28); Hembroff-Schleicher suggests a Victoria friend, Maude McVicker (Interview, Edythe Hembroff-Schleicher, Nov. 1984).
11. Lugrin, "Emily Carr," 3
12. See Appendix 1
13. KW, 6
14. KW, 10–11
15. "The Sharpening Stone," PABC
16. J., [Dec. 1934]
17. "The Sharpening Stone" (fragmentary draft), PABC
18. GP, 80
19. GP, 10
20. Colman, "Emily Carr," 29

Chapter 9

1. GP, 87
2. GP, 90
3. MT, 41
4. Emily wrote in an unpublished story that her drawing-classmates (that is, Theresa Wylde and Sophie Pemberton) attended the Westminster School ("A Three Girls Drawing Class," PABC). This was definitely not true of Pemberton,

who studied at the Cape Nichol
School of Art and later at the
Académie Julian in Paris. Wylde's
history is harder to trace, but she was
at the Kensington Art School from
1892–97, and according to Tippett
studied at some point at the Slade
School (MT, 75).
5. GP, 102
6. GP ms
7. GP, 104
8. GP, 147
9. GP, 100

10. GP, 121
11. MT, 22
12. GP ms
13. Paddon diary, 7 April 1901
14. GP ms
15. GP ms
16. MT, 43, 45
17. MT, 286; Interview, Carol Pearson,
Dec. 1979
18. GP ms
19. Colman, "My Friend"
20. GP, 139

Chapter 10

1. GP ms
2. MT, 47, 286
3. GP ms
4. GP ms
5. GP ms
6. GP ms
7. GP ms
8. GP, 172
9. Ira Dilworth, notes on Alice's diary,
PABC
10. GP, 175
11. GP ms
12. GP ms
13. GP ms
14. GP, 183–84; GP ms
15. Ira Dilworth, notes on Lizzie's diary,
13 July 1902, PABC
16. GP ms
17. GP ms
18. Ira Dilworth, notes on Lizzie's diary,
20 July 1902, PABC
19. Ira Dilworth, notes on Lizzie's diary,
18 Dec. 1902, PABC
20. Ira Dilworth, notes on Lizzie's diary,
21 Jan. 1903, PABC
21. MT, 57, 286. The Register of Patients
listing this diagnosis has disappeared.
In a letter to Hembroff-Schleicher,
the director of the hospital expressed

surprise that the diagnosis was
written into the register at all. Such a
procedure violated patient
confidentiality and would have been
highly irregular (Interview, Edythe
Hembroff-Schleicher, Nov. 1984).
22. Burns, "Emily Carr," 226. In a 1962
taped interview, Flora Burns referred
to Emily's illness as "pernicious
anemia" (Flora Hamilton Burns,
AHP). But pernicious anemia was an
incurable, very serious illness. If
Emily had had it she either would
have died of it or suffered recurring
attacks all her life.
23. *Pause*, 95
24. MT, 58–59
25. GP ms
26. GP ms
27. GP ms
28. GP ms
29. RH, 14 Jan. [1938]
30. GP, 188; *Pause,* 57
31. GP, 191
32. GP, 191
33. Sketchbook, Bushey 1904, PABC
34. Sketchbook, Bushey 1904, PABC
35. GP, 193; GP ms

CHAPTER 11

1. Watson wrote that Emily had "recently" visited Ucluelet, but he may have misunderstood a reference to her 1899 trip. In *Heart of a Peacock* Emily mentions a mid-winter trip "north," but there she implies it was several years later (*Peacock,* 74–75). She never mentioned a second trip to friends, or elsewhere in her writings.
2. Watson, "In the Haunts . . ."
3. *Colonist,* 11 Jan. 1905
4. "Dogs," PABC
5. *The Week,* 24 June 1905; 27 May 1905
6. Alice's kindergarten was held in various locations in its early years. At first it seems to have been in the Carr house. In 1905 it moved to the corner of Carr and Battery Streets, where it remained at least through 1908. In 1914 it was briefly held in the house Dede built at 231 St. Andrew's Street. When Alice moved across the street to her own new house in December, the school probably moved with her. (It is not listed at that address, nor at any other, in the city directories from 1914 through 1924.) It was closed in 1910–11 and again late in the decade, probably 1917–20.
7. GP, 205
8. She says twice a week, but according to an article in the Vancouver *Province* the figure class met weekly (*Province,* 25 Jan. 1906).
9. GP, 206
10. GP, 206
11. H-S, 341; *Province,* 7 Nov. 1908
12. Pauline Ginsberger Taylor, "Portrait in Memory" (CBC, 9 April 1958), PABC
13. GP ms
14. GP ms
15. J., 28 Dec. 1940

CHAPTER 12

1. *Province,* 14 Nov. 1908
2. *Wild Lilies* has a beguiling history. Lizzie, who normally showed no interest in Emily's art, loved this painting and Emily gave it to her. It hung over the mantlepiece in the old house until Lizzie's death in 1936. By then Emily, having gone through several later styles, was embarrassed by it and wanted to paint something else over it. But Lizzie would not part with it, and when she died she left it to St. Joseph's Hospital, safely out of Emily's reach (Interview, Mrs. Dorothy Carmichael, 1979).
3. *Province,* 30 March 1907; 1 April 1908; 31 March 1909; 26 June 1909
4. ID, Epistle No. II, Sunday 7 P.M. [16 Feb. 1942]
5. "Bill," PABC
6. GP ms
7. GP ms
8. GP, 228
9. GP ms
10. J., [25 Dec. 1927]
11. The whereabouts of the Alaska Sketchbook is not known, but a few photographs of excerpts are in the PABC and have been published in several places, among them the Vancouver *News-Herald* (28 Oct. 1953) and *Sound Heritage* 4, no. 2 (1975), 42–44.
12. J., 1937–40 (early draft GP)
13. GP, 211
14. *Province,* 26 June 1909

CHAPTER 13

1. According to H-S, 28, they later moved to 96 boulevard du Montparnasse.
2. GP ms
3. GP ms
4. GP, 216
5. GP, 216
6. GP, 216
7. GP ms
8. Murry, 150–51
9. Murry, 154
10. GP ms
11. GP ms; Burns, "Emily Carr," 227–28
12. GP ms
13. ID, Epistle 2 [7? Jan. 1944]
14. Ira Dilworth, notes on Alice's diary, n.d., PABC
15. GP, 219
16. GP ms
17. GP ms
18. GP ms
19. GP, 219–20
20. GP ms
21. GP, 220
22. McCormick, *Works,* 30
23. GP ms

CHAPTER 14

1. GP ms
2. *Province,* 25 March 1912
3. *Province,* 27 March 1912
4. *Province,* 27 March 1912
5. GP ms
6. *Colonist,* 19 Oct. 1913
7. *Province,* 3 April 1912
8. *Province,* 8 April 1912
9. Pauline Ginsberger Taylor, "Portrait in Memory" (CBC, 9 April 1958), PABC
10. GP, 227
11. GP, 227
12. Burns, "Emily Carr," 230
13. Interview, Edythe Hembroff-Schleicher, Nov. 1984. Hembroff-Schleicher confirmed this with Humphrey Toms, nephew of the Misses Gordon.
14. MT, 102
15. GP, 228
16. Lecture on totems, 1913, PABC
17. Lecture on totems, 1913, PABC
18. *Peacock,* 62–64
19. KW, 11–14
20. KW, 18
21. KW, 21
22. KW, 65
23. Lecture on totems, 1913, PABC; MT, 107; Tippett, "Emily Carr's *Klee Wyck*," 57

CHAPTER 15

1. *Province,* 14 Sept. 1912; Vancouver *Daily News-Advertiser,* 15 Sept. 1912
2. MT, 107; Shadbolt, 38–40
3. C. F. Newcombe to Francis Kermode, 17 Jan. 1913, PABC
4. J., 1937–40 (early draft, GP)
5. Lecture on totems, 1913, PABC
6. MT, 107, 289
7. *Province,* 16 April 1913
8. GP, 227
9. Ira Dilworth, notes on Lizzie's diary, 26 Dec. 1913, PABC
10. HAS, 5
11. "Friction," PABC
12. HAS, 5
13. Original plans, courtesy Edythe Hembroff-Schleicher

CHAPTER 16

1. H-S, 66
2. Lugrin, "Emily Carr." Despite Lugrin's reference to the monkey Emily acquired in 1923, I think this winter sojourn must have taken place some years earlier.
3. GP ms
4. GP ms
5. GP ms
6. HAS, 47
7. HAS, 58
8. HAS, 68
9. HAS, 55
10. HAS, 7
11. Mrs. Catherine Maclure, taped interview, AHP
12. HAS, 13
13. Mrs. Kate Mather, taped interview, AHP
14. Nesbitt, "The Genius," 13, 29
15. HAS, 54, 59, 69
16. HAS, 110–11, 161–62; "Fist," "Struck," PABC
17. Mrs. Kate Mather, taped interview, AHP
18. HAS, 37
19. HAS, 31
20. HAS, 84–86
21. HAS, 92
22. HAS, 91
23. *Times,* 18 Oct. 1913
24. *Colonist,* 19 Oct. 1913
25. HAS, 92
26. MT, 116
27. Mrs. Kate Mather, taped interview, AHP
28. Flora Hamilton Burns, taped interview, AHP
29. Margaret Clay, taped interview, AHP
30. Max Maynard, taped interview, AHP

CHAPTER 17

1. Mrs. Kate Mather, taped interview, AHP
2. HAS, 89
3. GP, 232
4. *Western Woman's Weekly,* 9 Nov. 1918
5. C. Marius Barbeau to Grace Pincoe, 28 Aug. 1945, AGO
6. MT, 132–34, 140–41, 292; Tippett, "Who Discovered Emily Carr?"
7. H-S, 107–121
8. C. Marius Barbeau to Grace Pincoe, 28 Aug. 1945, AGO
9. H. Mortimer Lamb to Barbara Swann, 14 July 1945, AGO
10. Isak Dinesen, *Out of Africa* (New York, Random House, 1970), 251–52
11. Flora Burns, whose memory was good but not infallible, maintained that Emily's 1923 surgery was for gall bladder. Emily herself mentioned it only obliquely, in a letter to Fred Redden, where she said she had had a "serious operation" five weeks earlier. "I hope to be up for Xmas," she added, "but don't know. My spine is behaving disagreeably" (EC to Fred Redden, 9 Dec. 1923, VAG). This does not, to me, justify Tippet's belief that the spine was the site of the surgery (MT, 126).
12. Interview, Mrs. Phyllis Eltringham, Nov. 1984
13. Dufour, "Emily Carr," 25
14. Interview, Mrs. Phyllis Eltringham, Nov. 1984
15. The Hennells lived on Simcoe Street near the Carrs until about 1916–17, when they moved to Oak Bay. Alice probably went with them then. I have no reliable date for her return, but guess she came home early in 1920, following Dede's death. She is listed as living in the Government Street house in the 1921 City Directory.

16. "Death," PABC
17. "Death," PABC
18. HAS, 145
19. J., 28 Nov. 1937
20. MT, 137; Interview, Edythe Hembroff-Schleicher, Nov. 1984
21. Madge Wolfenden Hamilton, taped interview with Edythe Hembroff-Schleicher, PABC
22. HAS, 10
23. McDonald, "Emily Carr," 20; Max Maynard, taped interview, AHP
24. Nesbitt, *Album,* 43
25. Mrs. Duncan Robertson, taped interview, AHP. Mrs. Robertson's memory is confused here. By the time Emily lived with Alice, in the late thirties, the monkey was gone.
26. "Portrait in Memory" (9 April 1958, CBC), PABC
27. MT, 78
28. HAS, 162
29. BS, 24
30. HAS, 122
31. J., [Sept. 1936]
32. HAS, 139
33. MT, 125. I have not seen Dede's will, but the remaining Carr land was subdivided in 1921.

Chapter 18

1. Mrs. Kate Mather, taped interview, AHP. I have not been been able to find the review Mather mentions. Emily entered work in the Island Arts and Crafts Society's show in 1924, breaking her ten-year boycott. Neither she nor most of the other painters were mentioned in the local press accounts, which were mostly concerned with the crafts exhibits and various social ceremonies.
2. Mrs. Kate Mather, taped interview, AHP
3. Mrs. Kate Mather, taped interview, AHP
4. Frederick Brand, taped interview with Edythe Hembroff-Schleicher, PABC
5. *Peacock,* 188
6. *Peacock,* 216
7. Newcombe Family papers, Vol. 16, Folder 3, PABC
8. J., [May 1936]
9. Interview, Carol Pearson, Dec. 1979
10. Colman, "Emily Carr," 29
11. Flora Hamilton Burns, taped interview, AHP
12. Writing School Lessons, 1927, Lesson 1, PABC
13. Writing School Lessons, 1927, Lesson 13 D, 8 April, PABC
14. Comments, Writing School Lessons, 1927, PABC
15. Flora Hamilton Burns, taped interview, AHP
16. Dufour, "Emily Carr," 25
17. EC to Fred Redden, Sept. 1924, VAG
18. EC to Eric Brown, 1 Nov. 1927, NGC
19. *Colonist,* 18 Aug. 1926
20. RH, 22 Aug. 1937
21. Telephone interview, Mrs. Viola Patterson, Dec. 1979

Chapter 19

1. EC to C. Marius Barbeau, 23 Oct. [1926], Folk Studies
2. H-S, 110
3. Brown, 103
4. H&T, 10 Nov. 1927, 4
5. J., [11–13 Nov. 1927]
6. Housser, 14, 15, 17
7. Housser, 15
8. Mellen, 99
9. Housser, 155

10. Housser, 146
11. GP, 235
12. H&T, 14 Nov. 1927, 5
13. GP ms
14. H&T, 16 Nov. 1927, 6
15. H&T, 16 Nov. 1927, 6
16. H&T, 18 Nov. 1927, 7
17. H&T, 18 Nov. 1927, 8
18. H&T, 16 Nov. 1927, 6
19. Reid, *Concise History,* 187
20. GP ms
21. GP ms
22. J., [21 Nov. 1927]
23. H&T, 22 Nov. 1927, 10
24. Brewster, "Some Ladies"
25. The opening date is confirmed by the Ottawa *Citizen,* 3 Dec. 1927.
26. H&T, 5 Dec. 1927, 11–12
27. H&T, 5 Dec. 1927, 12
28. The medium of her paintings is not listed in the catalogue, but is confirmed by Hembroff-Schleicher (H-S, 368). Emily also had sent twenty watercolour sketches, ten of which were framed by the National Gallery and hung, with two of her oils, in the Third Annual Exhibition of Canadian Art in January.
29. GP ms
30. Ottawa *Citizen,* 2 Dec. 1927
31. Ottawa *Citizen,* 3 Dec. 1927
32. GP ms
33. GP ms
34. H&T, 25 Dec. 1927, 19

CHAPTER 20

1. Brewster, "Some Ladies"
2. C. Marius Barbeau to EC, 11 Jan. 1928, Folk Studies
3. Lawren Harris to EC, 8 Jan. 1928, PABC
4. Eric Brown to EC, 14 Jan. 1928, PABC
5. EC to Eric Brown, 9 March [1928], PABC
6. *Colonist,* 14 Sept. 1927
7. *Colonist,* 27 March 1928
8. H&T, 25 Jan. 1933, 32–33
9. EC to Eric Brown, 9 March [1928], PABC
10. EC to C. Marius Barbeau, 12 Feb. [1928], Folk Studies
11. EC to Eric Brown, 23 March [1928], PABC
12. C. Marius Barbeau to EC, 14 March 1928, Folk Studies; EC to Eric Brown, 29 April [1928], PABC
13. EC to Eric Brown, 29 April [1928]; Eric Brown to EC, 7 May [1928], PABC
14. EC to H.O. McCurry, 9 May [1928]; H.O. McCurry to EC, 23 May 1928, PABC
15. EC to Eric Brown, 29 April [1928], PABC
16. H-S, 243
17. EC to Eric Brown, 19 Oct. [1934], PABC
18. "Soothe of Beast," "So Big, So Little, So Shy, So Brave," PABC
19. Jackson, 110
20. EC to Eric Brown, 11 Aug. 1928, PABC
21. The stories were true. The people of Kitwancool harboured a grudge against foreigners, dating from the early shooting of one of their chiefs by a white constable and the forcible quelling of an uprising by military force (Large, 95–96). Louis Shotridge, a Tlingit Indian who visited the village in 1918, is one of those who testified to their hostility to all outsiders, Indian or white (Shotridge, 139). Their steadfast independence protected their poles for many years, and as late as 1952 the anthropologist Wilson Duff remarked that the poles of Kitwancool were "still . . . the largest and finest group of totem-poles to be found in their native setting anywhere" (Duff, "Gitksan Totem-Poles," 23).
22. KW, 104–5
23. EC to Eric Brown, 11 Aug. 1928, PABC
24. KW, 102
25. KW, 49

26. Carr, "Modern and Indian Art," 21
27. EC to Eric Brown, 11 Aug. 1928, PABC
28. Tippett points out that Emily's niece Emily English and her husband March were living in South Bay

(MT, 155). Emily probably stayed with them or at least saw them, but she never mentioned it.

29. EC to Eric Brown, 11 Aug. 1928, PABC

CHAPTER 21

1. *Times,* 25 March 1957
2. Mark Tobey to Donald Buchanan, [April 1951], NGC
3. MT, 160
4. Seattle *Times,* 15 June 1975
5. EC to Eric Brown, Oct. [1928], PABC
6. Shadbolt, 70–71
7. Tobey, "Reminiscence and Reverie," 231
8. J., 24 Nov. 1930

9. J., 24 Nov. 1930, quoted as it appears in H&T, 21
10. EC to Eric Brown, 1 Oct. [1928], PABC
11. EC to Eric Brown, 1 Oct. [1928], PABC
12. *Colonist,* 24 Oct. 1928
13. *Colonist,* 28 Nov. 1928
14. Lawren Harris to EC, [March 1929], PABC
15. ID, 9:30 Sunday Night [5 Jan. 1942]

CHAPTER 22

1. Carr, "Modern and Indian Art"
2. A Group of Seven show in Vancouver in February 1928 had been roundly scourged by the reactionary critics then in power there. The ridicule and abuse was sharper than anything Emily ever experienced, at least in print.
3. Carr, "Modern and Indian Art," 19
4. Carr, "Modern and Indian Art," 20
5. Carr, "Modern and Indian Art," 21
6. Carr, "Modern and Indian Art," 19–20
7. Carr, "Modern and Indian Art," 20
8. GP, 239
9. "Nootka Had a Hotel," PABC
10. J., "Nootka Sunday" [May 1929]
11. "Nootka Had a Hotel," PABC
12. J., [1944]; J., "San Raffel" [May 1929]
13. J., "San Raffel" [May 1929]

14. J., [1944]
15. J., [1944]. The details of Emily's stay with the Fishes and her meetings with the Russian are taken from her 1944 journal and the unpublished story "Nootka Had a Hotel" (PABC). They have been embellished somewhat: she writes, for example, that she was fifty years old then, when in fact she was fifty-seven. A 1929 journal entry, however, confirms her visit to the lighthouse, and Tom Fish was indeed the lighthouse keeper, just arrived that year.
16. Obviously not the real Sophie, who was a kind of symbolic incarnation of native womanhood to Emily.
17. J., [Aug. 1929]

CHAPTER 23

1. C. Marius Barbeau to Grace Pincoe, 28 Aug. 1945, AGO
2. Lawren Harris to EC, [spring 1929], PABC
3. GP, 252
4. H&T, 5 Dec. 1930, 23
5. J., 28 Jan. 1930
6. Salinger, "Comment on Art," 209–10
7. Lawren Harris to EC, [Mar. 1930], PABC
8. Eric Brown to EC, 19 March 1928, PABC
9. Vancouver *Sun*, 21 Feb. 1928
10. *Province*, 18 Feb. 1928
11. *Province*, 21 Nov. 1929
12. EC to Nan Cheney, 11 Nov. 1930, UBCL
13. GP, 253
14. *Colonist*, 2 March 1930
15. *Province*, 10 March 1930
16. There were two landscapes and four native paintings, one of which was curiously titled *June 9, 1928.* Shadbolt has identified this picture as *Kitwancool,* now at the Glenbow-Alberta Institute in Calgary. Because the date inscribed on the back, June 9, 1928, predates Emily's visit to Kitwancool, Shadbolt believes this picture was painted from photos. But the date may not be Emily's own, and it may have been carelessly written. If it read "July 9, 1928" it would correspond with Emily's stay in the village (Shadbolt, 70, 72, 203).
17. Lawren Harris to EC, 12 March [1930], PABC
18. GP ms
19. GP, 247

CHAPTER 24

1. List, probably in Emily's hand, PABC
2. GP, 250
3. Carr, *Fresh Seeing,* 11
4. GP, 250
5. Frederick Brand, taped interview with Edythe Hembroff-Schleicher, PABC
6. HAS, 52–53
7. HAS, 107–9
8. Max Maynard, taped interview, AHP
9. Max Maynard, taped interview, AHP
10. Max Maynard, taped interview, AHP
11. H&T, [Oct. 1933], 63
12. H&T, [Oct. 1933], 64
13. John Davis Hatch to EC, 14 Jan. [1934], PABC
14. *M.E.,* 1–11; H-S, 12–13. In the later book Hembroff-Schleicher edited out the tea party, describing only her first visit to Emily's studio.
15. H-S, 13
16. EC to Edythe Hembroff-Brand, [16 Oct. 1935], PABC
17. The 1934 show, dated 1935 by Tippett (MT, 202) and 1936 by Hembroff-Schleicher (H-S, 383–84), is confirmed by an article in the UBC paper, the *Ubyssey* (22 Feb. 1934, "Art Exhibit is Excellent"). An entry in Emily's journal a full year later (H&T, 18 Feb. 1935, 171) clearly refers to this exhibition and is an anomaly, since it appears in an apparently unbroken sequence of entries.
18. J., 19 Aug. 1930
19. The figure has been identified as a male figure on Quattische Island. It has been said that Emily, who called her watercolour of this subject *Koskimo,* mistook both figure and village (H-S, 373, 378; Shadbolt, 205). But the village on Quattische Island did belong to the Koskemo tribe; the confusion comes in because there was another village on Quatsino Sound specifically bearing the name Koskemo or Koskimo.
20. KW, 39–40
21. H&T, 1 Feb. 1931, 26
22. H&T, 1 Feb. 1931, 26

CHAPTER 25

1. H&T, 12 Jan. 1931, 24
2. J., 14 July [1933]
3. J., [spring 1933]
4. J., 20 Jan. 1931, from Horace Shipp, *The New Art of Lawrence Atkinson*
5. J., n.d. [1931–32]
6. J., n.d. [1931–32]
7. Extracts from quoted passage, J., n.d. [1931–32]
8. J., Sept. 1931
9. *M.E.,* 30
10. H-S, 127
11. H&T, 27 Jan. 1933, 34
12. H&T, 17 June 1931, 29
13. J., 31 Jan. [1931]
14. EC to Nan Cheney, 7 Feb. [1932], UBCL
15. EC to Nan Cheney, [14 Dec. 1931], UBCL
16. Lawren Harris to EC, 20 Dec. 1931, PABC
17. Lawren Harris to EC, 20 March 1932, PABC
18. Lawren Harris to EC, [summer 1932], PABC
19. People's Gallery Speech, 1932, PABC
20. People's Gallery Speech, 1932, PABC
21. People's Gallery Speech, 1932, PABC
22. EC to Eric Brown, 15 Dec. [1932], PABC
23. Eric Brown to EC, 21 Dec. [1932], PABC
24. EC to Eric Brown, 3 Jan. [1933], PABC
25. EC to Eric Brown, 20 Jan. [1933], PABC
26. Lawren Harris to EC, [March 1931], PABC
27. Lawren Harris to EC, [May 1933], PABC
28. H&T, 2 March 1934, 99
29. Lugrin, "Woman Potters"
30. *Peacock,* 110–19
31. Lugrin, "Emily Carr"
32. H&T, 9 Nov. 1934, 155
33. Margaret Clay, taped interview, AHP; "Smash," PABC; GP, 214
34. H&T, [Feb. 1935], 171; 10 Dec. 1934, 159–60

CHAPTER 26

1. H&T, 12 Dec. 1933, 87
2. H&T, 3 May 1934, 117
3. Interview, Mrs. Helen Hembroff-Ruch, Nov. 1984
4. H&T, 7 Aug. 1933, 47
5. H&T, 5 Oct. 1933, 64
6. GP ms
7. GP ms
8. H&T, 5–6[?] June 1934, 130–31
9. GP ms
10. H&T, 28 Nov. 1935, 207
11. H&T, 29 Sept. 1935, 199–200
12. H&T, 8 April 1936, 232
13. H&T, 27 Aug. 1934, 144
14. *Saturday Night,* 7 Dec. 1935
15. J., 12 Dec. 1935
16. Lamb, "A British Columbia Painter"
17. J., [Sept. 1935]

CHAPTER 27

1. Lawren Harris to EC, 19 May 1933, PABC
2. "Arthur Lismer's crit. of some of my sketches," [June 1933], PABC
3. GP ms
4. H&T, [April 1934], 116
5. H&T, 20 Nov. 1933, 83
6. Isabel McLaughlin was a painter, the first private collector in the east to buy a major canvas of Emily's.

7. H&T, [Dec. 1933], 87
8. H&T, 16 Jan. 1934, 92
9. Bess Housser to EC, 20 Feb. 1934, PABC
10. Lawren Harris to EC, 16 Feb. 1934, PABC
11. J., 4 Aug. 1934
12. EC to Nan Cheney, [9 Dec. 1938], UBCL
13. ID, Sunday morning after Xmas [28 Dec. 1941]
14. EC to Eric Brown, 19 Oct. [1934], PABC
15. Hembroff-Schleicher, *The Modern Room,* 17
16. H&T, 1 Sept. 1934[?], 145
17. H&T, 20 June 1934, 135
18. J., [Aug. 1935]
19. Adaskin came to see Emily whenever he was in Victoria, about once a year.

A friend of the Harrises and the Houssers, he became one of Emily's "beloveds in the east" in 1933 (H&T, 28 Nov. 1933, 84). He visited her soon after the double divorce and helped prevent a complete break. "His view of it is big and broad and true and made me ashamed, for the whole affair had cut and seared," she wrote. "I shall write to them now, I think. Before I did not seem to know what to say" (J., 18 Nov. 1934).
20. Carr, Fresh Seeing, 27–38
21. H&T, [April 1934], 108
22. Nesbitt, "The Genius"
23. J., [April 1935]
24. J., [Dec. 1935]
25. J., "Sunday" [20 Oct. 1935]
26. J., Easter Monday, 1935
27. J., [Nov. 1935]

CHAPTER 28

1. J., [20 March 1936]
2. J., [March 1936]
3. J., [1 April 1936]
4. H&T, 2 March 1936, 226
5. Mrs. Drake is named Mrs. Crane, BS, 41–52.
6. J., [Aug. 1936]
7. J., [Aug. 1936]
8. J., [July 1936]
9. J., [May 1936]
10. J., [May 1936]
11. H&T, 23 Sept. 1936, 261
12. *Province,* 17 April 1936
13. H&T, 9 Jan. 1937, 274
14. J., [Jan. 1937]
15. Eric Newton, foreword to Buchanan, *The Growth of Canadian Painting,* 16
16. EC to Edythe Hembroff-Brand, [29 Jan. 1937], PABC
17. *Saturday Night,* 3 April 1936
18. ID, Epistle No. II Sunday 7 P.M. [16 Feb. 1942]
19. J., [Feb. 1937]
20. RH, [22 June 1937]
21. EC to Edythe Hembroff-Brand, 7 Aug. [1937], PABC
22. Interview, Mrs. Helen Hembroff-Ruch, Nov. 1984
23. H&T, 1 Feb. 1937, 280
24. J., 25 March 1937
25. J., [April 1937]
26. J., 16 March 1937
27. J., 20 Aug. 1938
28. H&T, 10 Dec. 1936, 269
29. J., 11 Dec. 1936
30. J., 10 May 1936; [Nov. 1936]
31. H&T, 23 April 1936, 234–35
32. J., [Sept. 1936]
33. J., 4 April (4/4) 1936 (misdated 3/4 by Emily)
34. J., 8 Aug. (8/8) 1936 (misdated 7/8 by Emily)
35. J., 16 Aug. 1936

CHAPTER 29

1. H&T, 12 Oct. 1937, 294. The house did not "go to the city" for taxes, as she thought it would. A buyer was found.
2. Eric Brown to Nan Cheney, 22 April 1937, PABC
3. EC to John Davis Hatch, [14 Dec. 1938], AAA
4. London *Times,* 15 Oct. 1938; Manchester *Guardian,* 15 Oct. 1938 (signed "N."); see also London *Sunday Times,* 16 Oct. 1938
5. Newton, "Canadian Art," 345
6. Burns, "Emily Carr," 237
7. ID, notes on Alice's diary, 6 Feb. 1940, PABC
8. Dr. D. M. Baillie, whose personal kindness and conscientious care of Emily somewhat compensated for the inadequacy of the medical treatments available to him.
9. ID, Friday [June 1943]
10. ID, Monday [June? 1942]
11. H&T, 21 Dec. 1937, 296
12. Tobin, "An Appreciation"
13. The date is taken from Burns, "Emily Carr," 237. A reference in one of Emily's letters to Nan Cheney, however, suggests that some of the stories may have gone "east" (to Oxford) in early May (EC to Nan

Cheney, [1 May 1940], UBCL).
14. EC to Nan Cheney, 13 Oct. [1940], UBCL
15. ID, 6 May 1942
16. William H. Clarke to Eric Brown, 16 June 1941, PABC. Clarke, who was not aware of Brown's death, wrote to arrange a solo travelling show of Emily's work, sponsored by the National Gallery. The plan was stillborn because solo shows of living artists were against gallery policy.
17. *Saturday Night,* 1 Nov. 1941; 8 Nov. 1941
18. Toronto *Globe and Mail,* 8 Nov. 1941
19. Montreal *Gazette,* 8 Nov. 1941
20. *Colonist,* 13 Dec. 1941
21. *Saturday Night,* 8 Nov. 1941
22. Toronto *Star Weekly,* 21 Jan. 1928
23. *Times,* 13 March 1940
24. *Times* (Magazine), 27 Dec. 1941
25. *Province,* 9 Nov. 1940
26. *Province,* 5 Dec. 1942
27. ID, frag. [June 1943]
28. ID, 9:30 Sunday night [7 Dec. 1941]
29. ID, 3:30 A.M. Sunday morn [14 Dec. 1941]
30. ID, 9:30 Sunday [14-16 Dec. 1941]
31. ID, Sunday morning after Xmas [28 Dec. 1941]

CHAPTER 30

1. BS, 10
2. ID, Tuesday [Nov. 1942]
3. EC to Nan Cheney, [13 March 1941], UBCL
4. *Colonist,* 9 Dec. 1942; *Times,* 5 Dec. 1942
5. ID, 30[?] Nov. 1942
6. ID, frag. [Apr. 1944?]
7. Myfanwy Spencer Campbell first met Emily when she was about six. She was a gifted child, and Emily took an interest in her development, arranging a solo show for her when she was fifteen. In the 1940s

Myfanwy visited often in intervals between frequent travels. Emily's trust in her was such that when Emily was very ill, in December 1942 or January 1943, Myfanwy brought her paints, brushes and Mt. Douglas sketches to the hospital and, under Emily's supervision, touched up and signed several paintings (H-S, 216; Myfanwy Pavelic, taped interview with Hembroff-Schleicher, PABC).
8. ID, 26 Aug. 1941
9. ID, Tuesday [Nov. 1943]

10. ID, 14 Feb. [1942]

11. ID, 14 Feb. [1942]; 6 April 1942

12. ID, Epistle No. II Sunday 7 P.M. [16 Feb. 1942]

13. For a fuller discussion of the Emily Carr Trust, see H-S, 145–67.

14. ID, 2 Aug. 1942

15. ID, Tuesday [Aug. 1942]

16. ID, Tuesday [Nov. 1942]

17. ID, 22 Nov. [1942]

18. EC to Mrs. Dilworth, Sat. [summer 1943]

19. ID, 4 Aug. 1943

20. ID, [Sept. 1943]

21. MT, 246, 300; Vancouver *Sun,* 25 Oct. 1941

22. Vancouver *Sun,* 16 June 1943

23. Montreal *Gazette,* 9 Jan. 1943

24. Dominion Gallery, "Statement of Paintings Sold," 6 Dec. 1944, PABC

25. EC to Max Stern, 1 Nov. [1944] (misdated 1 Oct. by Emily), PABC

26. ID, Friday [Jan. 1944]

Selected Bibliography

Amsden, Philip. "Memories of Emily Carr." *Canadian Forum* 27 (Dec. 1947), 206–7.

Barbeau, Marius. *The Downfall of Temlaham.* Toronto: Macmillan, 1928.

———. *Totem Poles.* Bulletin 119. Ottawa: National Museum of Canada, 1950 (2 vols.).

———. *Totem Poles of the Gitksan, Upper Skeena River, British Columbia.* Bulletin 61. Ottawa: National Museum of Man, 1929.

Baxter, Robert W. and Wade Williams. *Richard Carr Residence: Exterior Architectural Analysis.* Victoria: Heritage Conservation Branch, Ministry of the Provincial Secretary and Government Services, April 1984.

Bell, James. "Gold Rush Days in Victoria." *The British Columbia Historical Quarterly* 12, no. 3 (July 1948): 231–46.

Breuer, Michael, and Kerry Mason Dodd. *Sunlight in the Shadows: The Landscape of Emily Carr.* Toronto: Oxford University Press, 1984.

Brewster, Muriel. "Some Ladies Prefer Indians." Toronto *Star Weekly,* 21 Jan. 1928.

Brown, F. Maud. *Breaking Barriers: Eric Brown and the National Gallery.* [Toronto:] Society of Art Publications, 1964.

Buchanan, Donald. *Emily Carr—Painter of the West Coast. Canadian Geographical Journal* 33, no. 4 (Oct. 1946): 186–87.

———. "The Gentle and the Austere: A Comparison in Landscape Painting." *University of Toronto Quarterly* 11 (Oct. 1941): 71–72.

———. *The Growth of Canadian Painting.* London: William Collins and Sons, 1950.

Burns, Flora Hamilton. "Emily Carr." In Mary Quayle Innis, ed., *The Clear Spirit: Twenty Canadian Women and Their Times.* Toronto: University of Toronto Press, 1966.

———. "Emily Carr and the Newcombe Collection." *Beaver* 293 (Summer 1962): 27–35. Also in *The World of Emily Carr* (Exhibition catalogue), Hudson's Bay Company, 1962.

Camas Historical Group. *Camas Chronicles of James Bay.* Victoria: Evergreen Press, 1978.

Canadian Broadcasting Company. "Portrait in Memory" (taped broadcast), 9 April 1958.

Carr, Emily. *The Book of Small.* 2nd edition. Toronto: Clarke, Irwin, 1966.

———. *Fresh Seeing. Two Addresses by Emily Carr.* Toronto: Clarke, Irwin, 1972.

———. *Growing Pains: The Autobiography of Emily Carr.* 2nd edition. Toronto: Clarke, Irwin, 1966.

———. *The Heart of a Peacock.* Edited by Ira Dilworth. Toronto: Oxford University Press, 1953.

———. *The House of All Sorts.* 3rd edition. Toronto: Clarke, Irwin, 1971.

————. *Hundreds and Thousands: The Journals of Emily Carr*. 2nd edition. Toronto: Clarke, Irwin, 1966.

————. *Klee Wyck*. 5th edition. Toronto: Clarke, Irwin, 1971.

————. "Modern and Indian Art of the West Coast." Supplement to the *McGill News,* June 1929, 18–22.

————. *Pause: A Sketch Book*. Toronto: Clarke, Irwin, 1953.

Chalmers, John W. "Klee Wyck." *Alaska Journal* 5, no. 4 (Autumn 1975): 231–38.

Clay, Margaret. "Emily Carr as I Knew Her." *The Business and Professional Woman* 26, no. 9 (Nov.-Dec. 1959): 1, 9.

Coburn, Kathleen. "Emily Carr: In Memoriam." *Canadian Forum* 25 (April 1945): 24.

Colman, Mary Elizabeth. "Emily Carr and Her Sisters." *Dalhousie Review* 27, no. 1 (April 1947): 29–32.

————. "My Friend, Emily Carr," Vancouver *Sun,* 12 April 1952: 14.

Dickson, Samuel. *Tales of San Francisco*. Stanford, Cal.: Stanford University Press, 1957.

Dilworth, Ira. "Emily Carr—Canadian Artist-author." *Saturday Night,* 1 Nov. 1941: 26.

————. "Emily Carr—Canadian Painter and Poet in Prose." *Saturday Night,* 8 Nov. 1941: 26.

————. "M. Emily Carr." *Canadian Library Association Bulletin* 3, no. 4 (April 1947): 112–13.

Duff, Wilson. "Gitksan Totem-Poles, 1952." *Anthropology in British Columbia,* no. 3 (1952): 21–30.

————. *The Indian History of British Columbia*, Vol. I. Victoria: Provincial Museum of British Columbia, 1980.

Dufour, Pat. "Emily Carr Was Her Landlady." *Victoria Times,* 24 March 1964: 25.

Duval, Paul. "Emily Carr's Was a Growing Art." *Saturday Night,* 3 Nov. 1945.

Fawcett, Edgar. *Some Reminiscences of Old Victoria*. Toronto: William Briggs, 1911.

Gessler, Trisha Corliss. "Emily Carr on the Queen Charlotte Islands." *The Charlottes* 5 (1980): 30–40.

Gregson, Harry. *A History of Victoria*. Victoria: Victoria Observer, 1970.

Harris, Lawren. "Emily Carr and Her Work." *Canadian Forum* 21 (Dec. 1941): 277–78.

————. "The Paintings and Drawings of Emily Carr." In *Emily Carr: Her Paintings and Sketches, 1945* (Catalogue). Ottawa: National Gallery of Canada, 1945.

Hembroff-Schleicher, Edythe. "A Cluster of Sunburst—Our Emily." In catalogue for opening of Emily Carr Gallery, Provincial Archives of British Columbia, 8 July 1977.

————. *Emily Carr: The Untold Story*. Saanichton, B.C.: Hancock House, 1978.

————. *M. E.; A Portrayal of Emily Carr*. Toronto: Clarke, Irwin, 1969.

————. *The Modern Room*. Prepared for an exhibition at the Emily Carr Gallery, Victoria, 19 May–11 Sept. 1981.

Housser, F. B. *A Canadian Art Movement*. Toronto: Macmillan, 1926.

Humphrey, Ruth. "Emily Carr: An Appreciation." *Queen's Quarterly* 65 (Summer 1958): 270–76.

————. "Letters from Emily Carr." *University of Toronto Quarterly* 41, no. 2 (Winter 1972): 93–150.

————. "Maria Tippett, 'A Paste Solitaire in a Steel-Claw Setting: Emily Carr and Her Public." (A reply.) *B.C. Studies* no. 23 (Fall 1974): 47–49.

Kearley, Mark Hudson. *Canadian Premiere of "Klee Wyck."* Victoria: Acme Press, 1947.

Kritzwiser, Kay. "Carr: The Angry Artist in Retrospect." Toronto *Globe and Mail,* 13 Dec. 1971.

Jackson, A. Y. *A Painter's Country. The Autobiography of A. Y. Jackson*. Toronto: Clarke, Irwin, 1964.

Lamb, J. Mortimer. "A British Columbia Painter." *Saturday Night,* 14 Jan 1933: 3.

Lambert, R. S. "Artistic Motives—Hidden and Revealed." *Saturday Night,* 27 Feb. 1942: 20.

Large, R. G. *The Skeena: River of Destiny.* Vancouver: Mitchell Press, 1957.

Lugrin, N. de Bertrand. "Emily Carr as I Knew Her." Victoria *Sunday Times Magazine,* 22 Sept. 1951: 3.

———. "Woman Potters and Indian Themes. *Maclean's Magazine,* 15 March 1927: 78–79.

McCormick, E. H. *The Expatriate: A Study of Frances Hodgkins.* Wellington, New Zealand: Wellington University Press, 1954.

———. *Works of Frances Hodgkins.* Auckland (New Zealand) City Art Gallery, 1954.

McDonald, J. A. "Emily Carr: Painter and Writer." *British Columbia Library Quarterly* 22, no. 4 (April 1959): 17–23.

MacFall, Haldane. "The Paintings of John Duncan Fergusson, R.B.A." *International Studio* 31 (May 1907): 202–10.

McGeer, Ada. "The Emily Carr I Knew." Victoria *Daily Colonist,* 25 Nov. 1973: 3.

McInnes, Graham. "World of Art." *Saturday Night,* 7 Dec. 1935: 27.

———. "World of Art." *Saturday Night,* 3 April 1937: 8.

Mellen, Peter. *The Group of Seven.* Toronto: McClelland and Stewart, 1970.

Morgan, Roland and Emily Disher. *Victoria Then and Now.* Vancouver: Bodima, 1977.

Murry, John Middleton. *Autobiography: Between Two Worlds.* New York: Messner, 1936.

National Film Board of Canada. "Klee Wyck." Film, 1948.

Neering, Rosemary. *Emily Carr.* The Canadians Series. Don Mills, Ontario: Fitzhenry and Whiteside, 1975.

Nesbitt, James K. *Album of Victoria Old Homes and Families.* Victoria: Hebden Printing Co., 1956.

———. "The Genius We Laughed At." *Maclean's Magazine,* 1 Jan. 1951: 12–13, 29–30.

Newton, Eric. "Canadian Art Through English Eyes." *Canadian Forum* 18 (Feb. 1939): 344–45.

Nicholles, Richard, as told to T. W. Paterson. "The Real Emily Carr." Victoria *Daily Colonist,* 18 March 1973: 12–13.

Patterson, Nancy-Lou. "Emily Carr's Forest." In *Emily Carr* (Catalogue). Waterloo, Ontario: University of Waterloo, 1967.

Pearson, Carol. *Emily Carr as I Knew Her.* Toronto: Clarke, Irwin, 1954.

Pethick, Derek. *Victoria: The Fort.* Vancouver: Mitchell Press, 1968.

Reid, Dennis. *A Concise History of Canadian Painting.* Toronto: Oxford University Press, 1973.

Rutter, Frank. "The Portrait Paintings of John Duncan Fergusson." *International Studio* 45, no. 179 (Jan. 1912): 203–7.

Ryley, Nancy. "Growing Pains" and "Little Old Lady on the Edge of Nowhere." Two-part film documentary, CBC, 1975.

Salinger, Jehanne Bietry. "Comment on Art." *Canadian Forum* 10, (March 1930): 209–11.

Segger, Martin and Douglas Franklin. *Victoria: A Primer for Regional History in Architecture.* Victoria: Heritage Architectural Guides, 1979.

Scott, Andrew. "Emily Carr." *Arts West* 4, no. 6 (Nov.-Dec. 1979): 24–30.

Seitz, William C. *Mark Tobey.* New York: Metropolitan Museum of Art, 1962.

Shadbolt, Doris. *The Art of Emily Carr.* 1976. Reissued 1987. Vancouver: Douglas & McIntyre; Seattle: University of Washington Press.

———. *Emily Carr* (Catalogue). Vancouver: Vancouver Art Gallery, 1971.

Shotridge, Louis. "A Visit to the Tsimshian Indians." University of Pennsylvania *Museum Journal* 10 (1919): 49–67, 117–48.

Stacton, Derek. "The Art of Emily Carr." *Queen's Quarterly* 57, no. 4 (Winter 1950–51): 499–509.

Stokes, A. G. Folliott. "The Landscape Paintings of Mr. Algernon M. Talmage." *International Studio* 33, no. 131 (Jan. 1908): 188–93.

Swartout, Melvyn. *On the West Coast of Vancouver Island.* Manuscript (by Charles Haicks, pseudonym), Provincial Archives of British Columbia.

Tasker, Peter, and Kerry Dodd. "Travels with Emily." *Beautiful British Columbia* 24, no. 1 (Summer 1982): 36–45.

Taylor, Charles. *Six Journeys: A Canadian Pattern.* Toronto: Anansi, 1977.

Thom, William Wylie."Emily Carr in Vancouver: 1906–1913." In *The Fine Arts in Vancouver, 1886–1930: An Historical Survey.* M. A. Thesis, Department of Fine Arts, University of British Columbia, 1969.

Tippett, Maria. "'A Paste Solitaire in a Steel-Claw Setting': Emily Carr and Her Public." *B.C. Studies* no. 20 (Winter 1973–74): 3–14.

———. *Emily Carr: A Biography.* Toronto: Oxford University Press, 1979.

———. *Emily Carr's "Blunden Harbour."* National Gallery of Canada Bulletin no. 25 (1975): 33–37.

———. "Emily Carr's Forest." *Journal of Forest History* 18, no. 4 (Oct. 1974): 132–37.

———. "Emily Carr's *Klee Wyck.*" *Canadian Literature* no. 72 (Spring 1977): 49–58.

———. "Who 'Discovered' Emily Carr?" *Journal of Canadian Art History* 1, no. 2 (Fall 1974): 30–34.

Tippett, Maria, and Douglas Cole. *From Desolation to Splendour: Changing Perceptions of the British Columbia Landscape.* Toronto: Clarke, Irwin, 1977.

Tobey, Mark. "Reminiscence and Reverie." *Magazine of Art* 44, no. 6 (Oct. 1951): 228–32.

Tobin, B. A. "An Appreciation." Victoria *Times,* 26 Nov. 1962.

Watson, Arnold. "In the Haunts of a Picture Maker." *The Week,* 18 Feb. 1905: 1–2.

Index

Colour reproduction numbers are indicated by **boldface** figures